D1260182

ML B5 T 1/19

AN AMERICAN ODYSSEY

AN AMERICAN ODYSSEY

THE LIFE AND WORK OF ROMARE BEARDEN

MARY SCHMIDT CAMPBELL

OXFORD
UNIVERSITY PRESS

OXFORD
UNIVERSITY PRESS

Oxford University Press is a department of the University of Oxford.
It furthers the University's objective of excellence in research, scholarship,
and education by publishing worldwide. Oxford is a registered trade mark of
Oxford University Press in the UK and certain other countries.

Published in the United States of America by Oxford University Press
198 Madison Avenue, New York, NY 10016, United States of America.

Library of Congress Cataloging-in-Publication Data
Names: Campbell, Mary Schmidt, author.
Title: An American odyssey: the life and work of Romare Bearden/
Mary Schmidt Campbell.
Description: New York: Oxford University Press, 2018.
Includes bibliographical references and index.
Identifiers: LCCN 2017052005 | ISBN 9780195059090 (hardback)
Subjects: LCSH: Bearden, Romare, 1911–1988. | Artists—United
States—Biography. | African American artists—Biography. | BISAC: ART /
General. | BIOGRAPHY & AUTOBIOGRAPHY / Artists, Architects, Photographers.
Classification: LCC N6537.B4 C36 2018 | DDC 700.92—dc23
LC record available at https://lccn.loc.gov/2017052005

1 3 5 7 9 8 6 4 2
Printed by Sheridan Books, Inc.,
United States of America

To Harvey and Elaine, who nurtured and nourished.
To George, who loves unconditionally.
To Garikai and Diana; Sekou and Jasmine;
Britt and Jill who continue to inspire.
January 2018

CONTENTS

IN-TEXT ILLUSTRATIONS

ILLUSTRATIONS IN
GALLERY OF COLOR PLATES

AN AMERICAN ODYSSEY

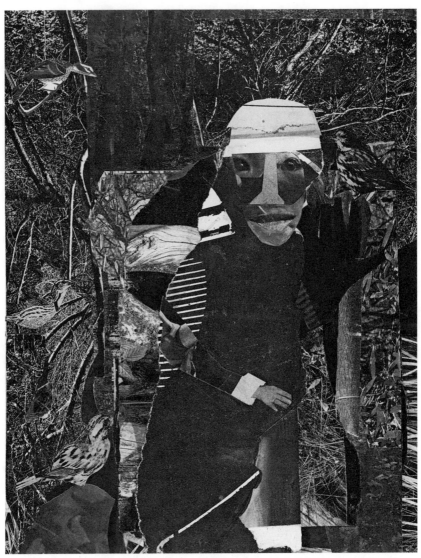

Conjur Woman, 1964. Photo projection on paper, 64 × 50 in. Studio Museum in Harlem. Gift of the Artist, 1972.5.

INTRODUCTION

On October 6, 1964, at the height of the American civil rights movement, fifty-three-year-old Romare Bearden, a mature artist with a moderately successful career as a painter behind him, debuted nearly two dozen billboard-size, black-and-white, photographic enlargements of collages—*Projections,* he called them. Instead of the large abstract work he had been painting up to then, he filled his canvases with the faces of black people. Their expressions, unflinching and intense, dominated crowded city streets, southern cotton fields, and ecstatic rituals. Spontaneous passions seemed to erupt from these works, filling the walls of Cordier-Ekstrom, Bearden's gallery on the Upper East Side of New York.

Some called his creations a sign of the turbulent times: the 1950s Montgomery bus boycott and *Brown v. Board of Education* Supreme Court ruling; 1960s lunch counter sit-ins, freedom rides, the March on Washington, and passage of the Civil Rights Act in 1964, the year of *Projections.* A surge of civil rights activism swept the country, compelling an urgent need for change. Figures in Bearden's *Projections* embody that urgency, confronting their viewers like characters in a play caught in mid-action.[1] At first glance the figures in *Projections* look ordinary, as if the artist were merely reporting a news event, except faces are fractured and dislocated, their hands swollen to twice their normal size, bodies pieced together from startling juxtapositions, including, as one commentator notes, "parts of African masks, animal eyes, marbles, corn and mossy vegetation."

"Grotesque" might be too harsh a word to describe some of the figures in the *Projections.* Yet they evoke a history of distortions of black

life even as they also reenvision that life. Bearden's friend Ralph Ellison used the word "disturbing" to describe the figures in the work; their stridency, he noted, was completely out of character for an artist who, until that exhibition, was not known for representations of race.[2] Why did Bearden so emphatically and comprehensively change the style and subject matter of his art? What light does it shed on Bearden's identity as an artist, and on the ironies and complexities of twentieth- and now twenty-first-century representation of black bodies? Those questions go to the heart of this biography.

One of those *Projections* hung for many years in my office at the Studio Museum in Harlem. Entitled *Conjur Woman*, it was a gift from the artist to the museum's permanent collection and asserted a commanding presence in a busy place, several floors above the noise and congestion of 125th Street. Bearden has depicted her in the solitude of the woods, birds flocking to her. Everything about her challenges the conventions of American beauty defined by movie stars or fashion models. Her face is a mask composed of cut paper; her eyes are made from photographs of a cat. She is "disturbing," as Ellison said. Her body is dislocated: her enlarged left hand presses close to the front of the picture plane; her right hand is tiny and white. She wears a band of gold on her finger, and her elbow, which consists of an X-ray, exposes bone. Bearden deliberately both gave her the appearance of a relic from the past and endowed her with her own very present authority. He found a means to disinter a world, in Ralph Ellison's words, "long hidden by the clichés of sociology and rendered cloudy by the distortions of newsprint."[3]

The world Romare Bearden unearthed and reconstructed for the *Projections*—a world he continued to develop in collages from 1964 until his death in 1988—was both celebration and assault, as disturbing as it was joyful. He celebrated the continuity of his past, the traditions and ceremonies of black culture, and connected its rituals to the rituals of other cultures. The organizing phrase he invented for that continuity—*The Prevalence of Ritual*—became the guiding principle of his collages. At the same time he set out to reimagine his past, he conducted an assault on the distortions of that past. Bearden's collages struck at the heart of what author and activist, bell hooks, has called,

2

"American visual politics"—the realization that all seeing takes place, ultimately, within a political frame.[4]

Bearden's meticulously handcrafted collages acknowledged that American visual culture had become as powerful as the written word in forging identity and establishing civic legitimacy. Technology fueled its ascent. The invention of photography and later color print techniques in the nineteenth century gave national news magazines and periodicals the means to fill their pages with images. The invention of portable cameras, the circulation of popular prints, sheet music, and commercial catalogues meant that even before the advent of cinema and later television inundated the country with mass entertainment, visual narratives were etching themselves into national consciousness. Bearden came of age during a debate centering on the representation of black life and culture.

Bearden himself steadfastly rejected political explanations of his art, even *Projections*. Yet, his life—his childhood, coming of age, and emergence as a major artist—intersected squarely with a battle over representation. It was not a new fight, for it had started in the aftermath of the Civil War and become a proxy for a violent and desperate war in the public, social, and legislative spheres over who enjoys the rights and privileges of citizenship. Before the Civil War, American citizenship flatly excluded slaves, the status of the overwhelming majority of black people in the New World. Emancipation and the Thirteenth, Fourteenth, and Fifteenth Amendments radically changed that status. Theoretically, they defined, and should have safeguarded, citizenship rights for newly freed slaves. To celebrate and record and, most of all, project their newly acquired identities, black Americans often turned to self-representation, to photography.

Henry and Rosa Kennedy, Bearden's great-grandparents, proud of their new citizenship status, understood the affirmative documentary value of photographs. An enlarged photographic image of them (probably taken in the 1920s) hung on the wall of Bearden's studio. Former slaves, the Kennedys had become prosperous landowners and entrepreneurs after the Civil War in Charlotte, North Carolina. "Romie," as he was called, was born in their home on September 2, 1911. The photograph

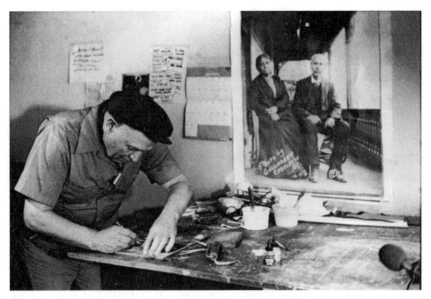

Romare Bearden in his Long Island City studio
with a photograph (ca. 1920) of H. B. and Rosa Kennedy on
their porch. Photo: Frank Stewart.

shows the Kennedys sitting on the porch of their home. Rosa Kennedy looks into the camera with almost open defiance. Bearden did not discover this photograph until he returned to Charlotte years after the 1964 debut of the *Projections*. Nonetheless, he replicated her fierceness in the faces in *Projections*. He captures the same quality of interior life present in this ancestral photograph. As sociologist Robin Kelly observes, early photographs often captured "the interior life of Black America, the world either hidden from public view or forced into oblivion by the constant flood of stereotypes."[5]

Long before Bearden's grandparents recognized the value of photography, Frederick Douglass addressed the topic of representation in a series of lectures begun in 1861, entitled "Pictures and Progress."[6] Douglass, who with his thick mane of hair and powerful facial features became one of the most photographed figures in the nineteenth century, grasped the power of the photograph to counter prevailing stereotypes. At the time that he was preparing his lectures, black people were being

caricatured in widely popular minstrel shows. By the end of the nineteenth century, a range of methods—lithographs, wood engravings, etchings, and, of course, photography—translated the distortions of minstrel imagery into print, enabling mass distribution of demeaning visual images of black people. By the end of the nineteenth century, as Henry Louis Gates has noted, "It would have been possible for a middle class white American to see Sambo images from toaster and teapot covers on his breakfast table, to advertisements in magazines, to popular postcards in drug stores."[7]

In the decade before Bearden's birth, W. E. B. Du Bois, like Douglass before him, recognized the potency of visual images. On the occasion of the 1900 Paris Exposition, Du Bois was asked to participate in the organization of a Negro section of the American Pavilion. Housed in a building separate from the main American Pavilion, the Negro section included, among other presentations, an exhibition of 300 photographs of educated, entrepreneurial, black middle-class citizens. The handsome men and women at work, in classrooms, and living out their daily life in fastidiously appointed homes demonstrated to the world, in Du Bois's estimation, that the transformation from slave to contributing citizen was a triumph of American democracy. Photographs were the visual evidence of progress. The triumph was short-lived. On Du Bois's return to the United States, after a brief exhibition in upstate New York, the photographic display was dismantled. The photographs, artifacts, and evidence of past lives were preserved by a black archivist in the Library of Congress archives, hidden, until recently, from public view. Recognition, loss, and re-discovery are recurrent themes in Bearden's odyssey.

Du Bois would become one of Bearden's patrons and supporters and a friend of the Bearden family. He and a growing number of black photographers—as well as men and women like Rosa and Henry Kennedy, who commissioned their work, and those who displayed and preserved them—were the foot soldiers in a resistance movement. That movement became increasingly assertive in the twentieth century. Less than twenty years after Du Bois's exhibition publicly displayed the content of the lives and culture of the country's new black citizens, D. W. Griffiths

produced the first cinematic blockbuster, *The Birth of a Nation*. In an instant, cinema replaced photography in creating in the public imagination an encyclopedic collection of demeaning and, in the case of *The Birth of a Nation*, threatening images of black people. Over time, print media, film, television, advertising, and journalism generated volumes of "clichés" that threatened to bury a more authentic visual world. Bearden may have disavowed politics, but the visual world in which his images existed was—and would remain—intensely political.

To tell Romare Bearden's story, his personal odyssey, is to recount as well the story of how that world came to be. By the time Bearden was constructing his collage paintings in the 1960s and then blowing them up into black-and-white enlargements, film, television, advertising, journalism, and documentary photography were standard bearers of beauty and fashion, symbols of mainstream American cultural identity, and acting as sales pitches for everything from televisions to politicians. With the advent of the Internet and social media in the twenty-first century, the potency of visual culture's reach only continued to grow.

Bearden insisted that his work—paintings and collages—was neither propaganda nor sociology. During his life and after his death, his reputation has rested primarily on his collages, a blend of visual memoir and emotional realism that evokes a rapidly disappearing past. When I was a graduate student, he wrote me a letter in which he explained the phrase he has used for images of the past in *Projections*—the "prevalence of ritual": "My paintings can't be only what they appear to represent. People in a Baptism, in a Virginia stream, are linked to St. John the Baptist, to ancient purification rites and to their African heritage. I feel this continuation of ritual gives a dimension to the works so that the works are something other than mere designs." The "continuation of ritual" allowed him to link a quotidian scene of black women in a courtyard to a seventeenth-century Pieter de Hooch painting of Dutch women in a courtyard. A mother holding her child is made to resemble a thirteenth-century Byzantine painting of the Madonna and Child. Pages of correspondence, diary entries, interviews, his own writings, and the book that he co-authored with Carl Holty, *The Painter's Mind: A Study of the Relations of Structure and Space in Painting,* in which

they set out to articulate the common formal attributes that all great art shared, all attest to a lifetime of artistic exploration.[8]

By his own account, Bearden was first and foremost a student of painting. He spent a lifetime methodically studying and copying masterpieces of Western painting and studying art forms as varied as Persian miniatures, classical Chinese scrolls, and African antiquities. Viewing his collages is like taking a tour of the Uffizi, the Louvre, the Metropolitan Museum of Art, the Musée de L'Homme and the Studio Museum in Harlem; reading the history of Chinese painting; and viewing a collection of Persian miniatures—all at once. His collages reap the benefits of André Malraux's Musée Imaginaire or "Museum without Walls," an idea Malraux introduced just after World War II.[9] Malraux observed that museums around the world housed vast amounts of art from all periods, styles, and cultures. Photographic reproduction made it possible to access these global repositories of art and construct in our imaginations our own museum, the museum of the imagination or the museum without walls. Bearden's collages are a testament to the vitality of Malraux's ideas.

A connoisseur of the past, Bearden was also a master of European and American modernists. From the time he published his first essay on art in 1934, "The Negro Artist and Modern Art," he declared his loyalty to modernism's new ways of seeing and representing. Under the tutelage of the German modernist George Grosz, with whom he studied during the Depression years, he opened himself up to modernism's formal dislocations and distortions as well as its subversiveness. Bearden's odyssey was an often tortuous journey of making art, a decades-long process of first trying on then discarding one approach to painting after another, finally culminating with the *Projections*. The collages he completed in the last two decades of his life compare with those by modernism's great collage artists—Pablo Picasso, Georges Braque, Kurt Schwitters, Hannah Höch, and Robert Rauschenberg, and in the twenty-first century, Kara Walker and Wangechi Mutu.

Yet to understand Romare Bearden's odyssey is to take into account the clashes and contradictions of the world into which he was born. That world was one of quarreling visual images and, to borrow a phrase from

scholar/poet, Kevin Young, "multiple inheritances."[10] Bearden was born into a world in which mainstream American visual culture, on the one hand, promoted reductive images of black people. Douglass and Du Bois, on the other hand, were early observers of the potency of visual images as an assertion of identity, cultural complexity, and truth-telling. Bearden's collages are a lightning rod for the clashes and contradictions of those "multiple inheritances." Those contradictions manifest themselves in the multiple labels that adhere to him. Was he an artist, a black artist, or an artist who happened to be black? Critics and curators have placed him in any number of contexts—with collage artists, with black Atlantic artists, among American Abstractionists, or with artists from the civil rights era. He confounds the taxonomies of conventional art, and it is tempting to see him as an artistic Everyman. His beginnings were rooted in a sharply divided American culture, and reconciling these divisions was one source of his artistic restlessness. In the last interview he gave before his death in March 1988 (published months after he died), he reaffirmed his need to take in everything, "like a whale or something; you're going along, you're taking what you have to eat, the plankton or whatever get [sic] in there; and what you don't like, you just spew out." Still, every artist needs an anchor, a sense of self. "But I think that you first have to assert what you are. And you look in and find what your art needs."[11]

Bearden had the great good fortune of being anchored by Harlem's New Negro Movement, in which he came of age, though he spent time as well in the segregated precincts of Pittsburgh, Charlotte, and the outskirts of Baltimore. His mother, early in their Harlem residency, a ticket-taker at the Lafayette Theater on 132nd Street and Seventh Avenue during its glamorous heyday, introduced him to the spectacle of live theater. As a boy he stood on the curb on Seventh Avenue, watching the magnificent parades, men and women marching in organizational regalia; as a young adult, he frequented Harlem's cabarets and dance halls, taking in the elaborately costumed chorines and fastidiously garbed musicians. In Harlem he encountered the works of gifted black sculptors, painters, photographers and printmakers and joined a close-knit community of black creative artists. His childhood offered a banquet

of visual complexity and sophistication, and he came to celebrate it as completely as the paintings of Western masters he studied. Yet as opulent as this heritage may have been, for many years he was unable to see and understand its meaning or find a way of applying it to his art.

Odysseus journeyed for a decade before he reached home. It would take Bearden nearly thirty years for him to discover what his past had given him. To follow that discovery, we need to follow the chronology of his life: his birth in Charlotte and itinerant childhood that took him to the Tenderloin district in New York, briefly to Saskatchewan, Canada, then to Harlem with summers in Charlotte, and Lutherville, Maryland. Harlem was home, but twice he spent time during the school year in Pittsburgh. He lived in the homes of his parents, grandparents, and great-grandparents and became a keen observer of each household's rules and culture. He witnessed the lives of the children who worked the cotton fields that bordered his home in Charlotte, the migrants who came back from the steel mills to his grandparents' boarding house in Pittsburgh with scorched backs, and the rituals of family and church that wove through his various homes.

Bearden was anchored by a Harlem that valued the arts, though the world was still deeply ambivalent about the role of black visual artists and the rights and privileges of black citizenship. His great-grandparents were the products of Reconstruction, bent on embodying a new image of prosperity and success to represent the country's newest citizens. Bearden's parents escaped the constraints of a Jim Crow South believing that the promise of a more expansive life awaited them in the North. Bearden spent his childhood at the heart of the New Negro Movement, his mother fully realizing those opportunities as she cycled through her multiple roles, in addition to her work at the Lafayette: political impresario, social arbiter, journalist, community activist, renowned spokesperson and public figure, and most of all keeper of one of the most vibrant artistic salons of the time. Her son came of age as an artist at the height of the Depression, when public support of the arts briefly opened doors for black and white artists alike, and Harlem's night life was an incubator for daring musicianship and artistry. When public support halted and doors shut, Bearden began to redefine his artistic identity.

9

Bearden's life consists of a series of artistic self-redefinitions. Political cartoonist in his youth, he was an unabashed "race man." As a caseworker assigned to the tenements of Harlem after he graduated from New York University in 1935, he was a painter of social injustice. Though he enjoyed the admiration of some of his peers, he encountered critiques from some of his friends, who considered his representations of black laborers and struggling families unflattering and unrepresentative of the middle-class life he enjoyed. He enlisted in the US Army during World War II just as alienation from his own community had begun to affect him deeply. His mother's sudden death during the war, the indignities of serving in a segregated army, and the cultivation of a new set of artistic relationships all pushed Bearden to abandon black subject matter. He turned to literature and to universal themes of death, rebirth, and war that inspired lyrically figurative abstractions.

After his discharge from the army, Bearden's life took what he believed at the time was a fortuitous turn. He was invited to join the Samuel Kootz Gallery, one of New York's arbiters of up-and-coming Abstract Expressionists. His membership turned out to be short-lived. Kootz determined that Bearden's brand of abstraction, reminiscent of Picasso and Cubism, was no longer in the vanguard but regressive. Bearden turned his back on the New York art world and, with assistance from the GI Bill, sailed to Paris, where he lived and studied for several months.

On his return to New York at the end of the summer of 1950, he resumed his job as a social worker—a job he would keep well into the 1960s—and became a songwriter. A bachelor and principal caretaker for his widowed father, he had resisted marriage until his forties. In the fall of 1954 he married a model and fashion designer, Nanette Rohan. Nanette would prove to be his North Star. When he suffered a nervous breakdown—the timing of which is often disputed—she prodded him back to painting, encouraging him to leave the distractions of songwriting, and clearing a path to the way home.

Bearden's return to painting after his breakdown resulted in large nonobjective, expressive oils with poetic titles—*Friends of the Night, Night Watches in Silence, Wine Star, Silent Valley of the Sunrise, Old*

Poem. A new dealer, Arne Ekstrom, like Nanette, would prove to be an expert guide and navigator. Ekstrom recognized that though Bearden's abstract paintings enjoyed positive critical success, they were becoming repetitive. On Ekstrom's advice, Bearden allowed what had been some artistic experiments to take center stage. A series of events in 1963 encouraged these experiments. Inspired by the March on Washington, Bearden, along with several other black artists—Norman Lewis, Hale Woodruff and Charles Alston—formed the artists' collective Spiral. Spiral was a turning point in Bearden's life. The reestablishment of a community of black artists, the energy of a nationally televised march, and Ekstrom's wise advice emboldened the public debut of Bearden's radically transformed approach to painting and to representation. A year after the march, *Projections* literally burst on the scene at the Cordier-Ekstrom Gallery.

Publicly, *Projections* and the collages looked as though they came out of nowhere. But they were the result of several years of on-again, off-again experiments in representation and in collage. After his return from Paris, Bearden resumed drawing from models, from black models in particular, experimenting with collage, and building on motifs from earlier works. He exhibited few of these experimental works. They demonstrate, nonetheless, that images of black men and women—especially women—were seeping back into his artistic consciousness and onto his canvases. When *Projections* debuted, Ernest Crichlow, a fellow Spiral member and co-founder, with Bearden and Norman Lewis, of the Cinque Gallery, referred to them as a "homecoming."[12]

Bearden's exhibition of *Projections* was widely hailed as a breakthrough. In choosing collage, Bearden intentionally selected a medium in which he could substitute the ready-made with the imaginative reconstruction of the visual world. The works that followed are the product of a life that ran parallel to America's own struggle with old ways of seeing and knowing. Civil rights, a catalyst of Bearden's full embrace of his new work, attempted to forge a new way of being American, to open up the single narrative to multiple stories—an effort still under way.

In *Prevalence of Ritual* Bearden was finding his way home by rediscovering black subject matter, but home for him was as global as it was

local; as black as it was white; North American, Middle Eastern, European, Asian, and African. Home was a battlefield and a fortress, a past and a future, and a way of seeing and knowing race, culture, and identity. Bearden may be an Odysseus, but he is a modern Odysseus, and home for him suggests the complexities of identity, self, gender, race, ethnicity, and nationality that keep fracturing comfortable notions of unity. Following Bearden as he searched for his way back is the subject of this book.

PART I

TERMS OF THE DEBATE

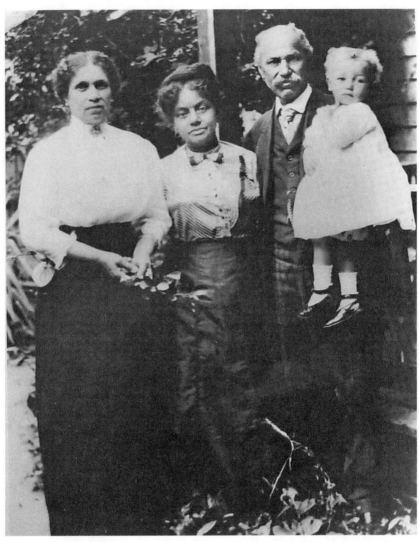

H. B. Kennedy holding Romare Bearden in his arms,
standing next to Rosa Kennedy and Cattie Kennedy Bearden
in front of the family home in Charlotte, NC, ca. 1912/1913.
Romare Bearden Foundation Archive, New York.

ORIGINS

Life begins well, it begins enclosed, protected, all warm in the bosom of
the house.

—Gaston Bachelard, *The Poetics of Space*, 1958

Fred Howard Romare Bearden was a beautiful child. In a photo taken
in 1912 or 1913, his great-grandfather Henry Kennedy—the family
patriarch—proudly holds the baby boy in his arms. Romie (as his family
came to call him) was a light-skinned boy with pale eyes and light brown
curls, and in this photo he wears a white dress, white ankle socks, and
black patent leather shoes. Next to Kennedy stands his wife, Rosa, and,
next to her, their widowed daughter and Romie's grandmother, Catherine
"Cattie" Kennedy Bearden. They are a handsome group. The two women
exude self-assured elegance, wearing long skirts and blouses buttoned
high on the neck. Their hair is neatly coiffed—one wears a severe middle
part and the other sports a careful bun. Kennedy is formally dressed in
a suit, tie, vest, and cravat, his watch chain barely visible, a walrus mus-
tache draped over his lip. The photographer has staged the family in the
front yard of the Kennedys' Victorian home in Charlotte, North Carolina.
A wind chime hangs on the porch and a well-tended garden graces the
exterior. H. B., as Henry Kennedy was known, owned not only this
house but several surrounding properties as well. A businessman and
property owner, H. B. was part of a tiny circle of black families who
thrived in Charlotte from the end of the nineteenth century to the early
years of the twentieth.[1] Their lives, aesthetics, traditions, and rituals
were among the legacies the toddler perched on his great-grandfather's
arm would come to use as an artist.

Mundane as the photograph might seem, it was a vital record of the family's status at a time when visual images were fast asserting power and influence. Romie Bearden was born into a privileged world on September 2, 1911, delivered in a room of the gabled house at 401 South Graham Street by one of Charlotte's several black physicians.[2] The Kennedy and Bearden families were united when Richard P. Bearden and Cattie married around 1882, and they all became prosperous Charlotte businesspeople. Their photograph captures a successful post-Reconstruction black family that had hoisted themselves "up from slavery" and were filling their home with successive generations of black citizens—contributing members to Charlotte's thriving economy. The portrait is one of several of the Kennedy-Bearden family that has them, consciously or unconsciously, engaging in a national debate over the representation of the country's newest citizens—a debate which, decades later, Bearden would continue in his art. That debate grew louder and more urgent as Henry and Rosa Kennedy attempted to claim and then retain their rights and privileges as full-fledged American citizens in the years after the Civil War.

These claims came at a transformative time for American visual culture. Just as the Kennedys and others were enjoying the fruits of their new entitlements, there was a backlash, turn-of-the-century vitriol that fueled verbal and written debates about the millions of newly enfranchised black citizens. The increasing use of lithographs, wood engravings, and etchings as well as photography enabled the wide circulation of cruel and demeaning parodies and satires of everything families like the Kennedys were striving to achieve. In the years after slavery, pictures of sambos; lusty bucks; buffoonish coons; solicitous, grinning mammies; and—as Bearden himself would write as an adult—"head in the watermelon caricatures" proliferated.[3] Facilitated by illustrated magazines, which rose to prominence as an early form of mass media, satirical illustrations mocking black aspirations could be found in *Harper's*, *Puck*, *Nation*, and *Frank Leslie's Illustrated Newspaper*, as well as *Currier and Ives*, the publishers of popular prints. Circulations of the illustrated periodicals grew rapidly to tens of thousands and—in the case of *Harper's* during its heyday—hundreds of thousands. Bearden's

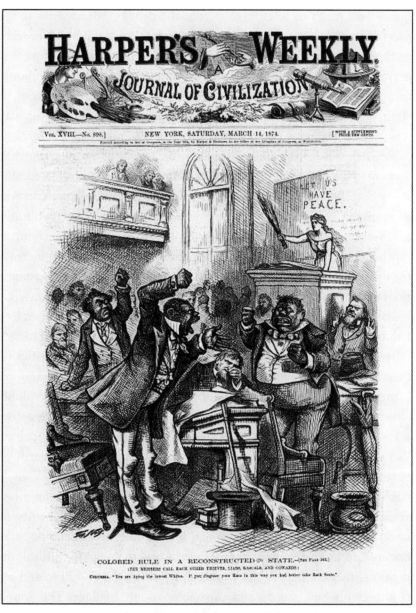

Thomas Nast, "Colored Rule in a Reconstructed (?) State
(The Members Call Each Other Thieves, Liars, Rascals and Cowards)."
Harper's Weekly 18, no. 898 (March 14, 1874), 229 (cover).
Library of Congress, Prints & Photographs Division.

family had much to lose or gain from the debate. Advertisements for everyday products, sheet music, theater, the new medium of moving pictures, and photographs—especially the macabre practice of photographing the lynching of black citizens—attempted to reduce the industriousness of families like the Kennedys and Beardens to allegories of sloth, or worse, a threat to the moral order. American visual politics was a battlefield. Representation was a matter of life and death, not just art.

Bearden would eventually invent a visual legacy of his own, one that accounted for such representational disruptions of art and life. Ironically, the same technological advances that made rampant the misrepresentation of emerging black citizens in the United States catalyzed a revolution for Western art in Europe. Photography and other forms of mechanical reproduction that could faithfully "imitate reality" inspired an increasing number of European artists to question the most inviolable assumptions about painting and its mimetic relationship to the real world. What are now considered masterpieces of twentieth-century modernism like Pablo Picasso's *Les Demoiselles d'Avignon*, 1907, or Henri Matisse's *Portrait of Madame Matisse*, 1905, were regarded by some critics of their time as grotesque distortions of the real world. Artifacts and art forms from all over the world, the spoils of European trade and colonialism, made their way to Europe's cities, giving artists access to alternative ways of thinking and seeing. Peruvian death masks, Japanese prints, Iberian sculpture, African masks and statuary challenged standards of beauty and modes of representation. As an artist, Bearden acknowledged and sought to emulate the formal distortions of European modernism. As a mature artist he would use those formal elements to undermine and comment on political distortions prevalent in popular culture and fine arts. His accomplishment was to navigate cultural imperatives that cut across black and white, old world and new, and reconstruct his own sturdy and capacious visual language. The young Bearden who inherited those multiple cultures was heir, too, to a rich visual tradition that blossomed in the homes and churches of Charlotte's newest citizens, on the streets where they gathered in front of storefronts, in the cotton fields and textile mills that bordered Mr. Kennedy's home, and on the trains Bearden came to know well.

Long after the Victorian House on 4th Street and Graham was de-molished, Bearden's enlarged 1920 photograph of Henry and Rosa Kennedy sitting on their porch greeted visitors to his Long Island City studio in New York. As Bearden stood at his drafting table piecing to-gether his collages, Henry and Rosa were close by. Their story is the foundation of Romare Bearden's future stories.

Henry Kennedy was born in 1845 in Chester, South Carolina.[4] Rosa Catherine Gosprey, the woman who would become his wife during the Civil War, was born around 1847 in Charleston Neck, South Carolina, on the plantation of a well-to-do carpenter Francis Gosprey.[5] Rosa and Henry gave birth to their first and only child, Rosa Catherine, in Chester on December 22, 1863, the year of the Emancipation Proclamation—an auspicious sign.[6] The Kennedy family eventually made their way to Augusta, Georgia, where for several years Henry was the servant of Joseph Wilson, the father of future President Woodrow Wilson.[7] Reverend Wilson, a staunch Confederate who during the war trans-formed his home into a hospital for wounded Confederate soldiers, held little hope for the improvement of blacks during Reconstruction. Henry, nonetheless, was proud of a chair gifted to him by his former employer. Augusta also gave Henry his first business experience, when he worked in an ice cream saloon. Rosa, a homemaker, taking advan-tage of her new citizenship rights, opened an account at the short-lived Freedman's bank.[8] In the twilight of Reconstruction, the Kennedys moved to Charlotte, where city records show that Henry began acquir-ing land.[9] Charlotte was a city that, for a few brief decades, permitted a sturdy minority of the country's newest citizens to convert the skills they had acquired during slavery into prosperous livelihoods.[10]

Of all of the legacies the Kennedys bequeathed to their great grand-son, none was more instructive than their capacity for reinvention. By the end of Reconstruction, which lasted from 1865 to 1877, they had shed their old indentured identities. With the ratification of the Thirteenth, Fourteenth, and Fifteenth Amendments to the Constitution between 1865 and 1870, the promise of that new life seemed guaranteed. At least, the-oretically, they could now own property, work for their own gain, deposit money in one of the several Freedman's banks, amass wealth, attend

school, participate in governance, sit on juries, sue and be sued, and not only could they vote but hold public office. South Carolina, the state of Rosa and Henry's birth, boasted more elected black legislators than any other state during Reconstruction. Many were literate property owners and taxpayers, their rising political power demonstrating the results of fully enfranchised black citizenry.

Bearden's great-grandparents, a minority, were able to take advantage of the opportunity. At the turn of the nineteenth century, over 50 percent of the black population in North Carolina was illiterate. Most black laborers were landless, indentured to Carolina cotton plantations through a brutal and feudal sharecropping system. In testimony before a Senate Committee in 1883, Thomas Fortune, a black editor of the *New York Globe*, the *New York Freeman*, and the *New York Age*, described conditions for farm laborers throughout the South. Historian, Howard Zinn, in his classic, *A People's History of the United States*, recounts Fortune's testimony:

> The average wage of Negro farm laborers in the South was about 50 cents a day....He was usually paid in "orders" not money, which he could use only at a store controlled by the planter, "a system of fraud." The Negro farmer, to get the wherewithal to plant his crop, had to promise it to the store, and when everything was added up at the end of the year he was in debt, so his crop was constantly owed to someone, and he was tied to the land, with the records kept by the planter and storekeeper so that the Negroes "are swindled and kept forever in debt."

As for the penitentiary system, its main purpose, in Fortune's words, was "to terrorize the blacks and furnish victims for contractors, who purchase the labor of these wretches from the State for a song,"[11] perpetuating a state of de facto slavery for many.

Legislation and Supreme Court decisions were of little support to Bearden's family. So-called Black Codes passed by southern states in 1865 and 1866 set limits on newly won constitutional rights, limiting mobility, attempting to reenslave with indenturing labor laws, and prohibiting the franchise with overbearing restrictions. With the

departure of federal troops in 1877 came a raft of separatist Jim Crow legislation buttressed by a spate of Supreme Court decisions that reinforced restrictions on social mobility and political freedom. The Court struck down the Civil Rights Act of 1875, and the 1896 *Plessy vs. Fergusson* case legalized segregation. By the time of Bearden's birth, American law had erected a wall of racial divisions enforced by physical violence. Armed militia, such as the Red Shirts, Ku Klux Klan, and Knights of the White Camellia mobilized to halt the ascendance of this new group of citizens by intimidating officeholders and public officials.

Henry and Rosa's decision to move to Charlotte was fortuitous. The city, briefly, was an island of racial détente. Henry and Rosa, along with their daughter Catherine, adopted what they believed was a winning strategy—hard work and visible respectability. Clarence Smith, founder and editor of Charlotte's first black newspaper, the *Charlotte Messenger*, prescribed this respectability in his June 1882 inaugural edition. Smith advises newly minted citizens to own land and avoid "smoking cigars, drinking whiskey, pleasure riding, wearing jewelry, fine dress."[12] Education and impeccable morals were imperative for success, according to Smith. When H. B. and Rosa arrived with Cattie, Charlotte was a city on the move. In 1890, its population was 7,000. By 1900, it boasted 18,000 residents. Blacks gained a solid foothold in the city between 1880 and 1920, and this burgeoning black middle class held any number of skilled jobs: barbering; carpentry, bricklaying, construction, and owning and managing grocery stores, funeral homes, insurance companies, butcher shops, drug stores, funeral parlors, churches, hotels, and schools.

Though Charlotte was progressive, it was still mostly segregated.[13] Built on a grid, the city was divided into four wards. After Reconstruction, the second and third wards—Mr. Kennedy's properties were in the third—were virtually all black. Despite or perhaps because of segregation, black businesses thrived, often housed in imposing physical structures. The all-black nurses, doctors, and technicians of the Good Samaritan Hospital, for example, worked and cared for patients in a red brick, block-long building, fronted by a meticulously kept lawn. Several of the city's many black churches were housed in handsome brick structures with modern facilities. Black professionals occupied elegant Victorian wood frame homes.

Long before Bearden's birth, H. B. established himself as one of Charlotte's leading citizens. He was once proposed as a candidate for assayer of the city, a prestigious post that would not have normally gone to a "colored," as he is identified in the April 8, 1897, *Charlotte Observer*.[14] Out of such achievement, Bearden was born into a community that longed to believe that their shared progressive goals, optimism, and visible success were everlasting.

Trains played a key role in Charlotte's rapid growth and, consequently, in Henry Kennedy's success.[15] Charlotte had become a railroad hub where several major new lines converged connecting the city to the cotton fields of the Deep South and markets in the North, a connection that fueled the growth of its fast-growing textile industry. H. B. first found work in Charlotte as a mail agent for the Charlotte, Columbia, and Augusta Railroad, a short line that ran the 191-mile route from Augusta, Georgia, through Columbia, South Carolina, north to Charlotte. During the 1870s, the practice of sorting mail aboard trains was increasing the efficiency of the United States Postal Service, and mail agent, an enviable job, required the ability to read and think quickly.

WANTS TO BE ASSAYER.

Congressman White Couldn't Endorse Kennedy Because He is Supporting Clanton—His Other Endorsements.

Special to the Observer.

Washington, April 7.—Representative White, of the third district, has received a petition signed by the Conference of the A. M. E. Zion Church, recently held at Charlotte, strongly urging the endorsement of Henry B. Kennedy, a prominent member of the colored race in North Carolina, who wants the position of assayer of the Charlotte mint.

On account of a promise given in January last, Representative White has already endorsed the application of J. D. Clanton for that position, but he filed with Secretary Gage, not only the petition of the members of the Conference, but other papers urging the selection of Kennedy.

H. B. Kennedy's nomination for Assayer position. *Charlotte Observer*, April 8, 1897, 1.

H. B. held that position for several years, even as he developed other businesses and sources of income. Bordering H. B.'s home was the Southern Railway trestle, so close that Bearden could sit on the porch with his great-grandfather and watch the trains go by. In the process, tutored by H. B., he became a connoisseur of trains, their destinations, and the meanings of their blasts and whistles.[16]

Beyond work on the railroad, Charlotte land and financial records document H. B.'s forays into business. He first acquired property in 1878 and a year later became a grocery store owner and a wood dealer. In subsequent years, as city property records indicate, he shrewdly parlayed his original quarter-acre lot into an impressive group of properties that stretched along the old Southern railway, including several houses, which he rented out. At the height of his prosperity, he owned four houses on south Mint Street aside from his own four-bedroom home and grocery store. With the railroad trestle on one side of his property and the Magnolia Textile Mill, one of the many mills that began to populate Charlotte at the turn of the century, bordering the other side, H. B.'s land was bounded by Charlotte's most important industries—railroads and textiles. His properties were also within walking distance to cotton fields. Picking cotton, back-breaking labor, fueled the city's growing industries even as it defined the lives of the black men and women Bearden would eventually paint.

Despite the fact that they were in the minority, H. B. and Rosa had every reason to believe that with their arrival in Charlotte, they had reached the Promised Land. Many in the black middle class shared their view. A December 13, 1888, article in the *Star of Zion,* a publication of one of Charlotte's African Methodist Episcopal (AME) churches, expressed the optimism that a family like the Kennedys must have felt in their cosmopolitan Southern city: "There can never be, while times last, any change in the status of the colored people on this continent except for the better....They have all been raised to the high position of full citizenship, and the laws of the most advanced and most enlightened progressive and best system of government on the face of the earth." The writer was convinced that given the successes of the black middle class, "The world does not move backwards."

Women played a prominent role in this progressive view of the world, and especially in the Kennedy family, women reigned. Bearden's great-grandmother Rosa was a stern presence who maintained a strict household. She asserted fierce control over her meticulously kept home and admitted few diversions. Rosa and Cattie, both temperance advocates, forbade alcohol in the house. Music, other than religious hymns played on the piano, was also strictly forbidden. Church was a central institution in their lives, and the family was active in the sedate Episcopal Church, Saint Michaels and All Angels, where Bearden was baptized, and where Romie's father, Howard Bearden, played the organ often on Sunday. Reverend Primus Alston presided at Saint Michaels and when he died, his widow Anna Alston married Cattie's oldest son and Bearden's uncle Harry, making his stepson, Charles Alston—who would also become an accomplished artist—a cousin by marriage.[17]

The homes of Rosa Kennedy and Cattie Kennedy Bearden were not without pleasures. As was the custom in the South, the women tended gardens that yielded dazzling beauty; quilts made by local women's groups brightened bedrooms; and Romare Bearden remembered paintings by H. B. and his grandmother hanging in his great-grandfather's grocery store. Bearden's father was an accomplished pianist (in addition to playing the organ), and Romie's uncle Harry enjoyed the opera and played the pianola. Anna, his father's sister, who lived in Goldsboro, North Carolina, also played the organ in church and taught music and organ.[18]

Cattie was considerably less formidable than Bearden's great-grandmother but no less a remarkable woman. An only child, she married young and was widowed young. Two small medallion photographs from the 1880s, one of a young Cattie the other of her future husband, Richard Bearden, capture the faces of two radiantly handsome young people. Richard, like H. B., was an entrepreneur, and is listed in the 1879 city directory, along with William Hinton, as proprietor of a meat market and grocery store at the northwest corner of Trade and A.[19] The twin photos of Richard and Cattie, probably taken to celebrate their marriage, were similar to thousands of portraits taken of American families, once photography became the principal means by which a private citizen could construct a self-authored record of a social or civic identity.[20]

Cattie Kennedy and Richard Bearden, both ca. 1880.
Mecklenburg County Public Library, Robinson-Spangler
Room, Charlotte, North Carolina.

By 1881, Richard and Cattie were married; their first child, Harry
Pierce Bearden, was born on November 10, 1881. His birth was fol-
lowed two years later by the birth of Anna. Richard Howard, Bearden's
father, born in 1888, was the youngest.[21] Richard, Bearden's grandfather,
who reappears in the Charlotte directory in 1889 as a member of the
household at S. Graham, died in 1891, long before the birth of his grand-
son. Cattie was left to care for her three children but, with the help and
support of H. B. and Rosa, she was by no means alone. She and her off-
spring maintained her parents' success: Anna became an accomplished
musician and music teacher; Harry, a dentist; and Richard Howard (who
would be known simply as Howard) a New York City civil servant.
Rosa's professional career bears mentioning as well, since it served as
inspiration for Bessye, Romie's mother, who found in Cattie a model
for a modern, independent-minded, twentieth-century black woman.

Cattie assumed the role of teacher, dormitory matron, and preceptor at Bennett College, in Greensboro, North Carolina. Shortly after her grandson's birth, she remarried in 1912, to Reverend George Cummings. Their wedding was a grand event, and Cattie's wedding dress, a work of art, in and of itself, was described in detail in the *Baltimore Afro-American*, at the time the country's most widely read black periodical. Her dress was of "heliotrope pearlnilla cloth, Persian silk and marquisette, with hat to match and [she] carried a huge bouquet of sweet peas and ferns."[22] Cattie remained close to Romie, sometimes hosting him in her home in Lutherville, Maryland, where she and Reverend Cummings lived.[23] (Reverend Cummings, an alumnus of Lincoln University, was listed on Bearden's application to the school as a reference.) Cattie developed a close friendship with her daughter-in-law, Bessye, as well, perhaps detecting a kindred artistic spirit, and exchanged loving notes with her long after both had moved from Charlotte.

After Cattie's death on September 1, 1925, Bessye and Howard Bearden gave Bennett College in Greensboro a gate in her honor. On the occasion of the dedication of "Bearden Gate," a gate and pathway leading to the college's chapel, Bessye Bearden, a skilled speaker, delivered a moving tribute to her mother-in-law.[24] Bessye lamented in her speech that years ago the talents of women like Catherine Bearden were hidden from the world.

> The difficulties in the path of the women leaders in her day were very great. It was an unimaginable thing for a woman to make her way in the world and to live in independence. Weaker spirits than hers would have yielded or snapped, but she and these extraordinary women like her held firm, and fought their way with amazing persistency to victory. Although times have changed and wrought much improvement let us not forget women who were pioneers like Catherine Kennedy Bearden.[25]

Women like those whom Romare Bearden knew growing up bore no resemblance to prevailing stereotypes. And it is women like them who figure prominently in his work in a multitude of personas. Women appear in his early social realist paintings as heavy bodied matrons; or, after

26

World War II, in the context of his literary abstractions as biblical figures; or as characters in illustrations of poems by Federico Garcia Lorca, Rabelais, or Homer; or, as direct literary allusions fell away in his work during the late 1940s, as poetic abstractions. Even during the 1950s when he painted sporadically, he continued to draw from live models. During a period of painting large nonobjective oils in the late 1950s and early 1960s, Bearden sometimes included the human form. When he concentrated primarily on collage after 1964, the black female body rose to prominence in his work.

From the debut of *Projections* in October 1964 until his death in 1988, women dominate his work. Bearden would go on to create a breathtaking range of women characters: matriarchs; Conjur Women— mysterious powerful figures of magic from black folklore; religious icons; mother and child; Virgin Mary with annunciate angel; women engaging in the everyday routine rituals of their lives; sensuous nudes, lounging and bathing; young women with older women; women with men or alone. From the majestic to the quotidian, from the magical to the ordinary, from the sacred to the profane, from the voluptuous and erotic to, some would say, racy, women were his touchstones.

Of all of the women in his household in Charlotte, the one who would influence and perhaps haunt Bearden the most was his mother, Bessye.[26] Admire Cattie though she did, Bessye mourned the fact that the constraints faced by early twentieth-century women prohibited her mother-in-law from finding a path to make her way in the world. She was determined not to let the same fate befall her. Bessye was a gregarious woman who, with her dark hair and light skin, was often thought to be Italian or Middle Eastern. Born in Goldsboro, North Carolina, some ninety miles north of Charlotte, she was a northerner at heart. She grew up in Atlantic City, the then bustling seaside resort in southern New Jersey, which, like Charlotte, boasted a small, prosperous black middle class of entrepreneurs and professionals in the early years of the twentieth century. In 1909, the family moved to Pittsburgh where young Bessye quickly became the toast of society, and her name appeared frequently in the social columns of the black press. Two 1909 *New York Age* articles announce her arrival in Pittsburgh and the impact of her presence.[27]

Despite the fanfare that accompanied her in Pittsburgh, by the next year she had returned to Atlantic City, where she lived with Mr. and Mrs. Benjamin Fitzgerald, the heads of a prominent black family.[28] Benjamin Fitzgerald owned Fitzgerald's Auditorium located at 32 North Kentucky Avenue, where Bessye worked as a ticket taker.[29] The auditorium next door to the Fitzgerald café was a focal point for black middle-class society. With its fashionable restaurant and ballroom, the prosperous black business attracted thousands of visitors every year.[30] Bessye's active social life, well documented in the black press, allowed her to indulge her political interests, such as support for women's suffrage, as well. Vivacious and politically astute, Bessye was quite the catch. She attended Hartshorn Memorial College in Richmond, Virginia, one of the country's early African American women's colleges, and graduated from what was then Virginia Normal and Industrial Institute in Petersburg.[31] Howard, also college educated and of course a member of one of Charlotte's most respected families, must have seemed the perfect match.

Though Bessye and Howard came from similar backgrounds, they were polar opposites in personality and disposition. Howard was reserved and quiet, with a mischievous sense of humor. He had briefly attended Bennett College, the site of his mother's professional career, which at the time of his attendance was a co-educational high school and college for black men and women.[32] But, he left college before graduating. Feeling constrained by the increasing limits of Jim Crow legislation in the South, he went looking for work in the North and found a job as a servant in Atlantic City.[33] Bessye and Howard likely traveled in the same social circles in Atlantic City, though there is no mention of them as a couple in the social pages. According to a brief news clipping in the *New York Age*, they married on March 14, 1911, in the rectory of St. Simon's Episcopal Church in Philadelphia. The *New York Age* reported, "Owing to the illness of the bride's mother, the wedding was very quiet."[34] Their courtship was unremarked in the press, and their quiet wedding in March, coupled with the absence of Bessye's mother and the birth of Bearden in September, suggest that theirs was a necessary marriage. Bessye and Howard, who joined the Kennedy

household in time for the birth of their first and only child, Romare, set-
tled in with the Kennedy/Bearden family in Charlotte.[35] After the bright
lights of the social spotlight to which she was accustomed, Bessye led
a more staid existence in the Kennedy/Bearden household. Along with
her new husband, she spent her first year in Charlotte tending H. B.'s
grocery store and teaching in the school next door to the church where
Romie was baptized.[36]

In a family portrait of the Kennedy-Beardens, most likely taken in
1917 in one of Charlotte's popular black photographic studios, a six-
year-old Romie is surrounded by adults. His cheeks have grown round
and full, his hair, a sandy brown mop of curls. One hand lightly touches
the knee of H. B., who sits smiling on his right; his great-grandmother,
who is holding a small purse and wearing an elegant taffeta dress, sits
to his left. Behind Romie are his parents. Bessye, barely smiling with
her dark hair framing chiseled features, wears a dress cut so that her

Portrait of Howard Bearden and Bessye Johnson Banks, 1910.
Engagement photo in Atlantic City. Romare Bearden
Foundation Archive, New York.

neck is exposed. She stands next to Howard, who is flanked by his sister, Anna. Cattie stands at the far right. As in the 1912 photograph, everyone is impeccably groomed, the ladies in their Sunday best and the two men in three-piece suits, cravats, and starched shirts. Young Romie sports a fashionable sailor suit. What the portrait fails to depict, however, is that Bessye and Howard had already fled Charlotte and moved to New York. They had been in Charlotte for only a brief visit when the picture was taken.

Their decision to leave Charlotte was not surprising. By the turn of the century, one state legislature after another—North Carolina included—had set back the clock on voting rights. In 1900, the North Carolina state legislature proposed a constitutional amendment that would require every voter to be able to read and write any section of the constitution and pay a poll tax. If they had an ancestor who voted before 1867 they had the right to vote, even if they could not read or write. Half of the black population in North Carolina was illiterate, hence ineligible. And even if they could read and write, most were impoverished, which meant they couldn't pay the poll tax. And for former slaves, having ancestors who had voted before 1867 was not an option.[37] For Bessye, who had championed voting rights for women in Atlantic City and who would later become instrumental in bringing about a major political shift in the voting practices of black citizens in the North, North Carolina's restraints must have been suffocating. These changes were foreshadowed long before Bessye and Howard arrived in Charlotte. The turning point in North Carolina was the devastating 1898 race riot in Wilmington, an ominous harbinger of the turn-of-the-century legislative change. Charlotte newspapers began to publish articles in favor of an amendment to the North Carolina constitution that limited black voting rights. A speech by a Charlotte citizen, reprinted in the May 20, 1900, edition of the *Charlotte Observer*, for example, argues that "the Negro has ever been the idle race of the world," and that the "most notable event in the history of the negro race was his slavery in America."[38] The amendment to limit voting rights in the state of North Carolina passed.

When Bessye and Howard arrived in Charlotte a decade later, they experienced firsthand the dangerously deteriorating living conditions for blacks, including the successful Kennedy/Bearden clan. Romare Bearden's biographer, Myron Schwartzman, retells two stories that made an indelible impression on Bearden, both involving his father.[39] One day, Bessye and Howard brought a young Romie on a shopping trip in Charlotte. Bessye, light enough to pass for white had she been so inclined, which she was not, left her son with her brown skin husband while she went off to do an errand. Howard stepped away briefly to look at something in a shop window, and when he sought to reunite with his pale-skinned little boy, he was mistaken for a kidnapper. As Bearden recalls, Bessye arrived just as a crowd of angry white citizens was gathering. She reserved her fury, however, not for a system that would question her husband's paternity but for her husband himself, who in leaving the boy unattended, in her view, had put them all at risk. A few years later, during a summer excursion to Charlotte, Howard went for an after-dinner walk, an old habit from his childhood years. He was arrested for violating the curfew imposed by Charlotte's vagrancy laws for black citizens, and he spent the night in jail. Bearden would later recall his father angrily waking the family early the next morning so that they could board the next train back to New York.

The Bearden family had reason to feel their lives were in danger in Charlotte. Penalties for breaking the law during those years could be fatal. Between 1880 and 1918, vigilante justice condemned an estimated 3,000 black citizens throughout the South—men, women, and even children—to death by lynching.[40] Constructing, displaying, and distributing photographs of a lynching became an integral part of the ritual executions. W. E. B. Du Bois, editor from its founding in 1910 to 1934 of *Crisis* magazine, the official publication of the NAACP, published, when possible, eye-witness accounts. The June 1915 edition describes the lynching of a man named Brooks in Tennessee:

Hundreds of Kodaks clicked all morning at the scene of the lynching. People in automobiles and carriages came from miles around to view the

corpse dangling from the end of a rope....Picture card photographers installed a portable printing plant at the bridge and reaped a harvest in selling postcards showing a photograph of the lynched Negro. Women and children were there by the scores. At a number of country schools the day's routine was delayed until boy and girl pupils could get back from viewing the lynched man.[41]

Kodak cameras were invented in 1888 by Eastman House, and by the 1900s their Brownie camera was selling for $1.00. Metal development boxes manufactured by the company gave customers not only the means of taking a picture but also the ability to develop it on the spot, in daylight.[42] The new device quickly was used to photograph and distribute images of public lynchings. Black journalists like Ida B. Wells, the anti-lynching activist, made use of these graphic images in the pages of the *Crisis* magazine to advocate anti-lynching legislation. Postcards of lynchings with notes on the back were circulated by the United States Postal Service, until the practice was outlawed in 1908.[43] Local law enforcement, churches, newspapers, legislators, and the judicial system offered little hope for redress against violence against blacks. Respected members of the community were frequent participants. It was a form of grotesque theater replete with its own afterlife in the form of images.

As definitive as the evidence might have been of the South's deteriorating conditions, many black citizens clung fiercely to optimism. As late as 1915, one of Charlotte's black leaders, AME Zion bishop and journalist George Wylie Clinton contributed an introduction and C. H. Watson wrote and published a pamphlet on the occasion of the fiftieth anniversary of the end of the Civil War.[44] It extolled the progress of Charlotte's black middle-class citizens. Bishop Clinton cited specific examples of the town's most successful black professionals, businessmen, educators, and religious leaders, among them Henry B. Kennedy. Clinton noted not only H. B.'s responsible positions as a mail agent and grocer but observed that he had in his possession a chair given to him by his former employer, the father of President Woodrow Wilson. Clinton made no mention of Reverend Wilson's loyalties to the Confederacy, and he ignored the fact that President Wilson had segregated federal

employment in Washington and in several southern states, putting countless hardworking black citizens out of work. Instead, he argued that the future of black southerners depended "almost entirely upon themselves" and "by their frugality, economy and wise investments."

The bishop's hopeful rhetoric echoes in some of the upbeat narratives Bearden wrote as an adult about his family and his Charlotte upbringing. A favorite was about a flower in his great grandmother's garden. Every day, delighted by the colors, he looked at a "beautiful tan, orange and brown flower" until one day it was gone and, in its place, "only a green stem trembling in the air like a small garter snake." H. B., sensing that the sensitive boy was upset, told him that his great-grandmother had picked it that morning to wear in her hat to church and not to worry; it would return next year.[45] As a boy, Bearden, safe in the cocoon of his family, had every reason to believe that his idyllic life would continue and be sustained and renewed, year after year.

Bearden's privilege—the protection of his great-grandmother's garden—never blinded him to the divide that separated his life from those of his friends who lived close by. Because H. B.'s property also abutted the cotton fields, he came to understand the demands on those who worked those fields. He would later complete two series of autobiographical collages, one in 1978 and the other in 1981. In preparation for the work and inspired by his interviews with *New Yorker* writer Calvin Tomkins, Bearden wrote a series of narrative remembrances. One describes a collage from *Profile/Part I, Liza in High Cotton*, 1978 (29 x 41 inches), that includes, according to Bearden, an image of his first childhood sweetheart, Liza. He recalls that one day, when he sought the company of Liza, her grandmother told him that she could not meet him: "she's going out to the fields because we're in high cotton." When Bearden offered to help, Liza's grandmother told him that the work was too hard for him. Eager to be with Liza, Bearden did help and came back a week later to pick the remainder, called "gleens" [*sic*]. His recollection of his work in the cotton fields not only informs his later autobiographical painting—the neatly represented rows of cotton, clothes and faces of the laborers, an interlocking weave of back-breaking work, heat, and beauty—but acknowledges its foreignness

to his life: "I said I was going to be good in Miss Pinkney's school after that because I wanted to learn, because if I had to go out there and be a cotton-picker, I wouldn't think that I'd last." His fascination with physical labor was, nevertheless, a constant in his life.[46]

Bearden's sense of a world divided came not only from the experiences of his father or the cotton field next to his great-grandfather's land in Charlotte. He later often recalled catching a glimpse of the body of the widow of Confederate hero Stonewall Jackson. H. B. had hoisted him up on his shoulders at Charlotte's handsome new train depot to see the open coffin of Mary Anna Jackson, who had died in March 1915, fifty years after her husband's death during the Civil War.[47] During her long widowhood, Mrs. Jackson, who lived in Charlotte, had become the living, breathing symbol of the Old South. A member of the Daughters of the Revolution, she was known as the "Widow of the Confederacy." Her tribute at the Charlotte railroad station, much like the tribute to Confederate generals that would come to be carved into Georgia's Stone Mountain, was similar to gestures throughout the South to keep the Confederacy's values alive. As Jim Crow legislation was taking root and the Supreme Court in *Plessy v. Ferguson* reinforced old values, her status soared in her old age. Bearden remembered that a large crowd gathered at Charlotte's depot to watch as her coffin was loaded in the train to be transported to Virginia so that she could be buried next to her husband. Two soldiers stood at attention on either side of the coffin and the body of Mrs. Jackson was covered with "as many flowers as there were in our garden."

The turnout for a celebrated hero of the Confederate past offered Romie a glimpse of the future of the South—one that did not bode well for the Kennedy/Bearden family in Charlotte. It was a future that all but obliterated the narrative they had painstakingly invented during and after Reconstruction through their hard work and diligent respectability. Redemption, the return of white supremacy, and the dismantling of black citizenship rights was the South's new narrative. That Redemption narrative was epitomized in the theatrical release in 1915 of David Wark Griffith's film *The Birth of a Nation*. Its popularity quickly exceeded that of any film before it. An unabashed polemic, the

34

two-and-a-half-hour film, also longer than any film to that point, suggested that Reconstruction, rather than encouraging respectability and industriousness among black citizens, engendered brutality and a hunger for power of the part of the country's new black citizens. To make his point, Griffith brought to bear a range of cinematic techniques; none of them were new, but in his hands they added to the film's rhetorical force: a moving camera; skillful choreography of close-ups and medium shots to record emotions; attention to lighting and location to enhance dramatic impact of scenes; and crosscutting multiple story lines.[48] Griffith's technique may have been modernist, but the film's message was distinctly revisionist. He rewrote the script of the Reconstruction narrative in a way that H. B. and Rosa Kennedy would have found unrecognizable. *The Birth of a Nation* retold the story of the antebellum era, Civil War, and Reconstruction as one of pre-war national unity, followed by the tragic fall of a noble way of life and the ignorance and cruelty of the new black citizens. The movie's saviors are the Ku Klux Klan, protecting white womanhood from black lust. A box-office hit, the film drew on nineteenth-century traditions of minstrel performance and dramatically widened the audience for its distortions.

The Birth of a Nation provoked what might be considered the first major mass protest on the part of black citizens.[49] Black leader Monroe Trotter assembled 500 to protest on the steps of the state house in Boston, pleading with the governor to ban the film. The state of Ohio did ban it. Booker T. Washington denounced it, black minister Francis D. Grimké published a pamphlet entitled "Fighting a Vicious Film," and the NAACP, under Du Bois's editorial leadership, ran a monthly series entitled "Fighting Race Calumny."[50] Some whites joined in the protest. Oswald Garrison Villard, editor of the *New York Evening Post* and a founding member of the NAACP, wrote in the *New York Times* that the film was "improper, immoral and unjust." Rabbi Stephen Wise, a member of New York City's censorship board denounced the film as an "indescribably foul and loathsome libel of a race of human beings."[51]

Despite resistance to the film, however, some 5 million people saw *Birth* in the first five years of its release. Their cheers in movie theaters testify to its popularity. President Wilson as well as members of

Congress and the Supreme Court had admiring words, and even the
writer and film critic James Agee observed admiringly, "To watch his
work is like being witness to the beginning of melody, or the first con-
scious use of the lever or the wheel, the emergence, coordination, and
first eloquence of language, the birth of an art."[52] Griffith's film was not
the first to treat racial themes; William Porter's 1903 film version of
Uncle Tom's Cabin, based on Harriet Beecher Stowe's successful book
that had been turned into a successful stage play, introduced race into
American film. A small army of black filmmakers emerged in the early
years of the twentieth century. The same year that *The Birth of a Nation*
appeared, the Chicago-based, white-owned Ebony Film Company re-
leased its first film created by black artists. A year later, the actor Noble
Johnson launched the Lincoln Film Company, a black-owned film com-
pany. None was as successful as the black filmmaker Oscar Micheaux,
who started the Micheaux Book and Film Company in 1919. Popular
in the burgeoning black neighborhoods in the North as well as the
South, Micheaux's films managed to attract the glamorous Bessye
Bearden. She had a bit part in Micheaux's now lost film, *The Gunsaulus
Mystery*. As popular as black-produced films may have been, none
could boast the audience of a growing American commercial film in-
dustry. In the wake of that new industry, *Birth* established a vocabulary
of stereotypes and caricatures, merging art, race, and representation
that became embedded in the American psyche.

Even before the rise in popularity of the moving image, three of the
country's most prominent race leaders—Frederick Douglass, Booker T.
Washington, and W. E. B. Du Bois—recognized and wrote about the
public implications of visual images. Douglass was a man whose "intel-
lectual vigor and honesty" Bearden admired, and Du Bois, as men-
tioned earlier, would become a patron and family friend. As noted in
the Introduction, Douglass and Du Bois, in particular, understood the
need for a visual language to transcribe the complexity of black life.
Before emancipation and decades before the Civil War, Douglass had
complained about the representations of black people, writing, "Negroes
can never have impartial portraits, at the hands of white artists. It seems
to us next to impossible for white people to take likenesses of black

men, without most grossly exaggerating their distinctive features."[53] Douglass goes on to identify specific reasons. "The Negro is pictured with features distorted, lips exaggerated—forehead low and depressed—and the whole countenance made to harmonize with the popular idea of Negro ignorance, degradation and imbecility." Keenly aware of the power of visual images, Douglass delivered and wrote a series of four lectures and articles beginning with "Pictures and Progress," delivered in 1861, followed by "Lectures and Pictures." He then wrote a revised version in 1865 of "Pictures and Progress," and followed that with his last article on the subject, "Life Pictures."

His first lecture, "Pictures and Progress," was immensely unpopular and focused on photography as a means of giving even those on the bottom rungs of society the ability to invent themselves. Despite their unpopularity, his lectures presented observations that were prescient. Photographic images were ubiquitous, democratically accessible, and capable of adorning or disfiguring their subject. "What was once the exclusive luxury of the rich and great is now within reach of all."[54] With this right of self-authorship came the ability to combat the dehumanizing stereotypes that promoted "scientific racism," what Bearden, decades later, would refer to as "pseudo-science." "Physiognomie," popular in the nineteenth century, especially among visual and literary artists, proposed that facial features were dispositive of behavior. In other words, "science" could prove that certain facial features, negroid among them, were predictive of degrading, immoral, and/or criminal behavior. Douglass insisted that photographic representations of impressive black people made a compelling case against this so-called scientific evidence.

With the death of Douglass in 1895, Booker T. Washington inherited the mantle of national black leadership. Washington's perspective on former slaves and their progeny was quite different from Douglass's and became clear at the 1895 Atlanta and Cotton States Exposition, when he counseled black people to "Cast your bucket down where you are."[55] His calling for hard work and manual labor was not unlike the advice given to Charlotte's black citizens by the editor of the *Charlotte Messenger*. Washington went further, however, and cautioned against

political involvement—the "agitations of questions of social equality"—calling it the "extremist folly." Washington's 1900 book, entitled *A New Negro for a New Century: An Accurate and Up-to-Date Record of the Upward Struggle of the Negro Race,* cites exceptional black people who made themselves worthy of citizenship by virtue of their hard work, heroism, and moral righteousness. Edited and written by Washington with the assistance of N. B. Wood, and Fannie Barrier Williams, the volume makes use of photographs to argue its case for the exceptional: they are of heroic soldiers, acclaimed poets, and black leaders from a wide range of professions, particularly medicine and education. The Kennedy-Bearden family portraits would have fit comfortably in this collection.

Much like Bishop Clinton's more modest pamphlet fifteen years later that featured H. B. Kennedy, Washington's grand volume—428 pages in all—intended to show, in his words, the life of Afro-American people "in light of achievements that will be surprising to people who are ignorant of the enlarging life of these remarkable people." Most of the photographs were head shots—with an occasional full-length image of a soldier—the written text bearing the weight of the argument. In that same year, the man who would become Washington's chief intellectual rival, W. E. B. Du Bois, mounted a landmark exhibition in Paris. Du Bois used photographs of prosperous turn-of-the-century black people to argue that one of America's accomplishments was the evolution of blacks from slaves to productive citizen. His argument extended beyond Washingtonian designation of worthiness to a few individuals. Du Bois's selection of photographs asserted the emergence of a full and expansive culture, one that was integral and vital to the understanding of American culture.

Du Bois's exhibition came about when his former Fisk classmate, Thomas Callaway, invited him to organize a Negro Pavilion for the exposition in Paris, an occasion to celebrate the grand themes of "progress, scientific accomplishments, and commercial and economic success," of the participating countries.[56] For the United States, the international world's fair was an opportunity to demonstrate on a world stage the industrial progress the country had made since the Civil War. As

conceived by the American exhibit's organizers, national progress was best expressed by labor-saving devices like the McCormick Reaper and the Singer Sewing machine. Callaway, who served as a state commissioner for the 1895 Atlanta and Cotton States Exposition, believed otherwise. He engaged Du Bois to participate in an exhibition that would demonstrate black progress. By 1900, Du Bois was a professor of sociology at Atlanta University (now, after a merger with Clark College, Clark Atlanta University), a scholar with two major studies completed, the recipient of degrees from Fisk and Harvard Universities, and a former student at the University of Berlin. He came to the assignment with impressive credentials.

Aided by research assistants, Du Bois assembled a multitude of charts, maps, graphs, and statistics—factual proof of black progress in the United States. Quantitative data that tracked black progress in Georgia (the state with the highest black population in 1900) was not enough. Du Bois also included 363 photographs of professional black people. His intent, he wrote, was to organize "an honest, straightforward exhibit of a small nation of people, picturing their life and development without apology or gloss, and above all made by themselves."[57] Photographs of black people, made by black people, represented their self-authored selves. Bearden's forebears would have found Du Bois's collection of photographs an accurate and welcome reflection of their lives. Recognizing, as did Douglass, the power of the photograph, Du Bois chose as the core of the photographic exhibit the work of black Atlanta photographer Thomas Askew. In addition to the photographs Askew was commissioned to take of Atlanta blacks, Du Bois obtained photographs from a selection of black colleges—Atlanta University, Fisk, Hampton Institute, Howard University, and Tuskegee. They picture men and women at work in laboratories and libraries, attending class, and building the sturdy brick buildings that graced the campuses. Curated to illustrate black progress, the exhibit omitted "lynching peonage, poverty, votelessness."[58] Du Bois's narrative followed the prevailing narrative of black intellectuals of the time, "Archibald Grimké, Mary Terrell, and Monroe Trotter, who thought of themselves first as Americans."[59]

Du Bois's exhibit showcased the architecture of homes not unlike H. B.'s at 4th and Graham, capturing their orderly, finely decorated interiors. Fashion, beautifully crafted dresses, covered buttons, piping, elegant hats, and delicate bracelets and earrings adorned the women; the men and children were equally well turned-out. There were pictures of black churches and every imaginable cultural and athletic organization: baseball teams, bands, music ensembles, civic groups, labor unions. The photos included offices of black-owned newspapers, funeral parlors, shoe stores, hotels, and grocery stores. In short, the photographs offered a visual compendium of a way of life, an entire culture, that was as sophisticated as it was beautiful. It was the world which H. B. and Rosa, their daughter Cattie, and Richard Bearden had created for their families in Charlotte. It would become as much a part of Bearden's aesthetic as Cubism, classical Chinese Painting, seventeenth-century Dutch painting, ancient African artifacts, or any other art form that would influence him. H. B. and Rosa Kennedy's world may have been exceptional, but as Du Bois's exhibition demonstrated, it was not an aberration. The life they had invented was educated, progressive, industrious, and aesthetically rich, and it was taking root in American culture. Looking at image after image of these anonymous people is to look at self-assurance and pride. The question was, however, who was bothering to look?

As impressive as the Paris exhibition may have been, the world of these photographs remained as hidden from the nation as the sketches of Cattie Bearden. Though 50 million people attended the Paris Exposition, and though "The Negro Exhibit"—as it was called—received medals and citations there, the exhibit went almost unnoticed in the United States. Black media applauded the photographs; the white press ignored them. The exhibition traveled to the Buffalo Exposition, held a year after the Paris Exposition, but went no further. For over a century the photographs remained on the periphery of the country's attention.[60]

Representation was not the only issue Du Bois's Negro Exhibition posed. Over a century after the exposition was mounted, and years after Bearden's death, a selection of photographs from the Paris exposition

was assembled in a Library of Congress publication. The 2003 illus-
trated text, *A Small Nation of People: W. E. B. DuBois and African
American Portraits of Progress*, contains essays by David Levering
Lewis and Deborah Willis. The volume reproduces 150 of the photo-
graphs displayed a century earlier. In her essay on the photographs
from the exposition, Willis coins the term "subversive resistance" to
describe the insistent and comprehensive documentation of a way of
life that, even as it was constructed, was subject to assault.[61] Examples
of subversive resistance, the photographs of the past were also evidence
of a past that was all but invisible for much of the twentieth century.
Preserved at the Library of Congress by Daniel Murray, the son of a
freed slave who worked at the Library of Congress for half a century,
the photographs were part of his mission to make sure that the nation's
library contained the historical legacy of its new black citizens.[62] Murray,
who compiled a complete turn of the century bibliography of works by
black authors—the list numbered 1400, 200 of which, as Lewis notes,
were included in The Negro Exhibit—worked closely with Callaway
and Du Bois. His diligence was a hedge against loss. Loss and recovery
would become themes in Bearden's art as he experienced through the
years the disappearance of places and people, the cultures that shaped
him and as he battled against invisibility.

After the Exposition closed, Du Bois's optimism became tinged with
a sobering realism and, as Lewis notes, just three years after the exhibition
was mounted, Du Bois wrote *The Souls of Black Folk*. In it he acknowl-
edged what the accumulation of Jim Crow law was signaling: "The
Problem of the Twentieth Century is the problem of the color-line."[63]
Du Bois turned his attention in the ensuing years to the establishment of
the Niagara Movement and assisted in the founding of the NAACP and
the founding and editing of *Crisis* magazine. A mix of literary journal,
social critique, and artistic platform, *Crisis,* under Du Bois's leadership
became a leading literary journal, publishing white and black authors
and artists alike and counting Bearden as one of its contributors.

As a mature artist, Bearden would extend the conversation begun by
Douglass, Washington, and Du Bois. In the course of his artistic career,
he struggled to come to terms with issues of race and representation.

In a 1946 essay titled "The Negro Artist's Dilemma" (discussed at length in Chapter 5) Bearden laments the visual images of black people that emerged during Reconstruction:

> It is the privilege of the oppressor to depict the oppressed. Consequently, the picture of the Negro that appealed to the South was that of a shiftless, dim-witted buffoon. This concept, pleasing to the Southern ego, was both a rationalization and one of the means of keeping the Negro in his dark corner. Pseudo-scientific books were written; ministers gave long-winded sermons to prove that the Negro was a creature driven by animal spirits, possessing only limited capacities, and best suited to a servile existence.[64]

Unlike Douglass, Washington, or Du Bois, Bearden's motivation in writing the essay is not to prove the worthiness of Negro citizens; rather, he writes as a painter trying to articulate his responsibilities as an artist. He fears that racial distortions have become so absorbed into the culture that they limit the expressive culture of black people and American artists alike. Both seeing as well as representing have been sullied. The true artist cannot afford to fall into the trap these historical misrepresentations set, however. How Bearden came to handle this dilemma is at the heart of the story of his odyssey as an artist. He was determined to free himself from the "tyranny of the mind" posed by a history of misrepresentation, an exercise that constantly pushed him to consider social and political as well as aesthetic realities.

And those realities were impossible to ignore. Bessye and Howard Bearden's departure from the South was part of a storm surge that gathered force in the first half of the twentieth century and, quietly and irrevocably, changed the face of the United States. Between the time of Du Bois's Paris exhibit and the start of World War II, over 5 million black people relocated from the cities and rural towns of the South to the cities of the North, Midwest, and West. Their departure from the South tore them from their roots and origins as if they were immigrants from another country. Language, food, local customs, the pace and rhythm of life, the nature of work, love and marriage were as foreign

to relocated southerners as they were to European immigrants. From the migration there would emerge a new civic narrative, one that unfolded during the twentieth century in literature, music, visual arts, and film. One version of this new narrative was that of the New Negro. Announced in grand style by one of its intellectual guardians, the Harvard-trained philosopher and Howard University professor Alain Locke, the narrative of the New Negro perfectly described Bessye and Howard Bearden.

Settling at first in Hell's Kitchen, the couple eventually found their way uptown to Harlem, to what would become the country's black cultural capital. James Weldon Johnson, a chronicler of Harlem, wrote about the Harlem into which the Beardens settled: "Forces...are going far towards smashing the stereotype that the Negro is nothing more than a beggar at the gates of the nation.... [H]e is a contributor to the nation's common cultural store; in fact, he is helping to form American civilization."[65] The Beardens, their only child in tow, settled in Harlem with much of the same fierce optimism and hopefulness as did Henry and Rosa Kennedy, when they moved with their only child to Charlotte. Harlem, for the young Bearden family, for the New Negro, was the new Promised Land.

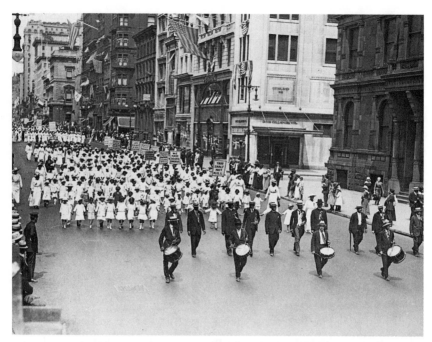

Silent Parade, July 28, 1917. Photo: Underwood & Underwood. Courtesy of James Weldon Johnson Memorial Collection of African American Arts and Letters, Yale Collection of American Literature, Beinecke Rare Book and Manuscript Library, Yale University.

HARLEM

THE PROMISED LAND

The problem of the Twentieth Century is the problem of the color line.

—W. E. B. Du Bois, *The Souls of Black Folk*, 1903

Sometime around 1915, Bessye and Howard brought a four-year-old Romie to New York, a city full of grand gestures. One took place on the morning of July 28, 1917, when 8,000 black women and girls in white dresses, men and boys in dark suits—the men wearing straw boaters—assembled at the 59th Street Armory in Manhattan.[1] They marched the thirty-six blocks down Fifth Avenue to Madison Square Park in silence—except for the sound of muffled drums. Though the immediate catalyst was a particularly brutal race riot in East St. Louis that had resulted in the deaths of at least forty black citizens earlier in the month, protesters held aloft placards that called attention to a broad inventory of social injustices: "America has lynched without trial 2,867 Negroes in thirty-one years and not a single murderer has suffered," read one; "We have fought for the liberty of white Americans in six wars; our reward is East St. Louis," another declared. Yet another, "Make America Safe for Democracy," played on President Wilson's rhetorical defense for taking the country to war, in order to "Make the world safe for democracy." The idea for a silent protest came from NAACP Field Secretary James Weldon Johnson, and was organized by a coalition of the NAACP and church and civic leaders among Harlem's elite, all of them intent on rallying to the causes that would become Bessye Bearden's life work and an essential part of the education of her

only son.[2] By the time of the parade, the Beardens had settled into the first of the apartments in Harlem that would become home to many of those very same Harlem elite.

The parade, like the protest against D. W. Griffith's film, was among the early mass public protests on behalf of black America. This one, however, was visually stunning as well.[3] In shades of black and white, the impeccably dressed marchers moved slowly and silently down Fifth Avenue, as if in a slow motion film, unspooling an epic narrative of racial and civic injustice. The silent protest foreshadowed the kind of public visual spectacle in Harlem that captivated Bearden as a child and contributed to the densely rich culture that was the foundation of his work. The Harlem of the first half of the twentieth century surrounded Bearden with sophisticated, and at times transgressive, rebuttals to the caricatures of black people in American culture. Johnson's idea of the Silent Parade (with inspiration from Oswald Garrison Villard, who was also a participant in the anti-Griffith protests) is a good example. A former diplomat in the administration of Theodore Roosevelt, he was also a poet, essayist, and novelist, an artist in his own right and astute collector of artifacts. He would also befriend a young Bearden.[4] Johnson wrote in his weekly column for the *New York Age* of the deliberate effort to make a visual appeal with the organization of the parade: "The power of the parade consisted in its being not a mere argument in words, but a demonstration to the sight. Here were thousands of orderly, well-behaved, clean, sober earnest people marching in a quiet dignified manner, declaring to New York and to the country that their brothers and sisters, people just like them, had been massacred by scores in East St. Louis for no other offense than seeking to earn an honest living."[5]

By the time Bearden was an adolescent, parades and pageantry had become as much a part of his life in Harlem as Sunday morning church service. All he had to do was stand on the curb every Sunday to watch rituals that involved everything from politics to civic organizations, to social functions, to honoring the dead. The Silent Parade was a preview of the visual pageantry to come, one that announced a new way of imagining the visual construction of race in the public sphere. In addition

to the constant street theater, there was legitimate theater, the cabaret scene, and functions at which the general sartorial requirements for being "cool" defined an all-encompassing visual style among Harlem's black middle class. Romie and his family arrived just in time to see the curtain rise on that new scene.

Bessye and Howard Bearden's start in New York was less than auspicious, however. The family moved frequently as they searched for steady jobs and a place to call home. The 1915 New York City Directory records a West 52nd Street address for the family. Howard Bearden's draft registration dated April 1917 lists the family in Harlem at 231 West 131st Street, while the 1918 directory lists yet another address. While his parents looked for work, their outgoing, cherubic-looking son moved from one household to another, living with family members in Charlotte, Harlem, and Pittsburgh. Highly observant and unrepentantly curious, Bearden threaded his way through the disparate lifestyles in each of his homes, into what many years later would become coherent tableaux. For the time being, each home served the precocious little boy as a source of adventure. Romie's earliest memories of New York are of staying with his mother and father in the home of his father's family in the Tenderloin district of Manhattan.[6] Hell's Kitchen, as it was sometimes called, was frayed by racial conflict, but before Harlem, the Tenderloin was the neighborhood of choice for new black migrants. Harlem quickly supplanted the Tenderloin, however, and by the time their family portrait with his great-grandparents was taken during a visit to Charlotte, the family had moved uptown.

Trains continued to reassert their importance in the Bearden household when Howard turned to the railroads for work. Tall, slender, and good-looking, he was hired as a dining car waiter for the Atlantic Coast Line, which stretched from Washington, DC, to Key West, Florida. The route may have kept him from his family for long stretches, but it was a highly respected position for an educated black man. Soon, however, World War I would change their lives yet again; the United States' decision to enter the Great War in April 1917 required Howard to register for the draft.[7] Howard's draft registration is dated July 1917 and, at the time, he was still listed as a New York resident. Sometime after his

draft registration, Howard left the United States and pursued work in Canada, becoming a steward on a run between the boom town of Edmonton, Alberta, and Moose Jaw, Saskatchewan. Little of the family history survives from that period, but Bearden remembers that he and his mother joined his father there. Romie spent a year of elementary school, probably first or second grade, in Moose Jaw. One surviving photograph shows his mother standing outside of the Royal Bank of Canada building, a sturdy stone edifice erected in 1914 and still standing. Bessye can be seen among a group of white women, presumably employees of the bank, where she was probably employed while Howard worked with the railroad.[8]

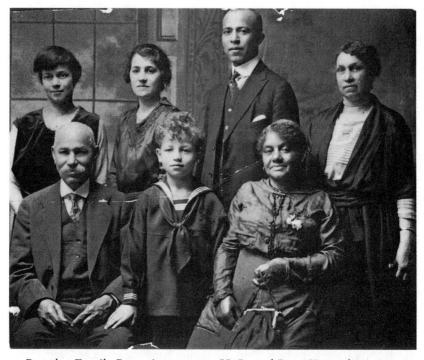

Bearden Family Portrait, ca. 1917. H. B. and Rosa Kennedy sitting. Romare Bearden standing between his great-grandparents. Standing from left to right Anna Bearden, Bessye Bearden, Howard Bearden and Cattie Kennedy Bearden Cummings, Bearden's grandmother. Romare Bearden Foundation Archive, New York.

After the war, Romie and his family returned to Harlem, where, by 1921, Bessye's name reappears in the black press and where Harlem was ascending as the country's black cultural capital. One of the most noteworthy pageants to mark the end of the war and to celebrate that ascent was the march along Fifth Avenue of the 369th Infantry, formerly known as the 15th Regiment and popularly known as the "Harlem Hell-fighters," on February 19, 1919.[9] The Harlem Hell-fighters, honored in France with the Croix de Guerre for their "exceptional valor on the battlefield," marched from Madison Square Park, up Fifth Avenue— in celebration rather than in protest. Solemn-looking in their battered tin helmets, in perfect formation, the band of James Reese Europe playing staid military music, they marched past cheering onlookers—white and black. When they crossed 110th Street north of Central Park, however, Europe and his band picked up the tempo, causing the Harlem crowd to explode and the veterans to break formation and dance in the street. Having displayed to the entire world their courage and skill, these black men returned to their country with a more expansive sense of possibility. The Bearden family, Bessye especially, shared that feeling.

World War I's end and the ever-quickening pace of blacks leaving the South for the cities of the North raised expectations among families like the Beardens. Those expectations pushed against the limitation of Jim Crow laws, like rising water against a levee. Quarrels about citizenship heightened. Returning black soldiers expected acknowledgment for their service in the form of jobs and basic civil liberties. What they met with, instead, in the summer of 1919 were bloody race riots in over two dozen cities.

Race relations were not the only changes afoot—two constitutional amendments would affect the Bearden family. The Eighteenth Amendment, passed in 1920 and establishing Prohibition, fueled the rise of Harlem's cabaret life. Harlem night life later provided some of Bearden's richest subject matter from elegant nightclubs like the Cotton Club and Connie's Inn—designed for a whites-only downtown crowd—to the countless illegal juke joints, neighborhood rent parties, and cabarets. Bootlegged liquor was plentiful. Harlem, a focus of that defiance, became a magnet for world-class performers and musicians who entertained in upscale

venues and modest establishments alike, turning Harlem into a cultural demilitarized zone. It became a place where, if only briefly, cultural boundaries could be crossed, if not eliminated, at a time when cultural divides elsewhere were hardening. By night, Harlem was as vibrant as Paris or Berlin. The steady flow of booze was a constant temptation to Howard, much to Bessye's dismay.

Passage of the Nineteenth Amendment, also in 1920, gave women the right to vote, which boosted Bessye Bearden's aspirations and ambitions. Eager to undertake a social justice agenda that attacked racial and social inequities, she became an activist. She threw herself into New York City politics at a time of increased political opportunity for black women, assisted by her gregarious personality and active social life.

You had to walk fast to keep up with Bessye Bearden. Bessye hit her stride when the Bearden family returned from Canada, and as she made her way briskly down Harlem streets she greeted everyone with a "Hi Baby," or "What can you do for my baaa-by," drawing out the syllables. She not only found her way into Harlem's inner circle but she also helped define and expand its perimeter. Her prominence was evident as Bessye's name began to appear in the social columns of the black press, along with the names of Harlem's social luminaries like businesswoman and arts supporter A'Lelia Walker, who would become one of Bessye's best friends.[10] Bessye sharpened her innate skills and enrolled at Columbia University shortly after her arrival in Harlem, taking courses in public opinion, city history, and civic organization—excellent training for what would become her life's work.

Among her already impressive number of contacts, from her days as a socialite in Atlantic City, Pittsburgh, and Philadelphia, was E. C. Brown, the Philadelphia realtor. She worked in his New York office and as a ticket taker at the Lafayette Theater, which Brown's entertainment company briefly owned.[11] Her friendship with A'Lelia Walker that began in Atlantic City blossomed as A'Lelia's reputation as the grand dame of Harlem society ascended. Though Bessye quickly took center stage in New York, at the outset, Howard's early jobs on the railroad kept him away from home. Bessye would later complain that New York

in her early years was hostile to a young mother alone in a strange city. In an interview for the *Pittsburgh Courier*, she lamented to a reporter, "Do you think anyone here went out of his or her way to direct or encourage me? Well, I should say not! Who was there to care about me, a young woman attempting to make her way alone?"[12]

When Howard found a job with the New York City Department of Health as an inspector, he and Bessye became the well-educated, socially striving couple that fit squarely into Harlem's status-conscious social circles.[13] Their Harlem was experiencing a "golden era." As the curtain went up on the "Jazz Age," the "Roaring Twenties," the "New Negro Movement," and the "Harlem Renaissance"—epithets that to this day evoke the Harlem of the 1920s and 1930s—the young Bearden family not only believed in this Promised Land but believed that they had much to contribute. Bessye, Howard, and their son found themselves on the stage of a lavishly costumed and richly cast, operatic drama, one in which first Bessye, then her precocious son Romie would assume leading roles.

Romie, a full-cheeked, slightly built little boy, was about eight, when he and his mother returned to New York from Canada. In New York, he came to know intimately the terraces and steep hills of Harlem that, from their highest point, presented sweeping views of Manhattan and beyond. A part of the city still full of open space, Harlem offered ample opportunities for sandlot baseball, allowing him to hone what would become considerable skills as a baseball player. Harlem rooftops served as playgrounds, and when he lived on West 141st Street, the block that stretched from 139th Street to 140th Street and from Seventh Avenue to Lenox enclosed an almost magical oasis. The little oasis in the middle of a concrete city was dotted with ponds and still had a glacial rock formation that yielded hours of exploration for Romie and his friends.[14]

During the summer, a platform covered by a tent permitted the residents to dance to live jazz in the "Garden of Delight." Harlem also attracted people with outsized dreams; Bearden recalled the exploits of Colonel Herbert Julian, who spent one summer attempting to construct on the lot an airplane that he intended to fly to Europe. As Bearden remembered, "When the motor was tuned, the noise could be heard all

over what was then the narrow confines of the Harlem where black people lived. The colonel was attempting to land in this lot when he became the first person to make a parachute jump onto Manhattan. On the Sunday, however, contrary winds carried him a block away to Eighth Avenue."[15] Eventually, the glacial rock was blasted and in place of the oasis, Bearden's future elementary school, P.S. 139, was constructed alongside stores and tenements.

Harlem was changing quickly. At the turn of the century, it had been seized upon by speculative developers who designed a neighborhood that could serve as a haven for upper-middle class German Jews, Irish, and Italians looking for a respectable place to live. They commissioned leading architects—Dutch architect Edward Mowbray; Stanford White and his firm McKim, Mead and White; and William Tuthill—to build what Bearden would later label as "sermons in stone." Townhouses made of limestone or brick, brownstones, opera houses, churches, synagogues, and schools were built to attract an anticipated influx of middle- and upper-middle-class families. Interiors of the most elegant townhouses favored a baroque decor. Some multi-floor dwellings featured elaborately carved millwork, sculptured fireplaces, grand foyers and high-ceilinged parlors, festooned with plaster of Paris molding. Elegance and good design became a hallmark of Harlem. An early black architect, Vertner Tandy, who would design Madame C. J. Walker's Villa Lewaro in upstate New York in 1918, made a mark on the architectural landscape with the construction of St. Phillip's Episcopal Church in 1910–1911.[16] The completion of the Lenox Avenue subway line in November of 1904 linked Harlem to the downtown business district. Sprawling parks—Morningside, Mount Morris (now Marcus Garvey Park), St. Nicholas—broke up the concrete and steel with rolling green hills, and Seventh, Lenox, St. Nicholas, and Edgecombe, wide boulevards lined with trees, were as beautiful as the Champs Élysées or the Via Veneto.

The Harlem that Bearden experienced was a racially mixed neighborhood. But even as the Beardens settled in, white families were making plans to move out. The numbers of white families had fallen short of developers' predictions and black families were arriving uptown

at what they, whites, perceived to be an alarming rate. Several enterprising black realtors stepped in, among them the Philadelphian (and Bessye Bearden patron) E. C. Brown and the indefatigable Philip Payton. They marketed the neighborhood to black migrants—like the Bearden family—streaming into the city from the South and the West Indies. Bearden soaked up every detail—the landscape, the architecture, the dramas that played out in the interiors.

Public school in New York, by comparison, was dull. Bearden's first school in New York City, P.S. 5 on Edgecombe Avenue, reflected Harlem's mix of ethnicities and cultures in the 1920s; his classes were full of Irish, Italian, German, and Jewish children whose families had not yet moved. He found most of his teachers uninspiring, their rote methods so tedious that even a subject he would later embrace—mathematics—barely interested him. His reading tastes ran to adventure stories: Tom Sawyer, Robinson Crusoe, and Moby-Dick. When PS 139 was constructed on the former site of his playground and oasis, he transferred there and, at the age of twelve, was in the first class to graduate. Despite his professed disinterest in academics and the need for his mother's intervention when his performance lapsed temporarily, he was precocious enough to skip a grade at the end of the sixth grade, into the eighth. Even before he skipped a grade, restless and bored with school, he made a change of venue that would impact his mature art. Pittsburgh was the site of a brief relationship he would develop with a young artist whose candid drawings of the life that surrounded him fascinated Bearden and introduced him to the power of art and representation just as his interest in drawing was awakening.

Pittsburgh competed with Harlem as the formative city of Bearden's early years. He lived there twice during his childhood. His first time away was in 1920 or 1921, probably when he was in the fourth or fifth grade, not long after his family had spent time in Canada. He joined his maternal grandparents Carrie and George Banks to spend a year in public school in Pittsburgh, where they had settled sometime in the early 1900s.[17] He would return there in 1927 to finish his last two years of high school. Pittsburgh offered Romie a close look at the world of migrant steel mill workers, a contrast to the glamorous social circles

that Bessye and Howard inhabited in Harlem. His grandparents, Mr. and Mrs. Banks, ran a boarding house frequented by migrant workers from the South who had come north to work in the steel mills. Pittsburgh's steel mills loomed over all of the city, smoke from the mills covering Romie's white shirts in soot by the time he got home from school. His grandparents' first home was in a section of Pittsburgh known as Lawrenceville, a plain-spoken neighborhood that bore no resemblance to the architectural splendor and wide tree-lined boulevards of Harlem.

As an adult, Bearden would later return to Pittsburgh during the Depression while he worked on a piece of documentary journalism that examined the role of black laborers in the steel mills. As part of the project, he included a photograph of Lawrenceville that was published in the *Amsterdam News*. It was a neighborhood of narrow alleys and wood-frame houses. Scenes of Pittsburgh are pervasive in his art, from his earliest political cartoons that took up the cause of oppressed mill workers to his early social realist paintings that represented the lives of struggling families and laborers. Pittsburgh appears again, more forcefully, in his mature collages, often as a city of mysteries and secrets. Pittsburgh was as appealing to his imagination as the grand architecture of Harlem, and the city—like Charlotte, the city of his birth, and Baltimore, where he spent summers, and New York—would later honor him with a major public commission.

Mr. and Mrs. Banks housed their boarders in a three-story house on Penn Avenue. Bearden, although no stranger to the practice of housing boarders—his parents' household at one time included his mother's sister, her sister's two sons, and one or another nonfamily member—was not used to sharing his residence with two dozen grown men. They were organized so that some had individual rooms on the first and second floor and others slept dormitory style on the third floor. A single bath on each floor served all of them. Still, the conditions at the boarding house were far better than the broken-down houses assigned by the mills to steel workers with families. Carrie Banks did all of the cooking. From the windows of their boarding house, Bearden could see flames from the mills. He watched the men walking the

soot-filled streets, returning from work where, when they took off the heavy protective asbestos shirts as relief from the heat, they discovered that the flames had scorched their skin. Bearden remembers Mrs. Banks applying cocoa butter to their backs. They fascinated Bearden: "I looked up to all the men in the boarding house. They were big powerful men. They went to work early in the morning: they were off to work at 6 o'clock."[18]

The Banks' boarding house was strictly regimented. Mrs. Banks cooked breakfast and dinner every day and made lunch for the men to take with them. Carrie and George Banks maintained formality, addressing each other as Mr. and Mrs. Mr. Banks would ask permission to enter Mrs. Banks's kitchen, which, with its several stoves, was like the kitchen of a small restaurant. Breakfast was "hot biscuits, bacon and eggs, sausage, fried apples and pots of coffee. Most of the men took tin lunch boxes with them filled with her big sandwiches, fruit, a slice of pie and biscuits." Bearden describes dinner portions as being equally generous: "When the men came home at six in the evening they all sat down at a big table in the dining room for the evening meal. There would be meat, smothered cabbage, potatoes, green beans, beets, hot bread, and for dessert, home-made ice cream, and apple pie."[19] After work, the men sat out on the porch of the boarding house and Bearden and his friends sat with them, listening to their stories.

A life-long reverence for work and the conditions of labor are evident in Bearden's art. In Pittsburgh, living around workingmen may have inspired a pre-adolescent effort to become part of the working world. On his own, he found a job with the local iceman. Before the widespread use of electric-powered refrigerators, blocks of ice, delivered daily, were stored in an icebox that sat outdoors. Romie convinced the iceman to give him a job unloading the morning's ice. On his first day, he jumped out of bed in the pre-dawn hours and worked harder than he had ever worked before—all for 50 cents. He returned to his grandparents' home and the ten-year-old announced to them and the men at the table that he was now a workingman, just like them. The men celebrated by lifting him up and swinging him around. He was a member of their working class fraternity and he loved it.

Pittsburgh allowed Bearden to explore not only the world of working-class men, but it also introduced him to a world of working women whose lives were a stark contrast to the black bourgeois respectability religiously upheld by the women who surrounded him during his early years—Rosa Kennedy, Cattie Bearden Cummings, Bessye. A brief but intense friendship forged during a summer visit literally opened his eyes to a world otherwise invisible to him. Eugene Bailey, a year or so older than Bearden, was born out of wedlock to a prostitute and grew up in a brothel. Too sick to go to school—he had infantile paralysis and wore braces on both legs—he spent his time drawing what he saw in the brothel. Through the cracks in the floor board of his bedroom, the sickly boy could witness men and women below.[20] After an altercation, in which Mrs. Banks interfered and encouraged the two boys to be friends, Eugene shared his artistic talent with his Romie. He drew him a picture of a Victrola with the buttocks of a naked woman protruding from the fluted speaker. Eugene's tutelage included, as well, drawings of daily life. In one, he drew a house without a facade with a gunshot through it. In Eugene's drawing, the bullet passed through a variety of orifices of the men and women in the brothel, and came out as coins that fell into the open purse of a madam waiting below. Mrs. Banks, thinking the boys were enjoying themselves, encouraged the drawing lessons until she at last saw their work. Horrified, she threw the papers in the furnace and demanded to know how Eugene had come to make work like that. When he told her, Mrs. Banks went to his home, demanded his clothes, and announced to his mother that the boy was coming to live with her. On their visit to the brothel, Romie climbed the steps with Eugene, and the frail young man showed Romie the pigeons and doves he kept on the roof, his constant companions. He also showed his friend the cracks in the floor boards.

Eugene and his pigeons lived with Romie in the Banks' boarding house. Bearden recalls Eugene's mother's weekly visits. After he moved away from the brothel, Eugene may have lived in a healthier environment, but, as Romie recalled, he never drew again, and, soon after, contracted pneumonia and died of a lung hemorrhage.

The story of Eugene and his Toulouse Lautrec-like drawings of his mother's life is almost always presented as Bearden's introduction to drawing. But Bearden had already seen the drawings of his great-grandfather H. B. Kennedy and his grandmother Catherine, and even if it is true that Eugene did teach Bearden to draw, what was more influential was that he introduced Bearden to a world that conflicted squarely with the respectability that Carrie and George Banks, Bessye and Howard, or H. B. and Rosa Kennedy maintained in their respective homes. Peering through the floorboards with Eugene brought to Bearden explicit encounters that remained indelibly fixed in his memory. These encounters undermined the coin of the realm for striving black citizens: respectability. Respectability permeated the photographs that Du Bois assembled for the Paris exposition and was essential to the political strategy of James Weldon Johnson, when he suggested the format of the Silent Parade. The lack of respectability is part of what the black middle class abhorred in the gross distortions of minstrel performance, the caricatured portrayal of blacks in D. W. Griffith's historic film, and the grotesque exaggerations in the countless cartoons, sheet music covers, and Currier and Ives prints. But respectable or not, Eugene's world captivated Bearden, though in his earliest cartoons and serious paintings and drawings, Bearden rarely strayed from a tone of reverent respectfulness. In his later work, however, he established a deliberate dialectic between the respectable and the low down, creating images that defied easy categorization.

Eugene represented, too, Bearden's earliest encounter with loss. Romie had promised Eugene that, after his death, he would set free the doves and pigeons that once gave his friend companionship. The birds were his final remembrance of Eugene. As an only child, Bearden struggled with the loss of his friend. For the rest of Bearden's life, Eugene Bailey would appear repeatedly in his work—in stories, poems, and interviews; in a painting of his funeral completed over fifty years later; and in a painting of the brothel.

The funeral painting is perhaps the most haunting—in a surface jammed with figures appears the ghostly figure of what looks like an angel. Around Eugene's diminutive coffin, Bearden assembled a crowd

of faces and figures as a band plays. Text written in Bearden's graceful longhand accompanied the painting in the published catalogue and on the gallery walls, reading: "The sporting people were allowed to come but they had to stand on the far right." Eugene's pigeons and doves have all become doves and flutter across a sky empty except for a bright orange sun. The pale face of a grown man crammed among the mourners looks skyward, and Bearden identified this as an image of himself as an adult—a rare self-portrait. In tone and structure, the collage is distinctive in Bearden's oeuvre.

Bearden probably returned from Pittsburgh to New York City sometime around 1922. A story he liked to tell was of a surprise gift of a Victrola that his mother made to his father. She told Romie the secret of the gift and, in his excitement, the boy drew on the envelope of the birthday card a perfect rendition of the early record player—in his version (unlike Eugene's) without the emerging female figure.[21]

Bearden returned from Pittsburgh in time to experience his mother's rise to prominence in Harlem's cultural, political, and social scenes. In 1922, Bessye was elected to New York City School Board #15, becoming the first woman and first black woman to hold the position. She eventually assumed the role of secretary, then chairperson, of the board. Politics fit her as naturally as a well-tailored dress. Her activism came at a time of deeply consequential change in party affiliation on the part of black citizens and the increasing influence of women in politics. Once fiercely loyal to the Republican Party—the party of Lincoln and Reconstruction—blacks began to question the party's lassitude in the face of Jim Crow.[22] Buttressed by the recent enfranchisement of women as well as black dissatisfaction, Bessye seized the opportunities offered to her. She was elected in 1924 to the presidency of the National Colored Women's Democratic League, an organization that had as its mission the goal of registering women and turning out the vote on Election Day.[23] She brought to the job a persuasive speaking style, a willingness to travel all over the state on behalf of the party, and her personal charisma—which made her indispensable to the party. Her reward, years later, would be an invitation to President Franklin Roosevelt's first inauguration.

In 1927, she added the role of journalist to her resume, becoming the New York social correspondent for the *Chicago Defender*, one of the country's most influential black newspapers.[24] Banned in several states, the *Defender* advocated the migration of black southerners to the West, Midwest, and Northeast, and it shrewdly employed dining car waiters (as her husband Howard had been) and train porters to distribute the paper. Circulation at its height was 100,000, but readership reached an estimated 500,000 because the paper was shared widely. Bessye faithfully chronicled the details of black New York's stylish social scene every week. Her columns named every attendee of every socially significant event, and she attentively documented what men and women wore, what food was served, and the details of the décor. Her columns serve as a travelogue through the upper reaches of Harlem society.[25]

Activist as she was, Bessye was not without her contradictions about race. As she boasted in her *Pittsburgh Courier* interview, "I have always been proud of the fact that I am a Negro," adding "Somehow, I have always felt that as a Negro I have a great work to perform."[26] Proud though she may have been, she was not above extolling the virtues of being light-skinned in a color-conscious black social circle. She allowed her naturally pale face to be used in a full-page advertisement for "Genuine Black and White Bleaching Cream" in the September 26, 1931, *Chicago Defender* advertisement. As her son would say later, the New Negro world had its own prescribed racial hierarchy based on appearance. Race and racial attitudes were rarely simple and straightforward.[27] Still, he affectionately referred to his mother as his "drill sergeant" and regarded her with a mix of fear and awe. He was fascinated by her ability to attract all kinds of people, filling their various apartments with some of the world's most creative and sophisticated thinkers. Her 131st Street apartment, which became famous, was decorated in a Spanish, Moroccan theme, including wrought iron gates on the interior, velvet drapes, and plush furniture.[28] Black architect Vertner Tandy had designed the apartment expressly for Emma Layton, wife of the songwriter Turner Layton, before they moved in 1929.

A spectacular cast of characters assembled there.[29] Political activists were high on Bessye's list, including, in addition to A'Lelia Walker,

Mary McLeod Bethune, president of the National Association of Colored Women and founder and president of what would become Bethune-Cookman College. Others included Paul Robeson, Marcus Garvey, and Hubert Harrison.[30] Robeson, gifted bass-baritone, actor, lawyer, and activist, was engaged in politics that would veer far to the left of Bessye's. Garvey, who founded the Universal Negro Improvement Association, based on his "Back to Africa" vision, was also among the more radical, as was his chief lieutenant, Harrison. Garvey's public persona, his carefully choreographed parades, replete with military costumes, was a form of visual pageantry that captivated Bearden. Bessye herself briefly supported a trip in 1932 to Russia by a group of black artists, activists, and intellectuals to make a film on the development of the Negro in America; but she quickly removed her name from the sponsorship list before the controversial group set sail.[31]

Bessye's generosity to writers was legendary. The poet and novelist Countee Cullen often visited, accompanied by the handsome boulevardier and highly educated school teacher, Harold Jackman. Jackman would become a good friend of Bearden's and an avid supporter of the writers and artists who congregated in Harlem during the 1920s and 1930s.[32] Bessye's support of writers was evident, when a group of artists that included Zora Neal Hurston and Cullen wanted to host a reception in Bessye's apartment to celebrate Arna Bontemps's new novel *God Sends Sunday*, Bessye obliged.[33] Bearden recalled that Langston Hughes once brought to the house Garcia Lorca, the Spanish poet, who would later die in the Spanish Civil War, in which Hughes would also fight. After Bessye's death, Bearden used Lorca's elegy for a fallen bullfighter, *Lament for Ignacio Sanchez Mejias*, as a theme for one of his paintings. Musicians were as well represented as activists and poets. Bearden writes: "Andy Razaf, 'Fats' Waller (the great songwriting team of the 1920s), Turner Layton—'Way Down Yonder in New Orleans'—later went to London & with Tandy Johnston became the outstanding vaudeville team—so many others."[34]

Bearden was privy to uncensored exchanges and connected the spirited salon conversations directly to the world outside. That world, literally outside his bedroom window, was the back entrance of the

Lafayette Theater. The Lafayette was home to some of New York's finest productions, from the films of black filmmakers to floor shows from some of Harlem's famous cabarets, featuring distinguished performers. Bearden could look out his window and watch performers—Bill "Bojangles" Robinson, Juan Hernandez, Ralph Cooper, and Dusty Fletcher—clustering around the famous "tree of hope," and rubbing its bark for good luck. Even though Bojangles, dancing partner of child actor Shirley Temple, who had danced in Hollywood films, and Ralph Cooper, "one of the most charismatic actors to come out of 'race movies,'" were stars, "they honored the tree's supposed power."[35] A tall elm that stood on 132nd Street between the Lafayette Theater and Connie's Inn, the tree of hope was rumored to bring good luck to the performers who touched it. What is left of the talismanic elm is a memorial stump that stands on the stage of the twenty-first-century Apollo Theater on 125th Street, still touched by performers for good luck as they walk on stage.

Filmmaking was active in Harlem. Early in her New York career, Bessye's striking beauty—she was once described as "small in stature, striking in appearance," and a "smouldering [sic], dark-haired woman of the Latin type"—caught the eye of the black filmmaker Oscar Micheaux, probably when she was a ticket taker at the Lafayette.[36] Bessye soon found herself cast in his (now lost) 1921 movie *The Gunsaulus Mystery*. Romare, who was as fond of Saturday movies as he was of Sunday parades, would have probably seen the film when it played at the Lafayette in April 1921.[37] Bearden had ample opportunity to view the films of not only Micheaux but any number of black filmmakers who made race films—films produced with black casts and expressly for black audiences. Readily available in Harlem, they played not only at the Lafayette, but also at the Lincoln, Renaissance, Roosevelt, and Alhambra theaters. Micheaux in particular was as prolific as he was versatile. Between 1918 and 1948, he made nearly forty feature-length films, wrote seven novels, and became a one-man production and distribution machine for his films throughout the country and abroad.[38]

Though no other black filmmaker was as prolific as Micheaux, the community included several other artist/entrepreneurs, including Nobel

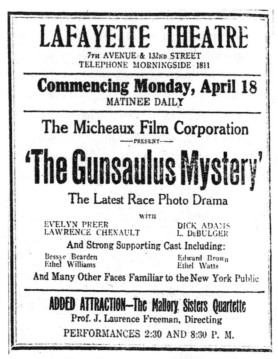

Advertisement for *The Gunsaulus Mystery*, 1921 film by Oscar Micheaux.
Bessye Bearden listed as a member of the cast. *The New York Age*,
April 16, 1921, 6.

and George Johnson and their Lincoln Motion Pictures Company in
Omaha, Nebraska, and then Los Angeles (1916–1921) and the Frederick
Douglass Company in Jersey City (1916–1919). There were more than
a dozen others.[39] Those companies, spread out across the country, ex-
tended beyond New York to Chicago; Roanoke, Virginia; Hollywood;
Philadelphia; and Florida. A close alliance between the black press and
black film companies provided assistance with bookings and pro-
motion. That same relationship supported New York Theater as well.
Black theater, the Lafayette Players in particular, was often a source for
silent film casts.[40]

A great deal of the films from the silent era are now lost, but Bessye's
participation in the Micheaux film suggests that she at least introduced
her son to what was then a real and, if only briefly, thriving "circle,"

that is, "a culture of race filmmakers who defined themselves by their audience." Like the growing number of black studio photographers, the filmmakers were primarily operating a business, but the business was to make images, and was one of several precursors to the more organized efforts during the Depression to seize control of representations of black life and culture. Their success was limited, particularly in comparison to the mass audiences and growing dominance of Hollywood films like *The Birth of a Nation* or *The Jazz Singer*, both of which perpetuated and reinforced stereotypes. The films of Micheaux and others reveal the same tensions between race advocacy and color consciousness that plagued the black press and the black bourgeoisie, but their ambitions presaged the future.

Bearden's father became as quiet and withdrawn as Bessye was gregarious. When the two first arrived in Harlem, Howard and his glamorous wife often made the social columns of New York's black papers. But Howard shared little of his wife's outgoing personality, and eventually Bessye's name appeared alone in the social pages. By the 1930s, social columns reported them vacationing in separate locations. A talented pianist, Howard tried his hand at sketches—not unlike his mother Catherine. He enjoyed the simple freedom of listening to whatever music he liked—and of drinking alcohol, of which Harlem had an abundance. The joints, speakeasies, and pervasive uptown rent parties were virtually unmolested by New York City law enforcement. Bearden recalls that more than once his mother would go out to search the after-hours joints and bring Howard home, relegating him to the couch for the night.[41] She was not above taunting Howard, even in the presence of friends. On one of their yachting vacations, as Howard downed one drink after another, Bessye, chewing the ice she liked to keep in her mouth, chided him: "All right. Go ahead. Go ahead. I'll enjoy your pension."[42] Fate, however, had other plans.

In 1925, as Bearden was about to start high school, his grandmother Catherine Bearden Cummings died.[43] Her death came on the heels of that of his great-grandmother Rosa Kennedy, who had passed away earlier that summer.[44] Bearden's visits to the South all but stopped, and

although memories of the South would weave their way in and out of his work, he did not travel to the South again until long after he had graduated from college and his career had been firmly established.

When Bearden entered Dewitt Clinton High School, he did so with a sense of loss. Dewitt, located in Manhattan during Bearden's tenure, was one of the largest high schools in the country. It would become an incubator for some of New York's most famous citizens, but when Bearden attended, the school, which then was all-male, was so severely overcrowded that it was forced to operate in several annexes. Bearden found himself shuttled off to one such annex on 116th Street, and to make matters worse, little interested him in school. By his own account, he had no ear for the required classics, Latin and Greek, or Spanish and French.[45] He convinced his parents to send him back to his grandparents in Pittsburgh. Bearden left again for Pittsburgh in 1927, where he completed his last two years of school at Peabody High School. Mr. and Mrs. Banks were now living in the East Liberty section of the city, and Bearden continued drawing. A popular story from his time in high school involves his grandmother encouraging him to enter two poster contests. One was sponsored by a movie theater. Bearden avidly researched how to advertise a World War I film entitled *The Big Parade*. His grandmother offered him advice on how to simplify the design and in the end he won the grand prize of $25, as well as a year's pass to the movie theater.[46] The second contest was a cleanup campaign; again, by taking his grandmother's advice, he won the contest.

His interest in athletics increased at Peabody, too, and though he did not make the football team, he was a member of the track team and threw the discus. A talented pitcher, he never joined the high school baseball team. Bearden reported to Myron Schwartzman that he was training for the discus when one day he threw a stray baseball back to some players. In Bearden's words, "I was way out, past the outfielders. So I threw the ball to the second baseman, straight in, on a low line."[47] The players were impressed. Bearden had no interest, however, in accepting the coach's invitation to join the team. His preference was for the games that he played on a lot near a local bakery. Bearden's interest in baseball would grow more serious a little later, when he attended

Boston University and played for BU and, briefly, for the Boston Tigers, a team in the Negro Leagues.

Pittsburgh not only gave the teenaged Bearden an opportunity to sharpen his drawing skills and his athletic talents; it also gave him the chance to continue probing a lifelong fascination with labor, sparked by his admiration for the steelworkers living in his aunt's boarding house. In an interview with Schwartzman, he recounted the efforts he and a friend undertook to get summer jobs in the steel mills. Their first assignment at U.S. Steel, a night shift, took them to the furnace. As Bearden recounts, "Just opening the door to where you were going was like opening the furnace to hell." They asked for a transfer and were assigned to coat the top of the mill with black paint, but that job produced unbearable heat as well. An assignment to roll steel product from the mills to the barge proved overwhelming, when "Romare lost control of the steel he was rolling toward the barge and went into the canal with it." Romie eventually found a partner whose strength was a match to his organizational capacity, and he survived the close up experience of the working at the steel mills.[48] Not all was work that his family would have found respectable, however. As graduation from high school in June of 1929 drew near, Bearden was employed by a small-time hustler and assigned to collect money from one of his speakeasies. Bearden earned the gangster's trust, restoring to him all of his money after the police had conducted a raid on his boss's joint. The man repaid him with enough money to cover his first year of college.[49] The timing for this largesse could not have been better, as the bottom fell out of the American economy that fall.

Bearden's parents were still in New York during the years that Bearden was in high school, and New York was the site of what some deemed a revolution in race and representation. The March 25, 1925, edition of the magazine *Survey Graphics*, founded and edited by social reformer Paul Kellogg, published a special edition edited by Alain Locke. Locke titled it "Harlem: Mecca of the New Negro" and wrote the lead article, which trumpeted news of a transformation led by artists and poets, embraced by the masses and centered in Harlem. Later that year, the issue, expanded by additional contributions, was published

as an anthology of essays and illustrations entitled *The New Negro*. The term, which had appeared as early as the nineteenth century, became firmly associated with Locke and defined a set of assumptions about art, assumptions that went to the core of Bearden's Harlem and to the coming of age of black America. Even as a teenager Bearden was well acquainted with the contributors, many of whom were frequent visitors to his mother's parlor.

Locke, like Du Bois, was keenly aware of the role of representation and visual imagery on the perception of Negro progress. In his introductory essay "Enter the Negro," he writes of the problems of the past as ones of perspective as much as reality: "Through having had to appeal from the unjust stereotypes of his oppressors and traducers to those of his liberators, friends and benefactors, he has subscribed to the traditional positions from which his case has been viewed. Little true social or self-understanding has or could come from such a situation."[50]

Locke's evidence of change lies in cultural expression—poetry and art in addition to education and a "new outlook." Using the image of a butterfly shedding its chrysalis, Locke asserts that what has been shed, at least in part, are stereotypes: "The day of 'aunties,' 'uncles' and 'mammies' is equally gone. Uncle Tom and Sambo have passed on, and even the 'Colonel' and 'George' play barnstorm roles from which they escape with relief when the public spotlight is off."[51] Locke ends the essay with a plea for black citizens to contribute to and collaborate with American civilization. At various points during his career, as Bearden tried to make sense of his own relationship to American culture versus an African heritage, he found himself either agreeing or at odds with Locke's perspective on art and culture.

A year after Locke's influential anthology appeared, the William H. Harmon Foundation established an award in literature and the fine arts, and black fine artists as a collective acquired their first patron.[52] Though Bearden, as a young artist, found fault with the Harmon Foundation, Harmon patronage did have the effect of providing, at the very least, annual exhibitions of the work of black fine artists, and, for those who won the Harmon annual competition, cash prizes. Black artists from all over the country participated and even those who did

not live in Harlem briefly became part of the New York art scene when the exhibition was on display in the city. The Harmon Foundation awards revealed that a growing number of artists were building a life in the arts, many of them choosing to represent scenes of black life as they saw them. The results were sometimes controversial.

Several were trained at some of the country's leading art schools—both the Art Institute of Chicago and Cooper Union for the Advancement of Science and Art were particularly open to them. Painter Archibald Motley, sculptor Richmond Barthes, and cartoonist E. Simms Campbell trained at the Art Institute, and Augusta Savage and Palmer Hayden studied at Cooper Union. Others trained at a range of colleges and universities—the University of Nebraska, Columbia University, and the John Herron Art School in Indianapolis, for example, were training grounds for Aaron Douglas, Charles Alston, and Hale Woodruff, respectively. Hayden, Savage, Woodruff, H. Johnson, and Barthes traveled to Paris or other parts of Europe in the 1920s for additional training and, in many instances, the opportunity to visit the aging black painter, Henry Tanner. Tanner, who had trained at the Philadelphia Academy of Art with, among others, Thomas Eakins, had established a life and career in Paris.[53] Paris offered black artists firsthand access to modernism's latest pictorial challenges and unfettered access to classical work that expanded their sense of possibility for their own art. In the second half of the twentieth century Bearden would join those who made the trip before him, seeking many of the same solutions to what he perceived were many of the same problems—most pressingly, an identity as an artist, unfettered by racial preconceptions.

The Harmon Foundation's power and influence grew with the number of painters and artists who participated in their annual competition and group shows, organized by director, Mary Brady, a matronly white woman who had no training in the arts and little knowledge of black culture. Nonetheless, Brady was a savvy marketer and committed to the mission of the awards. Allying the selection process with the College Art Association, the major association of fine arts professionals and collegiate scholars, she assembled panels of art specialists who, having been asked to judge the work, were introduced to the talent and

skill of a range of black artists. Winning the Harmon Foundation awards was often a career boost as well as a means of support. Palmer Hayden was the first awardee, and his success was announced widely in the black press.

There was a downside, too, however. As Bearden formulated his own perspective of art and race, he would come to loathe the image that the Harmon Foundation promulgated for black artists. He and his cousin Charles Alston never submitted work, and Bearden, in particular, in the 1930s, would deliver the Foundation's most scathing public criticism. But in its early days, few would deny that it was the first to offer institutional support for black artists. Archibald Motley and William H. Johnson both received solo exhibitions in New York as a result of their work being on display at one of the annual Harmon Foundation exhibitions. Several artists received favorable reviews and others, like Hale Woodruff, made use of the money from the prize to study abroad. The Foundation supported black artists but also promoted demeaning aesthetic expectations. This dilemma forced Bearden to reconcile his desire to have an artistic career with his need for aesthetic freedom.[54]

Even as Locke was publishing his anthology and the Harmon Foundation was winning public recognition, perhaps the most successful black artist was neither a painter nor a sculptor, but the photographer James Van Der Zee (1886–1983). There is no evidence that Bearden knew Van Der Zee while he was growing up in Harlem. But no one captured the visual legacy of Harlem, its ritual pageantry, and its people more comprehensively and more inventively than did Van Der Zee. The photographer was not content to simply record events; he also embellished and commented on them. Long before the arrival of Photoshop, he unabashedly etched in details, added figures through double exposure, hand tinted for editorial comment parts of a photographic image, superimposed one image over another, and, in his studio compositions, dressed and arranged his subjects. His intention was to convey a sense of the "New Negro" self-assurance and, as W. E. B. Du Bois characterized the black social and intellectual elite, Talented Tenth-like confidence. Van Der Zee's subject matter covered

a wide range. He placed his camera at the center of the action on Harlem streets, composed portraits in his studio, and showed up at ceremonial events. By 1917 he had established a studio on 135th Street, and during the 1920s, 1930s, and 1940s amassed what would become an encyclopedic inventory of photographs of Harlem's public and private rituals.

Everything that Bessye Bearden would have chronicled in her *Chicago Defender* social column—the returning war heroes decorated with their medals; the parades of Marcus Garvey; A'Lelia Walker's Dark Tower (A'Lelia's cultural salon on a floor of her Harlem brownstone); the Black Cross nurses; the men bedecked in Garvey's ceremonial ribbons and medals; the religious rites of Daddy Grace, one of Harlem's flamboyant religious leaders who combined faith with a deep responsibility to community care-taking; the basketball teams and fraternal organizations; the dinner parties and church socials; weddings and funerals; and thousands upon thousands of portraits—Van Der Zee captured them all. Contemporary celebrities like Florence Mills, or Walker, or boxer Jack Johnson show up frequently. Van Der Zee was a sought-after photographer. The Harlem that he composed was one the Bearden family would have immediately recognized.

Bearden, who was exposed to the African nationalist rhetoric of Garvey and Harrison in his mother's home, no doubt witnessed the Garvey pageantry on one of those days he stood on the curb waiting for a parade to pass. As Van Der Zee's several photographs of Garvey's parade attest, more than visual pageantry was involved. Just as James Weldon Johnson had used theater to call attention to Jim Crow injustices, Garvey used it to win supporters for his cause. Garvey believed that it was useless to try to right the wrongs against black America; instead, he invited his members to buy shares of the Black Star Line, a shipping company that proposed to acquire a vessel, a captain, and a staff, and begin the process of shipping black Americans back to the continent of their origin. Not a new idea—some abolitionists and Abraham Lincoln himself had once favored the recolonization of America's black people to Africa—few possessed the ardor and appeal of Garvey. At its height, the Universal Negro Improvement Association (UNIA) boasted that

its membership was 2 million nationally. (Du Bois, who led the rival NAACP, estimated 300,000).[55] Garvey's audacious ideas were accompanied by equally audacious theater. James Weldon Johnson, in his 1929 book on the black presence in New York, gives the following account: "There were gorgeous uniforms, regalia, decorations and insignia," for the "dukes and duchesses, knight commanders of the Distinguished Order of Ethiopia and knight commanders of the Sublime Order of the Nile." Bearden's fondness for parades coupled with his personal acquaintance with Garvey made it all but certain that he was well acquainted with this lush visual vocabulary.[56]

Death also created opportunities for public display, and Van Der Zee captured those. The funerals of both Florence Mills and A'Lelia Walker (in 1927 and 1931, respectively) are cases in point. Mills, a cabaret singer and dancer, and another celebrity Bearden knew through his mother from her days at the Lafayette Theater, was the darling of popular theater and one of the performers who emerged from the burst of black theater-making in the 1920s. She gained international fame, moving in 1921 from a Harlem cabaret to Broadway as the star of *Shuffle Along,* the first Broadway musical written and performed by black artists. Written and composed by Flournoy Miller and Aubrey Lyles, close friends of the Bearden family, with music and lyrics composed and written by Eubie Blake and Noble Sissel, *Shuffle Along* catapulted Mills to international stardom. After her Broadway success, she performed on a tour in Europe that included an audience with the Prince of Wales. Exhausted from her European tour, featuring the *Blackbirds Revue,* she returned to New York to accompany the show to Broadway but died—at age thirty-one—from an infection following an operation, before her opening night.

Van Der Zee captured her funeral, and Bearden was among the 150,000 gathered along the streets as Harlemites waved out of windows from rooftops and stood in doorsteps, waiting for a glimpse of Mills's casket as the cortege departed from Mother Zion Church in Harlem. Bearden "recalls that at the burial a low-flying airplane released a flock of Black birds over the ceremony and another came scattering roses."[57]

In Van Der Zee's photographs, Harlem appears to be a vast and rich network of social, religious, and political organizations, as glittering and ritually organized as any in history. But Harlem was also changing dramatically, even as Van Der Zee was composing his photographs. As black migrants continued to pour into the city, and as the scare tactics of white realtors took effect, Harlem's white population declined precipitously, altering the chemistry of the neighborhood. Johnson, in *Black Manhattan,* likened the exodus to "a community in the Middle Ages fleeing before an epidemic of the black plague, except for the fact that here the reasons were not so sound."[58] What began as an integrated neighborhood with a lively cultural diversity became increasingly segregated and poor, the living conditions deteriorating as white residents moved out and landlords grew neglectful. The stock market crash that devastated the entire country in the fall of 1929 only hastened the economic decline of Harlem.

Bearden, however, would be miles away from New York, attending Lincoln University, the black men's college on the outskirts of Philadelphia—the first of a string of colleges he would attend—when the crash took place. When he finally returned to New York for his final college experience, the country was deeply entrenched in the Depression.

Romare Bearden photograph attached to his 1929 application to Lincoln University; masthead for Lincoln University Yearbook, listing H. R. Bearden as a cartoonist, 1930–31. Courtesy of Langston Hughes Memorial Library, Lincoln University, Oxford, PA.

THE EVOLUTION
OF A RACE MAN

If it is the race question, the social struggle, or whatever else that needs expression, it is to that the artist must surrender himself. An intense, eager devotion to present day life, to study it, to help relieve it, this is the calling of the Negro artist.

—Romare Bearden, "The Negro Artist and Modern Art," 1934

Attached to Bearden's application to Lincoln University is a photograph of an athletic young man, 5' 9" and 165 pounds, a former discus thrower and sandlot baseball devotee. In addition to being good-looking, the applicant also laid claim to a distinguished family pedigree. "Through my parents I have met many of the outstanding men of this country. Many of these gentlemen have attended Lincoln. Successful doctors, lawyers, ministers and business men profess Lincoln as their college."[1]

Gaining admittance, Bearden made use of his unexpected financial windfall from his erstwhile Pittsburgh underworld patron to attend, in the fall of 1929, the elite black men's college located forty miles outside of Philadelphia. With its reputation for educating talented black men, Lincoln seemed like the perfect choice for Bearden. The school's alumni included some of the country's leading black doctors, lawyers, and clergymen—Reverend Cummings, Catherine Bearden's second husband, included. A recent Lincoln alumnus, Langston Hughes—one of many visitors to the Bearden household—graduated from the college the same year Bearden entered. Hughes wrote glowingly about Lincoln to

the writer and photographer Carl Van Vechten as "more like what home ought to be than any place I've ever seen."[2]

Bearden did not share Hughes's enthusiasm for the college. His application, written in uninspired prose, lists medicine as his intended occupation. He enrolled in what appears to have been a pre-med program and took courses in Greek, Spanish, biology, rhetoric, and trigonometry.[3] His pre-med ambitions, however, did not preclude his joining the staff of the 1930 yearbook, in which he is listed as "H. R. Bearden, cartoonist," but he did not stay long enough to make good on his budding interest in cartooning.[4] After only one year, he left Lincoln and enrolled in the art department of the School of Education at Boston University (BU), the second of what would be three colleges he would eventually attend.

Only weeks after Bearden entered Lincoln in the fall of 1929, the stock market crashed. The immediate impact was devastating. More than 5,000 banks closed, bank accounts and jobs evaporated, mortgages were foreclosed, and businesses went under. Unemployment soared to between 25 and 33 percent overall—and in Harlem to more than 50 percent. Garcia Lorca, the young Spanish poet and a visitor to the Bearden household, had just arrived in the city that summer. A student at Columbia University, Lorca liked to roam the streets of New York and did so almost as often as he attended classes. He happened to be near Wall Street when the crash occurred and described the scene in a letter to his parents: "The streets...were filled with hysteria and chaos, and you cannot possibly imagine the suffering and anguish of the crowd."[5] Bearden, on the other hand, was spared the worst of the Depression. His parents continued to work, and, though he would move from one university to another, there was never a break in his college attendance. These years were a time when he began to define his artistic persona, found a direction for his work, and joined a circle of friends who would become part of a powerful surge of creative energy in Harlem and throughout the country.

Protected from the financial collapse though Bearden might have been, there were harbingers of what lay ahead for Harlem's economy. In the December 6, 1930, issue of the *Chicago Defender*, Bessye Bearden

wrote a detailed account of the auctioning off of the contents of her friend and patron A'Lelia Walker's Irvington-on-the-Hudson residence, Villa Lewaro. The estate had been one of the heiress's havens for the Harlem literati. Built by A'Lelia's mother, Madam C. J. Walker (the successful black businesswoman whose wealth was one of her legacies to her only child), and designed by Vertner Tandy (the decorator of one of Bessye's apartments), the Villa was a symbol of black accomplishment in business and art. A'Lelia had rapidly consumed her inheritance with her high living, and the Villa became too costly to maintain. Bessye traveled to Irvington to witness the dismantling of not only an estate but a way of life. She recorded the auction prices of each item: rare books, artwork and rugs, an Aubusson tapestry, Hepplewhite mahogany, a Flemish oak billiard table, fourteen volumes of the Bible bound in half wood and half pigskin and printed on imperishable paper—testaments to an unsustainable extravagance that had become part of the New Negro style. "A few of us who had once enjoyed the hospitalities of the mansion stood with wet eyes and looked on."[6]

Despite her financial difficulties, A'Lelia bravely carried on in Manhattan. Bearden and his mother were listed among the attendees at a swank 1930 New Year's Eve open house at A'Lelia's home on 80 Edgecombe Avenue. The party would be among her last. A'Lelia died in August 1931, and with her death an era in Harlem came to an end.[7] Bessye and Howard attended A'Lelia's funeral. Howard served as one of the pallbearers, helping to carry her elegant bronze casket as mourners— in the thousands, according to headlines—gathered in the streets.[8] At the interment at Woodlawn Cemetery in the Bronx, Colonel Julian's plane, which Bearden had once watched take off from his playground and which had brought blackbirds to the funeral of Florence Mills, returned once again, this time loaded with a floral tribute for A'Lelia. With her death came the closing of the Dark Tower, A'Lelia's townhouse, where she had hosted established artists and writers as well as aspiring artists and writers. Langston Hughes would refer to A'Lelia's death as "the end of the gay times of the New Negro era in Harlem."[9]

From Bearden's perspective, "gay times of the New Negro era" were embodied not just in A'Lelia but also in Bessye and her circle. As he

came of age as an artist, he would look back on his mother's era ruefully, labeling it "soiree" society—social and political change conducted from Persian-carpeted rooms. Soiree society did not, of course, die altogether—Bessye, Howard, and others, like Bearden's artistic mentor Aaron Douglas and his wife Alta, would continue to host salons and gatherings. But A'Lelia's death marked a significant shift in the tone and temper of the social, political, and artistic life in Harlem. After college, Bearden and his artist friends would come to prefer their own sparsely furnished studios and brand of activism. As an adult, looking back on the Depression years, Bearden wrote in his book, *A History of African American Artists: From 1792 to the Present,* co-authored with Harry Henderson, that the new activism took place in "kitchens and on curbstones, on breadlines and job lines, in churches and saloons." Landing a job as a welfare case worker, after he graduated from college, Bearden worked in a Harlem that substituted "rent parties, sit-ins at welfare offices, mass demonstrations, picket lines, and the blocking of evictions" for Bessye Bearden's galas and balls. In place of soiree society, his generation had what Bearden referred to as "the movement, a turn in the 1930s towards a critique of social conditions and injustices, made worse by the country's financial collapse."[10]

After only a year, Bearden left Lincoln and his pre-med career and in the fall of 1930 enrolled in the art department of the School of Education at Boston University. He immediately indulged two of his passions—drawing cartoons and playing baseball. Having established himself as a cartoonist in the Lincoln University Yearbook, in the summer of 1930, he continued to pursue cartooning. Eventually, he would progress from college humor to serious political cartoons, published on the pages of publications like *Crisis* magazine. *Crisis* editor W. E. B. Du Bois was a firm believer in the power of the visual image, as he had demonstrated with his interest in the photographic exhibition of black citizens for the Negro Exhibition at the 1900 Paris World's Fair, and in his continuing inclusion of images on the pages of *Crisis.* From the first issue of *Crisis,* Du Bois made his arguments about race relations in the United States with visual images, poetry, and literature as often as he did with

sociological, historical, or political data.[11] Bearden's early cartoons, however, were a far cry from *Crisis* magazine material.

After a year at BU, Bearden started drawing for the *Beanpot*, the university's humor magazine, and by March of 1932—his last semester at BU before transferring again, this time to New York University (NYU)—he was the editor.[12] His output included four covers and, signing his name Howard Bearden as he did at Lincoln, he displayed a sharp eye for body types and facial expressions and a dry wit that pandered to the wise-cracking tastes of a collegiate audience. In one of his rare allusions to race, a plump black woman, purse in hand and prim hat perched on her head, issues a request to a clearly baffled white clerk that read, "Flesh colored stockings, please!"[13]

Beyond a number of corny gangster representations, there is no clear theme in Bearden's BU cartoons. He drew what he thought would get a laugh and what his skills allowed him to draw. Bearden took a range of art classes: painting, design, and color, cast drawing, perspective, drawing of ornament, freehand drawing, and art history.[14] For many years in interviews, he would claim that he had no formal training in art beyond his time in the studio with George Grosz, which might be a reflection on what he thought about his college art courses.

When he wasn't in class or drawing cartoons for the *Beanpot,* Bearden indulged his other passion, baseball. Baseball was not just a pastime; it was a symbol of the country and its racial constructions in the first half of the twentieth century.[15] Bearden's involvement with the sport, and the choices it presented him, speaks volumes about intractable racial practices. At BU Bearden was able to play varsity baseball as a pitcher, and his lifelong pride in this accomplishment was evidenced by the BU 1931 certificate of merit that hung in his Canal Street studio until the end of his life.[16] Negro league teams often scouted talent at local high schools and colleges, and the Boston (Colored) Tigers, a highly regarded team once referred to as "the champs of New England," took note of Bearden's skills.[17] The Tigers were at that time the most distinguished of Boston's roster of Negro league baseball teams.[18]

Mainstream American baseball took note, too. But unlike boxing—an arena in which black heroes were abundant and championed by blacks

and whites alike—baseball strictly excluded black talent. Black talent was bountiful nonetheless. In the face of exclusion, the Negro leagues were the only game in town for black players, and the Negro leagues assembled some of the greatest players in the game. The Boston (Colored) Tigers presented Bearden with the opportunity to play with some of that talent, including members of the Pittsburgh Crawfords and the Kansas City Monarchs. On one occasion Bearden pitched against Leroy "Satchel" Paige, when Bearden played for the Pittsburgh Crawfords and before Paige went to the Cleveland Indians.[19] When the Tigers were not playing against another team in the Negro leagues, they had the opportunity to play white teams—"all manner of factory, semi-pro, town and park teams."[20]

Segregated baseball teams created their own culture, one among many examples in black culture that Bearden experienced intimately. Negro league teams went around the country—throughout the Northeast, the Midwest, and all over the South. Winn's Field in Charlotte, Bearden's birthplace, was one such site. The arrival of a Negro league team was greeted by ceremonial bands, a fanfare meant to stir up interest in the games. The players worked year-round. When they completed their seasons in the United States, Negro league teams sometimes played during spring training for major league teams or traveled to countries with more open attitudes toward race—Puerto Rico, the Dominican Republic, Cuba, and Venezuela—and in the process had access to additional practice, competition, and world-class talent. Bearden was told often that he was good enough to compete in the Negro leagues.

One summer while Bearden was at BU, Mickey Cochrane, a catcher for the Philadelphia Athletics, brought some teammates to Boston for an exhibition game against the university team. Bearden gave up one hit. Connie Mack, owner of the Athletics, talked with Bearden about a pro-baseball contract—but only if he were willing to pass for white. He was not. Bearden later discussed his decision to turn down the opportunity to play professional ball, and the assumption that with his pale skin and European features he could have simply stepped out of a world that in the early 1930s was tightly circumscribed by law and

social practice and into a world of relative privilege. Light-skinned though he was, doing so was out of the question for Bearden, just as it had been for his mother. Throughout his life, though he was constantly mistaken for white, he was always keenly aware of his identity as a black person. He was also keenly aware of the intellectual and cultural capital, handed down from one generation of his family to the next, of which he was the beneficiary. To "pass" would force him to deny its value. He would have to give up his connection to H. B. and Rosa's history of reinvention or forget Carrie and George Banks's boarding house and the lessons learned on the streets of Pittsburgh. He would need to disconnect from the resilient network of family and friends that extended from Charlotte to Goldsboro to Lutherville, Maryland, in the South and up north to Harlem and Pittsburgh. Consciously or not, the choice heightened his sense of a cultural DNA, the loss of which was unthinkable and—though he had no way of knowing at the time— without which his artistic future would have been impossible.

After two summers pitching with the Boston Tigers, Bearden sustained an injury to his thumb that required him to set baseball aside.[21] His interest in the game began to wane as his success with cartoons grew. In March 1932, *Opportunity*, the official publication of the Urban League (the NAACP's rival civil rights organization), published his sketch of urban industry on its cover. This was one of the earliest recognitions Bearden received from a noncollegiate publication, and it marked his official debut if not as an artist, then at least as a serious illustrator.

A few months after landing the cover of *Opportunity*, Bearden learned the news of H. B.'s death. Like countless other Americans, H. B. had been hit hard by the Depression. His property in Charlotte had been foreclosed and bought by the Empire Investment Company and, at the time of his death, he was living in Greensboro, North Carolina. Charlotte's May 15, 1932, edition of the *Sunday Observer* noted about H. B. that he was an "old and highly respected negro [*sic*]."[22] Both Rosa and Catherine had died several years earlier, and with Henry's property gone, Charlotte, the early site of Bearden's childhood, was gone as well.

His baseball prospects ending, Bearden left BU at the end of the spring 1932 semester and enrolled at New York University in the fall as an art education major. As an adult, Bearden often insisted on identifying himself as a math major at NYU. A look at his NYU transcript, however, reveals that he took primarily art courses—figure drawing, water color painting, linoleum block printing, mechanical drawing, lettering appreciation of art, and observation of teaching in high schools.[23] Outside of his classes, he regularly produced cartoons for the university's humor magazine the *Medley* which, much like his cartoons for the *Beanpot,* indulged their college audiences with stock characters and illustrated the extent to which Bearden was able to segregate the work he did for his college humor magazine from the work he did for the black press.

Cases in point are the cartoons he drew in 1934 and 1935 for *Crisis.* For the April 1934 issue of the *Medley*, Bearden blithely used the same stereotypes he would years later scathingly critique. He pictured a group of half-shaven, pot-bellied men standing in front of a wood oven. One of them is holding an opened straight razor and the caption reads, "Dis Razor Ain't Been a Bit of Good...Since Dat time I shaved Wid it." Even when he did tackle serious subjects like labor unrest, he did so with a light touch. A cartoon in the March 1935 issue of the *Medley* pictures a group of dissatisfied workers protesting with the caption, "Morris is becoming very conservative lately"—the punchline referring to a marcher with a sign that reads "Workers Reflect." By contrast, for the July 1934 issue of *Crisis*—a black publication—he drew a cartoon entitled "Picket Line," that pictured angry black protesters whose signs read "Begin to Trade Where You Can Also Find Work" and "Give Us a Job." Above the protesters' heads are newsprint headlines that blast the hypocrisy of stores that accept Negro patronage but don't give Negroes jobs. Whichever cartoon "voice" he chose, Bearden's cartooning was a serious endeavor and his entrée into the art world, one that introduced him to his most significant mentor.

After his first year back in New York, while still a student at NYU, Bearden decided to take the advice of some of his friends and enroll in a course at the Art Students' League (ASL). The League, founded after

the Civil War, offered low-cost art instruction to amateurs and professionals both, and boasted a history of faculty made up of accomplished artists. With no set curriculum and no degree, the League offered traditional courses in life drawing and, in the style of a nineteenth-century French atelier, afforded aspiring artists the opportunity to study with working artists. When Bearden walked into the French Renaissance building at 215 West 57th Street one August day in 1933, he entered the studio of an artist who had not only found his passion but was willing to make major sacrifices for it. George Grosz, who described himself in his autobiography as "the merciless critic of German bourgeoisie and German institutions," had arrived from Berlin earlier in the year.[24] He left Germany just weeks before Hitler became chancellor. His caricatures and exposés of German corruption and fraud were scathing enough for the National Socialist government to strip him of his citizenship.

Grosz took a liking to the easygoing yet eager young cartoonist who walked into his sweltering League studio. Still struggling with his limited English, he managed to teach Bearden some lessons he would remember the rest of his life. Ironically, though Bearden came looking for Grosz the political satirist, it was Grosz the artist who proved the most instructive. Grosz urged the aspiring cartoonist to observe the world with eyes unfiltered by prevailing opinions. He encouraged drawing from a live model, a practice Bearden continued long after he left Grosz's studio. Recognizing Bearden's facility in cartooning, Grosz connected the young man's skill at drawing, along with his talent for rendering body types, hands, and facial expressions to communicate mood, character, and narrative tone, to a more expansive set of artistic possibilities such as color, light, space, and composition. Grosz directed the ambitious cartoonist to European painters—Pieter Brueghel, Francisco Goya, Honoré Daumier, Käthe Kollwitz, among them—who painted human foibles but with complexity and nuance. ASL records show that Bearden's encounters with his German mentor were brief—they only met the summer of 1933 and again in the fall of 1935 after he had graduated from NYU. But the impact of those studies was lasting. For one, Bearden learned to be his own best teacher. Grosz's advice to study

European masters inspired Bearden's methodical practice of copying the best-known works of artistic celebrities in addition to life drawing. Grosz exemplified someone who had sacrificed everything for his art: his home, his safety, his successful career in Germany. Grosz's work—and the German government's response to it—was proof of the disruptive force of the subversive image.

A year after his first encounter with Grosz, Bearden was secure enough about this artistic identity to write a brash and controversial essay on race and art, the first of two major statements he devoted to the subject. Much anthologized after its rediscovery years later, "The Negro Artist and Modern Art" originally appeared on the pages of the December 1934 issue of *Opportunity*.[25] Though only a college senior, with the confidence of a seasoned artist, the young cartoonist expressed his true feelings about the damage to black artists of the patronage of the William H. Harmon Foundation. Bearden identifies what he sees as the deficiencies of black painters and sculptors. He attributes these deficiencies in part to an inadequate patronage system and in part to the artists' own lack of vision. The article claims that authentic art comes from a connection to the world as it is lived and experienced by people in their everyday lives.

His criticism of his fellow black artists, in the essay, is particularly harsh. He contemptuously refers to the work of some as "hackneyed and uninspired" and criticizes the "tepid" approach of most Negro artists who, unlike the creators of the bold original work of African antiquity, have "seen nothing with their own eyes" and are content to mimic the work of others. Pointing to the stinging social indictments of works by eighteenth-century English artists like William Hogarth or William Cruickshank or nineteenth-century drawings of Daumier as models (some of whom Grosz had introduced him to), he faults Negro artists for failing to observe their own world and instead choosing to paint scenes of "Scandinavian life"—a barely disguised attack on William H. Johnson, a black artist who lived for a time in Denmark and was known for painting picturesque Scandinavian scenes. Bearden's harshest attack, however, was reserved for the Harmon Foundation, the Harlem Renaissance's chief artistic patrons. Despite their financial support,

and despite the exhibition opportunities and professional alliances they forged on behalf of the artists, the Foundation affixed what Bearden saw as demeaning aesthetic labels to black artists. They encouraged the identification of "inherent Negro traits," and praised black artists for their "natural rhythm," "optimism," "humor," and "simplicity."[26]

When Bearden wrote his 1934 essay, he was foreshadowing a generation of artists that succeeded those of the Harlem Renaissance with different interests and subject matter. From Bearden's perspective, he was part of an unabashedly political generation that saw themselves as part of "The Movement."[27] Faced with the realities of the Depression, artists—black and white alike—made use of their art to expose social inequities and deprivations. Bearden's early paintings, for example, included scenes of men and women in breadlines, factory workers receiving pink slips, families gathering to partake of meager meals, farm laborers working unyielding soil. Black artists added to social critique canvases that documented the unique history of Africans in America. Seeds of race pride planted during the New Negro era of the 1920s blossomed into epic statements of racial heritage and culture during the 1930s and 1940s in the works of artists as varied as Hale Woodruff, Jacob Lawrence, and Aaron Douglas. They, along with Bearden, claimed as their artistic heroes the Mexican muralist painters whose works combined twentieth-century modernism with cultural pride in a way that was championed—if briefly—by the New York art establishment.

Bearden lavishes praise on Mexican muralists, whom he deemed artistic models in his essay. In his eyes, they had discovered the very means to be modernists, to embrace their ethnic and cultural heritage, and to engage people to connect viscerally with their work. He singled out Diego Rivera, José Orozco, and David Siqueiros—"Les Tres Grandes," as they were known. All three had studied in Paris in the early decades of the twentieth century and become well versed in modernism's stylistic innovations and in its defiance of slavish reproductions of reality. They were equally inspired by the revolutionary events in their homeland and Mexico's indigenous past. All three employed a style that allowed them to embrace modernism, adopt a highly stylized realism,

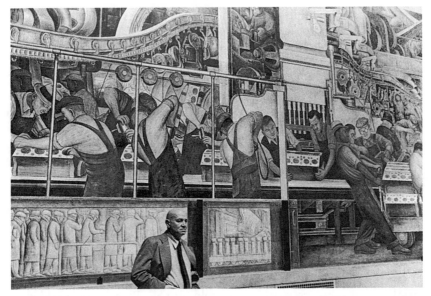

Bearden standing in front of Diego Rivera's *Detroit Industry, North Wall* mural, ca. 1987, Detroit Institute of Arts. Photo: Frank Stewart.

and portray unabashedly political and social justice content. Orozco had lost his arm fighting in the Mexican Revolution: "No wonder he depicted the persecution of the underclass Mexicans so vividly—it had all been a harrowing reality for him."[28]

Rivera's modernism, however, was not without controversy. Several months before Bearden wrote "The Negro Artist and Modern Art," Rivera's confrontational mural *Man at the Crossroads*, which had been commissioned by philanthropist and oil baron John D. Rockefeller for Rockefeller Center, was challenged in 1934. Rivera had chosen to paint a portrait of Lenin, in a highly visible section of the mural. Lenin's virulent anti-capitalism and pro-communist ideology was an affront to some. When Rivera refused to remove the portrait of Lenin, the mural was destroyed. Up until that point, Rivera and his artistic colleagues had been art establishment heroes in the United States as well as in Mexico. Rivera's modernist pedigree was established with a solo exhibition at the newly built Museum of Modern Art (chaired by Rockefeller) that ran from December 22, 1931, to January 27, 1932. It was only the

second solo show at the museum, with Matisse being the first from November 3 to December 6, 1931.[29] In Diego Rivera, Bearden laid claim to an artistic model, someone who championed national and cultural identity and who had won the respect and acclaim of one of modernism's standard bearers.

All three of Les Tres Grandes enjoyed commissions that placed their work in highly visible public sites. Orozco completed a mural for the New School for Social Research—now simply the New School—in 1931. During a residency at Dartmouth College from 1932 to 1934, Siqueiros completed an epic 150-foot mural for the reserve reading room in Baker Library. The Detroit Art Institute commissioned Rivera to paint his enduring homage to workers, his River Rouge mural, in 1932. Black artists were welcomed as apprentices, and during the Depression, several, including Charles Alston, who assisted Rivera on *Man at the Crossroads*, and others, like Hale Woodruff, Charles White, and Elizabeth Catlett, traveled to Mexico to work with Rivera there.

The American art establishment's enthusiasm cooled once the depth of the Mexican artists' radical left-wing politics became evident. Bearden remained enthusiastic, however, and taking his cue from them, he ends his youthful article on a triumphant note. He writes as if he has satisfied himself once and for all what authentic image making is about: "If it is the race question, the social struggle, or whatever else that needs expression, it is to that the artist must surrender himself. An intense, eager devotion to present day life, to study it, to help relieve it, this is the calling of the Negro artist."[30] Little did he know how radically his views would change as his art continued to mature and evolve.

Reaction to Bearden's essay was immediate. Both the *Pittsburgh Courier* and the *Amsterdam News* detailed his attack on the Harmon Foundation. The *Amsterdam News* headline read, "Young Bearden Hits at Harmon Awards: Charges Foundation Has Established Lower Art Standards for Negro." The *Pittsburgh Courier* was no less sensational: "Harmon Awards Harmful Artist Says...: Sets up Dual Art Standard His Claim." "The Negro Artist and Modern Art" was a lightning rod in the community. Bearden's critique had hit a nerve, and both Aaron Douglas and Augusta Savage seized the opportunity to organize.

They called a meeting of Harlem leaders and challenged them to take Bearden's critique as a call to action.[31] A. Philip Randolph, the labor leader and editor, alongside Owen Chandler of the radical black publication, the *Messenger* (and decades later a key figure in the civil rights movement), took up Bearden's challenge to offer a new form of support for black artists. He organized the Harlem Art Committee, whose first project was an exhibition of sixty-five artists at the 138th Street Harlem YWCA in March 1935. Painter Gwendolyn Bennett wrote in an article for the March 23 *Amsterdam News* that one of Bearden's contributions, "Breadline," "is beautiful in a strong, graphic manner."

By the time Bearden graduated from NYU in June 1935, he had made a name for himself as an aspiring artist. *Amsterdam News* columnist Roi Ottley included him in his popular column "The Town Crier" in a survey of the "best" New York had to offer. Ottley designated Jessie Owens "best" in track, Joe Louis "best" in Boxing, and Fats Waller "best" in songwriting. When he got to the category of artists, he wrote, "Among the artists who should achieve greatness: 1. Spinkie Alston 2. Romare Bearden 3. Ol Harrington."[32]

More important than Bearden's prominence in the black press social columns, with his 1934 essay, Bearden entered a chain of debates about racial identity and art that had begun a decade earlier. Alain Locke's essay in *The New Negro* of 1925 was an early entry. Locke had claimed that African antiquity provided African American artists with a distinctive legacy, a point of view Bearden now rejected in his 1934 essay. Bearden admired the formal elements of African art and its contribution to European modernism, extolling the African artist for the bold way in which he "would distort his figures, if by so doing he could achieve a more expressive form."[33]

He concluded his essay, however, by counseling Negro artists to find something "original or native like the spiritual or jazz music." Bearden's advice to his fellow artists evokes the quarrel between Langston Hughes and journalist George Schuyler, who debated race and art on the pages of the *Nation* magazine a year after Locke's essay appeared in print. Schuyler's "The Negro Art Hokum" debunked the idea of a distinctive Negro Art, asserting that Negroes were Americans and their art part of

an expression of a larger American identity. A rebuttal came a week later from Hughes, who wrote that the distinctive heritage and experience of Negroes shaped them profoundly and left them with a distinctive voice. A few years later, W. E. B. Du Bois weighed in, declaring that art should function as propaganda, an instrument that advocates change for the social and political status of black people.[34] Though Du Bois sidesteps Hughes's belief that there a distinctive culture that shapes black artists, he burdens black artists, nonetheless, with the responsibility of racial advocacy. As Bearden matured artistically, he would find himself conflicted by these multiple perspectives on race and its relationship to his art and to his identity as an artist.

Issues of race and representation arose in the dispensation of what would become the country's major federal arts patronage system.[35] As Bearden's article went to press, change was under way in the patronage of American artists. Roosevelt's New Deal Recovery Program would keep artists in America working throughout the Depression and have a transformative impact on the freedom of black artists in terms of their representations of race. Inspiration for the program came, in part, from the Mexican muralists. Holger Cahill, national director of the Federal Art Project, part of President Franklin Roosevelt's New Deal, shared Bearden's admiration for the work of Les Tres Grandes and pointed to their work in Mexico when looking for a model for New Deal arts programs. Cahill envisioned a similar burst of imagery of American life if American artists were given the wherewithal to paint such scenes on the walls of public buildings across the country. The New Deal Federal Arts programs would undergo several iterations before it became the Works Progress Administration of the Federal Art Project or the WPA/FAP, a federal program of support for artists that provided unprecedented public funding for American artists. Though Bearden did not qualify for the WPA (he was employed during the Depression as were his parents with whom he lived), scores of black artists participated in the federal largesse from the outset. Federal funds gave them the freedom to work ambitiously.

One of the first participants in an early iteration of New Deal support was Aaron Douglas, who, as "The Negro Artist and Modern Art" was

appearing in print, had just completed an epic four-panel representation of the African diaspora titled *Aspects of Negro Life*. Installed in the 135th Street branch of the New York Public Library, the murals assertively recounted a narrative of race on an epic scale. Douglas had won a coveted commission in 1934 from the Public Works of Art Project (PWAP), a precursor to the WPA/FAP. Douglas (as the requirements stipulated) was formally trained, making him one of only a handful of black artists even eligible for the commission—850 commissions were awarded, and only three of those were to black artists. Douglas not only had an MFA from University of Nebraska but he had access for a year to the works in the Albert Barnes Foundation, one of the world's most comprehensive collections of late nineteenth- and early twentieth-century modern European masters and African antiquity. Dr. Barnes, a medical doctor by training, who had acquired considerable wealth with the invention of Argyrol in the late nineteenth century (a solution that protected against blindness in infants) sequestered his collection—works by Picasso, Matisse, Cézanne, Renoir, Modigliani—in a mansion outside of Philadelphia. Hostile to the art establishment and Philadelphia society, Barnes maintained extremely limited access to his collection. No color reproductions of the works were allowed. Works were never loaned and no part of the collection was allowed to travel. Appointments were made by letter and often denied or accepted by Barnes himself.

In the course of his art collecting, Barnes came to know Alain Locke and contributed an essay to Locke's collection of essays in *Survey Graphics*. Douglas, whose illustrations were among those included at the time of the publication, was the most progressive of the Harlem Renaissance artists. Douglas boasted a prolific record of illustrations that included pieces in *Crisis* magazine in addition to Locke's *New Negro* anthology. His commissioned murals were mounted in Chicago, at Fisk University in Nashville, and on the walls of A'Lelia Walker's Dark Tower residence in New York. Impressed by Douglas and by his work, Barnes gave the artist unprecedented access for one year to the Barnes Foundation. For a year, masterpieces unavailable to the public or other artists formed the basis of Douglas's private tutorial.

Douglas was more than ten years older than Bearden, who affection-
ately referred to his colleague as "Doug" or "the Dean." The ambition
of *Aspects of Negro Life* was evidenced by the scale of the four murals
on display in the 135th Street Library. He painted the narrative scenes
in what had become his signature style in the late 1920s and early
1930s: highly stylized silhouetted figures, rendered in terra-cotta colors
and occupying a flattened two-dimensional space, divided into concen-
tric circles.[36] To punctuate action in the painting, Douglas introduced
theatrical shafts of light as if he were casting a spotlight on the main
action. Douglas used themes that literary figures had introduced during
the New Negro era and that artists and writers would continue. His
subject matter was the first epic representation of themes that captured
the African diaspora: the legacy of slavery, the dialectic between life
in the industrialized North and rural South, violence versus creative
resistance, the ubiquity of music and religion, and the power of speech
and the word. From a myth of origins to the current world, each mural
presented a major chapter in the transformation from African to
African American.

Douglas's suite of four panels begins with "The Negro in an African
Setting" and pictures a tribal ceremony. The second, a panoramic
canvas, documents the era of servitude. The third panel is entitled
"From Slavery through Reconstruction," and the last and final panel
reflects the cynicism brewing in Harlem of the 1930s. A central figure
appears in the middle of the canvas with a saxophone, representing the
individual black artist. He stands atop a giant cog, an obvious symbol
of modern America's devouring industrial machinery. Below him, an-
other figure with briefcase in hand runs from one machine cog to the
next. Lady Liberty, a distant ideal, appears faintly in the background.
Skyscrapers have taken the place of trees visible in earlier panels.
Douglas had hereby found his own style and visual language to accom-
plish what the Mexican muralists had done—he told a story of epochal
transformation. His four large canvases are likely the first to broach the
topic of the Great Migration in visual form.

Douglas's themes assert the presence of a narrative of black life that
added layers of nuance and complexity to the depictions of American

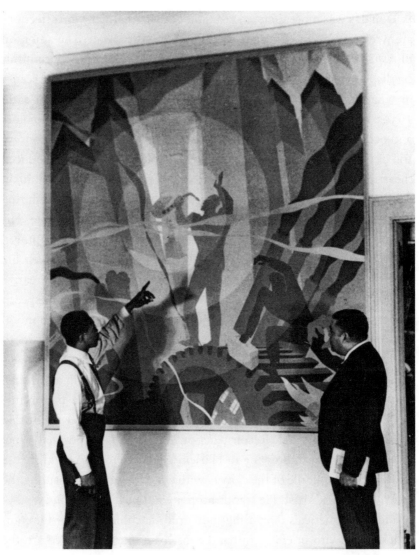

Aaron Douglas (left) and Arthur Schomburg standing in front of Aaron Douglas, *Aspects of Negro Life: Song of the Towers*, 1934. Schomburg Center for Research in Black Culture, The New York Public Library, Astor, Lenox and Tilden Foundations.

life funded by white American WPA-supported artists. His epic work prefigured works by Charles Alston, Jacob Lawrence, and Hale Woodruff, all of whom represented race narratives in a bold and unapologetic manner. Bearden's earliest paintings were as influenced by these artists as they were by the Mexican muralists he championed in his 1934 essay. Along with Les Tres Grandes, the works of Douglas and others and emerging aspects of life in Harlem collectively became major influences on Bearden's earliest work. Harlem, despite its poverty, was a fermenting brew of artistic, social justice, and political activism that made the community feel like an Open University populated with larger- than-life personalities.

One was "Spinky" Alston, Bearden's cousin, and one of the leaders in Harlem's artistic community. Two years after Douglas completed his epic murals, Alston found himself embroiled in a controversy at Harlem Hospital. In 1936, the WPA/FAP made Alston project director for a suite of murals to be installed on the walls of the Women's Pavilion of Harlem Hospital. The first African American artist to receive a supervisory role in the WPA, Alston was in charge of five other artists to design "narrative, celebratory images of Harlem, African-American life, children's fairy tales and stories."[37] After Alston had received approval from the WPA for his portion of the mural, which was to compare African healing rituals and modern medicine, with the latter picturing a harmoniously integrated hospital staff, hospital administrators intervened, stating that the murals "contain[ed] too much Negro subject matter." The administrators' protest came in the midst of labor disputes having to do with equitable representation of black medical personnel at the hospital. Alston was eventually allowed to continue.

Alston, who was trained at Columbia University and as a teacher at Columbia Teachers College, was an important presence in the Harlem artists' community. He worked with James Lesesne Wells, a master printmaker, educated at Lincoln and Columbia University, who also was a member of the art faculty at Howard University. Later, Henry "Mike" Bannarn, a noted sculptor and painter, who trained at the Minneapolis College of Art and Design, joined them to provide master workshops at the 135th Street Library. Alston worked, too, at Utopia House, a local

community center where he was an early teacher of the gifted young artist Jacob Lawrence. In addition to the Harlem Hospital mural, Alston received federal aid to host a workshop at the 135th Street Library. The number of those who responded was too overwhelming for the library space to manage, so Alston found a former stable house at 306 West 141st Street and established the federally funded workshop there with the assistance of Bannarn. Alston and Bannarn maintained apartments there. A magnet for working artists with its studios and exhibitions, "306" became a gathering place, and "the 306 Group" was the name assumed by its frequenters. Black and white guests alike flocked to 306. In the 1940s, the venue housed Bearden's first solo exhibition.

One of the most dominant figures among the senior artists in Harlem was the sculptor Augusta Savage. Savage had been a student at the highly selective Cooper Union and recognized immediately by her teachers as gifted. Some of her earliest sculpted heads were of prominent black figures—including W. E. B. Du Bois and Marcus Garvey. Her piece *Gamin*, 1924, won a Julius Rosenwald Fellowship, the prestigious awards sponsored by the successful businessman in support of black talent, and with Du Bois's assistance she won an American Academy in Rome scholarship. When she could not attend because she lacked traveling money, her Harlem community raised the funds for her to study in Paris instead at Académie de la Grande Chaumière. Her Paris studio in the Latin Quarter was a favorite place for other artists—Palmer Hayden, Hale Woodruff, Countee Cullen, and Alberta Hunter.[38] By 1932 she had established the Savage Studio of Arts and Crafts in Harlem. When Bearden and his childhood friend and artist, Norman Lewis, walked into the studio from the street, Savage wasted no time.[39] She handed them a broom and had them clean up. Bearden watched her at work, recognizing her single-minded seriousness and high level of proficiency.

Artists were not Bearden's only influence in Harlem of the 1930s. He often referred affectionately to Charles Christopher Seifert as "Professor," as the artists referred to him.[40] Seifert, like the Puerto Rican bibliophile and collector Arthur Schomburg, was a self-taught scholar of African and African American history. Born in Barbados, he became a successful building contractor in the 1930s. Seifert accumulated

books, maps, charts, manuscripts, paintings, and sculptures that documented African and African American history. According to Bearden, who enjoyed his company, he was a magnetic presence. He established a school, the Ethiopian School of Research, offered classes on African and African American history at 313 West 137th Street, and lectured to packed audiences at the Harlem YMCA. Bearden and several of his artist friends were among the beneficiaries of those lectures. When the Museum of Modern Art opened its monumental exhibition of African Art in 1935, Seifert took a group of artists, Bearden included, to see not only that exhibition but three others on African art in the city to increase their firsthand knowledge.

In the fall of 1935, not long after he had graduated from NYU, Bearden happened to see an advertisement for a meeting of Harlem artists at the 135th Street YMCA. The purpose of the meeting was to organize and lobby the federal government to locate one of its WPA-financed art centers in Harlem. When the young college graduate arrived at the meeting expecting to see only about half a dozen artists, he was surprised to find that more than fifty had turned up. A ripple of excitement circulated among the men and women in the group, who called themselves the Harlem Artists Guild. Their gathering was a landmark event. Until that point, the painters, sculptors, printmakers, and photographers who lived and worked in Harlem were unaware that the community of artists was so large.

The group quickly elected Aaron Douglas as their president, and the politically savvy Douglas forged ties with the larger and the more powerful organization, the Artists Union, which had formed a year earlier to push for federal support of artists. Protesting against the restrictive requirements of the PWAP, the artists' union formed as a collective of painters, printmakers, and sculptors united in their efforts to secure federal funding for working artists. When the WPA/FAP was established in 1935, a range of work opportunities became available for artists of varying levels of expertise. The Artists Union lobbied to ensure that the disposition of those jobs was fair and consistent. Their publication *Art Front* was edited by Stuart Davis, by then well on his way to becoming a major figure in American art. Davis attracted essays written by leading

artists, scholars, and critics. Fernand Léger, Meyer Schapiro, Harold Rosenberg, and Davis himself provided an ongoing conversation about issues of identity, subject matter, and the nature of art, all of which Bearden had written about in 1934. Bearden could hear echoes of some of his views in Schapiro's words.

Schapiro in particular, a Jewish scholar, avowed Marxist, and Columbia professor, was particularly vocal about issues of race and representation. Schapiro wrote an essay for *Art Front,* in 1936, "Race, Nationality and Art," two years after Bearden's "The Negro Artist and Modern Art." The Marxist art historian decried any form of cultural chauvinism. In a not too veiled reference to Alain Locke, Schapiro specifically chided "Negro liberals who teach that the American Negro artist should cultivate the old African styles, that his real racial genius has emerged most powerfully in those styles, and that he must give up his effort to paint and carve like a white man."[41] Schapiro warns of the deleterious effect of emulating African art. He notes that imitation of African art would yield inferior fabrications that amounted to little more than "tourist art."[42] Though Shapiro does not counsel Negro artists to turn to their experience for fresh new views, his counsel not to imitate African art would have been well received by Bearden.

Douglas's goal was to forge ties between the Harlem Artists Guild and the rapidly proliferating number of progressive downtown artist groups in the hopes of winning for Harlem a federally supported Community Art Center. He hoped that in Harlem's very own art academy, everyone from the established artist to the layperson could find first-rate instruction, and serious artists could find a venue for their work. Douglas was present when, a year after the founding of the Harlem Artists Guild, the Artist Congress, a Communist Party vehicle organized to combat the spread of fascism, was formed. He spoke out on behalf of the inclusiveness of artists' rights extending to black artists. Yet another organization that formed in 1936, during the tenure of the WPA/FAP, was American Abstract Artists, a group that committed itself to a modernist vocabulary as well as socially progressive ideas. At a time when abstract art was out of fashion, the organization provided exhibition opportunities for artists who embraced an abstract idiom.

Among the several organizations, whose meetings he regularly attended, Bearden had ample opportunity to meet a wide range of artists practicing a variety of styles.

Bearden's coming of age as an artist thus took place in a cauldron of competing approaches to art. Patriotism underscored the federal arts projects of the WPA, encouraging those artists who eschewed European modernism and sought a distinctively American style of painting. Thomas Hart Benton, Grant Wood, and John Steuart Curry drew from regional cultures—the West, Midwest, South—for themes that defined what they chose to paint. They were often not immune to prejudices and stereotypes. Benton's large-scale murals—for example, *America Today* (1929–1930) and *The Arts of Life in America* (commissioned by the Whitney Museum, 1932)—are filled with stereotypical images of Indians and black people. Artists such as Ben Shahn, Jack Levine, Reginald Marsh, and Robert Gwathmey, by contrast, painted scenes that included more sympathetic portraits of black subject matter. Even abstract painter Stuart Davis's early cartoons for *The Masses* contained blatant racial stereotypes. Davis later shed realism and became a leading American abstract painter, who revered jazz music. He would later become a close confidant and mentor to Bearden, coaching the young artist to listen closely to the compositions and improvisations of jazz musicians as models for his painting. Davis along with the abstract painters Walter Quirt and Carl Holty, members of the American Abstract Artists, became increasingly influential as Bearden's painting style transitioned from social realism to abstraction in the 1940s.

Douglas's strategy to win funding for a WPA-sponsored art center paid off in November of 1937, when the WPA/FAP set up classes temporarily in Augusta Savage's renovated art studio (a converted garage) in preparation for a permanent center. A month later, when the official center opened on the corner of 125th Street and Lenox Avenue, First Lady Eleanor Roosevelt paid a visit to the spacious loft that included classrooms and exhibition space. Bearden proudly referred to it as Harlem's "first museum." Harlem's "first museum" garnered significant community support. Douglas, Savage, Seifert, Ad Bates (who organized Bearden's first solo show), Gwendolyn Bennett, W. E. B. Du Bois, Alston,

Bannarn, A. Philip Randolph, the 306, and the 135th Street Library—not to mention the artists and intellectuals who frequented his mother's salons—were all part of a community of support. Artists in Harlem during the 1930s were not alone. As Bearden reminisced years later about their sense of community awareness. "We realized quite well whom we were painting for then. Of course, in a community economically depressed, we could not expect much financial reward for our works, but we did find sympathy, interest and sometimes understanding."[43] The support black artists received from one another was amplified by the financial sustenance of the WPA. The federal government in the form of the WPA proved to be a patron that provided a living for some and support for specific artistic projects for others. For black artists coming of age during the Depression, their sense of community combined with funds from the WPA gave them the time and resources to produce a suite of visual images that expanded the definition of American as well as African American identity.

Whatever sense of community Harlem brought to its artists, it was also a community in distress, weakened even more by the Depression. On the evening of March 19, 1935, frustration erupted into the first of a string of riots that would continue for several decades. The igniting incident was a white policeman who was reported to have been abusive toward a young man at a Harlem store. Before the evening was over, thousands of rioters had smashed storefronts, set fire to cars, and looted stores. Bearden, who had been privy to the complaints in meetings and organized protests, would not have been surprised at the rising anger in Harlem. While the national unemployment rate was 33 percent, Harlem's was 50 percent. Residents faced bureaucratic obstacles when they sought federal relief and found themselves barred from public facilities. After the riot, Mayor Fiorello La Guardia set up a commission to investigate the root cause of the riot, and Bessye Bearden was assigned by her paper to cover its work. Her son meanwhile became a temporary caseworker immediately after graduating from NYU, a job that, according to New York City employment records, would become permanent in 1938.[44] As a caseworker, his understanding of modern urban life was intimate but unsentimental.

Caseworkers were expected to make home visits, visits that were often intrusive; Bearden's colleagues would open refrigerators and rifle through closets and drawers, in violation of their clients' privacy, to discover any evidence of hidden assets.

Bearden approached his day job with the intent of knowing and experiencing worlds different from his own. Instead of knowing the contents of people's drawers and closets, he wanted to learn about their inner lives. As he traveled from one tenement to the next, he saw for himself the conditions that instigated the riots. Many of his social work clients were recent migrants from the South looking for a better life. What they received, instead, were rents uptown that were twice what they were elsewhere in Manhattan. Residents often had to take in boarders in apartments and houses designed for single families just to make ends meet, causing overcrowding. Landlords failed to make repairs, which then left the overcrowded tenants with unsanitary conditions and health problems exacerbated by poor medical care, making their lives even more fragile. On top of these already oppressive conditions, many were without jobs. Already in the lowest-paying jobs—porters, waiters, janitors, elevator operators, domestic workers—there seemed no way out.

It was around the time he began his job as a social worker that he became an avid political cartoonist, contributing monthly to *Crisis* and weekly to the *Baltimore Afro-American* from 1935 to 1938. In his cartoons he demonstrated that he intuitively grasped what Meyer Schapiro would describe in an article for *Art Front*, as "the legibility and pointedness of a cartoon" and the ability of the cartoon to "reach great masses of workers at little expense."[45] Understanding full well the satiric capacity and history of cartoons, Bearden deliberately used their legibility and pointedness to take emphatic stands on political, social, and racial issues.[46]

Several themes recur in the cartoon; the anti-lynching cause is one. Bearden's approach to anti-lynching themes is to avert his attention from the graphic horror of a corpse hanging from a tree. Unlike the images favored by many of his artistic peers and the photographs of lynched victims, he focused instead on the executioner and the spectators. His

emphasis in the anti-lynching cartoons is on the white citizenry's construction and staging of the event and their complicity. In one cartoon, for example, he portrays a larger-than-life figure—rope in hand, a band of ammunition across his chest—looming over a desolate landscape with a face monstrous and grimacing. The grotesqueness in these cartoons resides not in the disfigurement of a black body but in the dehumanizing distortions of unchecked white power.

Placing the terror of lynching in a global context, Bearden would often draw pictorial analogies equating German aggression with southern injustices and mob violence. A swastika on the sleeve of a hooded Klansman creates an analogy between the treatment of black citizens and the German persecution of Jewish citizens throughout Europe. Bearden's frequent critiques of lynching are scathing. Klansmen loom over huddled masses or the hulking figure of the Black Legion, a short-lived but savage vigilante group, rises up threateningly; or southern lynch mobs appear as grimacing figures. His anti-lynching cartoons also found a target in complacent legislators, who refused to pass anti-lynching legislation. Failure of the rule of law is as much a crime in Bearden's cartoons as any act of violence, and the number of cartoons that represent corrupt or paralyzed legislative action is substantial. His critiques were not only directed at conditions in the South and he lashed out at New Deal Recovery efforts for their failure to close the employment gap for black laborers or to improve labor conditions.

Ethiopia and fascism's threat to its independence was another issue that Bearden covered, a favorite topic in the black press as well. Emperor Haile Selassie's plea to the League of Nations to heed the invasion of his homeland by Mussolini's Italian Army as a warning sign fell on deaf ears. Bearden's cartoons are visual warning signs as well as illustrations of the strong association between issues on the continent of Africa and African American life.

As war became imminent, Bearden drew his most controversial cartoon, one that questions whether or not black citizens should serve in the armed forces. The cartoon is entitled, "News Item, 'Another War Imminent.'" In the first register of the cartoon, the caption has a loud-mouth politician reading, "In '17 the big boys told the colored soldiers

to go fight for their country and, if they did, when they returned, they would enjoy true democracy." In the next register, a helmeted "colored soldier" in uniform marches off, bayonet on his shoulder, the caption reading, "So the colored boys marched away to help save the world for democracy," and the next scene pictures soldiers in trenches. Bearden's punchline is hard-hitting. A man enjoying a meal with wine is captioned, "while the big boys on the other side piled up the dough." He ends the series with a lone, desolate figure whose caption reads, "So that when the boys got back many of them had to live this way. And soon they may be called on to go through the same thing again." In his writings, his cartoons, and the projects he chose, Bearden demonstrated he was first and foremost a race man.[47]

Bearden's militancy—from the time he finished college until his first solo exhibition—is evident not only in his cartoons but also in a journalistic project that directly took up the cause of labor unrest. Using his vacation time, he traveled to a number of cities in the Midwest that were home to what was commonly called "Little Steel." These smaller manufacturing companies refused to recognize the legitimacy of the union, the Congress of Industrialized Organizations (CIO), as had big steel companies, and this refusal instigated police violence against striking steelworkers.[48] Bearden set out to determine the role of black steelworkers in Little Steel as the CIO conducted its unionizing efforts. As he made his way from one town to the next, he snapped pictures of the workers and their living conditions, and interviewed black and white steelworkers and managers. Though his sympathies clearly resided with the unions and the rights of workers, he quickly discerned and reported on a breach between white and "colored" workers as well as a schism between labor and management. The outcome of his travels was two articles: the first, "They Make Steel," appeared on the pages of the *New York Amsterdam News* on October 23, 1937, and the second, "The Negro in Little Steel," on the pages of *Opportunity: A Journal of Negro Life,* December, 1937.[49]

For all of his serious work, by day—his essay, his job as a caseworker, work with the Harlem Artists Guild, the muckraking cartoons, and investigative journalism—Bearden liked to have fun. Harlem by

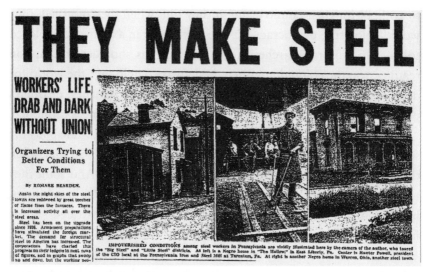

"They Make Steel," a Romare Bearden article illustrated with his photographs in the *New York Amsterdam News*, October 23, 1937, 13.

night was radically different from Harlem by day, and it was as much Bearden's world during the 1930s as any other part of Harlem.

By day Harlem belonged to the elements of "Negro Uplift" and cultural pursuits. By night it offered good music, good dancing, and good times. E. Simms Campbell drew a now-famous—or infamous—satirical map of Harlem's nightlife with its flattened space and ironic commentary on all of Harlem's major and minor hangouts; it could have served as a guide to Bearden's nightlife.[50] Even after the crash in 1929 and before the repeal of Prohibition in 1933, Harlem's nightlife was the envy of European capitals, and after an emotionally challenging day as a caseworker, Bearden took full advantage of what it offered. Albert Murray, the novelist, essayist, and jazz aficionado, and who would become Bearden's close friend and collaborator, recalled: "Almost overnight the bands of Fletcher Henderson, Duke Ellington, Chick Webb, Cab Calloway, Charley Johnson, Claude Hopkins, Jimmie Lunceford, McKinney's Cotton Pickers and the Savoy Sultans evolved on the scene or came to Harlem from elsewhere." Two things were required to hang out: "impeccable musical taste" and a sense of style.[51]

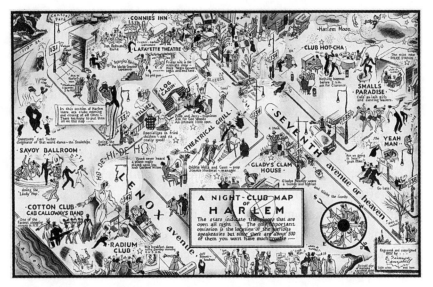

Elmer Simms Campbell, *A Night Club Map of Harlem*, 24 x 32 in.,
ink and watercolor on illustration board, 1932. Printed as a
centerfold in the first issue of the 1932 *Manhattan Magazine*.
Courtesy of James Weldon Johnson Memorial Collection of
African American Arts and Letters, Beinecke Rare Book
and Manuscript Library, Yale University.

The eligible young bachelor would end his work day at 5 P.M., then
go home to eat with his family and work on his cartoons. Later in the
evening, he changed his clothes so that he could "style." Style, in his
words—"Regardless of how good you might be at whatever else you
did...you also had to get with the music. The clothes you wore, the
way you talked (and I don't mean just jive talk), the way you stood,
(some used to say stashed) when you were just hanging out, the way
you drove an automobile or even just sat in it, everything you did was
you might say, geared to groove."[52]

"Geared to groove," he and his buddies called themselves the "Dawn
Patrol." Touring one night spot after another, downing beers and listening
to some of the best music in the world, they "stashed" until the early
hours of the morning.[53] At the time, Bearden made very little connection

between his art and what he did with the Dawn Patrol, the music he heard, or the styling. Art and "styling" were separate worlds altogether—or so he thought. A popular Dawn Patrol spot was the Savoy ballroom, which featured artists like Duke Ellington, Fletcher Henderson, and Ella Fitzgerald, as well as dancers who, along with the musicians, offered what Bearden referred to as "the best dancing in the world and the best music."[54]

Jungle Alley was the name Bearden and his friends gave to the stretch of cabarets, back rooms, clubs, restaurants, and night spots around 137th Street and Lenox Avenue—and it was this densely populated geography that E. Simms Campbell mapped. Jungle Alley provided Bearden with a community of artists as closely knit as those who frequented the cafés and bars of Montparnasse in the late nineteenth and early twentieth centuries. As Bearden recalls, "One place was Mom Young's. She let her patrons bring an empty one pound coffee can that she filled with homemade beer, and for a mere 25 cents you could buy a beer and a bowl of chili or okra or something, a different dish she made every night."[55] Mom Young reserved a special room just for the artists, and they flocked there from Downtown as well as Uptown.[56] Dark Tower restaurant, named after A'Lelia Walker's famous salon, was yet another interracial gathering place where Bearden recalls meeting Langston Hughes, Garcia Lorca, Hart Crane, and Carl Van Vechten.

If the pages of *Opportunity* and *Crisis* represented the uplift, the social justice agenda of Harlem, the nightlife was decidedly anti-uplift. One of Bearden's spots was the Clam House, where he and his drinking buddies listened to Gladys Bentley, a woman dressed up like a man who accompanied herself on the piano with "naughty" lyrics full of double entendres. The underworld was very much present uptown as well. Bearden's memories of Dutch Schultz are vivid. At one of the brothels Uptown, Schultz would come in and request the girls to take off their clothes, leaving on only their black stockings. As he talked to a girl, the others would parade around in their black stockings while the artists looked on. After brothels like Mamie Cole's, there was probably little that surprised young Bearden. He once went home with a showgirl, and when he woke up the next morning, a python she had

stowed in her bag slithered onto the floor. Another night, Lincoln Perry, better known as Stepin' Fetchit, by then a popular movie star, drove a group of the artists home at top speed right up on the sidewalk. Nightlife was the young man's adventure time, when anything could happen—and did.

"Style" had its own lessons to teach, though it would take another thirty years before he made full use of those lessons. Until then, lessons learned during the Dawn Patrol—in the small jazz clubs, dance halls, rent parties, back rooms and joints—lay dormant, waiting to be conjured back to life. As Bearden enjoyed his nights on Dawn Patrol, and spent his days working Harlem tenements, he moved increasingly away from cartoons and toward painting. By the end of the 1930s and the beginning of the 1940s, he began to amass a number of paintings that in subject matter, if not in style, extended far beyond the limits of cartoons. Painting, as he would come to realize, made being a "Negro Artist" involved in "Modern Art" a role fraught with unanticipated dilemmas and conflicts.

THE NEGRO ARTIST'S DILEMMA

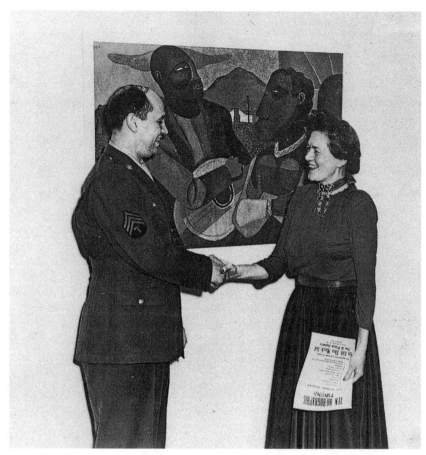

Romare Bearden (in uniform) with Caresse Crosby at the opening of his solo exhibition *Ten Hierographic Paintings by Sgt. Romare Bearden*, on February 13, 1944, at the G Place Gallery, Washington, DC.

THE MAKING OF AN AMERICAN ARTIST

They have seen in their own towns, in their own villages, in schoolhouses, in post offices, in the back rooms of shops and stores, pictures painted by their sons, their neighbors—people they have known and lived beside and talked to. They have seen, across these last few years, rooms full of paintings by Americans, walls covered with all the paintings of Americans—some of it good, some of it not good, but all of it native, human, eager and alive—all of it painted by their own kind in their own country, and painted about things they know and look at often and have touched and loved.[1]

—Franklin Roosevelt, March 1941

Within a few years of its launch, the Works Progress Administration (WPA) had supported enough art to cover the walls of federal buildings all over the country. On the occasion of the dedication of Washington, DC's new National Gallery of Art, Roosevelt evoked the panoramic display of American life created as a result of support from federal arts programs. He had every right to be proud. By the time the WPA came to an end in 1943, the government had employed and commissioned over 10,000 artists, who produced over 100,000 easel paintings, 18,000 sculptures, and more than 13,000 prints, 4,000 murals, and countless posters and photographs.[2]

Bearden's cartoons and paintings of the conditions of black life would not have been among those counted in the inventory of WPA images. Because of his family's income, he did not qualify for federal relief. However, thematically, Bearden was painting scenes that

placed him squarely within a tradition of American scene painting and social justice subjects, popular among many (though not all) WPA-supported artists.

Not everyone was as enthusiastic as President Roosevelt about the WPA and its achievements. When the head of the program Holger Cahill collected essays from dozens of artists for a program report, among them were some noteworthy and acerbic critiques.[3] Two of them were by Stuart Davis and Walter Quirt, who would become advisors and mentors to Bearden and eventually influence his views on painting. Both artists were convinced that the future of American art resided someplace other than the realism the WPA overwhelmingly supported. Davis praised the work of the 1913 Armory Show, which introduced European modernists to the American public. He identified the landmark exhibition as a milestone for American artists. He complained of a "Domestic naturalism" that preferred either the "chicken yard, the pussy cat, the farmer's wife, the artist's model, Route 16A, natural beauties of the home town" or the more proletariat vision of "the picket line, the Dust Bowl, the home-relief office, the evicted family." Bearden's Depression-era paintings fell decidedly into the latter category. For Davis, abstract painting, rather than domestic or some kind of faux proletariat naturalism, more truthfully captured the dynamism of contemporary life. Quirt, too, had little patience for realism. From Quirt's perspective, the unlocking of a fantasy life and the representations of emotions and feelings were the essence of painting.[4]

As the Depression wore on, however, Bearden continued to paint scenes of black life. Race, social justice, the reality of contemporary conditions—these were the realities that Bearden believed in the 1930s and early 1940s were his duty to represent.

Slowly, during the Depression years, he amassed enough works for his first solo show. On the evening of May 4, 1940, Bessye and Howard Bearden proudly stood in the middle of a crowded gallery in the converted stable called "306," as it was located at 306 West 141st Street, as a steady stream of visitors poured in to take a look at their son's work. Mounted by his friend Addison (Ad) Bates, dancer, choreographer, and furniture maker, the solo exhibition confirmed to the world—

his parents, his peers, to Bearden himself—that he was a serious artist. The opening was a major social event. Carl Van Vechten, the omnipresent photographer of New Negro talent, proclaimed to the *Amsterdam News* that "A crowd like this has not gathered since the days of the Dark Tower."[5] Guests included Alain Locke, lyricist Andy Razaf, and painters Charles White and Norman Lewis, all of whom "came early and stayed late."[6] For all the hoopla, Bearden's output had been modest: there were twenty-four works in all: oil paintings, gouache, watercolors, and drawings, completed between 1937 and 1940.

Somber men and women representing black life as Bearden had witnessed it in the rural South and urban North greeted the opening-night guests, works with such titles as *Street Corner*, *The Well*, *Women at a Pump*, *Men Eating*, and *Soup Kitchen*, exactly the "proletariat" types Stuart Davis had criticized in his essay. But the black press celebrated the work. The national edition of the *Chicago Defender* described Bearden's paintings as "distinctive because he is among the few Negro artists who have been interested in showing the transition of the colored workers from the agricultural to the urban, industrialized community."[7] The paintings offered a stark contrast to the cartoons even though Bearden had begun doing them while still drawing for the *Crisis* and the *Baltimore Afro-American*. His cartoons are full of expressive lines and explosive distortions of scale and proportion, and they had been militantly assertive statements about political or social issues. His paintings, on the other hand, were reflective—the contours of his sturdy figures calm, the faces stoic and mask-like, bodies stiffly articulated and still, as if they were carved from wood. Painted in earth tones and with muted reds and blues, the canvases portray men working in factories, hauling cotton, pumping water; families engaged in social routines of daily life and eating meals; and musicians standing on street corners. His palette recalls the somber canvases of Orozco and the hulking figures of Rivera. There are overtones of labor strife and the burden of poverty, and the strains they put on life. The works resemble the subject matter—if not the style—of social realists like William Gropper, Jack Levine, and Ben Shahn, whose subject matter focused on victims of social and political injustices.[8]

The exhibition was accompanied by a modest pamphlet. Its three short paragraphs earnestly restated the artistic mission he had articulated in his 1934 article: "I believe the function of the artist is to find ways of communicating, in sensible sensuous terms, those experiences, which do not find adequate expression in the daily round of living and for which, therefore, no ready-made means of communication exists." For Bearden, art was not personal expression but the expression of what his audience "feels and wants." That "fact, plus horse-sense, resolves all questions as to the place of 'propaganda,' the role of the artist in society, the subject matter of painting, the good or bad health of any particular work." The ideas and underlying assumptions published on the occasion of his inaugural solo show would be tested to the breaking point during the next decade.[9]

Though the exhibit hung for only a week, Bearden could not have chosen a better venue. The converted stable at "306" enjoyed a brief but intense iconic status not only in the Harlem community but in the New York art world. Over time, Bearden would come to have doubts about the realism and naturalism that offered a narrow representation of black life. In the 1940s, that naturalistic representation was popular. An example is a 1941 volume of photographs selected by Edwin Rosskam with accompanying prose by the novelist, Richard Wright, whose *Native Son* was a bestseller. Wright's anthology *12 Million Black Voices* documented the black migration, accompanied with photographs by Edward Rothstein, Dorothea Lange, and Walker Evans. Here was the kind of journalism that Bearden would first practice himself then eventually come to abjure. For now, his solo exhibition could have fit comfortably in the same space as Wright's unrelentingly bleak vision of black life in America.

Bleak or not, from Bearden's perspective, before and immediately after World War II, Negro artists were in vogue, and Bearden was a willing participant in the fashionable group art shows. Inevitably, the catalogues, essays, and reviews that accompanied these shows heralded them as evidence of the "coming of age" of the Negro artist. Even Bessye found the outpouring of attention significant enough for her social column. In her December 13, 1941, *Chicago Defender* social

I believe the function of the artist is to find ways of communicating, in sensible, sensuous terms, those experiences which do not find adequate expression in the daily round of living and for which, therefore, no ready-made means of communication exists.

I believe that art is an expression of what people feel and want...that this fact, plus horse-sense, resolves all questions as to the place of "propaganda," the role of the artist in society, the subject matter of painting, the good or bad health of any particular work.

In order for a painting to be "good" two things are necessary: that there be a communion of belief and desire between artist and spectator; that the artist be able to see and say something that enriches the fund of communicable feeling and the medium for expressing it.

ROMARE BEARDEN

ROMARE BEARDEN

Oils, Gouaches, Water Colors, Drawings

1937 - 1940

306 West 141st Street
New York City

May 4 to May 11

Page from Bearden scrapbook with photograph of *Rites of Spring*, *Cotton Workers*, and *The Visitation* (ca. 1937–1940). Includes statement from Romare Bearden inaugural solo exhibition at "306" West 141st Street. Archives of American Art, Smithsonian Institution, Washington, DC.

column, she wrote that the shows were bringing Negro artists to the attention of a discriminating public; and with the splendid cooperation of the brilliant sales forces in these galleries many sales are made.[10]

Truthfully, Bearden enjoyed the attention that came from exhibitions—for a while at least. In an undated letter to Cedric Dover, who was researching a book on black art, he characterized the group shows of the 1940s as a "turning point." Years after the shows were mounted, Bearden could still recite a list of the influential New York sponsors of one of the most highly regarded of those shows that opened in December 1941 at Edith Halpert's Downtown Gallery: "Mrs. Roosevelt and Mayor La Guardia, Mr. and Mrs. J. D. Rockefeller, Carl Van Vechten, Archibald McLeish, Edsel Ford, Countee Cullen..."[11]

By the time of the shows Bearden had secured a studio for himself, separate from the apartment he shared with his parents. Following a tip from Jacob Lawrence he leased a studio at 33 W. 125th street.[12] This gave him independence from his parents and allowed him to create his own social scene separate from their demanding schedule of Beaux Arts balls, costume parties, salons, and social club dates. At $8.00 a month, the dark, decrepit space seemed like a bargain until Bearden realized that it was unbearably cold—the landlord had removed the radiators and sold the metal as scrap. With only a kerosene heater, the studio became unlivable. Bessye, looking after her "baby" (who she believed was "throwing his life away"), appealed to the photographers Marvin and Morgan Smith, who had a spacious studio a few blocks west on 243 W. 125th street, above the famed Apollo Theater. With his mother's help, Bearden leased a space. His studio became part atelier, part home away from home, part hangout, part school. He kept the space above the Apollo for the next twenty years. During that time, he hosted an eclectic assortment of visitors: painters, photographers, models, composers, musicians, friends, wealthy gallery dealers, eager high school students, and, when he became a songwriter—as his wife would complain—all kinds of unsavory characters.[13]

The artists' studios in Harlem became the center of their world, private community gathering spots, buffers against what would be the highly unstable currency of black artists in the years after war. Alston

and Bates had demonstrated with "306" that an open working space could be a magnet for other artists. Augusta Savage had been an early occupant of her own studio space on West 143rd Street, and over time, others established their individual spaces, each with its own personality. By the 1940s, Norman Lewis, who had maintained a studio downtown for several years on 28th Street (in the same building as Jackson Pollock and Lee Krasner), also maintained a studio over the Apollo Theater, where he kept exotic plants and tanks of fish. Photographers Morgan and Marvin Smith ran a lively photography studio that took up the length of an entire floor, and writers Claude McKay and Bill Attaway worked in the building as well.

Bearden's studio was sparsely furnished—a table and some chairs, an easel, reproductions of works—Cézanne's *Cardplayers*, Duccio's *Maesta*, Giotto's *Lamentation* and other images—tacked on the wall. Coming home from his caseworker job, Bearden could count on not only a space independent of his parents' home but a place where he could find a sense of community.

During the Christmas holidays in 1940, after the success of his first solo show, Bearden traveled south at the invitation of his "cousin" Spinky Alston. Alston had gone south two years earlier with Farm Security Administration (FSA) photographers who were documenting conditions. Supported on both trips by a Rosenwald Fellowship, Alston took Bearden along and they stopped to visit relatives in Greensboro and Goldsboro, North Carolina. Their trip covered a lot of ground: "small towns...farming arears [sic] in Virginia, North Carolina, South Carolina, Georgia, Alabama, and Arkansas."[14] According to an application for a Guggenheim Fellowship that Bearden submitted, the trip had a "profound influence" on his work. Going south was like "going home" and "marked the end of a lonely 'self-expression,'" and by his own account, gave his work "an emotional anchor."[15]

In Atlanta, Bearden and Alston met an artist many were proclaiming to be the standard-bearer for a more complex narrative about race, representation, and identity—Hale Woodruff. Woodruff, like Aaron Douglas before him, had taken on a monumental assignment, a mural that would depict an epic story—in this case, the rebellion on the slave

ship *Amistad* in 1839, the trial of its leader Cinque, and the successful return of the African mutineers to their Sierra Leone homeland.

Woodruff, a slender, courtly man with a head of thick, dark hair that would turn snow white as he aged, had been born in Cairo, Illinois. Unlike Alston and Bearden, who spent most of their childhood in the North, Woodruff grew up in the South in Nashville, Tennessee. Woodruff's implacable determination was evident early on. An only child, he decided that he would be an artist and headed to Indianapolis, where he attended the John Herron Art School and became one of a small number of black artists in the 1920s who benefited from formal training in the arts.[16] Woodruff spent several years in Paris (from 1927 to 1931), met Henry Tanner, and along with Palmer Hayden and others frequented Augusta Savage's studio.[17] In 1931, Woodruff took on the job of starting one of the few fine arts departments at a black college, Atlanta University. For some time his was a one-person department.

Woodruff created an environment in which young painters, sculptors, and printmakers could thrive. He established the Atlanta Annual exhibition of black artists and built an excellent permanent collection for what is now the Clark Atlanta University Art Museum, the acquisitions resulting from annual exhibits. Woodruff was fearless in his support of his students and personally convinced Atlanta's then segregated High Museum to open its doors to them. Except for a brief time studying in Mexico with Diego Rivera in 1936 and a Rosenwald Fellowship in New York in 1943, Woodruff spent the Depression and war years in Atlanta. His impact—through the Atlanta Annual, the artists he trained, and the murals he painted—was as consequential as that of any artist who lived and worked in New York.

Woodruff's *Amistad* murals firmly established his career as a major artist; they were supported by the WPA and heralded on the pages of *Crisis*, as well as reproduced in a special edition of the W. E. B. Du Bois–edited *Phylon* magazine.[18] Commissioned by Talladega College president and civil rights activist Buell Gallagher, the murals then inspired Gallagher to write about the project in the April 1939 issue of *Crisis*.[19] Located in Talladega, Alabama, the historically black college

planned to build a library named after former slave George Savery, one of the educational leaders who inspired its founding. The first three panels of Woodruff's murals were commissioned in 1938, dedicated in 1939, and then placed in the Savery Library.

Like Douglas, Woodruff engaged a visual narrative that was ennobling and that belied the accumulating stereotypes and caricatures that littered the popular culture landscape. An early influence on the way in which Bearden would conceptualize the past visually, they merit extended discussion.[20] Each of the first three panels of the *Amistad* murals is monumental in scale, measuring anywhere from six feet by ten feet to six feet by twenty feet. The first panel depicts the mutiny and violent uprising led by Cinque aboard the Portuguese slave ship, carrying slaves and bound illegally for Cuba with the intent of then traveling up the coast of the Atlantic seaboard; the second panel depicts the trial of Cinque and the mutineers, who were defended successfully in the Supreme Court by former president John Quincy Adams; the third presents the repatriation of the freed Africans to their homeland, Sierra Leone, and their alliance with their white American allies who became the founders of the American Missionary Association, which established several historically black colleges and universities, including Talladega College, as well as Atlanta University, Fisk University, Tougaloo College, and Dillard University among others. A second set of three mural panels completed in 1940 continued the story with a panel depicting the Underground Railroad, the founding of Talladega and the building of the Savery Library. These panels were most likely still in Woodruff's studio when Alston and Bearden visited.[21]

Woodruff's approach was daring for the time. On the one hand, he painted the first panel, the scene of mutiny and resistance, as one of open conflict between black slaves and white slave traffickers. He details the ferocity and violence of the Africans with their machetes raised, rising up against their white captors. Each resister is painted as a heroic individual in bright vivid colors that highlights his beauty, power, and strength. Painting a scene of black rebellion in the Jim Crow South, at a time when lynching was still common, was not without its risks. Woodruff balances violent resistance in the first panel with an interracial scene in

the second panel, at the center of which is the striking figure of Cinque in full colonial garb, arguing his case along with his white attorneys. A self-portrait of Woodruff bears witness to the scene. The third panel offers a stark contrast to the armed conflict of the first panel. It portrays Cinque and members of the Amistad Committee—named for the ship on which the mutiny took place—sailing back to his homeland in Sierra Leone.

Woodruff's meticulous research imbues the murals with historic verisimilitude. He spent three months in New Haven, Connecticut, where the captives had awaited trial. Woodruff pored over notes, trial transcripts, and published pamphlets based on the incident, all of which are archived at Yale University. He looked as well at contemporary sketches of the participants. Nathaniel Jocelyn painted a handsome portrait of Cinque (1839) and William H. Townsend completed pen-and-ink and pencil sketches while the defendants were awaiting trial, each captioned with the name of each of the defendants. Woodruff's assistant, the painter Robert Neal, posed for each figure in the mural and assisted in transcribing the cartoons and sketches to the mural site. The result is a panorama of dramatic vitality that offers life-like portraits of each of the participants.

Bearden and Alston's trip not only gave them yet another example of an influential black image-maker but it also provided the beginning of lifelong relationships the artists forged with each other. Alston some years later would reunite with Woodruff to complete a mural on the African American contribution to California history. Installed in 1949 in the newly designed headquarters of Golden State Mutual, a Los Angeles insurance company, the mural was one of few post–World War II public commissions for black artists. On the other hand, Bearden and Woodruff would maintain a cordial but strained correspondence after Bearden publicly declared his withdrawal from the Atlanta Annual art exhibition. Bearden, who had been an eager participant in such shows, would reverse his views after the war, opposing the idea of shows reserved for "Negro artists" for being organized around other than aesthetic considerations. He reunited in New York in the 1960s with Woodruff, who had by then become an established figure at NYU and

in the lower Manhattan art scene. In response to the landmark 1963 March on Washington, Bearden enlisted Woodruff, along with Alston and Norman Lewis, to organize the groundbreaking black artists collective, Spiral.

Woodruff's enduring artistic influence would be evident some thirty years after he and Bearden met when Bearden tackled the subject of the *Amistad* mutiny in a public commission awarded to celebrate the American Bicentennial. Beyond a specific commission, however, Woodruff represented for Bearden an ambition exemplified in Aaron Douglas's work, though he would endow the event with a bolder palette and grander scale. The influence of Woodruff's murals, ensconced in Talladega's Savery Library, has been often overlooked in art history. Attention to their originality and vitality was renewed by a touring exhibit in 2013. During their stop at NYU, where Woodruff had been a distinguished faculty member for several decades, *New York Times* art critic Roberta Smith observed: "There is nothing in American art quite like the elegant, urgent, boldly colored murals that Hale Woodruff painted between 1938 and 1942 for Talladega College."[22] Woodruff and Douglas both demonstrated that race-based narrative could marry formal concerns, offering compatibility in a way that enlivened both. A third artist would soon join their example of race-based narratives, this time a peer of Bearden's: the quietly intense prodigy, Jacob Lawrence.

After returning from his trip through the South, Bearden continued to paint but produced a relatively small body of work in the years between 1937 and 1942, before he would enlist in the United States Army. Painting was a struggle for him, and he was easily distracted. Prostitutes hung around his building and often jangled their keys to attract clients. One evening, as Bearden and Claude McKay were coming down the stairs, a woman named Ida jangled her keys in Bearden's direction. The young painter didn't find her attractive and dismissed her entreaties, though she lowered her price from $2.00 to $1.00 and, when he refused again, lowered it to 50 cents, then a quarter, and finally, in exasperation, she pleaded, "just take me." Bearden told his mother about his encounter, and she arranged for Ida to clean his studio. One day, Ida saw the young artist sitting forlornly in front of an empty canvas and

asked him why he wasn't painting. His reply was, "I don't know what to paint."[23] She then shed her clothes and suggested, "Paint me. If you can see beauty in me, you can paint anything."

Bearden's anecdote aside, finding support to work must have been a constant struggle. WPA/FAP projects, therefore, were a godsend to black artists. Now federally supported, black artists had time to paint, to learn about their materials, to practice, to teach, and even, in some cases, to make a living from their art. They formed not just a local community but an interracial one. There was a downside, however. The entire infrastructure, from Bearden's perspective, required a Herculean effort to maintain. He had only to witness the artists living in his neighborhood like Augusta Savage, who eventually experienced a slow decline in her artistic output. He saw members of the Harlem Artists' Guild work constantly to win and then keep the support of the WPA to enable the employment of individual black artists. The guild had to be unrelenting in its efforts to convince the administrators of black artists' competence for supervisory jobs and for a WPA-supported art center in Harlem.[24] As salutary as government patronage may have been, it was fragile and, as Bearden would learn, politically vulnerable.

None of this seemed to matter to Jacob Lawrence. In contrast to Bearden's block, Lawrence could not seem to paint fast enough. The young painter could move deftly through historical subject matter, tackling grand themes like Douglas and Woodruff or a more closely observed day-to-day reality. Of all of the painters that Bearden came to know during the Depression years, Lawrence, with his edgy, unsentimental, and highly original style, overwhelmingly won the most critical praise and mainstream acclaim. His works employed the dynamism of abstraction yet still managed to map in intimate detail the day-to-day cadences of black life. Between 1937 and 1941, Lawrence completed more than 170 paintings.[25]

As a young man, Lawrence was serious and intense. Born in Atlantic City in 1917, he experienced a childhood that could not have been more different from Bearden's. Lawrence was the product of a poor, single-parent household. Dropping out of high school after two years,

he had limited formal education. He did, however, benefit from the "Open University" atmosphere of Depression-era Harlem. His mother sent him to the after-school program at Utopia House where he was taught by Charles Alston, who immediately recognized Lawrence's gifts.[26] Lawrence was then welcomed in the studios of Alston and Mike Bannarn. Savage as well became a mentor and teacher, ensuring that Lawrence was enrolled in the WPA easel project as soon as he was old enough to be eligible. Lawrence was enamored of many of the same artists Bearden admired: the Mexican muralists Les Tres Grandes, the graphic work of the German artist Käthe Kollwitz, and the paintings of everyday life of the sixteenth-century Flemish painter Pieter Brueghel. Between a two-year stint at the American Artists School on West 14th Street and, a decade later, time at Black Mountain College, where he encountered the teaching of Josef Albers, Lawrence's formal education was completed.

By the time of Bearden's 1940 solo exhibition, Lawrence had completed three series based on heroic individuals who, like Cinque, resisted the status quo: Frederick Douglass, famed black abolitionist; Toussaint L'Ouverture, the Haitian general responsible for creating the first independent black republic in the new world; and Harriet Tubman, a leader in the Underground Railroad. The mainstream art world took note. The Baltimore Museum of Art accorded Lawrence's Toussaint series its own separate room as part of its 1939 exhibition of Negro Art, and by age twenty Lawrence had already enjoyed two solo exhibitions. Edith Halpert included both Bearden's and Lawrence's work in the group exhibition *American Negro Art of the Nineteenth and Twentieth Century* at her Downtown Gallery on East 51st Street. Opening on December 9, 1941, two days after the Japanese attack on Pearl Harbor, the exhibition's purpose—to demonstrate a history of artistic contributions on the part of Negro artists—was lost on a public overwhelmed by the news. Nonetheless, Lawrence, with his aggressive themes of resistance and rebellion, became part of Halpert's Gallery with his richly complex narratives of black life.

In many ways, like Woodruff, Douglas, and Alston before him, Lawrence embodied what the artist Bearden described in his 1934

essay: he searched for what was unique and distinctive in black culture and found a style to match. Lawrence's 1941 masterpiece *The Migration Series*, comprising sixty panels depicting the mass migration of black citizens from the South to the North, was an example of an artist seizing what was unique in the African American experience and inventing a unique visual style.[27] *The Migration Series* was yet another project supported by a Rosenwald grant, and Lawrence—as did Woodruff—combined historical accuracy and his own stylistic prerogatives. He took field trips to the South and roamed the stacks at the 135th Street Public Library. A 2015 exhibition at the Museum of Modern Art (MoMA) reunited all sixty pieces demonstrating how skillfully Lawrence conjoined form and content.[28] Lawrence's novelty was evident in yet another way because he wrote captions for each painting, and the text functioned as a counterpoint to the visual narrative, a practice Bearden borrowed decades later.

More dramatically than any artist before him, Lawrence mapped the narrative of migration, and from that, the North/South dialectic—a dichotomy that still divides America. Half of the scenes in his *Migration Series* laid bare the Jim Crow South—harsh labor conditions, the threat of being lynched, famine, and grueling poverty—all of which drove people north. The other half pictures the struggles and realities of a North that erected barriers of its own. Starkly stylized, faces are masklike, gestures exaggerated, and color is often unmodulated and flat. Expanses of flat empty space in one panel are juxtaposed with space overloaded with figures in another; densely populated canvases are interspersed with abstract scenes of a depleted landscape. Bearden may have been praised in his 1940 solo show for showing the North/South dialectic, but as yet he came nowhere near Lawrence's ability to capture the cadence and sweeping rhythms of the seemingly unending migration. Moreover, Lawrence painted in a style unique to him.

Lawrence was embraced by the art world. Exhibited at the Museum of Modern Art and the Philips Collection in Washington, DC, *The Migration Series* was so popular that the museums fought over it for their permanent collections. They finally settled their dispute by dividing the series between the two museums, where each half still resides today.

Bearden may have had the advantage of a college education, well-connected parents, and famous friends, but Lawrence had what he didn't—time to paint, from WPA support, Rosenwald fellowships, loans from the Harmon Foundation. Lawrence had neither a job nor social obligations, giving him the opportunity to focus exclusively on developing a body of work. As America's entry into World War II approached, it seemed as though Jacob Lawrence, not Romare Bearden, would be the artist responsible for visually redefining the American narrative on race.

Germany invaded Poland in 1939 and moved inexorably forward in 1940 with invasions of Denmark, Norway, Belgium, Luxembourg, the Netherlands, and France. Thousands of leading European artists, intellectuals, and scientists fled to the United States, and primarily to New York City. Their presence set the stage for a major postwar shift within American painting. What started as ripples on the edge of the art world—debates about representation and abstraction between high art and popular culture—began to sweep through American artistic and intellectual circles with the force of a tsunami. Bearden would find the change disruptive yet energizing.

Having studied at the Art Students' League (ASL) in 1933 and 1935 with George Grosz, an early arrival from Europe, Bearden had already come into direct contact with modernism's disruptive potential. Grosz was affiliated with both Dada and the photomontage of artists like John Heartfield and Hannah Höch, allowing Bearden to meet a number of abstract artists during the 1940s. Their views led him to question his own assumptions about representation and the role of race in painting. In addition to Stuart Davis and Walter Quirt, Bearden became close friends with Carl Holty, an abstract painter several years his senior. Holty then brought the young artist to regular gatherings in the studio of the avant-garde painter John Graham. Graham's Greenwich Street studio was a focal point for many of the artists who would come to be hailed as the pioneers of American painting—Willem de Kooning, Arshile Gorky, and Jackson Pollock.[29] Bearden thoroughly enjoyed Graham's lectures and studied his 1937 collection of philosophical writings, *Systems and Dialectics*, which opened up for him

new vistas and unexpected associations between art, philosophy, poetry, and life.[30]

Bearden was not the only Harlem artist who was beginning to question his artistic directions. His childhood friend Norman Lewis was employed by the WPA to teach junior high school but became increasingly dissatisfied with the organization's professed preference for realism. Born in Harlem, Lewis was a self-made man who had gone to sea immediately after high school. Upon returning to New York, he wandered into Augusta Savage's studio one day and became one of her protégés.[31] Lewis had a deceptively mournful look—until he spoke. Direct to the point of bluntness, he minced no words when expressing his feelings or sharing his often pungent opinions with his trademark dry humor. He was one of the movement's most committed activists. Yet, by his own account, he came to the realization that protest and physical action might incite change but that "painting, like music, had something inherent in itself which I had to discover." In other words, light, color, motion, and space could be as effective as picking up a placard or joining a picket line. Though Lewis produced several moving figurative paintings, increasingly he found that his painting was becoming less referential and more abstract as he pursued his own aesthetic train of thought. Woodruff, too, by the time he had moved to New York in 1946, had introduced an increasingly abstract system of signs and totems, often with references to African art, into his oil paintings.

Institutionally, European modernism—as distinct from its American counterpart—had gained a foothold on the New York art scene when the Museum of Modern Art opened its doors just days after the stock market crash. Alfred Barr, MoMA's inaugural director, assembled comprehensive exhibitions and published substantive catalogues of major modernists. Groundbreaking exhibitions on artists like Matisse, Diego Rivera, Vincent van Gogh, and Paul Gauguin, along with a survey of African art that Bearden and Lawrence saw at the urging of their mentor, Professor Christopher Seifert, were among the exhibitions Barr presented during the years before World War II. Barr also exhibited unconventional artists, including black sculptor, William Edmundson. MoMA's galleries were almost always filled with work that raised

questions about easy notions of verisimilitude, and in which the gro-
tesque had less to do with politics or social justice and more to do with
expressive needs or the formal requirements of a work.

American modernism was not without its champions, however.
Bearden's future gallery dealer, the one-time Virginia lawyer Samuel
M. Kootz, published the first of two books critiquing American paint-
ing. In his first, *Modern American Painters* published in 1930, Kootz
declared that "there seems little to gain in beseeching our painters
to portray American scenes."[32] Another important perspective was
that of critic, Clement Greenberg, who emerged as a powerful voice on
behalf of modernism with his 1939 *Partisan Review* article, "Avant-
Garde and Kitsch." His essay acknowledged the overwhelming clutter
of industrially manufactured images, what Greenberg referred to as
"*Kitsch:* popular, commercial art and literature with their chromeotypes,
magazine covers, illustrations, ads, slick and pulp fiction, comics, Tin
Pan Alley music, tap dancing, Hollywood movies, etc."[33] Lumping
all of those together, he characterized them as the formulaic products
of a mass culture that provided diversions for the urban masses. By
contrast, according to Greenberg, modernists like Picasso, Braque,
Mondrian, Miró, Kandinsky, Brancusi, Klee, Matisse, and Cézanne do
not look for inspiration from an external reality, rather they follow the
internal logic of the painting.[34] Their concern, according to Greenberg,
was not with subject matter but with formal elements, that is space,
color, shape, line, design. Avant-garde artists transcended the clutter
and confusions of ideological conflict and the clutter of popular culture
to concern themselves solely with the demands of the medium. Bearden
had launched his career with a declaration of his adherence to social
justice, but as the Depression wore on, he heard more voices cham-
pion an art unmoored from politics, social issues, race, and the repre-
sentation of a so-called real world. More frequently, he heard artists
and theorists assert the integrity and autonomy of the artist's two-
dimensional canvas.

Modernism was not the only challenge to the Depression era's dom-
inance of American scene painting. The Roosevelt administration
may have considered the work of the WPA artists patriotic, but two

self-appointed guardians of American culture—Congressmen Martin Dies and Samuel Dickstein—found the social justice critiques, which Davis had labeled proletarian realism, suspiciously communist. They formed what would become the House Un-American Activities Committee, or HUAC, in May 1938, also known as the Dies Committee. Bearden began to see the impact of the HUAC in his own neighborhood. Convinced that the WPA as well as the Federal Theater Project (FTP) harbored communists, not the patriots its government advocates professed, HUAC doomed the FTP, forcing it to close in 1939.[35] The FTP, in the words of Hallie Flanagan, was conceived to be "free, adult and uncensored." And Harlem's FTP-supported theater lived up wholeheartedly to the challenge.[36]

Theater in Harlem during the Depression offered up visual pageantry that rivaled that of the cabaret scene or the parades traversing Seventh Avenue, and, whether he was conscious of it or not, it became part of Bearden's visual heritage. John Houseman, who had taken over the direction of the FTP in Harlem in 1935, had created excitement with his innovative though short-lived leadership. Building on Harlem's theater tradition, Houseman was able to convene 700 actors, dancers, musicians, choreographers, composers, and stagehands at the Lafayette Theater at the project's kickoff. Though Houseman's supply of work by black authors was sparse—Arna Bontemps's adaptation of Rudolph Fisher's *Conjur Man* was one of the few—productions like the 1936 all-African-American-cast *Voodoo Macbeth*, set in nineteenth-century Haiti and directed by a young Orson Welles, were critically acclaimed, and performances at the Lafayette sold out. Of all of the federally supported programs, the Federal Theater Program was deemed the most seditious by the HUAC. Its closing in 1939 immediately put hundreds of artists out of work, an impact that registered immediately in the Bearden household since so many of the theater artists, like Canada Lee, were guests in their home.

Two years later, the visual arts were under assault as well, and all of the hard work that Bearden and his fellow artists in the Harlem Artists Guild had put into building an art center was at risk. Charges were brought against Gwendolyn Bennett, the spirited black writer and

president of the Harlem Cultural Art Center on the corner of 125th and Lenox. The Center was the pinnacle of a network of exhibition spaces in Harlem dating back to the 1920s, and it was one of the triumphs the Harlem Artists Guild could claim. The day after Bennett's papers were served, the spacious 125th Street facility was packed with supporters demanding her reinstatement. When she took over from Augusta Savage, she had intended to "make the Harlem Community Art Center the nucleus of a National Race museum."[37] In the end, the charges against Bennett were dropped, and by the end of the year Bessye Bearden was cheerfully announcing in the *Chicago Defender* news of the annual Beaux Arts fundraising ball, which would raise money to make the Center permanent. But Bearden and other Harlem artists took note of the fact that Bennett's outspokenness about race provoked government suspicion. Government interpretation of the American scene diverged from Harlem's view of it.

In the midst of these challenges to institutions that supported black artists, Bearden was restless, and his work reflected new views about image-making. Three paintings—*The Visitation*, *The Family*, and *They That Are Delivered from the Noise of the Archers*—chart the progress of those changes. *Visitation*, ca. 1941, gouache with ink and graphite on brown paper, depicts two women encountering one another in a desolate space. That space has been flattened, the figures are highly stylized, and the resemblances to African art are striking.[38] Biblical allusions begin to appear in his paintings of this period. *The Family*, ca. 1941, gouache with ink and graphite on brown paper, pictures a mother and father. The mother holds a child while the family sits at a table with a kerosene lamp, a fork, and a piece of food without a plate on the table. A twin portrait, perhaps a photo, hangs on the wall. The figures are stylized, their faces mask-like; surface textures are reduced to striated lines in her hair, in the grain of the wood of the table, and the father's raised hand—all driving the painting away from naturalism and toward abstraction.

This tension between the abstract and the representational is especially evident in the 1942 painting *They That Are Delivered from the Noise of the Archers*, a gouache with ink and graphite on brown paper.

The title comes from a fragment of an Old Testament verse, Judges 5:11, and is painted on the upper left-hand corner of the painting. Bearden has flattened the planes of the face, made the hands disproportionately large, and broken the buildings in the background into overlapping planes. Making use of a Cubist vocabulary, he has given a mask-like aura to each face. The painting is reminiscent of Picasso's *Les Demoiselles d'Avignon*. Verging on the abstract, the tableau is still representational, the group identifiably a family—mother and father at center, children on either side. Bearden's use of biblical text is an early preview of what would become his sustained interest in yoking together the visual and the written. The full King James Version of the verse is "They that are delivered from the noise of the Archer in the places of drawing water; there shall they rehearse the righteous acts of the Lord," which suggests liberation, deliverance from suffering. Without providing a direct key to the understanding of the mise-en-scene in the painting, the verse is evocative rather than descriptive.

As Bearden pushed away from naturalism, he began a correspondence with Walter Quirt. In Quirt, Bearden found someone with whom he could have a conversation about what it means to be an artist. Quirt, almost ten years Bearden's senior, offered the younger artist, whom he said had "fire" in him and a future ahead, advice, telling him to resist "insidious and disguised pressures directed toward frustrating any expansion into that creative future."[39]

Quirt also warns Bearden of the solitude of being an artist. Artists, according to Quirt need to "have little or nothing to do with one's contemporaries except perhaps for surface social comforts."[40]

The extent of Bearden's restlessness and frustration over the direction of his art is evident in a letter he wrote to Quirt just months before he enlisted in the army. He worried that though the press was "often enthusiastic" about his work, he wanted more than "popular success." He quoted a southern painter who told him that his work was "forced and deliberately painted to cater to what the critics think a Negro should paint like." But to others it was "disgusting and morbid."[41]

Bearden's comments reflect an ongoing debate about black bourgeois society and its seriousness, or lack of it, when it came to art. Despite the

availability of support from other artists in the Harlem community, public support was questionable. "Fashionable society," as Bessye would argue in one of her columns, always supported artists financially and intellectually.[42] But many black intellectuals complained of the shallowness and pretense of that support. Wallace Thurman painted a blistering portrait of that pretense in the late 1920s when he referred to Bessye's fashionable society as "stupid and snobbish as is their class in any race."[43] E. Franklin Frasier, the black sociologist whom New York mayor Fiorello La Guardia appointed chair of the commission to investigate the 1935 Harlem riot, would observe of the black bourgeoisie, "Although they may pretend to appreciate 'cultural' things, this class as a whole has no real appreciation of art, literature, or music."[44]

Bearden, though he was surrounded by fashionable society, painted what he saw as a social worker, the steel mills he saw growing up in Allegheny County, and his Charlotte home and environment that bordered the cotton fields in Mecklenburg County. According to his letter to Quirt, there were those who found Bearden's work "disgusting and morbid," and wanted him to paint scenes of Negro progress. He remarks that he had begun writing an article about what and how an artist should paint, though the article would not be published until years later.

For all of the public art on the walls of hospitals, public schools, colleges and universities, airports, post offices, and libraries, none of those images and nothing the fine arts specialists wrote or said commanded anywhere near the public attention that moving images garnered. Clement Greenberg may have called it kitsch, but the world of moving images dominated. Attendance at movies reached a peak during the Depression years. Demographic surveys of attendance suggest that well-educated affluent Americans were consuming a spectrum of Hollywood fantasies: horror movies, comedies, gangster films, and musicals that allayed their anxieties and catered to their idea of what was desirable and what was not.[45]

Bearden and his parents knew many of the black screen artists personally. Lincoln Perry, for example, perfected a choreography of dim-witted lazybones. When talkies were introduced, he placed his voice in

perfect coordination with movement, gesture, and facial expression to recreate a nineteenth-century minstrel. Perry's film progeny were popular and even beloved by the American public: Willie Best, who often performed a version of Perry's indolence; Bill "Bojangles" Robinson, who became the artful dancing companion, protector, and nurturer of American kewpie doll Shirley Temple; and Montan Moorland's quivering bug-eyed characters all became famous. They filled screens with images that continued the visual arguments begun in the Currier and Ives prints, cartoons in *Puck* and *Harper's Weekly,* and the grinning caricatures plastered on Americana from banks to children's toys to boxes of pancake mix.[46]

The black press, among Bearden's principal patrons during the Depression, celebrated and lionized the fame and success of its cinema stars. Hattie McDaniel's Mammy and Butterfly McQueen's Prissy in *Gone with the Wind* may have been stereotypical roles, but the authority and wisdom McDaniel brought to her role or the parody of servility that McQueen created allowed both to reveal their skills as actors. Writers in the black press often commented on the skill as separate from the role created. Moreover, the black press was keenly aware that in the middle of the Depression, film was a means of making a living— a good living. Black musicians, whose performances were often embedded into a narrative—Duke Ellington, Louis Armstrong, or Lena Horne were among the most popular—at least got to perform as themselves and broaden audiences for their work.

Hollywood studios learned that there was an audience for race films, and they constructed their own version of race and representation, separate from what black filmmakers were doing. Hollywood's black world was more often than not an Eden of contentment and happiness, as in *Green Pastures*, or, as in the case of George Gershwin's *Porgy and Bess* (first a celebrated opera), a community of naiveté and innocence threatened by pure evil. Despite whatever else was going on in the country—strikes, riots, protests, unemployment—the movies for the most part offered a vision of racial harmony in America peopled by happy Negroes. By the end of the 1930s, *Gone with the Wind,* a pioneer in the technique of Technicolor in 1939, and like *The Birth of a Nation*

an adaptation of a popular novel, reinforced the desirability of a racial caste system.

Gone constructed an idealized American past of plantations, well-tended slaves, and the natural order of the world, all of which were disrupted by the Civil War and Emancipation. Like *The Birth of a Nation, Gone with the Wind* was a blockbuster and is to this day among the all-time film favorites. When Bearden finally published his article "The Negro Artist's Dilemma," he made pointed reference to what he believed was the debilitating influence of cinematic as well as fine arts images of a people and their culture. He would argue that cinematic caricatures were making seeing impossible.

Whatever misgivings Bearden may have been harboring about race and representation, they were overshadowed by the United States' entry into World War II. Bessye Bearden wrote candidly and fearfully about the ideals the war was meant to uphold:

> Like millions of other American mothers, I, too, have a son who must fight in this war. In giving him to our country I would like to feel secure in the knowledge that if he must fight, it will not have been in vain; that when the fighting is over he, as well as generations of other negroes to come, will be able to enjoy in their own country some of the peace, freedom and justice for which he fought.
>
> But as things are now going, I sometimes get a rather hopeless feeling about it all. Not only are our boys segregated and discriminated against in their country's armed forces but we who must carry on the fight on the home front find that in almost every one of the organizations participating in the country's civilian defense program the same policy of segregation and discrimination is being carried out by those Americans of inward totalitarian minds who would pay only lip service to the principles of democracy.
>
> —Bessye Bearden, *Chicago Defender*[47]

In April 1942, Bearden enlisted in the army. His once-athletic frame had thickened, his weight reaching close to 200 pounds, and his once thick mop of hair had grown thin. A photograph of Bearden in uniform

taken by Van Vechten pictures him looking less than enthusiastic. War came just as Bearden was questioning his art, questioning his subject matter, questioning the responses he was receiving to his works, and questioning whether what he had once regarded as a close-knit community understood what he was trying to accomplish artistically. He was still contributing his works to "Negro Art Exhibitions," but he felt increasingly discontented over the idea of having his art measured against just one community of artists, not all art, and over being exhibited in a racial context instead of an aesthetic one. War and his service in the army were disruption enough, but yet another event upended his life even more during his second year of service.

Bessye Bearden's almost frantic schedule of events and speaking engagements, work for civilian defense—Charles Alston had drawn the image of her radiantly beautiful face on a war bond advertisement— and her job as deputy tax collector were punishing. A routine gall bladder operation in the midst of this whirlwind landed her in Harlem Hospital, and though she was expected to fully recover, she contracted pneumonia and declined precipitously. When Bearden visited her in the hospital, from under her oxygen tent she lifted her hand in a V, still displaying war-time patriotism, and smiled. She died on September 16, 1943.[48]

Bessye's death was as devastating as it was sudden. Front-page news in the black press, her death was covered as well by the *New York Times*. The *Amsterdam News* reported her funeral in a full page of articles and photos, picturing Bearden in full dress uniform, a grieving Howard, and a heavily veiled Carrie Banks, Bessye's mother, in the procession from the church. The *Pittsburgh Courier*, published in the town where Bessye was once the belle of the ball and where her mother and stepfather ran their boarding house, referred to her as someone who "touched the greatest and smallest negroes throughout the country."[49] As hard as Bessye's death may have been on the neighborhood and the black community she served so energetically, it was devastating for Bearden and his father. Howard had been proud of his wife. A thoughtful man who loved to talk politics, he had none of Bessye's outgoing activist personality, but he had reveled in his wife's involvement in

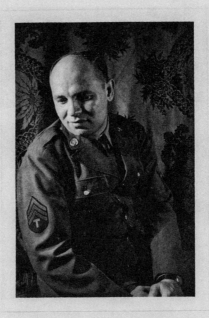

Carl Van Vechten, *Romare Bearden, from the portfolio 'O Write My Name': American Portraits, Harlem Heroes*, 1944, printed 1983, photogravure, Smithsonian American Art Museum, Photograph © Van Vechten Trust; Compilation/Publication © Eakins Press Foundation. From *'O Write My Name': American Portraits, Harlem Heroes* (Eakins, Transfer from the National Endowment for the Arts, 1983.63.163).

OPPORTUNITY
Journal of Negro Life

**Three Decades
In the Field of
Social Work**
By EUGENE KINCKLE JONES

•

Half-Bright
(A Short Story)
By MARIAN MINUS

•

**Colonial
Students
In Wartime**
By MARY TREVELYAN

•

**The Boy
Who Painted
Christ Black**
(A Short Story)
By JOHN HENRIK CLARKE

September, 1940 **15 Cent**

Bessye Bearden on the cover of *Opportunity, Journal of Negro Life,*
September 1940, with caption "Mrs. Bessye J. Bearden from a
portrait in oils by Robert M. Jackson."

culture, politics of change, and progress, as well as her obvious enjoyment of her social life. Bessye, who had policed Howard's bad habits in the past, could no longer watch over her husband. After her death, his drinking continued and, without her to bring him home when he stayed too long at the local bar, he quietly slipped into an irrevocable melancholy.

Bessye's death was preceded that summer by yet another riot on the streets of Harlem. On a hot Sunday evening in August, a black soldier attempted to stop a policeman from hitting a black woman accused of disturbing the peace. When the policeman's physical response sent the soldier to Harlem Hospital, rumors circulated quickly throughout the neighborhood. Anger overflowed. Stores were looted, six people were reported dead, and $5 million in damage was done to black and white businesses alike. Mayor La Guardia, now dealing with the second deadly riot uptown during his tenure, called in 6,000 police officers, National Guard, and military personnel, and he established a curfew and sent food to appease the anger. La Guardia's investigation into the 1935 riots had yielded very little change for the neighborhood, and conditions had only grown worse since then. Although E. Franklin Frazier, as his commission chair, had assembled census data from government records, statistics on housing, relief efforts, employment, health and transportation records, and education data, the mayor never released the commission report. Documented on its pages was irrefutable evidence that surrounding black Harlem was an intractable wall of scarce resources, joblessness, overcrowded housing, and poor public health resources.[50]

Whatever optimism New Negro Harlem—and after it the "Movement" in the 1930s—kindled in Bearden, a segregated army thoroughly extinguished it. His mother's *Chicago Defender* concerns were prescient. His military experience, like the choice professional baseball once offered him, sharpened Bearden's sense of the absurdity of the country's gaping racial divide. He was assigned to First Headquarters, Fifteenth Regiment, an all-black 372nd infantry division. For the next three years he was deployed as needed, moving from Fort Dix, to Harlem where he guarded the New York subways against sabotage, to Camp Davis in North Carolina for Officer Candidate School. He also moved through

Pine Camp, Alaska; Fort Breckinridge, Kentucky; Fort Huachuca, Arizona; and Camp Edwards, Massachusetts. Bearden's difficulties in the army are the subject of a brief note in Billy Rowe's gossip column for the *Pittsburgh Courier,* who noted that "Romare Bearden the artist serving in the 372nd Infantry ran into 'cracker' trouble in his try for a commission and gave up without his bars after two months of it."[51] More than forty years later, to an interviewer, Bearden offered the following recollection that sheds light on the "cracker trouble" and the endemic bigotry in the armed forces: "In the Army, at Camp Davis [NC], we had this big separate place. The other cabins were painted white and written in pencil was 'No Mexicans, No Negroes.' Things like that can really wreck you." Artistically, during his army tenure, he weighed whether to pursue the representation of race or to immerse himself in subject matter that was racially neutral. Circumstances may have helped dictate his choice.[52]

After his mother's death, Bearden took every opportunity to escape military service and work in his 125th Street studio while on leave. During one of those leaves, a few months after her death, the black artist William H. Johnson, who had lived and worked in Denmark, brought a visitor to his studio who would change the course of Bearden's artistic career. Caresse Crosby, the flamboyant, international impresario of new talent and widow of Harry Crosby, who, with her help, had founded the Black Sun Press, was on a mission to find talented new artists. Crosby's experience in finding new talent was extensive. During the 1920s and beyond, the Black Sun Press had been synonymous with the literary avant-garde in Paris. A forward-looking small press that published the work of talented writers in small, exquisitely produced editions, Black Sun gave early support to the writing of James Joyce, Ernest Hemingway, and Hart Crane. After Harry's death, Caresse continued to seek out gifted avant-garde writers, and when she moved to Washington, DC, in 1941, she opened the G Place Gallery located near DuPont Circle, determined to make Washington the new center of the art world. She had recently merged her DC gallery with that of David

Porter, a young economist, who also ran an art gallery in Georgetown. Together they set up shop in a three-story townhouse at 910 G Place, Northwest.[53]

Crosby's fateful visit to Bearden's studio resulted in a solo exhibition from February 13 to March 3, 1944, while he was still in the army—his first since his 1940 exhibition at 306 West 141st Street. A photograph of Bearden in uniform at the opening pictures him with Caresse Crosby, in front of one of his figurative social realist paintings, *Serenade*. His solo show at the G Place was modest. Entitled *Ten Hierographic Paintings by Sgt. Romare Bearden*, the exhibition featured primarily scenes of black life painted in tempera on brown paper that he had completed sometime between 1941 and 1943. Art historian James Porter, chair of the Howard University Art Department, wrote the catalogue for Bearden's solo exhibition. He observed a balance between an exploration of the artistic and the human. Porter writes: "His work contains that nicety of balance between the conceptual and the expressive which seems to point the way towards a new and influential integration of art and social interest, establishing an important crux of artistic form and human quality which cannot be ignored."[54]

While many of Bearden's pieces in the small show reflected a naturalistic, social realist style, the exhibition also included one seemingly anomalous painting entitled *Lovers*. The work was a preview of a new direction Bearden was about to take in his art. Shedding any pretense of reproducing a racially identifiable subject matter, Bearden adopted a more overt synthetic Cubist vocabulary to represent a couple embracing.

Crosby's promotion of Bearden's work was conscientious. In preparation for Bearden's first show, she offered to call George Grosz to obtain a statement for the publicity.[55] She included Bearden in an exhibition of all black artists entitled *New Names in American Art*, and, not limiting him to all-black shows, she also included a reproduction of Bearden's work in an exclusive quarterly entitled *Portfolio* comprising work by Henry Moore, Pietro Lazzori, and Jean Helion among others in 1944.[56] Bearden found that having an older woman take such a serious interest in him so soon after his mother's death salutary. Though

Bearden was moved from base to base, apologizing in his letters to Crosby for the changes, he was no longer struggling with what to paint. These letters describe the genesis of a newfound ethos, a public turning away from the representation of race, though not the end of Bearden's personal struggles with the "dilemma" of being a Negro artist.

In a note to Crosby from Bearden dated April 11, 1944, written from his studio just months after his G Place Gallery solo show but while he was still in the army, he announced that he had an idea for a series based on the Passion of Christ. His idea eventually became the *Passion of Christ* series of gouaches that opened June 10, 1945, at the G Place Gallery a few months after his discharge. The *Passion* series was a turning point for Bearden. Subject matter and style now placed him solidly in the category of American modernist, a seemingly clean break with his past as a social justice painter. As fate would have it, the series with its religious content would also be a stepping-stone from Washington, DC, to the New York art world.

During brief furloughs home in 1944 and during his leisure time on base, even as Bearden moved from base to base, the *Passion of Christ* series came to fruition. He had been assigned to Camp Breckenridge in Kentucky in the summer of 1944 and by the fall of that year was transferred to Pine Camp, New York. As he explains to Crosby, while on maneuvers, he wrenched and strained his chest and was disqualified from going overseas.[57] He goes on to write that he is stationed in a very good camp and he should be able to complete a great deal of work, particularly because he has been assigned to the visual aids department. Confined to stateside because of his injury, Bearden described his interest in the *Passion* series to Crosby: "This is of course in my own terms and it ought to develope [*sic*] pretty interestingly—as I don't guess many artists would consider such a theme. Therefore, you can look forward to this series."

Transferred again, this time to Camp Edwards in Massachusetts, and writing from the Convalescent Hospital there, Bearden gave Crosby a detailed overview of the series. His source is the Four Gospels. He wrote, "The title and the scenes depicted (if one is able to recognize them) are all from the Chapters of Mark, Matthew, Luke, and John in

the New Testament.... The Christ theme," he went on, "seems to me an enormous one. I'm sure artists will continue to draw upon its source for material, for it has great human elements. Here is material that has significance for all points of view. And even considered as myth, we must reckon with the mighty range of its influence throughout the ages."[58]

The *Passion of Christ* placed Bearden's painting at a nexus between a Western art historical canon and his personal experience with the black church. Thematically, the *Passion* was a staple in European Renaissance painting, and it linked Bearden to a vast reservoir of classically composed scenarios. Personally, his grounding in Christianity and religion gave him an intimate knowledge and facility with the details of the life of Christ. His letter to Crosby suggests that he also saw his personal circumstances as a soldier in a segregated army reflected in the *Passion*, and particularly in the persecuted figure of Christ. Weighing the balance between representation and abstraction, Bearden makes it clear in his letter to Crosby that though the formal elements are important, he has a humanist story to tell. "For me, it would never do to freeze myself into the cold and severe mathematical attitude towards painting. I should feel like a frog held in suspended animation. I want my work to be directed at the stomach, and if by osmosis the impact should reach the head so much the better."

When the paintings arrived at the G Place Gallery, Crosby sent an ecstatic letter to Bearden, lavishly praising the new work.[59]

In my last letter I merely said that your paintings had arrived. In this I want to tell you how absolutely beautiful I think the series is. Your development in technique and clarity is tremendous, and I am glad to see the same spiritual integrity is there. As you know, I was first struck by your painting because of a certain nobility of theme as well as a rich execution—and now added to this is expertness in design and clarification in color that is most exciting. I feel more than justified in my first enthusiasm.[60]

As Bearden was excitedly preparing for the debut of his *Passion of Christ* series, his enthusiasm was tempered by his father's deteriorating

health. In February of 1945, Bearden felt compelled to write to his commanding general at Fort Edwards to request an early discharge from the army to care for Howard. Howard simply could not cope with Bessye's death and Romie's absence. Shortly after Bessye died, Howard fell ill and took a medical leave of absence from his job with the New York Sanitation Department. When Howard's condition worsened, Bearden was forced to hire a nurse, and by the end of 1944, Howard had to resign from his job as a city health inspector altogether. Bearden described his father's illness as mental: "manifested by a severe nervous condition." He pleaded his case to his commanding officer, explaining that not only is his father out of work but "utterly unable to manage his affairs." A supporting letter from the Rector at St. Martin's Episcopal Church attests that "Sgt. Romare Bearden's presence is required in his home because of the mental breakdown and precarious health of his father. He is the only close relative who can care for him." Shortly after the letter was sent, Bearden left the army to care for his father and to put the finishing touches on his G Place Gallery show, a show that marked a turning point in his artistic career.[61]

Bearden's turning point was in a direction that took him away from his pre-war work. Pre-war, his images had been a standard-bearer for black social justice issues. *Fortune* magazine reproduced his 1942 painting *Factory Workers* as a full color frontispiece for their June 1942 issue to introduce the article "The Negro's War." The essay lambasted discrimination against black workers barred from certain forms of war-time employment. *Factory Workers*, an example of "proletariat realism" at its best, pictured three men in the foreground who stand wearily on a corner, smokestacks in the background, their idleness an indictment of a system gone wrong. Bearden was an artistic champion, before the war, of such plights. Before the war, he had embraced the identity of race man. His representations of black life in his paintings had won him a place in a growing pantheon of black artists. He had successfully spun out of his mother's powerful orbit into a sphere of his own, distinguishing himself with his outspoken 1930s political cartoons,

his rowdy "Dawn Patrol" excursions, and his conscientious attention to social issues not only in his social justice paintings but in his day job as a caseworker for the New York City Department of Social Services. After the war, after the death of his mother, he rethought completely his views about the nature of art and his role as an artist.

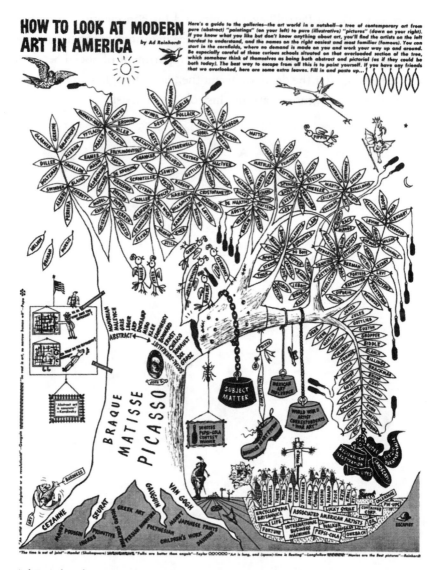

Ad Reinhardt, "How to Look at Modern Art in America," *PM Magazine*,
June 2, 1946, p. 36. Bearden's leaf hangs from the third branch on the
left and is the third leaf from the bottom on the left side of the branch.
©2013 Estate of Ad Reinhardt/Artist Rights Society (ARS), New York;
Courtesy David Zwirner, New York/London.

FAME AND EXILE

1945-1950

The traditions of Western humanitarianism are dying, and the scorching days of the Atomic Age are at hand. We cannot calculate what new forms will emerge, but the artist, of whatever race, must explore with integrity and sensitiveness the processes of life that he sees and feels. The Negro artist must come to think of himself not primarily as a Negro artist, but as an artist. Only in this way will he acquire the stature which is the component of every good artist.[1]

—Romare Bearden, November 1946
"The Negro Artist's Dilemma"

In the eyes of the art world, before and immediately after the war, Bearden fell squarely into the category of "Negro artist." Early in 1945, he exhibited three paintings—*Factory Workers* among them—in a comprehensive exhibition of contemporary artists at the Albany Institute of History and Art entitled *The Negro Artist Comes of Age: A National Survey*. In the spring, he contributed work to the Atlanta University annual, and, in the fall of that year, he contributed work to a group exhibition of Negro artists at the Newark Museum.[2] His worst fears regarding racial labeling, however, were realized in the language that some critics chose to characterize the work of the artists who exhibited in "Negro exhibitions." Words like "racial temperament and emotions" or describing their use of color as "barbaric" (the term used by *New Yorker* critic, Robert Coates) confirmed for Bearden how difficult it was for critics to see beyond their expectations.[3] After the war, these group shows tapered off and eventually died altogether as the New

141

York art world's interest in Negro artists waned. Interest in Harlem as a cultural destination declined as well. Prohibition's end and the onset of the Depression had already set that decline in motion, and the two riots in 1935 and 1943 diminished Harlem's allure as a cultural center.

Bearden's letter to Cedric Dover recounts the disintegration of the Harlem art scene. "In the early 40's," he noted, "most of the organizations formed exclusively for Negro participation began to disintegrate. In the mid-thirties we had formed an organization in New York called the Harlem Artists Guild. I know Aaron Douglas, Augusta Savage, and Charles Alston had served as Presidents of the club, which numbered at it [sic] peak 70 members....[W]ith the start of World War II, and the termination of the WPA, the H.A.G. was dissolved; and there had been no such close, and extended coming together of the Negro artists since that time."[4] As Bearden would report to Dover, some of his closest friends and associates left Harlem in the 1940s. Aaron Douglas, a mentor to Bearden and a pioneer in his approach to the representation of black culture, moved to Nashville, Tennessee, with his wife, Alta. Having taught part time at Fisk University, Douglas decided in 1944 to teach full-time in the South, eventually becoming chair of Fisk's art department. Augusta Savage, who had every reason to believe that her fortunes were looking up, eventually left Harlem. She had won international recognition for her sculpture *Lift Every Voice and Sing*, commissioned for the 1939 World's Fair (a smiling Bessye Bearden was photographed in front of it). After the fair, however, without funds to store or cast the plaster of Paris work in bronze, or without interest from a museum or collector, Savage had to let the landmark work be demolished. The loss of her masterpiece came on the heels of the demise of the WPA-funded Art Center. A few years later, in 1943, the WPA itself closed down. Savage valiantly attempted to run a private gallery uptown, but with the failure of that effort, she finally exiled herself to upstate New York, gave up sculpture, and, at least temporarily, took up farming.

Jacob Lawrence had won acclaim before the war with his *Migration Series*. Lawrence was able to continue his creative work as a member of the United States Coast Guard, where he completed a pictorial

record of that branch of the service. After the war, however, instead of moving back to Harlem, he and his wife, painter Gwendolyn Knight, moved to Bedford Stuyvesant, which was then the black section of Brooklyn. Norman Lewis stayed uptown immediately following the war. He, like Bearden, had reached a moment of change in his art. Like Bearden, he felt compelled to shed the representational in his work, a change that made him feel disconnected to other artists who continued to choose social justice themes in their work. Lewis too eventually left Harlem for the West Village.[5]

As the world around him changed, Bearden's thinking about himself as an artist in the world—a shift that started before he entered the army and continued to incubate during his service—changed as well. Between his discharge from the army and his trip to Paris in 1950, Bearden envisioned a role for himself as the individual artist, unmoored from the markers of race and community.[6] The shift in his thinking was manifest in the work he exhibited publicly between the years 1945 and 1948. His new work, remarkably consistent in style and approach to subject matter, was evidence of how thoroughly and intentionally Bearden had rethought his approach to art and the role of the artist. Each series he completed, exhibited as a solo show, was based on a written, Western, humanistic text and each communicated what he believed were universal, archetypal themes expressed with race-neutral abstract figures. The first, completed in 1945 was *The Passion of Christ*, followed in 1946 by a series based on the Garcia Lorca poem "Lament for a Bullfighter" (Llanto por Ignacio Sanchez Mejias). In 1947, he produced a series derived from a series of five ribald sixteenth-century novels, *Gargantua and Pantagruel*, by the Renaissance French writer François Rabelais. His last series, exhibited in 1948, was based on the *Iliad*. Allusions to myths permeated these works, as did the practice of visually quoting European masterpieces as Bearden brought to fruition his desire to make his work more universally appealing.

Color, muted in the social realist paintings, is exuberant in the literary abstractions—sensual and full of light. Stylistically, Bearden makes use of an abstract modernist vocabulary that mixes the syntax of cubism— flat two-dimensional overlapping planes of space, highly stylized figures,

flattened, shallow space that emphasizes surface design instead of re-
producing a deep perspective—with a suppleness of line reminiscent of
the drawings of Matisse of the 1930s and 1940s. This stylistic and the-
matic approach served him well. During the postwar years, his new
style won him a place, if only peripherally, in the vanguard of modern
American art. He won that place, at least temporarily, having relin-
quished the representation of race and black culture. As he did during
the Depression, Bearden would write a cogent essay that reflected
his new world view that, like his art, bore little resemblance to his pre-
war perspective.

After his discharge, Bearden moved in with his father and became
his principal caretaker. He resumed work at his social services job that
summer and rededicated himself to painting—and cleaning and paint-
ing his studio, looking no doubt, for a fresh start.[7]

Despite the departures of many of his colleagues, he kept his studio
above the Apollo Theater a haven for the working artists who remained
in Harlem. He held workshops and sessions for drawing from the
model, creating a supportive place where his fellow artists could gather.[8]
Though he was preparing for his exhibition of *The Passion* series at the
G Place Gallery, seemingly a new direction, Bearden still did not en-
tirely let go of his past identity as a "race man." Toward the end of his
stint in the army, in 1945, he applied for a Guggenheim Fellowship,
indicating that he still clung to his ambitions for a major project that
focused on black life in American.[9]

His application statement expresses his desire to show visually the
aesthetics of the Negro people, an aesthetic that, in his words, "has not

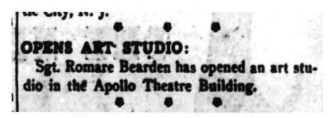

"Opens Art Studio," announcing Bearden's art studio in the Apollo
Theatre Building. *New York Age*, September 1, 1945, 4.

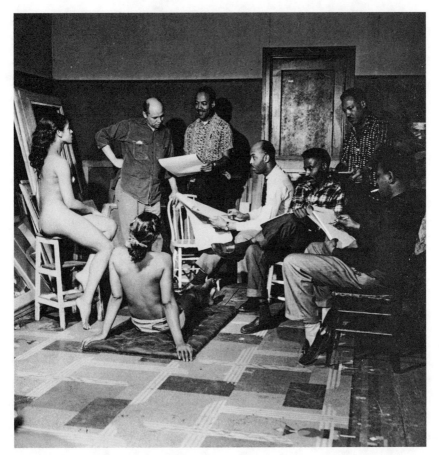

An art class at Romare Bearden's Studio, 243 West 125th Street
above the Apollo, 1954. Bearden (standing, second from left) with
Morgan and Marvin Smith. Seated are an unidentified person, James
Yeargans, and Bob Yeargans. The models have not been identified.
Photographs and Prints Division, © Morgan and Marvin Smith
Collection, Schomburg Center for Research in Black Culture, The
New York Public Library, Astor, Lenox and Tilden Foundations.

found real plastic expression primarily because of the interrelated lack
of an encouraging social atmosphere and individual opportunity."
Referring to the "pathos" of the Negro, he states that "local color and
external symbols" are not enough to capture its essence: "Plastic forms
are needed that are as inwardly genuine and universally valid as the

passionate assertions of the spiritual and the abstract rhythmic conflicts of jazz." Finding a medium, an artistic vocabulary, and a style that expressed the cultural realities he lived and experienced was Bearden's goal, what he refers to as "plastic forms." What jazz accomplished in music was an example of what he desired for painting. This statement is one of the earliest in which Bearden acknowledges that jazz might be a model in music for the "discovery and organization" of these genuine and universal plastic forms in the medium of painting.

His plan drew mixed reviews from his references. Alain Locke, for one, characterized Bearden's proposal to develop plastic forms that capture representative racial qualities as "problematic." James Thrall Soby, who as director of the Armed Service Program at the Museum of Modern Art had written a letter in support of Bearden, now ranked him merely as "at near the top of the second rank of Negro painters."[10] In Soby's estimation, Bearden was not "as talented as men like Jacob Lawrence and Pickens, but well above average." Bearden did receive some praise. *Fortune* magazine's Deborah Calkin referred to Bearden as "exceptional," and the painter and mentor Stuart Davis called the proposed project "vitally important to the development of American painting."[11] Ultimately, however, Bearden's failure to receive funding evidently put a stop to the direction he outlined in the Guggenheim application. Encouraged by Caresse Crosby, who gave him a solo show of his *Passion* series during the summer of 1945, Bearden abandoned—for the time being—the representation of race.

Bearden settled into his newly painted studio over the Apollo, and though the streets outside the theater were not the cultural hotbed they had been, they were still brimming with activism. Adam Clayton Powell Jr., pastor of Harlem's politically influential Abyssinian Baptist Church, had led boycotts of popular chain stores. The year before Bearden returned to Harlem, Powell had been elected to the United States Congress. Thurgood Marshall, a young attorney with the NAACP living at Harlem's 409 Edgecombe Avenue, was building a national reputation by traveling to southern states to take on cases. His successful litigation was a prelude to his work on the landmark 1954 *Brown v. Board of Education* Supreme Court decision, one of a number of events

during the 1950s that catapulted the modern civil rights movement to national attention. In the 1960s, years after Bearden moved his studio to Chinatown in lower Manhattan, a firebrand by the name of Malcolm Little would arouse audiences on the streets of Harlem with his oratory. Later he became known as Malcolm X. But Bearden's return to Harlem in the spring of 1945 engendered none of the political activism that once interested him; instead, he became more serious than ever about painting.

To make some extra money, Bearden tried to supplement his job and his painting with cartooning, but he found that it interfered with painting.[12] In his letters to Walter Quirt, he explained that he needed to be undistracted in his devotion to the medium of painting. As he settled into his studio space during the summer of 1945, he wrote to Quirt (who by then was teaching in Minnesota) of his need for social isolation. "I'm finally getting adjusted to civilian life and sticking close the studio, because I find that I've begun to alienate people, something I never did before. But now, things are phony I have to say so, no matter what—painting, people, women, etc. that's why I say I'm staying close to my work."[13] A month later, Bearden again expresses his disaffection with some of his old friends: "People say now, I'm this and that, adolescence, [sic] etc, because I haven't followed leads that have been suggested to me—but I really feel its [sic] other things that I want."[14]

Bearden was determined to study painting more conscientiously and methodically. He plunged himself into the study of European masters and filled the pages of his letters to Quirt with excitement over his discoveries. "I am back painting again, and honestly believe the new stuff is better than anything before. I've studied space rather hard, so that the paintings are more unified now—and the fantasy is held together. I'm so very anxious for you to see my new things.... I've tried to learn design of pictures studying Byzantine painting, and the old Italian primitives, etc."[15]

He acknowledges that "long periods of study and analyses" were "as important as your creative painting." In these years between his discharge from the army in 1945 and his departure for Paris five years later, Bearden's diaries, journals, and letters not only to Quirt but later

in the 1940s to Carl Holty document his focus on the fundamentals of painting. He concentrated on color, light, and compositional structure in painting and, in the years before his stay in Paris, he used what he learned to develop a distinctive abstract vocabulary, untethered, in his mind, from naturalism. As a mature artist, Bearden would look back on this period and recount the methodology of his study habits and the practices he adopted in his studio. Too inhibited to copy in a museum, during the 1940s, the young painter turned his studio into a repository of reproductions of masterworks and his copies of them. He has described the way he took command of the images he copied by taking photostats of reproductions of works by Giotto, Duccio, Veronese, Grünewald, Rembrandt, De Hooch, Manet, and Matisse and enlarging them.

Photostatic reproduction is an elaborate process. (In later years, replacing photostats, Bearden would make Xerox copies of photographic reproductions of art work, a process that his friend the photographer Sam Shaw noted flattened and abstracted the image.)[16] He would begin by using a large camera with a prism to photograph an image and develop the image by exposing it on a portion of light sensitive paper that came in large 350-foot rolls. The camera's prism reversed the image so that when the artist bathed the light sensitive paper in developing and fixer baths, the image was not only reversed but was a negative of the original. Having made this mechanical reproduction of a photographically reproduced work of art, Bearden proceeded to interpret the paintings by "substituting my own choice of colors for those of these artists, except for those of Manet and Matisse when I was guided by color reproductions."[17] In the process of experimenting—copying the copy and freely reimagining it—Bearden gained a sense of proprietorship over the images. He made them his own, turning his studio into a laboratory not only for the mastery of canonical Western painting but artifacts from other cultures as well. For example, copying such seventeenth-century Dutch masters as Pieter de Hooch, Gerard ter Borch, and Johannes Vermeer taught him about compositional clarity, structure, and spatial unity. The work of Ingres, Dürer, Holbein, and Poussin taught him classical draftsmanship.[18] His studies were global and he commented on

the instructional value of non-Western artifacts like the great Benin heads that are "timeless and historically durable," and fundamental to his new visual language.[19]

Barrie Stavis, a playwright who became a companion of Bearden's many years later, in an interview with Myron Schwartzman, Bearden's biographer, marveled at Bearden's unwavering focus. Watching Bearden work, Stavis interpreted his concentrated effort as a feat of compartmentalization.

> Here was a man working for the relief agency, whose beat was Harlem— and we're dealing now with the poor in Harlem—and there was such serenity, such a sureness on his part, and the work he was doing was so far removed from the life he was living. This dichotomy was just unbelievable....
>
> When he talked with me about it thirty odd years ago...he talked about the endless, grinding poverty in slum areas; and here was a man who had to go into these homes, examining people for relief. And yet he did these canvases of glorious color, dealing with mythical subjects, and there seemed to be such a disassociation of one life from the other life.[20]

Contrary to Stavis's sense that Bearden was compartmentalizing, the artist was internalizing everything he experienced, absorbing it into his bone marrow in a way that would become an ineluctable part of him. In the 1940s, however, his abstract figurative "canvases of glorious color, dealing with mythical subjects" did seem to observers to be far removed from the realities on the streets outside his studio. These bright canvases briefly brought him what he desired most—serious attention as an artist rather than as a Negro artist. Crosby, buoyed by the positive reviews for *The Passion of Christ* series, introduced the young painter to Samuel M. Kootz. Kootz, a one-time lawyer and advertising and marketing executive, was passionate about modern painting and, in addition to the 1930 survey, *Modern American Painters*, he also wrote the 1943 *New Frontiers of American Painting*. *New Frontiers* articulated what many were coming to believe by the end of the WPA era: American art, liberated from naturalism, was poised to gain new stature as world

art.[21] Kootz had recently opened an art gallery when Crosby arranged for him to look at Bearden's work. Being introduced to Kootz brought Bearden to the doorstep of what was destined to become one of the most progressive galleries in the postwar New York art world.

By the time Crosby introduced Kootz to Bearden, the dealer had already begun assembling a group of what he believed were some of the pioneers of a distinctively American brand of modernism. Eventually he would gather into his circle of artists American painters Robert Motherwell, William Baziotes, Adolph Gottlieb, Carl Holty, and Byron Browne. Later he would add Europeans, like Hans Hofmann, and giants of European modernism such as Léger, Picasso, Arp, Braque, Miró, and Mondrian. In the summer of 1945, the dealer was still searching for new talent. The Kootz gallery provided the opportunity for Bearden and Holty to connect. When Bearden took his work to Kootz, Holty saw the work and, at that time, without having met Bearden, encouraged the dealer to include the young black painter in his new ensemble of artists. Impressed by *The Passion* series, Kootz invited Bearden to exhibit in the fall. The solo exhibition was Bearden's first in New York since his 1940 show at "306."[22]

Kootz wanted oils as well as watercolors for the fall exhibition. To accommodate his request, Bearden worked quickly, making photostatic enlargements of some of the watercolors he had shown at the G Place Gallery. He scaled up the small tableaux and copied them as larger oils—a technique he would use brilliantly years later to transform one-of-a-kind collages into enlarged photographic images.[23] The Kootz debut show contained eleven watercolors and thirteen oils and was a critical and commercial success. Ben Wolf, a critic for *Art Digest*, called Bearden "one of the most exciting creative artists" to emerge in "a very long time."[24] One of the works, *He Is Arisen,* landed in the permanent collection of MoMA, on whose advisory board Kootz sat. As for sales, within a week, all of the oils and most of watercolors were sold to, among others, Duke Ellington, as well as seasoned collectors and art connoisseurs like Samuel Lewisohn and Roy Neuberger.[25]

Bearden's exhibition was cause for celebration in the black community. Nora Holt, writing for the *New York Amsterdam News,*

recalled Bearden as a teenager, a "pink-faced cherub clinging precariously to the folds of Bessye's garments."[26] Less a review than a tribute, the article applauds Bearden's "chrysalis change into manhood and his fame." Holt quotes liberally from the positive reviews that Bearden's exhibition received in the art world press and refers to the Harlem artist as a "sensation," noting that eighteen pieces were sold during the first two weeks—"an exciting record for any artist." Even the scholar and impresario Alain Locke was enthusiastic. In a November 3, 1945, note to Bearden, Locke wrote that he "was amazed at the creative and vivid quality of the work."[27] Bearden's show confirmed both that he was well on his way to conquering the New York art world and that he remained a hero in the black community.

Bearden was a member of the Kootz Gallery from 1945 until 1948. His three years with Kootz allowed Bearden to add to his gathering of artists Uptown the camaraderie of a group of emerging Downtown artists. Kootz assembled his artists for monthly meetings and, over time, the Kootz artists and others who showed "advanced American art"—in exhibitions run by art dealers Betty Parsons, Charles Egan, Sidney Janis, and Marian Willard—would become the cornerstone of postwar American modernism. Art dealer Betty Parsons showed Mark Rothko, Jackson Pollock, Barnett Newman, Clyfford Still, and Ad Reinhardt. At the Charles Egan Gallery were Willem de Kooning, Franz Kline, and Louise Bourgeois. Marian Willard exhibited David Smith and Norman Lewis. Sidney Janis, who opened his gallery in 1948, exhibited many of the artists listed above as well as leading European artists and later a new generation of painters that included Jasper Johns and Robert Rauschenberg. Bearden was a part of this constellation.

New ideas about painting and sculpture during this period were being shaped in an animated social and intellectual scene centered in the West Village. At bars and pubs, in classrooms and studios, in formal and informal settings, artists gathered to discuss critical issues. A formal school established in an East 8th Street loft called "Subjects of the Artists" (founded by Kootz artists Motherwell, Gottlieb, and Baziotes along with David Hare, Barnett Newman, Clyfford Still, and Mark Rothko) printed a formal "curriculum" on its opening announcement.

The school was to act "as a spontaneous investigation in the subjects of the modern artist—what his subjects are, how they are arrived at, methods of inspiration and transformation, moral attitudes, possibilities for further explorations, what is being done now and what might be done, and so on."[28]

This school closed in less than a year, but while it lasted gave the public a chance to listen to guest artists. Eventually the space was taken over by a trio of NYU faculty who needed the space for their students but retained its public assembly function. Hale Woodruff, who had moved to New York in 1946 and ultimately served as an NYU faculty member for three decades, was the chief administrator, along with Robert Iglehart and Tony Smith. Known as Studio 35, the space continued to host Friday night lectures featuring a lineup of contemporary American and European painters and sculptors. In the fall of 1949, not far from Studio 35, De Kooning, Reinhardt, Kline, and others organized a group they called "The Club" that also featured weekly panel discussions. Conversations often spilled out into the Cedar Street Tavern and Five Spot Café. Bearden was well familiar with the neighborhood from his NYU days, and before the war, he had enjoyed attending the sessions hosted by Hans Hofmann, but, saddled with a demanding job and obligations to his father, he was not able to attend either the formal or informal sessions downtown. Fellow Harlem artist Norman Lewis did attend Studio 35 sessions, and like his peers, his painting moved toward nonobjective abstraction.

The artists who did participate in the weekly discussions and hung out at the downtown bars and cafés solidified their social connections with their own set of publications. Most of the journals and periodicals, such as *Icongraphy*, the *New Iconography*, the *Tiger's Eye,* and *Instead and Possibilities,* were short-lived but reflected attempts of the artists (and critics sympathetic to them) to articulate the ideas behind their painting and sculpture.[29]

In the years that Bearden was associated with Kootz, he enjoyed the full benefits of the dealer's salesmanship and, at least, peripheral membership in a burgeoning American vanguard. The entrepreneur/connoisseur not only provided him with a solo exhibition every year

from 1945 to 1947, but his paintings were included in Kootz's group exhibitions. Ever the marketer, Kootz organized shows centered on the collections of prominent collectors, like Roy Neuberger. Or he would organize a show titled *Modern Paintings for a Country Estate: Important Painting for Spacious Living* that unabashedly taught prospective patrons how to build a collection. Thematic exhibitions were another means by which Kootz showcased his artists. With such titles as *Under the Big Top*, or *Jazz*, the shows sometimes paired visual artists with poets and writers (Bearden was paired with the poet William Carlos Williams for a show on women). In the process he created opportunities for public and private collectors as well as the art world as a whole to see the work of his artists. Bearden's art during his time with Samuel Kootz, enjoyed high visibility.[30]

Bearden's paintings found their way into non-Kootz exhibitions with major American and European modernists as well. A show of religious painting, for example, at the Durand-Ruel Gallery in Paris, placed his work alongside that of Marc Chagall and Georges Rouault. He was regularly included in the Whitney Annual, a gathering of what the museum deemed the most exciting artists of the season. And in 1946 he was included in the Metropolitan Museum's effort at cultural diplomacy, *Advancing American Art* in 1946, a show that traveled to Europe and Latin America. The reviews of Bearden's solo exhibitions and the mentions seemed to announce a career in the making.

Another of Bearden's ardent champions during the 1940s was the painter Ad Reinhardt. Reinhardt, a member of the Betty Parsons Gallery, was an abstract painter whose work was devoid of any type of literary or historical content or emotional valence. But he was as avid a social activist as he was a minimalist. Before the war, he had contributed satirical cartoons to the left-wing publication, the *Masses*. And during the war, he was part of a creative team that produced a controversial pamphlet entitled *The Races of Mankind*, an effort to combat ideas of racial superiority. At the time that he offered Bearden assistance, Reinhardt was an editor and reporter at the left-leaning *PM Magazine* and had poked fun at the New York art scene in two cartoons. One was published in the August 12, 1946, issue of *Newsweek* magazine and pictures a

young girl—who stands for Art—being rescued from an oncoming train in the form of a handsome young man—who stands for abstract art. The train speeding toward the girl represents all of the destructive forces that threaten art and artists, one of them being "prejudice."

That same year, Reinhardt also published a cartoon in *PM Magazine* that would take a satirical swipe at the pretensions and obfuscations present in the New York art world. It was a pastiche of a drawing done by Alfred Barr, avid American proponent of European modernism (and founding director of the Museum of Modern Art). Barr had tried to explain the origins of modern art in his catalogue that accompanied the groundbreaking 1936 MoMA exhibition, *Cubism and Abstract Art.* On the dust jacket of the catalogue, Barr included a complicated hand-drawn chart that mapped the influences and development of modern art. Mocking Barr's byzantine drawing, Reinhardt's version of the chart focused on the American art scene and was entitled, "How to Look at Modern Art in America."[31] He describes his diagram as "a guide to the galleries—the art world in a nutshell—a tree of contemporary art form pure (abstract) 'paintings' (on your left) to pure (illustrative) 'pictures' (down on your right)."[32] Bearden had given Reinhardt his 1946 essay, "The Negro Artist's Dilemma," and Reinhardt recognized it for what it was—a piece of writing that would discomfort the art world. In an undated letter to Bearden, he writes admiringly that his publication, *PM Magazine*, where he held some sway, "ought to run a piece like yours—I thought it very good" and, added, the art world needed a "poke."[33]

In Reinhardt's cartoon, his own "poke" at that world, Bearden himself appears as a leaf toward the left-hand side of the tree.

"The Negro Artist's Dilemma" is a much-quoted essay. The quotes are almost always taken out of context, however, draining the essay of the simmering anger that characterizes the first half and overlooking the sense of struggle implicit in the logic of the argument overall.[34] The essay reflects Bearden's urgent need to identify the hurdles that he believed stood in his way of becoming an artist. He defines those hurdles as popular culture and fine arts misrepresentations of black culture, along with a "tyranny of mind" that shackles artists, audiences, and critics alike. Reserving an entire section of the essay for spectators and

critics, he observes that Negro audiences and leaders have surrounded themselves with visual distortions and outmoded critical concepts that employ false critical standards. Bearden's repudiation of the term "Negro artist" and his rejection in the essay of Negro exhibitions was for him a necessary and very public declaration of independence. By the time he published "Dilemma," he had had two successful solo shows with Kootz, and he was ready to shed completely his old identity as a race man for the unmodified label of "artist."

Published in the November 1946 issue of the journal *Critique: A Review of Contemporary Art*, the essay is divided into several parts. The first section begins with his account of a conversation with a Negro artist who could be a younger version of himself. The younger artist's work depicts racial injustices, and he is planning to exhibit in a segregated art show. Bearden laments the young artist's decision and his misplaced opinions about what he should paint and where he should exhibit. A defining quote in the essay, one that frames the premise of this book, as discussed in the introduction, describes the dilemma. History has distorted the representation of Negro culture and shackled the artist to the false idea that as a representational artist, he bears the responsibility to correct history's visual distortions. The quote is worth repeating here:

It is the privilege of the oppressor to depict the oppressed. Consequently, the picture of the Negro that appealed to the South was that of a shiftless dim-witted buffoon. This concept, pleasing to the Southern ego, was nothing but a rationalization and one of the means of keeping the Negro in his dark corner. Pseudo-scientific books were written; ministers gave long-winded sermons to prove that the Negro was a creature driven by animal spirits, possessing only limited capacities, and best suited to a servile existence.[35]

Bearden points to minstrel performance as the source. The trope of minstrelsy went on to repeat itself ad nauseum, and as Bearden notes, it is still alive in modern cinema, "in the present-day eye-rolling, grinning interpretation of the Negro on the screen by actors like Stepin Fetchit and Bill Robinson."[36] The Fine Arts are guilty of distortions as well,

and he singles out for special mention the genre paintings of Eastman Johnson, labeling him a member of the "head-in-the-watermelon" school of painters. Misrepresentations like these lead to false standards for artists and community alike. False standards in turn account for the fact that black people themselves put visual distortions of their culture up on their walls. Ignoring his own early cartoons, which feature such stereotypes as the razor-wielding Negro, Bearden describes an image that was especially offensive to him, the popular Currier and Ives print, *The Darktown Poker Club*: "Here was a group, such as Mr. Hoyle never imagined, gathered about a battered table on which rested a huge jug of corn whiskey, armed with razors and with stray aces hidden in shoes and hat brims."[37]

According to Bearden, visual distortions retarded the evolution and maturation of Negro artists in American culture. He acknowledges that there *were* artists who portrayed the Negro sympathetically: John Sloan, Robert Henri, George Luks, and George Bellows. Despite their example, however, New Negro artists, the public, and critics, all misguided by well-intentioned white philanthropy, succumb to "conforming expectations." Those expectations manifest themselves in the caricatures and stereotypes that filled print media, advertising and film.

As an artistic manifesto, "The Negro Artist's Dilemma" veers in a different direction from Bearden's 1934 essay and his erstwhile Guggenheim Foundation proposal. In those earlier writings he championed the need for Negro artists to invent a visual art inspired by the realities of daily life.[38] Bearden's new postwar view characterized American life as an "amalgam," a clash and collision of hybrid influences and cultural content, and that all art contains "patterns that link it to other cultures and peoples."[39] Bearden's idea of cultural interdependence, expressed in "The Negro Artist's Dilemma," contains seeds of the *Prevalence of Ritual*, the conceptual framework he would articulate for his collages in the 1960s. In "Dilemma," he identifies the universalism of black culture and its connections to world culture:

> The Negro spirituals have patterns that link it to other cultures and
> peoples. The Negro spirituals have a similar structural pattern to that of

the English four-part hymn. The Negro had to master the playing of the white man's instruments before he could develop jazz music. Benny Goodman, Max Kaminsky, and Joe Sullivan, and the other leading white practitioners of jazz music have not disdained to play in this idiom simply because it is essentially a Negro creation.[40]

He closes his essay with an argument against segregated art shows and with a passionate plea for the Negro artist "to think of himself not primarily as a Negro artist, but as an artist."[41] "Only in this way will he acquire the stature which is the component of every good artist."[42]

Shedding his exploration of race and representation, Bearden came to a conclusion that echoes ideas expressed by Clement Greenberg, the consummate spokesman of the New York School. Greenberg argued for a strict formalism that eschewed all types of subject matter be it historical, topical, religious, or political. Painting, according to Greenberg, referred only to itself. Bearden, echoing that line of thought, writes: "A good painting has its own world" and "What ideas it arouses are integral and in relation to itself."[43] Harold Rosenberg a year later would write the introduction for the catalogue of the ill-fated 1947 exhibition at the Galerie Maeght in Paris in which Bearden participated. Rosenberg preferred to regard the true American modernist as an artist who "belongs to no one country, race or cultural temperament." Bearden's modernist ideas, bending toward Greenberg and Rosenberg, countered the race politics that once shaped him. If W. E. B. Du Bois had identified the color line as the problem of the twentieth century, Bearden now envisioned the erasure of that line as the role of the artist.

Bearden's essay would certainly have been received sympathetically by Norman Lewis, whose work was exhibited at the Marion Willard Gallery during the 1940s and into the early 1960s. Lewis did go to places like The Club and the artists' gatherings in the temporary schools and pubs in the Village. He once noted that he was concerned "with greater freedom for the individual to be publicly first an artist (assuming merit) and incidentally a Negro."[44] Hale Woodruff, attempting to persuade Bearden to exhibit in a show organized by IBM, notes in a

January 30, 1947, letter that he had read his essay and "found it very stimulating and to the point." He added that the IBM show "had no emphasis whatsoever on a racial style in the works that have been submitted."[45] Other than these occasional mentions of support directed to Bearden, his "poke," unlike the attention his first essay garnered in the black press, seemed to have caused few ripples in either the mainstream art world or the black press.

Bearden's choice of subject matter and his painting style during the Kootz years came at a time when his fellow Kootz artists attached themselves to the idea of myth. Introduced to American painters by the European Surrealists who immigrated to the United States during World War II, myth became a useful means of disengaging from the chauvinism of past American painting and developing a more global visual language. In a 1960 interview with the British art historian David Sylvester, Adolph Gottlieb described his attachment to myth during the 1940s as a means of developing in new directions. Gottlieb cites 1942 as the year when he began to make use of mythological subjects as a means of breaking free of the American scene or social realism or cubism, and providing a pathway to a new direction in painting.[46]

During the decade, Gottlieb and Rothko co-authored what would become a widely quoted letter to the *New York Times*, affirming the importance of myth in painting. Referring to Gottlieb's painting, *The Rape of Persephone,* the artists asserted that the painting is a "poetic expression of the essence of myth; the representation of the concept of seed and its earth with all its brutal implications; the elemental truth."[47] They go on to ask, rhetorically, if a naturalistic representation would better serve this portrayal of such an elemental truth. In the same year they gave a radio interview in which both artists heralded the importance of myth. Rothko described myths as "eternal symbols upon which we must fall back to express basic psychological ideas."[48] Myth surfaces in Jackson Pollock's paintings of the 1940s—*Pasiphae* is an example—in titles that, in the words of art historian, Robert Hughes, "invoke" the presence of myth.[49]

Bearden announced his interest in myth as early as the introduction to the catalogue for the *Passion* series. In his introductory statement, he

Profile/Part I, The Twenties: Liza in High Cotton, 1978. Collage, 17-1/2 × 32-3/4 in. Private Collection. "I couldn't play with her that day, her grandmother said she was in the fields."

Profile/Part I, The Twenties: Pittsburgh Memories, Farewell Eugene, 1978. Collage of various papers with paint, ink, graphite, and bleached areas on fiberboard, 16-1/4 × 20-1/2 in. Private Collection. "The sporting people were allowed to come but they had to stand on the far right."

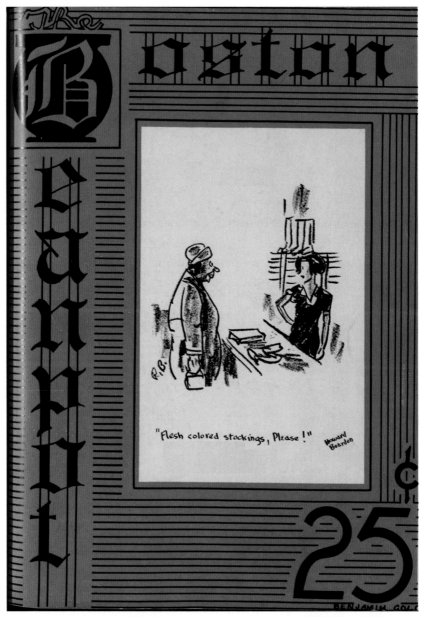

Cover Illustration: *The Boston Beanpot* 12, no. 3 (November 1931).
"Flesh Colored Stockings, Please!" signed, Howard Bearden. Courtesy
of Howard Gottlieb Archival Research Center, Boston University.

DIS RAZOR AIN'T BEEN A BIT OF GOOD...SINCE DAT TIME I SHAVED WID IT. Medley, April 1934. Courtesy of New York University Archives.

Morris is becoming very conservative lately. Medley, March 1935. Courtesy of New York University Archives.

Picket Line, Crisis Magazine, April 1934.

Why Stay in Dixie?, Baltimore Afro-American, June 20, 1936.

The Ghost Walks, Baltimore Afro-American, June 6, 1936.

News Item: Another War Imminent, Baltimore Afro-American,
March 21, 1936.

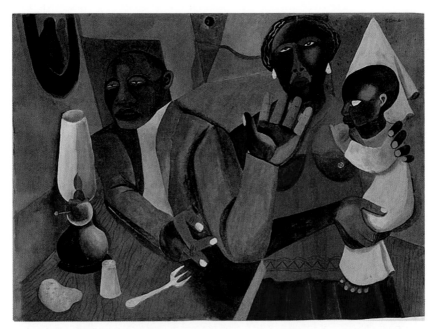

The Family, 1941. Gouache with ink and graphite on brown paper, 29-1/2 × 41-1/4 in. Collection of the National Gallery of Art, Washington, DC. Bequest of Earle Hyman in memory of Rolf Simes.

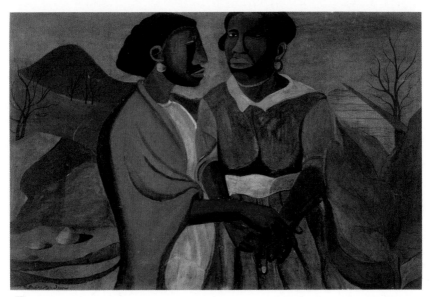

The Visitation, 1941. Gouache with ink and graphite on brown paper, 30-1/2 × 46-1/4 in. Museum of Modern Art, New York. Gift of Abby Aldrich Rockefeller (by exchange).

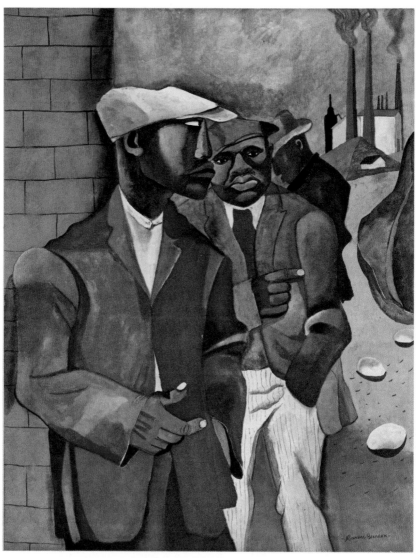

Factory Workers, reproduced in *Fortune Magazine*, June 1942, along with the article "The Negro's War." Courtesy of Romare Bearden Foundation Archives.

He Is Arisen, 1945. Ink on paper, 26 × 19-3/8 in. Museum of Modern Art, New York.

Madonna and Child, 1945. Oil on canvas, 38 × 30 in. Bryn Mawr College Art and Artifact Collections, Bryn Mawr, Pennsylvania. Gift of Mr. and Mrs. Roy R. Neuberger.

You Are Dead Forever, ca. 1945. Watercolor and ink on paper,
20-1/2 × 26-3/4 in. Private Collection.

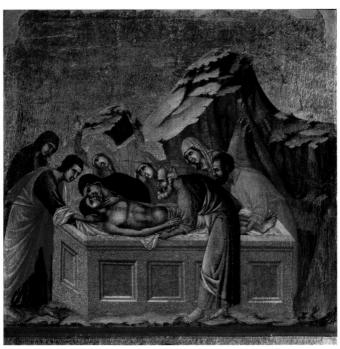

Duccio di Buoninsegna, *The Burial of Christ,* detail from *Maesta*
altarpiece, 1308–1311. Tempera and gold on panel. Museo dell' Opera
Metropolitana, Siena.

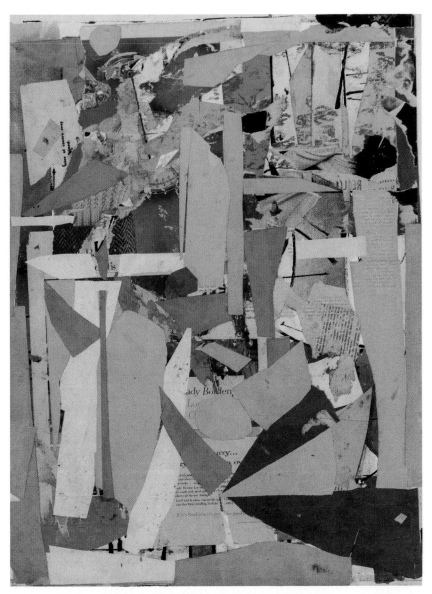

Untitled (double-sided), 1956. Gouache on paper, 25 × 19 in.
Courtesy of ACA Galleries, New York.

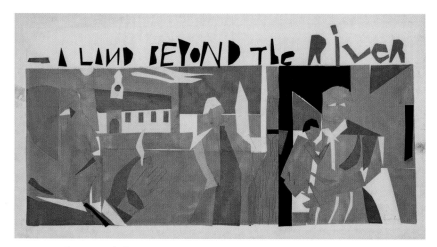

A Land Beyond the River, 1957. Collage on paper, 11 × 22 in. Gifted to Lofton Mitchell on the occasion of the opening of his play at the Vineyard Theater. Courtesy of ACA Galleries, New York.

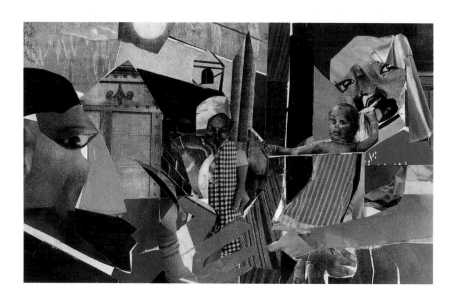

La Primavera, 1967. Collage of paper and synthetic polymer paint on composition board, 8-3/8 × 13-1/8 in. Private Collection.

River Mist, 1962. Oil on linen, collaged on board with oil paint, 54 × 40 in. Romare Bearden Foundation Archives, courtesy of D. C. Moore Gallery, New York.

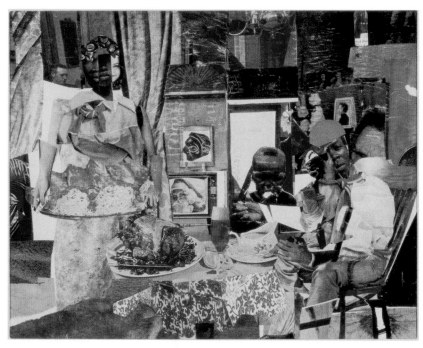

Evening Meal of Prophet Peterson, 1964. Collage of various papers with graphite on cardboard, 12 × 15-1/4 in. Private Collection.

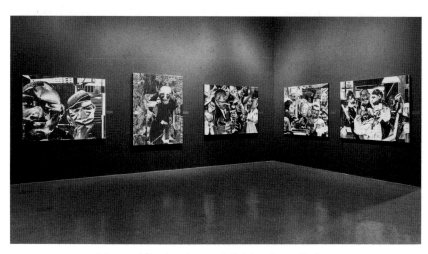

View of *Projections* exhibition installed at
the Cordier-Ekstrom Gallery, October 1964. Courtesy
Romare Bearden Foundation Archives.

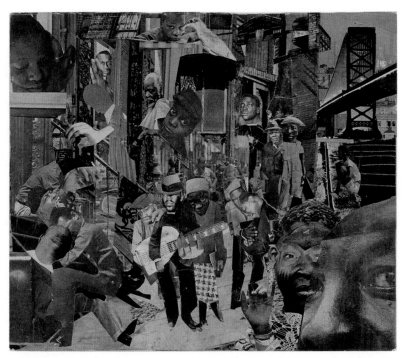

The Street, 1964. Photostat on fiberboard, 31 × 40 in. Art Institute of Chicago, Chicago, Illinois.

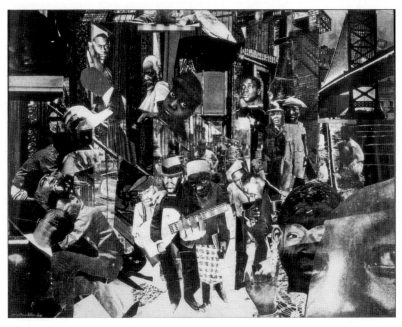

The Street, 1964. Collage of various papers on cardboard, 9-5/8 × 11-3/8 in. Milwaukee Art Museum. Gift of Friends of Art and the African American Art Acquisition Fund.

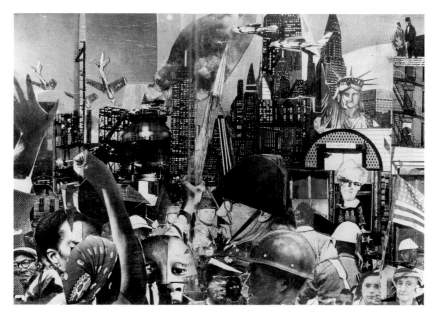

Untitled, 1964. Photomontage, 35 × 48 in. Private Collection.

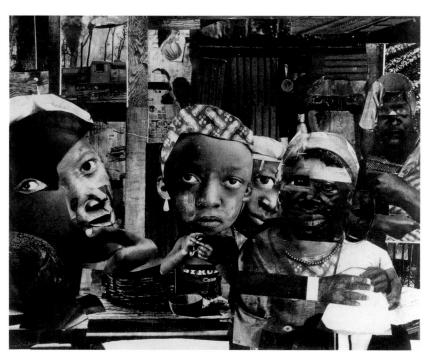

Mysteries, 1964. Collage on board, 11-1/4 × 14-1/4 in. Museum of Fine Arts, Boston. Ellen Kelleran Gardner Fund.

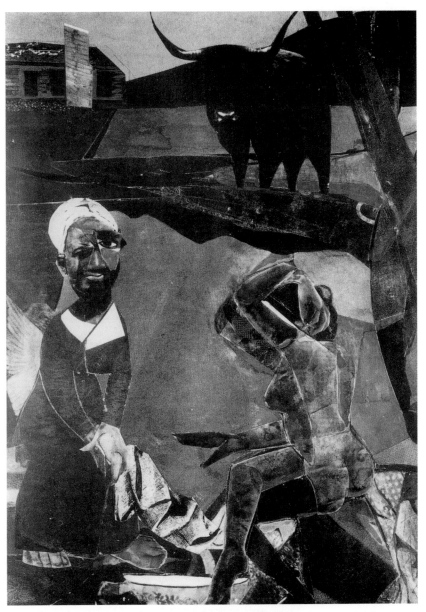

Prevalence of Ritual: Conjur Woman as an Angel, 1964. Collage of various papers with paint and ink on cardboard, 9-3/4 × 6-7/16 in. Museum of Fine Arts, Boston, Massachusetts. Gift of John P. Axelrod.

The Block, 1971. Collage of cut and pasted paper and synthetic polymer paint on Masonite; six panels, 48 × 216 in. Metropolitan Museum of Art, New York. Gift of Mr. and Mrs. Samuel Shore.

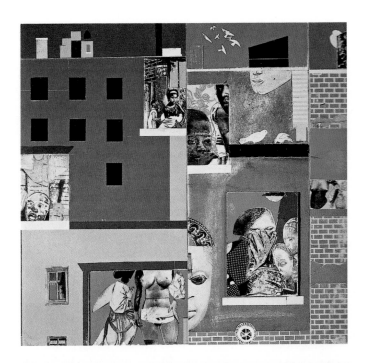

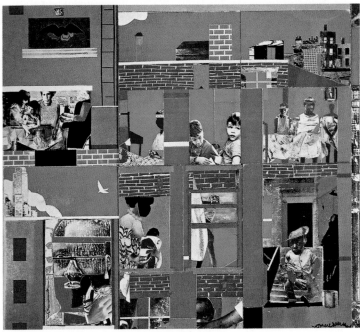

Details. *Cityscape*, 1976. Photo silkscreen and collage mural, 90 × 318 in. Bellevue Hospital Center, New York. New York City Health and Hospitals Corporation (HHC) Art Collection.

Midtown Manhattan, ca. 1979–1980. Watercolor, gouache, graphite, and bleached areas on paper, 9-1/2 × 12-3/4 in. Private collection.

White River, ca. 1979–1980. Watercolor, gouache, graphite, and bleached areas on paper, 11 × 16 in. Romare Bearden Foundation, courtesy of D.C. Moore Gallery, New York.
Both images from a series of cityscapes done for the opening credits in the 1980 John Cassavetes film Gloria.

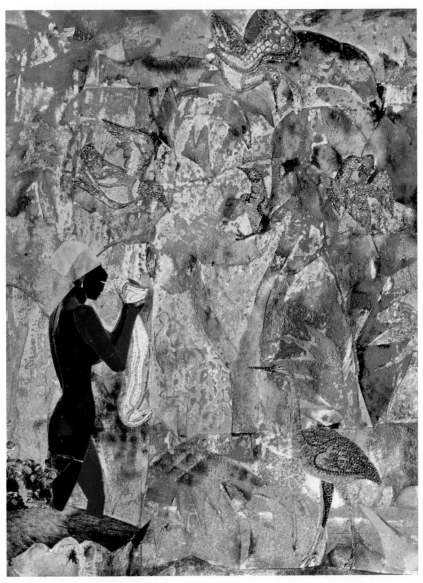

Byzantine Dimension, 1971. Collage, 24 × 18 in. Private Collection.

Of the Blues: Storyville, 1975. Collage with acrylic and lacquer on board, 15-1/4 × 20 in. Private Collection.

The Street, 1964. Collage, 12-7/8 × 15-3/8 in. Milwaukee Art Museum, Wisconsin. Friends of Art and the African American Acquisition Fund.

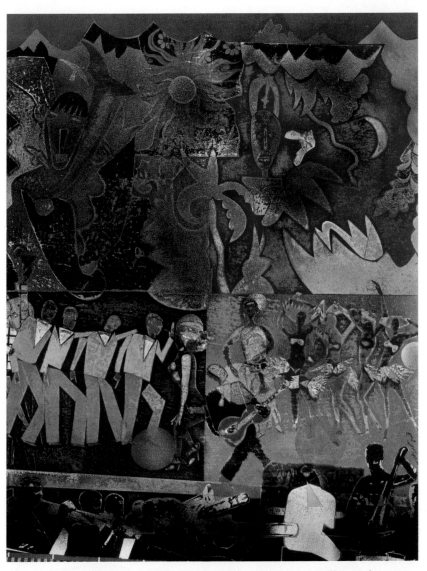

Of the Blues: Wrapping It Up at the Lafayette, 1974. Collage of various papers with fabric, paint, ink, and surface abrasion on fiberboard, 48 × 36 in. Cleveland Museum of Art, Ohio. Mr. and Mrs. William H. Marlatt Fund.

Profile/Part II, The Thirties: Artist with Painting and Model, 1981.
Collage on fiberboard, 44-1/16 × 56-1/16 in. High Museum of Art,
Atlanta, Georgia. "Every Friday Licia used to come to my studio
to model for me upstairs above the Apollo Theater."

Patchwork Quilt, 1970. Collage of cloth, paper, and synthetic polymer
paint on composition board, 35-3/4 × 47-7/8 in. Museum of Modern Art,
New York. Blanchette Rockefeller Fund.

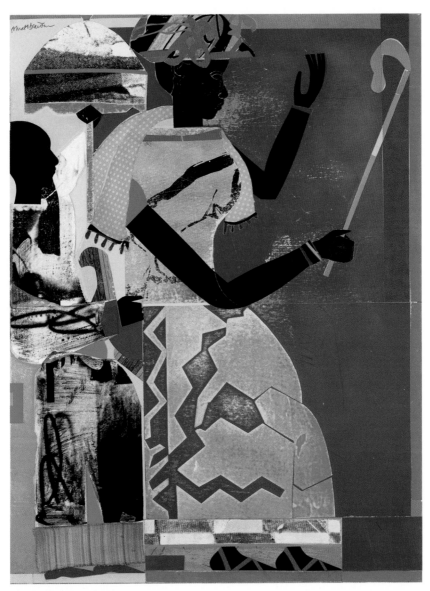

She-Ba, 1970. Romare Bearden, American, 1914–1988. Collage on paper, cloth and synthetic polymer paint on composition board, 48 × 35-7/8 in. Photography Credit: Allen Phillips/Wadsworth Atheneum. Wadsworth Atheneum Museum of Art, Hartford, Connecticut. The Ella Gallup Sumner and Mary Catlin Sumner Collection Fund, 1971.12.

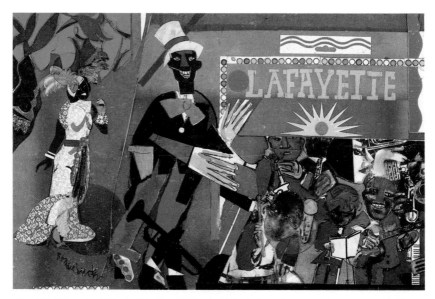

Profile/Part II, The Thirties: Johnny Hudgins Comes On, 1981. Collage on board, 16 × 24 in. Collection of Monica and Richard Segal, courtesy of Seavest Collection, New York. "He was my favorite of all the comedians. What Johnny Hudgins could do through mime on an empty stage helped show me how worlds were created on an empty canvas."

went to great lengths to sidestep religious implications and, as Rothko characterized myth, to emphasize myth as "eternal symbol."

> Incorporated in the myth of Jesus are such varying and intense emotional factors. This myth is one of the greatest, perhaps the greatest, expression of man's humanism. In none of the other mythologies or religious concepts is this sheer human quality so poignantly expressed. The concept supercedes [sic] reality and the usual conformist interpretations, so that it makes little difference as to the factual nature of the story, or even whether or not such a man as Christ actually existed. What is important, is that the idea has lived in men.[50]

Never a fan of surrealism, Bearden instead traced his attraction to myth to Pablo Picasso, whose 1939 retrospective at MoMA, organized by Alfred Barr, offered the young painter a panoramic view of Picasso's evolution as a painter. A founder along with Braque of cubism and the use of collage in modern painting, Picasso also made ample use of myth and ritual in his paintings. Myth, as Bearden began to understand it, establishes a visual language that stretches over different eras, different cultures, living from one era to the next, gaining new life in the hands of each successive generation of artists. Decades later, the phrase "the prevalence of ritual," would become the unifying concept of his collages and the *Passion of Christ* catalogue essay is prescient: "Consider the many interpretations of the Christ story in art; the pious approach of Fra Angelico; the sublimity of a fresco by Giotto; the electric rhythms of El Greco. Contrast these with the great crucifixion scenes of Cranach and Gruenwald and in these men's work there is a sadistic, recusant, challenging element. One can see told in art that the Reformation would start in the country of these painters."[51]

Establishing continuity between his art and painting through the ages, myth and ritual also served the purpose, according to novelist, Ralph Ellison, who sometimes visited Bearden in his studio as he painted, "as potent forms for ordering experience."[52] Bearden's series completed between 1945 and 1948 bore this mythic quality.[53]

In the spring of 1947, Bearden participated in an exhibition that would mark the beginning of his disassociation from his peers in the Kootz Gallery. Kootz mounted what would become a show at the Galerie Maeght in Paris. Before World War II, Paris was the undisputed center of the art world. The war, however, had driven scores of artists and intellectuals out of Europe and many of them to the United States. Postwar Paris lost its preeminent status, and Kootz believed that his artists, "the six most talked about, exhibited modernists in America," would then demonstrate the ascendance of American modernism. Along with works by Bearden, Kootz sent five paintings each by Gottlieb, Motherwell, Baziotes, Browne, and Holty. He enlisted Rosenberg to write the catalogue essay, an impassioned and convincing presentation of the new American ethos.

> On the western shore of the Atlantic, then, these men have sought out, made their own and applied to the needs of their special passion the international idiom of twentieth century painting—an idiom that belongs to no one country, race or cultural temperament (though it is associated above all with Paris), but that in fact achieves much of its energy, inventiveness and glory in negating what is local and folkloristic through assimilating all national vestiges into a transcendental world-style.[54]

Whatever Kootz may have hoped for his ensemble of painters and of Parisian critics, the show was a disappointment. Bearden in particular, along with Holty and Byron Browne, was singled out by some critics for especially harsh criticism.[55] Jean-José Marchand, writing for the April 9, 1947, edition of the publication *Combat*, applauded the Kootz Gallery for assembling the show but zeroes in on Bearden as "the worst of the lot, with a careless and facile brush stroke and colors laid down at random in a sort of jigsaw puzzle done in the loudest possible shades. A painter of this sort in France would be regarded as quite mediocre."[56]

French criticism of Bearden's work underscored significant differences that had begun to separate his work not only from some of his peers at the Kootz gallery but some of the vanguard artists who exhibited at Parsons, Egan, and Willard. Scale was one. Bearden's series

ranged in size from modest to mid-size.[57] Painters such as Pollock, Gottlieb, Rothko, Newman, and Motherwell, meanwhile, had already begun to work on a more monumental scale. Bearden's attachment to figure and ground was another. Noting the breakthrough work of Adolph Gottlieb, art historian Pepe Karmel wrote that Gottlieb's use of the grid had "pioneered the development of the 'allover composition,' breaking down the distinction between figure and ground, and occupying the totality of the visual field instead of separating into discrete figures set against a relatively empty background."[58] Pollock, the acknowledged "hero" of his generation, was by 1947 already attacking the surface of his canvases with an all-over approach. Motherwell, who in 1948 inspired by the same Lorca elegy that inspired Bearden two years earlier and fueled by his opposition to the fascist politics of Franco's Spain, created large paintings that eschew completely any reference to the figure. The surfaces of his paintings are thickly textured and tactile, the forms alternating between biomorphic globes and slashing lines. Color, in the hands of Bearden's peers, was unleashed from line.

Bearden, by contrast, was still drawing identifiable objects and people, and in some cases, presenting a mise-en-scene as if he were staging a theatrical event that referenced specific episodes in a specific literary text. For many of his peers, the event was the act of painting itself. The drama was between the artist and the canvas, the action of the paint applied to the surface as an expression of an individual imagination that needed no literary references to validate itself. Gottlieb, Motherwell, Pollock, Rothko, Reinhardt, and others had broken emphatically from the dominance of Picasso at a time when Bearden's interest in the modernist master was as keen as ever. An August 1947 entry in his diary reaffirms Bearden's admiration, commenting on a reproduction of the evolution of *Guernica* in *Cahiers d'Arts*:

> It was amazing to see the changes that Picasso made, strengthening his rhythms and shapes, always allowing the development of the painting to progress out of the body of the work. Matisse works in the same manner, with the initial lay in often having no relation to the final statement. And this is the true manner of working–since the artist takes what he finds.[59]

Despite the Paris review, and despite what he could see for himself were differences between the direction of his work and the work of his peers, Bearden felt supported by Sam Kootz. His solo New York exhibition at Kootz in the March of 1947 (the same month that the Galerie Maeght show opened) entitled *They Drink, They Drink*, was based on Chapter 5, Book 1 of Rabelais's sixteenth-century satirical series of novels, *Gargantua and Pantagruel*, and received positive reviews. The series revealed Bearden's penchant for racy subject matter, an inclination that would show up frequently in his mature work. According to the essay written by Barrie Stavis, the theme was a continuation of his search for universal themes and representative of his desire to "paint man and more man."[60] Kootz had also invited Bearden to participate in a large group exhibition, *Women: A Collaboration of Artists and Writers*. Bearden's painting *Woman with an Oracle*, a watercolor of a stately woman seated on a rock, was paired with a paragraph written by the poet William Carlos Williams, entitled "Woman as Operator." Picasso, Léger, Braque, Holty, Motherwell and others were included.

In a diary entry in the fall of 1948, Bearden reports a congenial visit with Dr. Williams in his New Jersey home, noting his keen taste in the astutely assembled collection.[61] Williams wrote a text that accompanied the painting in the exhibition catalogue and though it does not contain an overt racial reference, the poet obliquely links the theme of women to the racial identity of the artist:

> With woman there's something under the surface which we've been blind to, something profound, basic. We need, perhaps more than anything else today, to discover woman....Such a show as this, almost flippant certainly "wrong" as it may seem, at least avoids the more malicious flippancy which masquerades as "woman" today. Such a picture as Bearden's (taken with the others, good and bad) if it can link the basic conception of woman I have sketched with an art that is in the condition painting is in today becomes important....It is altogether fitting at such a time that her traits (no face) be celebrated—by the artist who alone among men resembles her.[62]

Williams's analogy between the faceless woman in the painting and the artist who portrayed her is a telling assessment of how Williams viewed the artist with whom he was paired. The show on women would be the last group exhibition that Bearden participated in at the Kootz Gallery.

Kootz surprised Bearden and all of his other artists when he announced in the summer of 1948 that he was closing his gallery to become the sole worldwide representative of the works of Pablo Picasso. That fall, Bearden's fourth and final literary series, based on the *Iliad*, this one was shown at the Niveau Gallery to tepid reviews. Critical disinterest was not surprising. Stylistically, the work resembled his three previous series. What had been a fresh inventive vocabulary with the *Passion* series had become rote, repeated in one series after another without any substantive change or development.[63]

Financially, the closing of the Kootz Gallery did not have much impact on Bearden. He had refused Kootz's offer of a monthly stipend in return for work, unlike all of the other Kootz artists who were dependent on the dealer. Socially, however, the closing did disconnect him from the Downtown artistic community, if not the thinning community of artists Uptown. His Downtown peers had established a vibrant network of gathering places in the village where most of them lived and worked in their studios. Despite the hardship of not having a regular income, they were able to continue a lively discourse and debate art and ideas. Bearden's letters to Holty illustrate, nonetheless, that he was under the impression that all was well between him and his former gallerist. He recounts with considerable pride Kootz's invitation to participate in a television show on the short-lived Dumont network. A weekly show, *The Court of Current Issues*, recreated a mock trial around a current critical issue. One guest played the role of defense attorney who then called other guests as witnesses to testify for the defense. Another guest played the role of the opposing attorney and argued a dissenting opinion and, in turn, called his witnesses to testify. The television viewing audience, serving as the courtroom jury, phoned in with a vote for one of the two arguments.

On the evening of September 7, 1948, Bearden assumed the role of defense and Kootz, trained as a lawyer, was the witness. Because of a

last-minute mix-up, the two, who were originally asked to argue in favor of nonobjective art, argued, instead, in favor of Expressionism. The term Expressionism seems to have been used to convey art work that, unlike the work of the budding Abstract Expressionists, contained topical subject matter. Bearden bragged later to Holty, "I was absolutely calm during the program, tore the others to bits and the John Q. Public Jury voted in favor of Expressionism. Can you Imagine?" Television had turned the artist into a public spokesman, if only briefly, for art, not just black art.[64]

Bearden's foray into television was brief. The Dumont network went out of business and the audience for shows like the *Court of Current Issues* was no match for entertainment shows such as Milton Berle's variety show, *Texaco Star Theater*, broadcast the same hour. Later in the 1950s, televised McCarthy hearings signaled the power of television to convert a "witnessed" you-are-there event into a cultural phenomenon. With the use of television in the 1952 presidential campaign and subsequently with the accelerating civil rights movement, the full visual power of television began to surface. After his television debut with Kootz, Bearden seems not to have had much interest in a new medium that could manufacture visual images at a rate exponentially greater than either photography or cinema. Television was just one more reason Bearden was persuaded that painting had to be about something other than mere representation.

At the time that Bearden accepted the assignment to appear with Kootz on the television show in the fall of 1948, he was also still taking care of his father. One winter day in 1948, Howard Bearden was the victim of an assault at the hands of one John LaPorte Given, a well-known philanthropist married to Irene Heinz, heir to the Heinz fortune. Given—the "pickle man," as the *Amsterdam News* described him—and Howard Bearden got into a dispute at a newsstand when Given raised his cane and shouted at him.[65] As reported in the paper, a crowd gathered around Bearden's father to protect him from Givens. When police intervened, they discovered a three-inch blade encased at the end of Givens's cane. Howard Bearden refused to press charges, but his son realized that he could hardly let his father live on his own.

Samuel Kootz's arrangement as Picasso's exclusive private dealer ended in less than a year. In the fall of 1949, he reopened the Samuel Kootz Gallery, assembling some of his old artists—Motherwell, Gottlieb, Baziotes, and Hans Hofmann, whom he had added in 1947. Missing were the artists who, in his words, "could not shake off the Picasso influence."[66] That meant Carl Holty, Byron Browne, and Romare Bearden. Kootz reopened his gallery with a show titled, *Intrasubjectives*. In addition to artists from his former gallery, he included in the show works by Pollock, Gorky, De Kooning, Rothko, Reinhardt, Morris Graves, Mark Tobey, and Bradley Walker Tomlin. Kootz wrote in the catalogue essay that those represented "make no attempt to chronicle the American scene, exploit momentary political struggles, or simulate nostalgia through familiar objects." They dealt, instead, "with inward emotions and experiences....Intrasubjectivism is a point of view in painting rather than an identical painting style."[67]

Abstraction untethered to race had felt like a form of freedom to Bearden. But validated by the New York art world in the late 1940s early 1950s, Abstract Expressionism became the dominant mode of painting, "almost tyrannical in its hold on the American art scene."[68] Bearden, along with Holty and Browne, found himself excommunicated from the sacred circle of chosen artists, and left to reconstruct his life. Bearden's break with Kootz would be the beginning of what would become an almost decade-long hiatus from the New York art world but not by any means from the world of art and image-making.

Romare Bearden in his studio on 125th Street in New York City, ca. 1940–41. Photo by Sam Shaw, © Sam Shaw, Inc. Licensed by Shaw Family Archives, Ltd.

A VOYAGE OF DISCOVERY

1950-1960

The camera, and the motion picture, and all these present means of expression has [*sic*] forced the artist to reconsider his position.... I can't say I have found certitude, because art is after all a kind of voyage of discovery.... I feel that perhaps the best I can offer my own people—and naturally all others—is an excellency within the means and limitations of my craft.[1]

—Romare Bearden, letter to Harry Henderson, 1949

Bearden's departure from the Kootz Gallery forced him to face the fact that he worked from aesthetic imperatives different from those of the Abstract Expressionists. In a letter to Carl Holty, for example, he shared his low opinion of what Jackson Pollock, William Baziotes, and others were trying to accomplish. They "have broken with....structure and returned to romanticism." Structure was and would remain an essential formal element for Bearden. Not only the absence of structure but the absence of a larger philosophy, in his view, was missing from the work of his peers. The romanticism of Pollock or Baziotes, in Bearden's estimation, had little to do with the great philosophical ideas, for example, of French romanticism, manifest in the paintings of an artist like Delacroix. In his letter he rhetorically asks Holty "what point their work has and to what end does it drive," and damns them by labeling them "specialists," their work constricted and self-referential.[2]

Stylistic or philosophical differences Bearden could accept. What distressed him more was his gradual erasure from the New York art world. For years, this world had been silent about his exhibitions and critical presence in the years between 1945 and 1948 (as it would be for other

artists who did not fit the Abstract Expressionist mold). Even Samuel Kootz, when interviewed years later for the Archives of American Art, lists all of the artists who exhibited in his gallery during the 1940s— except Romare Bearden.[3] Histories of the period have since put his name back into the gallery's 1940s narrative, but the sense of loss and invisibility lingered.

Evidence of the divide between Bearden and his former Kootz peers was especially apparent in his participation in the Metropolitan Museum of Art's exhibition, *American Art Today*. Almost as soon as the Met announced plans for the exhibition in January 1950, the show became controversial. A juried exhibition, the show evoked instant criticism over the conservative makeup of the regional and national juries. In a closed-door session of "Studio 35," Adolph Gottlieb, Robert Motherwell, William Baziotes, Hans Hofmann, and artists from other leading avant-garde galleries convened and decided to boycott the exhibition. They directed an open letter of protest to the museum's leadership, published in the *New York Times*. The frontpage headline read "18 Painters Boycott Metropolitan; Charge 'Hostility to Advanced Art.'"[4] The letter charged that the museum's director, Francis Henry Taylor, had "on more than one occasion publicly declared his contempt for modern painting," and that associate curator Robert Beverly Hale had assembled a jury "notoriously hostile to advanced art." Bearden's signature was not on the letter; quite the contrary. His 1949 painting, *Woman with an Oracle*, was exhibited in the lambasted show.

Bearden's fall from grace in the art world and the rise of Abstract Expressionism took place at a time when the popularity of mass media was on the rise. Ironically, despite the fact that the media was so openly disdained by the protesting artists, the press was instrumental in the rising fame of the American vanguard. A prime example is the November 1950 photograph that Nina Leem took of a group of fifteen of the eighteen protesting artists. The photo was published in the January 15, 1951, issue of *Life* magazine with a caption that read: "Irascible Group of Abstract Artists Led Fight against Show." The photograph has since become a milestone document in the history of American modernism. Spurned or not,

mass media was capable of capturing and communicating dramatic visual images and played a leading role in the public perception of contemporary art. Art and the media would remain ineluctably bound to one another in a symbiotic relationship that artists, whatever their feelings about the press, could not afford to ignore. Bearden's invisibility for much of the 1950s, extended not only to the art world, but to mass media as well.

Bearden's disappearance from the art scene came at a time of heightened visibility for the so-called advanced artists. Two years before the group portrait, Jackson Pollock had enjoyed a multi-page photographic spread in *Life* magazine of the artist at work. Photographs of his canvas covering the floor, his whole body engaged as he dripped and poured paint, focused on the drama of the artist's heroic confrontation with his canvas in the process of painting. *Life*, as well as *Look*, were large-format picture magazines and, along with the weekly news magazines *Time* and *Newsweek*, were bellwethers during the 1940s, 1950s, and into the 1960s. They covered presidential campaigns, major national and international events, and important figures in politics, sports, and entertainment, and they identified major cultural trends.[5]

Bearden had come of age as an artist when social justice publications like *Crisis* and *Opportunity* or artist-run journals were the major vehicle for the arts. During the postwar era, Americans increasingly received their news from picture magazines and news weeklies. A bachelor, who lived with his father, Bearden probably did not pay attention to the popular fashion magazines like *Harper's Bazaar* and *Vogue*. They took their place along with the cinema as purveyors of ideals of beauty, fashion, and style, linking art to fashion in an alliance that continues to this day. Women's magazines, another influential category of the popular press, heralded the ideal American lifestyle. Circulations for some of these magazines rose to the tens of millions at the height of their popularity as they became the visual text for a soaring postwar American prosperity. Their visual images presumed national values, common civic beliefs, and national identity. Until television's broadcast images challenged them mid-decade, the visual images of the 1950s periodicals wielded

power and influence. When Bearden did begin to cut and clip images in the 1960s, there is ample evidence that these are some of the periodicals he scavenged.[6]

The magazines *Ebony* and *Jet* were a future source of images for Bearden as well. Resolutely upbeat and considerably less politically assertive than either *Crisis* or *Opportunity* (certainly not as radical as the left-leaning *Messenger*), neither *Ebony* nor *Jet* shied away from some of the most dramatic events of the budding civil rights movement.[7] In format and size, designed to look like *Life* and *Look*, *Ebony* was a photojournalistic publication devoted to black cultural, entertainment, sports, social, and political issues. *Jet* was its pocket-sized companion. Founded by Chicago's John Johnson, both magazines employed a talented corps of photographers who captured some of the most dramatic images of the civil rights movement that unfolded during the 1950s and 1960s. Black periodicals created an encyclopedic visual narrative of monumental events—Thurgood Marshall's 1954 *Brown v. Board of Education* Supreme Court victory, Rosa Parks's defiance, the Montgomery bus boycott, *Jet* magazine's publication of a photo of Emmett Till in his casket, the 1957 desegregation of schools in Little Rock, Arkansas. Television, too, exponentially amplified the dramatic impact of this new civic narrative.

At the end of the 1940s, Bearden was not ready to see the meaning of the proliferation of media images. Concentrating on painting, he was still on a "voyage of discovery," as he would later explain to writer Harry Henderson.[8] His fierce opinions about the nature of art, expressed in his letters to Holty, however, masked his ambivalence about how to realize those opinions in his painting. Unmoored from the Kootz Gallery, Bearden, in the eyes of some of his friends, had embarked on this voyage with no destination in sight. In the period after he left Kootz, there were two people he relied on more than others. One was the German-born American painter Carl Holty, whose friendship was nurtured in their over two decades of correspondence. Their voluminous exchange culminated in the creative collaboration of a co-authored book, the 1967, *The Painter's Mind*.[9] Holty's rigorous discussions of formal elements in Bearden's painting as well as his own canvases and

of painting in general kept Bearden intensely focused on the art of painting, even as other distractions constantly competed for his attention.

The second and even more essential presence was Nanette Rohan, his future wife. A few years after his sojourn to Paris, they met and, after a short courtship, married. She created the conditions for his return to his life's work and, years after they married, introduced him to what would be an unexpected and, for his artistic imagination, fertile paradise, the island of St. Martin.

Bearden and Holty began their correspondence after Kootz temporarily closed his gallery in 1948 and Holty left New York to teach at the University of Georgia.[10] Ten years Bearden's senior, Holty deeply impressed Bearden, as is evident from a 1947 diary entry:[11]

> How much I owe him for any progress I have made with painting. He has really taught me what I know of the formal elements and has done this with such a patient and generous spirit. Carl is a fine man full of the joy of giving. This is an evangelical spirit that delights in the confraternity of his fellow men. He has inspired me to a real appetite and love for the art of painting. One of my reasons for keeping a journal has been to note certain ideas and thoughts for whose inspiration I am so much indebted to him. The pity is that few people will understand him, for few people cherish the generous nature.[12]

Holty had studied with Hans Hofmann in Europe and, an early proponent of abstract art when he came to New York in the 1930s, had been one of the founders of the American Abstract Artists with Stuart Davis. Letters between Holty and Bearden disclose their close friendship. Bearden, who was dating a woman named Jean—possibly an art student and a model—often socialized with Holty and his wife Elizabeth, and the two artists visited each other regularly in their studios. Holty was generous in connecting Bearden to members of the art world. He introduced him to the Spanish artist Joan Miró, who in 1947 was working in Holty's studio on a mural for a hotel in Cincinnati, Ohio.[13] And when Bearden did decide to travel to Paris, his

mentor provided letters of introduction to artists whom he knew from his studies abroad.

Holty had been severely disadvantaged financially when he, along with Bearden and Byron Browne, was expelled from the Kootz Gallery. As he had received a monthly stipend from the dealer in return for an annual quota of paintings, Holty was financially dependent on Kootz. After Holty's exclusion, Kootz was left with a surplus of paintings by Holty and Browne. The dealer hosted a champagne reception to sell the excess work, and when that effort failed, he put their paintings up for sale at bargain basement prices in Gimbel Brothers' department store. An ad in the November 4, 1951, Sunday *New York Times* announced that they would be sold at a price reduction of 50 percent.[14] In one fell swoop, the dealer—intentionally or not—devalued their paintings and their reputations. Browne never recuperated from the insult and suffered a serious heart attack. Holty, by contrast, with his tough, resilient ego, proved himself skillful at reinventing an artistic life.[15] He made a living giving lectures and accepting appointments at various American colleges and universities, leaving himself time to paint, exhibit, and write long letters to his friend about the fundamentals of painting. His advice to Bearden was often bracing and tough-minded.[16]

After making fun of their past colleagues at the Kootz gallery, Holty counseled the young artist to distract himself with travel. "But you do <u>need</u> [underline his] company good company and at least some of it should be from among the quick, so don't forget your plans to go abroad—where for a while good company will congregate again along with a legion of the world's bullshitters just to make it a game (telling one from the other)."[17]

Bearden, in turn, relied on Holty as a sounding board and confidante. He discussed with him the conflicting impulses that plagued him and weighed on his painting. One problem for Bearden was his social isolation. He was at odds with certain members of his community. In a letter to Holty, written in his beautifully scripted handwriting and composed over several days, he complained of a social encounter with an old friend, someone who owned one of his early paintings, a scene of black share-croppers. For his friend, his early, pre-war painting had "feeling" and

"meaning." She chastised him for his current abstractions, which for her were "repetitious…and cold." Bearden had not only been severed from the Kootz Gallery but also from at least part of the community of which he had once been a part and which he had helped shape—akin, in his words, to "having been torn from one's circumscribed orbit, to fly tangentily [*sic*] off on the precipitous flight through time and space." He goes on to write that "I feel this might be my fate, and yours and a few others like us for some time."[18]

Staying true to his art yet engaging a community posed itself as an acute dilemma for Bearden. In the same letter to Holty he cites the Elizabethan era as a model for the way in which poets and writers could construct work grounded in the popular imagination. He wrote Holty that he had recently come across a book of Elizabethan poetry, "a collection of poems taken from broadsides of Shakespeare's day that were sold much as the tabloid of this day to tell of murders, and other such notorious events." He found it fascinating. "The similitude of the broadsides to our tabloids, however, was only one of intent, because the old ballads were clear, full of vivid imaginative language, and in some cases the poetry was of the first order."

A common set of expectations for language linked artist and audience, as Bearden notes, "the Elizabethan dramatists had strong roots and deep, from which to draw water to the top branches of their creative efforts. Conversely, the average Elizabethan had some basis, some particular level where he could appreciate a Webster, a Johnson [*sic*], a Marlowe."[19]

By contrast, contemporary artists are "specialists," he writes, each one speaking in his or her own individual language which, for Bearden, impoverishes the art. The needs of the individual artist's painting versus a collective, a community's needs and expectations were at odds, a conflict that needed reconciliation, in Bearden's mind, if art were to be healthy.

Abstraction versus nature presented another set of conflicting impulses that challenged Bearden during this period. His letters to Holty are penetrating analyses of the formal challenges of painting, the push and pull of color, the problem of determining the entry

point into a picture, the challenge of controlling pictorial space. With his intricate and involved method of photostatically copying one painting after another, Bearden created an encyclopedic, mental warehouse that would resurface in his mature collages. As committed as Bearden was to understanding more deeply the enduring structure that all good paintings share, he was also avidly interested in the external world. "I have begun to draw from nature now and I find I can do it much easier than it was previously possible. In fact, I believe it will be a continuing necessity for me, for the set patterns of nature offers a jumping out point for re-invention"[20]

Of all of the advice Holty offered Bearden, none was taken to heart more earnestly than his advice to go to Paris. Though brief—five months in all—the time Bearden spent in Paris was intense and created not only a deep reservoir of vivid memories but a number of lasting relationships with artists he met during his visit. Paris was the celebratory leg of his "voyage of discovery," a station stop, where he could play and let his imagination and natural good humor unfurl. He swathed himself in the spirit of a city that exuded a love of art and artists. He met members of the colony of black writers living in Paris during the 1950s— Richard Wright, Sam Allen, James Baldwin, Albert Murray. His time with them, as he reflected years later, opened new portals into the possibilities of a black tradition. Most important, for an artist caught up in his day-to-day life in New York, the entanglements of his job, and the frustrations of painting, Paris was a place where there were no job obligations, no looking after his father (for whose care he had made arrangements during his five-month absence), no nagging racial dilemmas. In Paris, he was free.

Whatever frustrations and conflicts confronted Bearden in his 125th Street studio, they were not on display as he posed for photographs before the launch of the S.S. *America* at the end of February 1950.[21] Photographer Morgan Smith's photography studio, which he owned along with twin brother, Marvin, was next door to Bearden's 125th Street studio. Smith captured a photograph of the three handsome black men about to embark on an adventure abroad: twin Marvin, who intended to study painting with Léger in Paris; the low-keyed poet Myron O'Higgins,

who planned to attend Yale when he returned from a writing retreat in Paris; and Romare Bearden.[22] To manage his trip abroad, Bearden took a leave of absence from work.[23]

He intended to support an extended stay in Paris by applying for a Fulbright Fellowship, and submitted an application in the fall of 1949 for the following year. In the meantime, he applied to a graduate degree program at the Sorbonne, qualifying him for support—as a veteran—from the GI Bill. His proposal for a *doctorat* was ambitious: structure in painting as it appears in different historical times in painting, a subject he had raised in his letters to Holty, was his topic. He planned to examine structure both as a reflection of a historical epoch and of a manifestation of an artist's individual expression. Though he received his acceptance letter to L'Institut d'Archeologie at the Sorbonne April 22, the acceptance of his thesis topic came a month later with the advice to simplify his topic dramatically. Given Bearden's ambitious degree plans, any time he may have expected to spend painting would have had to compete with his studies.

A transcript issued a year later indicates that he started the term on March 1, 1950, and satisfactorily completed his studies for that term on June 30, 1950. His lecturer was Gaston Bachelard, a phenomenologist, whose seminal work *La Poétique de l'Espace* would be published in 1958. Bachelard investigated the poetics of intimate lived spaces—cellars, attics, kitchens, baths—that protect daydreams and the dreamer alike. Given Bearden's accounts of his time in Paris, it's doubtful that he heard too many of Bachelard's lectures. To Holty he observed that he felt he had the freedom to come and go to class as he pleased. Nonetheless, Bachelard's observation, "When images are new, the world is new," was not lost on him.[24]

Shortly after Bearden arrived, he found a living space at #5 Rue Fuelliantines, where for the sum of $37.50 a month ($40 if heat were included) he lived in a beautiful skylit studio. An elegant white limestone structure on a short stretch of a quiet street, the building was located in the Latin Quarter in the Fifth Arrondissement, the heart of the intellectual and artistic center of postwar Paris. He drew inspiration from the fact that according to a plaque on the wall, Victor Hugo

Romare Bearden (standing) with a group of friends in Paris, France, 1950. © Morgan & Marvin Smith. Photographs and Prints Division, Schomburg Center for Research in Black Culture, The New York Public Library, Astor, Lenox and Tilden Foundations.

once lived across the street. He settled in and learned the ropes quickly. When he was not in class, his days were spent at cafés with other writers and artists or looking at masterpieces in Parisian museums or going to visit master artists. Nights were filled with clubs and parties. Even the American Embassy, where he picked up his weekly check, was a party. As Bearden recalled, you never wanted to miss going to the Embassy for your check. There was always a party, and if you knew someone, he might supply you with whiskey—$10.50 got you five to seven bottles. He painted very little, yet he fell hopelessly in love with Paris.

When he arrived in Paris, armed with letters of introduction, Bearden was intent on paying homage in person to some of European modernism's masters. His stay in Paris included visits to Pablo Picasso, Fernand Léger, Jean Helion, and the Romanian sculptor Constantin Brancusi whom he would accompany to the market and with whom he would share meals. He paid homage, too, to Henry Tanner, the black painter

who exiled himself to Paris and, having enjoyed modest success, died there in 1937. A map that Bearden drew of the city shows Tanner's studio and his home near the Luxembourg Gardens.[25]

Bearden's letters to Holty during his stay in Paris portray an artist who cannot consume enough of the monuments, museums, and exhibitions of Paris. He joyfully described his eagerness to visit "the Louvre, the Cluny, the Museum of Oriental Art, the Bibliothèque National with Rembrandt Drawings, the Museum of Man (with African sculpture)."[26] Even as he acknowledged French indifference toward Americans, the limitations imposed by his less-than-fluent French, and his realization that Paris—postwar—was not the "gay" city he had imagined, he reveled in the attractions of the French capital.[27] He made ample use of his time to explore other regions. An invitation to travel from friends he had met on the ship took him to the Côte d'Azur where, as he wrote to Holty, he could come back to live.[28]

A trip to Italy took him from Paris–Marseilles, Toulous, Riviera, Genoa, Milan, Florence, Pisa, Siena, Orvieto–Rome and back via Rome, Arezzo, Livorgno, Genoa, Turin, Modane, Dijon, Paris. All of it, he reported, cost him the equivalent of $22.00. His letters recount as well the staggering visual riches of Italy: Michelangelo, Masaccio, Giotto, Fra Angelico, Duccio, Leonardo, and Signorelli are among the artists he names.

What struck Bearden most about Italy was its dissonance. Time periods, styles, approaches to art, philosophies collided incongruously. Jammed together, past and present were insouciantly juxtaposed. Standing in the main square of Siena, for example, a town that had retained a medieval feel, he "heard a sound of drums and out of a courtyard came a procession of young boys with medieval costumes of bright checked yellow and blue. There were drummers, and others, carrying flags. It was early in the day and for a moment I was transported back to the middle ages." In the afternoon, "however, one of the cafés on the square had a jazz orchestra that played real American jazz pieces in the organ grinder whirling styles that the Italians seem to love."[29] In another instance, he described to Holty how moved he was by the artwork he viewed in a museum, only to come outside to see stalls with corn plasters for sale. Paying homage to great artists and great monuments was

as much a part of Bearden's formal education as any of the few classes he may have attended at the Sorbonne.

For all of his respectful tributes to masters and monuments, Bearden's most telling observation was that "life was lived in the streets." Like the days of the Dawn Patrol in Harlem during the Depression, Bearden spent hours on the streets of Paris. By day, when he wasn't visiting monuments or attending class, he visited the cafés—Café Mabillon on Saint Germain des Prés, where, Baldwin recalled, "the dregs of Paris gathered. But they were very beautiful dregs, you know." There was also Café de Flore and Les Deux Magots, two of the most popular haunts of the Parisian avant-garde. Sartre had written of Parisian cafés in general, in *L'Etre et le Néant* (Being and Nothingness), "the café by itself with its patrons, its tables, its books, its mirror, its light, its smokey atmosphere, and the sounds of voices, rattling saucers, and the footsteps which fill it—the café is a fullness of being."[30] After a period of drought, here was Bearden's fullness of being.

Over two decades later, in conversation with Bearden, Albert Murray, and the dancer/choreographer Alvin Ailey, Baldwin spoke of the discoveries they all made in Paris during the 1950s, which included having to go far away to "come full circle." Baldwin in particular recalled that it was in Paris where he could hear the rhythms and cadences of Ellington and Bessie Smith in a new context, that he could "redeem" his own traditions and understand their value.

Redeeming tradition was a process that occurred over and over in Paris for Bearden and his artist friends. Murray, whom Bearden first met in Paris, recalled how he first discovered Bearden was a black man. One day as Murray sat at a café, he watched Bearden, who bore a striking resemblance to the playwright Jean Genet. Myron O'Higgins, who was sitting with Bearden, told a joke and, as Murray tells it, "all of a sudden Romie broke out laughing. He was laughing and started sucking his breath in through his teeth with tongue in his teeth you know...and I said, 'Oh that guy's from Harlem.'"[31] Another afternoon, Baldwin invited twenty or thirty people, Bearden among them, to come to lunch in his apartment. Baldwin was cooking for his friends that afternoon, using a frying pan to cook potatoes that was in Bearden's recollection

big enough to hold a person. As Baldwin read from his novel in process (what would become *Go Tell It on the Mountain*), Bearden listened to the rhythms of Baldwin's language, the cadences of black sermons that made Baldwin—northern-born—more southern than any of them.

One night while walking down the street, Bearden heard jazz and recognized right away that the musicians were not French. When he inquired, he discovered they were trumpeter Roy Eldridge and clarinetist Sidney Bechet, accompanied by vocalist Mina Cato, the wife of Andy Razaf. Their style, idiom, and mastery were immediately recognizable. He invited the musicians to a party, and when the police came because they were making too much noise, they took the party into the streets. Paris was Chez Inez—named after black vocalist Inez Cavanaugh—or Honey's, the painter Herb Gentry's club. Paris was, in the words of Baldwin, "partying and discovering," part of the value of being there. What Bearden discovered all over Paris were his own traditions, styles, rhythms, and gestures that at home failed to catch his attention. At home those traditions were like mute actors who, like so many expendable extras, moved about silently in somebody else's production. In Paris, those same traditions had all assumed speaking roles and, in some instances, were the featured attraction.[32] Paris was intoxicating, quite literally. One night, mistaking hash for Gauloise cigarettes, Bearden walked along the Seine, the moonlight illuminating Notre Dame cathedral, and he imagined he saw an angel walking on water. He was high on Paris, on the romance of a place where he believed race did not pose the obstacles, dilemmas, and contradictions that it did in the United States.

But postwar France, like much of Europe, was contending with its own racial conflicts. French colonies that once yielded artistically inspiring artifacts were now insisting on cultural and political independence. Before World War II, a critical mass of students and scholars had arrived in Paris from French colonies in North and West Africa and the Caribbean. Black artists from America had preceded them in the early years of the twentieth century, bringing a New Negro creative confidence.[33] Collaborations among black performers and musicians and leading French artists had been a source of innovation and experimentation.[34]

Inspired in part by the New Negro movement, France's new immigrants started publications such as *La Revue du Monde Noir* (1931–1932) and *L'Étudiant Noir*. Martinique-born Aimé Césaire popularized the term *Négritude*, which he first used in a 1935 issue of *L'Étudiant Noir*. The term caught on and was embraced by, among others, Leopold Senghor, the future president of Senegal, and Léon Damas, a French Guyanese poet. Opposition to French colonialism and a validation of non-Western black cultures would grow in the ensuing years.

Bearden had arrived in a country that was in the midst of fighting a bitter war in what had been French Indo-China, and which the United States would inherit over a decade later. Elsewhere in its empire, France had crushed an Algerian uprising on Algerian soil but not the revolution that would eventually come back to haunt Paris by the end of the 1950s. Great Britain was already experiencing the fracture of its empire, having lost the jewel in its crown, India, in 1947. Waves of general strikes in the 1950s in Kenya, South Africa, and Ghana and a more belligerent rhetoric of self-determination were laying the groundwork for insurgencies on several continents, including back in the United States. Other than making note in a letter to Barrie Stavis of student discontent, Bearden had little to say about politics. He noted only that the normally left-leaning students wanted De Gaulle to return to bring stability to France.[35] If he had any inkling that racial self-consciousness would become a movement with global consequence, he did not discuss it in his letters either to Stavis or to Holty.

Many decades after Bearden returned from Paris, the sculptor Melvin Edwards and his wife, the late poet Jayne Cortez, hosted the poet Léon Damas in their home. They invited Bearden to join them. Edwards and Cortez remembered the two artists spending almost the entire evening together in deep conversation, Bearden was thoroughly knowledgeable about Damas's poetry and the philosophy of Negritude. Additionally, in the last decade of his life, when he had built a home on the island of St. Martin in what is still a colony owned half by the French and half by the Dutch, Bearden would host Aimé Césaire at the restaurant of "Ma Chance," one of his favorites. Still, Bearden's time in Paris during the 1950s had had little to do with politics or percolating social movements.

If Paris was a party for Bearden, New York was the sober morning after. When he returned to the city, he received disappointing news: his application for the Fulbright was rejected. He was an alternate and therefore not able to return to Paris as he had planned. He quickly wrote a pleading letter to Howard Backus, the head of the program, to make a case for himself. Its contents provide a glimpse into Bearden's growing desperation. Age had begun to stalk him. Fearful that he had been rejected because he was approaching forty, he made the case that because of the war, France had been out of reach during his prime years, when he would have preferred to go abroad. He added that in France forty-five is young for a developing artist, and he was several years younger than that. To prove his seriousness, he pointed out that he was the sole breadwinner after the war and had to care for his sick father; nonetheless, he proudly pointed out, he produced a first-rate body of paintings, acclaimed in the United States and abroad. He also wrote that even during his most recent trip, he exhibited at the Delavoy Gallery in Paris. Bearden's pleas fell on deaf ears. Backus promptly wrote him back, stating that there were more qualified applicants than there were spots available. Though he assured Bearden that he was an alternate, he cautioned that the likelihood of his actually winning a spot was slight.

Bearden's desire to return to Paris became an end unto itself. Time he once spent on painting, he now spent on plotting his return. His single-minded devotion to return to Paris was understandable; the United States had grown aggressively inhospitable to artists and intellectuals. Several branches of US government etched the battle lines into law and public policy, and artists crossed those lines at their own peril. The logic was dizzying: left-wing protest against the status quo—whether civil rights or nuclear policy—was anti-American and, by definition, pro-communist. To be pro-communist was to be treasonous. The country's turn to the right was evident soon after the end of World War II, when President Truman's 1947 executive order 9835 called for the investigation of "disloyal persons" in the United States government. In the Senate, Senator Joseph McCarthy raised accusations of communist infiltration in government and even in the military, his charges riveting the nation's attention in televised hearings. Though television would also contribute

to McCarthy's downfall, in the years in which his interrogations and accusations held sway, they fueled an environment of fear. In Congress, the House Un-American Activities Committee continued its work of rooting out communists, begun before the war, by conducting its infamous public hearings. Film actors and writers who were called to testify pointed fingers at their colleagues. Consequences were enervating: some left the country; others went to jail; others had their names removed from film credits. Hollywood executives, fearing government retribution, blacklisted a host of creative professionals, prohibiting them from working in any capacity in the film industry.

The Department of Justice weighed in with a list of organizations that in their view might be "totalitarian, fascist, communist, or subversive...or is seeking to alter the form of government of the United States by unconstitutional means."[36] Along with the Ku Klux Klan and the Communist Party, the Harlem-based Committee for the Negro in the Arts was also included. A. Philip Randolph, W. E. B. Du Bois, and Paul Robeson were all under suspicion—all had been guests in Bessye's home in Harlem. Bearden himself does not appear to have been suspected of un-American activity even though at least one group of cartoons from 1934 to 1937 had openly championed a Communist Party organizer, Angelo Herndon. Herndon, who worked in Atlanta, advocated rent relief and, accused of inciting insurrection, received five years in prison. Bearden's cartoons had also agitated for a fair trial for the Scottsboro Boys, the nine teenagers wrongly accused of rape who had been nearly lynched. Walter Quirt had been an illustrator for the *New Masses* and a member of the Communist Party, as had Stuart Davis, an outspoken supporter of the Popular Front, president of the Artist's Union, and editor of *Art Front*. After the war, Bearden's only form of activism was going to work every day and earning the money that might get him back to Paris.

In various written accounts, interviews, and reminiscences, Bearden's five-month stay in Paris incorrectly swells to a year, eighteen months, and even, in some accounts, as much as two years.[37] His efforts to return were unrelenting. Bearden was certain that he had a talent for songwriting and decided that it would be his ticket back. His plan was to

write a hit song—not unlike his earlier plan to draw a syndicated cartoon that could finance him as an artist—so that the royalties would support a return and extended stay. His first effort at writing lyrics in 1951 started with the Bluebird Music Company, which he co-founded with Frank Ellis and which failed to produce anything. His second effort, this time with Fred Norman and Laertes "Larry" Douglas enjoyed modest success. Together the team published twenty songs for the Laertes Publishing Company. Of the songs he wrote, the most famous far and away was "Seabreeze," a ballad performed by the black balladeer Billy Eckstine. A handsome, smooth-toned baritone, Eckstine, along with Nat King Cole, was the epitome of 1950s cool. Seagrams' distillers popularized "Seabreeze" by using it in their advertisements to promote a drink by the same name. Leslie Uggams, then a child star, also sang some Bearden lyrics.

Writing lyrics has almost always been described as a distraction and a diversion for Bearden. That was certainly the strong opinion of philosophers and political theorists Hannah Arendt and Heinrich Blücher, who lived next to Howard Bearden's apartment on Morningside Drive. Blücher warned Bearden that he was throwing his life away with songwriting and that if he did not get back to painting, Bearden would dissipate his creative energy. But Bearden's attraction to words was almost as strong as his attraction to visual images. He wrote nonstop: journals, poems, letters, radio plays, stage plays, essays, photojournalist projects. Writing lyrics involved evoking feeling, mood, time, and place, and this appealed to him. Moreover, he had great respect for successful lyricists, some of whom he knew well. Andy Razaf, for example, collaborator with Fats Waller, had been a visitor in Bearden's home. Razaf's songs, including "Ain't Misbehavin'," "Honeysuckle Rose," "Stompin' at the Savoy," and "Black and Blue," were already part of the American mainstream, and Razaf had enjoyed great success in Europe.

Turner Layton was another lyricist and friend of the Bearden family who had won international acclaim. Layton and his partner Henry Creamer wrote "After You've Gone," popularized by Sophie Tucker. Layton's success extended to several Broadway musicals and to a career as a lyricist, composer, and performer in London for many years. Looking

at the examples of Razaf and Layton, Bearden believed that his Paris ambitions were within reason.[38]

Money from songwriting was supposed to go toward fulfilling Bearden's Parisian dreams. But his job as a caseworker was his livelihood and, despite his songwriting avocation, his vocation was serious. After Paris, Bearden was assigned a new caseworker partner, the black playwright Loften Mitchell. Mitchell, like Bearden, was an artist who relied on his job to make ends meet. The two were assigned to what they called then Gypsies, the Romani people nearly invisible to most New Yorkers but who in the 1950s maintained a colony in Brooklyn. Having Mitchell as his partner was propitious. Both men had grown up in 1920s Harlem. Both shared memories of 10-cent movies and Harlem's great theaters. Mitchell was enraptured by the Lafayette, the Lincoln and the Alhambra theaters with their vaudeville sketches, dramatic sketches, and all-black musical revues, as was Bearden, whose mother had, of course, once been a ticket taker at the Lafayette and a frequent host of famous theater artists. It is not surprising that the two hit it off. Nourished first by Harlem's theatrical world and the poems of Langston Hughes, Countee Cullen, Arna Bontemps, and Paul Laurence Dunbar, Mitchell revived an old dilemma in Bearden: that of racial politics. The playwright was vocal in his resentment of misrepresentations of black life in dramatic literature and was determined to write plays that portrayed people as he knew them.[39]

Together, Bearden and his new partner set out to get to know New York's Romani population. Their day began at the welfare offices, improbably located on the chic East 67th Street near Park Avenue. The ground floor was usually congested with clients or prospective clients, while on the second floor, about 100 caseworkers sat at their cubicles, jammed one against the other. By 11 A.M., the caseworkers left their offices to travel to their assignments in the field.[40] For Bearden and Mitchell, this meant traveling to Brooklyn and in Bearden's words "to all Gypsy weddings, trials, and funerals," all of the rituals that made up the culture within a culture, invisible to mainstream New York but a universe unto itself. Bearden made the Romani an object of study, learning their traditions and rituals and even strategies: the families who lent each other their children in order to

qualify for more welfare funds, trials where an elder presided, the men who were metalworkers, the women who told fortunes, the carnival, their unwritten language—all became his domain. Bearden was joined by Leonard Lutzker, who wrote an extensive research paper on the Romani—their rites involving birth, marriage, death; their systems of policing; their criminal and civil justice systems; their economy; and language. Bearden felt as if he were witness to a way of life that was dying.

Outside of work, Bearden continued to play host to artists and visitors, and as his songwriting career staggered along, musicians and composers visited his studio over the Apollo. Though not the media darling that the Abstract Expressionists had become, he was nonetheless something of a local attraction. His genial personality made his studio a favorite gathering place and he was a popular presence at local lectures.[41]

Joan Sandler, who would become a respected New York City arts administrator, remembers responding to ads Bearden posted in the newspapers. After graduating from New York's High School of Music and Art, she volunteered to model at several of those sessions. She and her friend, playwright Lorraine Hansberry, were both active in a variety of political causes—Hansberry worked at Paul Robeson's *Freedom* newspaper. Together they would go to the village dressed in black and wearing berets, considering themselves part of the Bohemian artist scene. Modeling for a famous Harlem artist fit the Bohemian spirit. The signed sketches Bearden drew of Sandler, reminiscent of Matisse, hung for many years on her living room wall.[42]

Bearden's studio was also a popular subject for photographers, and photographs by Sam Shaw and Marvin Smith document the studio milieu—artists working as a group from the model or Bearden drawing from the model on his own. A haunting 1951 photograph by Roy DeCarava shows Bearden with his back to the photographer, standing in silhouette in front of an easel. No one else is in the photo—no other artists, no model—just the artist alone facing his blank canvas. Bearden's body seems dark and flat, like a piece of cut paper against the white of the easel. Of all of the photographers who visited Bearden, DeCarava best captured an image of the artist as he truly was: isolated and vulnerable.

Bearden's sketch of Joan Sandler, ca. 1950; 10 x 6 in.; courtesy
of JoAnn K. Chase.

During the 1950s, Bearden met the woman who would change the course of his life. Nanette Rohan had built a career and a public presence long before she met Bearden. In the late 1940s she was a model with the prestigious Grace De Marco modeling agency, the brainchild of Ophelia DeVore. For DeVore, her modeling agency was as much a social uplift program as a business. She fervently believed that the images she staged would change the representation and perception of black women. She viewed her modeling agency as leading a campaign against the distortions of images of black women. Photographs of Nanette appeared in ads on the social pages of *New York Age*, and she made appearances in television commercials and print ads. Though not a dancer herself (her sister Sheila Rohan was), she would go on to found her own dance company. An early photograph of her shows a slender, dark-haired woman with an easy smile and dark eyes. She was twenty-nine when she met a forty-two-year-old Bearden in 1953 at a fundraiser for victims of a hurricane in the West Indies. He was immediately smitten.[43]

Nanette, the second oldest of eight girls, was born January 20, 1924, in Staten Island, New York, to a close-knit working-class family. Both of her parents had emigrated from the island of French St. Martin, where most of their large families still lived. After meeting, she and Bearden dated for about a year and married in September 1954, a marriage that was featured in the social pages of the black press. After their wedding, Nanette moved from her home with her large family into the apartment on Morningside Drive where Bearden lived with his father. His marriage to Nanette brought an immediate boost to his career, when his wife introduced her new husband to Laura Barone, a former model who had opened an art gallery. A year after the wedding, Bearden had produced enough paintings for a solo exhibition at the Barone Gallery, his first New York exhibition since he left Kootz.[44]

Nanette described this period of their life together as "hectic, frantic years."[45] Bearden was juggling a new marriage, his social worker job, his father's health, and preparation for his first solo painting exhibition. He was also still working at songwriting, buoyed by the success of "Seabreeze." Nanette recalls that his Harlem studio in those days was "a magnet for songwriters and musicians" full of "strange characters."

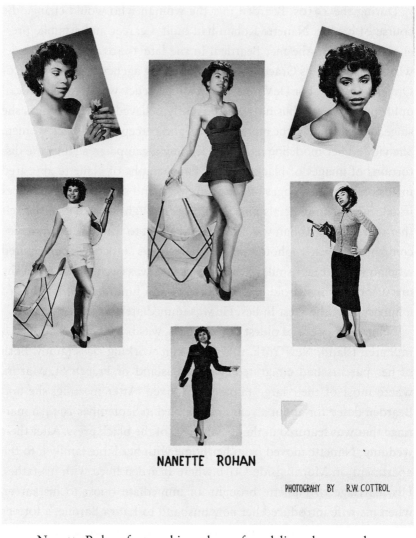

NANETTE ROHAN

PHOTOGRAHY BY R.W. COTTROL

Nanette Rohan featured in a sheet of modeling photographs.
Photography by R. W. Cottrol. Romare Bearden Foundation
Archives, New York.

Eventually it all caught up with him and sometime in the mid-1950s, he suffered a nervous breakdown.[46] Bearden's solo exhibition had forced him to consider what creative identity—lyricist or painter—he wanted for himself. His doctors suggested to Nanette that in order to recover his health, her husband needed to return to painting.[47] Years

later, reminiscing with Murray, Ailey, and Baldwin, Bearden recalled that he "blew a fuse."[48]

Bearden was hospitalized at Bellevue Hospital and although records from his hospital stay are not available, he and Nanette both have recounted details of his time there.[49] After his discharge from the hospital, Nanette made several fateful decisions. She moved his studio out of the Apollo Theater, away from the world of musicians and composers, so that he could concentrate on his art. Chinatown, at the opposite end of Manhattan, became their new home.[50] They exchanged a view of the rolling hills of Morningside Park for the noisy commercial clutter of Canal Street. Five stories above plumbing outlets, hardware shops, and street vendors, Nanette nursed her new husband back to health. She coaxed him away from smoking and, at one point, fearing his dependence on sedatives—Miltowns they were called—flushed the drugs down the toilet. Under her watchful eye, Bearden returned to painting on a regular basis, restoring to his life the discipline he had displayed earlier in his career. Nanette's presence was providential in another way as well. She reintroduced a sense of domestic peace, and, with her many siblings, a sense of family and home that had been so much a part of his childhood. Nanette brought a new ethos into his life as well. She often made her own clothes. Fabrics and patterns filled the Canal Street loft along with her magazines—*Vogue, Ladies Home Journal, Harper's Bazaar*, and the popular black publications *Ebony* and *Jet*—and all became visual fodder for her recovering husband.

On March 28, 1957, shortly after Bearden had recovered from his breakdown, Loften Mitchell, Bearden's work partner, opened his new play, *A Land Beyond the River*, at the Vineyard Theater. Though Mitchell conceded that it was not his best work, the play, based on *Brown v. Board of Education*, was a hit. Clarendon, South Carolina, had been the venue for efforts on the part of its black citizens to obtain bus transportation for black children in rural schools. At the urging of Thurgood Marshall, however, the plaintiffs turned it into a case advocating equal schools. Clarendon became one of four cases that made up *Brown v. Board of Education*, and Mitchell's play depicts the conflict in Clarendon. He invited his caseworker partner to see his work. Bearden

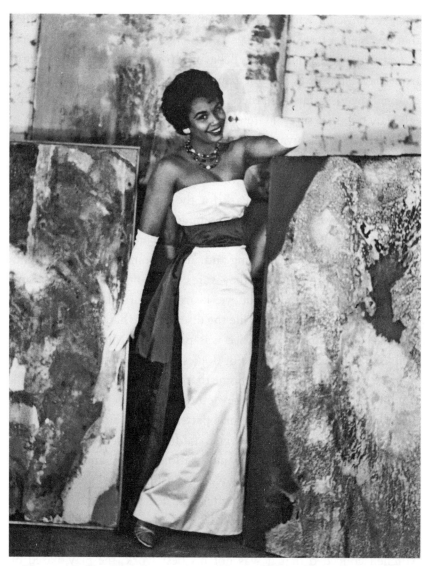

Nanette Rohan Bearden, posing with two of Bearden's abstract oils, ca. 1960/61. Nanette Bearden file, Photographs and Prints Division, Schomburg Center for Research in Black Culture at the New York Public Library, Astor, Lenox and Tilden Foundations.

was moved enough by the production to present Mitchell with a celebratory gift—a small collage, made of brown paper. There is now ample evidence that *Land Beyond the River* was not Bearden's earliest experiment in collage—there may have been collage works as early as 1952.[51] What is perhaps even more significant than the medium is the subject matter of the gift. Bearden used the collage medium to depict a scene of black life. He had re-envisioned in collage a scene he had painted in gouache in one of his pre-war social justice paintings of the early 1940s and included in his 1940 scrapbook. Mitchell's play provoked the painter's memory, opening a door to an enormous storehouse of images that in the coming years would return in a trickle and later surge in a flood, altering the course of his painting once and for all.[52]

Years would go by before more images emerged, sometimes unbidden, as Bearden would describe it. But the image he chose for his 1957 gift to his colleague was from his memory of a painting, not from life. He remembered an earlier visual construction and in years to come he would use the same methodology in constructing visual images, repeating the same composition several times over: establishing a theme and repeating it with variations—call and recall as Bearden would call it an evocation of the blues idiom—each containing a modifying detail and therefore a modification to the meaning. In choosing brown paper for the collage he made for Mitchell, Bearden removed color as a distracting formal element, something he would do later in his monochromatic *Projections*, the first public exhibition of his collages in 1964. For now, the past—past life and past art—was gathering around the periphery of his paintings, waiting as if for their cue, to enter en masse.

Loften Mitchell's play undoubtedly provoked Bearden's memory, but television in the late 1950s and early 1960s offered Bearden a menu of images as well. One that was particularly dramatic was the broadcast in 1957 of the attempted integration of public schools in Little Rock, Arkansas. When the governor of Arkansas, Orval Faubus, called up the Arkansas National Guard to block the entry of nine black students attempting to integrate Little Rock Central High School, President Eisenhower, in response, ordered the 101st Airborne Division to the city, federalized the National Guard, and ordered the troops to escort

the students to school. The episode, which stretched over several weeks in September 1957, was captured on television. The stoicism and quiet determination of the nine young men and women stood in stark contrast to the unexpurgated taunts of their protagonists—shouts of abuse, spitting, physical assaults. Little Rock signaled the beginning of an unplanned partnership between media makers and civil rights activists that briefly shifted the country's visual politics.

Bearden attended Mitchell's play at a time when a number of black artists were making breakthroughs in their art, arriving on the American cultural scene with new approaches to the representation of race. There was no Harmon Foundation, no New Negro manifesto, no public patron like the WPA to announce their arrival. Among the artists themselves, nonetheless, there was self-assurance and a sense of purpose: photographer Roy DeCarava; novelists Ralph Ellison and James Baldwin, excerpts of whose novel Bearden had listened to in Paris; dancer/choreographer Alvin Ailey; his work partner, the playwright Loften Mitchell; and a newcomer to the theatrical scene, a young woman named Lorraine Hansberry, whose work came alive in the voices of actors on the Broadway stage under the direction of the black director Lloyd Richards. This group would collectively produce sturdy American classics. All of their work was steeped in the rhythms, traditions, style, and gestures of black culture, essential to the alchemy of American culture. DeCarava and Ellison, in particular, were influential and instructive for Bearden.

DeCarava, for example, hoped to win a Guggenheim Fellowship for a photographic project he was planning in collaboration with Langston Hughes. He sought Bearden out for a recommendation. The project became the 1955 book *Sweet Flypaper of Life*. DeCarava described in the application his intent to reject any sociological statement about the Negro condition and simply bear witness. Bearden's letter of recommendation echoed this: "The photographs of Mr. DeCarava are some of the finest I have ever seen of Negro subject matter. It was my feeling that his photographs are not merely illustrative, or contrived, but have independent worth as an inquiry in certain normal predicaments of a human situation."[53] DeCarava, several years Bearden's junior, won recognition early in his career when photographers Edward Steichen and

Alfred Stieglitz included him in their epic 1952 MoMA exhibition, *The Family of Man.* When DeCarava won a Guggenheim Fellowship in 1952, he became the first black artist to do so. A student of painting at Cooper Union, DeCarava created an image of Harlem that was as formally compelling as it was deeply introspective and un-self-conscious: a table set for a meal; a girl in a dazzling white dress, walking into the shadows of a street, derelict and soiled with graffiti and debris; dancers disappearing into shadows thick as smoke at the Savoy ballroom; a father and his son caught cheek to cheek. As attentive to form, light, and color, the subtlest nuances of black, white, and shades of gray as he was to the nuances of emotion, relationships, and life rhythms, DeCarava's work embodied a formal translation for its cultural idioms.

Ralph Ellison was another black artist whose 1950s work would become canonical. Ellison often watched Bearden as he painted his abstract literary series in his 125th Street studio during the 1940s. His novel *Invisible Man,* published in 1952, won the National Book Award the next year. Its opening passage, with its famous statement of the existential condition of being black, could have been an anthem not only for Bearden but for all black artists during this undeclared renaissance of black art. Above all, Ellison's unnamed protagonist looks at the world and is able to represent what he sees. Point of view becomes the subject, as is seeing, seeing without the distorting lens of popular culture and history, an accomplishment that Ellison would recognize in Bearden over a decade later.[54]

While Bearden was coping with a breakdown, the Paris that he longed to revisit was the site of a radical redefining event. The First Congress of Negro Writers and Artists was held there in 1956. Organized by *Présence Africain: Revue Culturelle du Monde Noir,* a quarterly founded in 1947 by the Senegalese Aliounde Diop, the magazine had become a literary and political force among proponents of Pan-Africanism, Negritude, and anti-colonialism. *Présence* became a powerful global communications instrument for Pan-Africanism and anti-colonialism. Neither of its two American champions, W. E. B. Du Bois and Paul Robeson, was allowed to attend the conference. Because of political activities that the State Department found objectionable, Du Bois's passport was suspended between 1952 and 1958. Robeson had been

denied the renewal of his passport because he refused to sign an affida-
vit that disavowed membership in the Communist Party and affirmed
loyalty to the United States. Playwright Lorraine Hansberry attended
in place of Robeson, and even without two of their most prominent
champions, the Congress, held at the Sorbonne, attracted sixty dele-
gates from twenty-four countries and included representatives from
Europe, Africa, North America, and the Caribbean. Among them were
Richard Wright, Leopold Senghor, Aimé Césaire, Frantz Fanon, and
others, their efforts supported by leading French intellectuals—Jean-
Paul Sartre, Albert Camus, André Gide, and others. Picasso designed
the poster for the Congress. The ideas espoused by the First Writers
Congress were fueled by growing independent movements across the
African continent that inflamed relations between colonizers and colo-
nized. Ghana had won independence by the time of the Second Writer's
Congress held in 1959 in Rome, Algeria had brought its war of resist-
ance to the steps of Parisian police stations, and civil rights resistance
in the United States was growing more audacious and publicly visible.

Bearden remained in New York with Nanette by his side. The 1950s
had been a difficult decade for him. Expecting to find salvation in Paris,
the trip had proved to be only a brief and irretrievable interlude. His
return to New York from Paris returned him to the loss of his standing
in the art world, an unfulfilling career as a songwriter, the continuing
neediness of his father, and a mental breakdown. The intense conversa-
tions about art carried on in the correspondence between Bearden and
Holty, his city job that brought him into the life and culture of the
Romani, and his marriage to Nanette sustained him. The 1960s would
be kinder. He began the decade with a new dealer for his work, and,
with that, renewed visibility in the New York art world. His marriage
to Nanette brought him a devoted life partner. And the events of the
civil rights movement ignited the formation of a community of artists
that linked him to his past and created a pathway to the future. Bearden's
voyage of discovery would take him to a brave new world, a new terri-
tory that yielded new ways of making art, and constructing race and
reconciling the multiple inheritances that made up his identity.

PART III

THE PREVALENCE
OF RITUAL

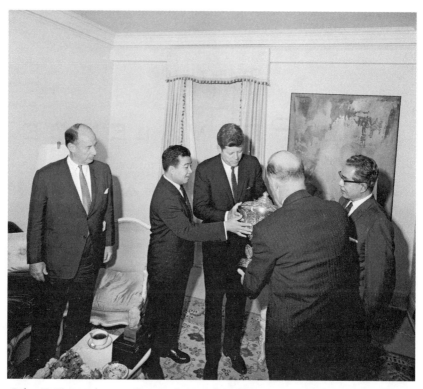

John F. Kennedy standing in front of Bearden's painting *Golden Dawn*, in the President's Suite at the Carlyle Hotel, New York City, September 25, 1961. Prince Norodom Sihanouk of Cambodia presents President Kennedy with a silver urn. (L-R) United States Ambassador to the United Nations Adlai Stevenson; Prince Sihanouk; President Kennedy; John Steeves, Deputy Assistant Secretary of State for Far Eastern Affairs (back to camera); Foreign Affairs Minister for Cambodia Nhiek Tioulong. Photo: Cecil Stoughton. White House Photographs. John F. Kennedy Presidential Library and Museum, Boston.

THE PREVALENCE OF RITUAL

PART I

Now I try to find what is in me that is common to, or touches other men—this is harder to do and to realize.[1]

—Romare Bearden, letter to Cedric Dover, ca. 1958/1959

Weeks before his inauguration, the young president-elect, John F. Kennedy, visited New York for a series of presidential briefings. His accommodations were a seven-room duplex at the luxurious Carlyle Hotel in a tower suite that offered panoramic views of Manhattan and New Jersey from the thirty-fourth and thirty-fifth floors. The interior included French Provincial and Louis XVI furniture, as well as world-class art: a Degas sketch, oils by Camille Pissarro, Bartolomé Esteban Murillo, Gilbert Stuart, and Mary Cassatt. There was only one work by a contemporary New York artist—Romare Bearden.[2] The inclusion of Bearden's *Golden Dawn,* a large nonobjective abstract oil, thanks to the efforts of Bearden's new dealer, brought the artist welcome media attention. Queried about the subject, Bearden was quoted in the *New York Times* where he pointedly described his work as a "painting without representational image." To the *Amsterdam News*, he quipped, "It's good to have a president who buys paintings rather than one who paints himself—from an artist's point of view," a reference perhaps to Kennedy's predecessor, Dwight Eisenhower, who indulged in painting watercolors.[3] Kennedy and First Lady Jacqueline Bouvier Kennedy made a point of pushing the arts into the forefront of the public agenda. From his inauguration ceremony (Robert Frost recited a poem, Marian Anderson sang) to the artists who made frequent appearances at the White House, and up to his last public speech (a meditation on the role

of the artist in a democratic culture) Kennedy signaled his high regard for art and imagination.

Civil rights was a less welcome agenda item for JFK. A visitor to the pre-inaugural suite, Roy Wilkins, executive secretary of the National Association for the Advancement of Colored People (NAACP), tried to impress on the new president the need for a grand civil rights gesture, an executive order on the scale of the Emancipation Proclamation. At the meeting, Kennedy displayed little interest in civil rights. The Cold War presented his presidency with urgent foreign affairs conflicts—Soviet aggression, Berlin, Cuba, Southeast Asia, the nuclear armaments race—that, in his estimation, pushed the civil rights agenda far down on his list of priorities.[4] Yet Wilkins, having spotted Bearden's painting, which he called "a great cheerful blob," considered the presence of the work a good omen.

Good omen or not, in 1961 Bearden's interest in civil rights was not evident in his work or his activism. For some (not Bearden), civil rights was synonymous with lack of patriotism. In a hearing held by the House Un-American Activities Committee in December of 1953, Bessye Bearden's name was listed as a member of a committee that selected artists, supported by the Communist Party, to travel to Russia to create a documentary film that glorified a so-called workers' paradise.[5] The trip, according to testimony, backfired and the American travelers became disillusioned. Though Bessye—never a member of the Communist Party—had long before resigned from the selection committee, the committee's hearings were a reminder of how many people and causes from Bearden's past, from the 1920s, '30s, and '40s, were considered threats in the 1950s to American citizens. Civil rights, for some in the United States government, was just another communist-orchestrated agitation.[6] Moreover, a dozen of his co-workers at the department of welfare resigned rather than undergo questioning in a "witch hunt," as Loften Mitchell characterized the investigation. In a few years, however, Bearden's views (as well as those of the president) and his desire for an active role would change dramatically. American citizenship—and along with it, the terms of the visual culture debate—would undergo its most serious challenge since emancipation so profoundly altered the lives of

Bearden's great-grandparents, H. B. and Rosa Kennedy. Bearden would find his art instrumental in redefining the terms of that debate.[7]

For Bearden, personally and professionally, having his painting hanging in the presidential suite was simply one more sign that after a long arid dormancy during the 1950s, his career was starting to take off. In his mind, his opposition to all-black shows allowed him to compete on purely artistic terms. In the letter to Cedric Dover, Bearden writes that the demands of his painting override any other concerns, and while he has "nothing against the expression of a representational image," the "demands, the direction, of the sign factors in my painting completely obliterate any representational image."[8] Bearden's words to Dover describe his paintings of this period. Surfaces are explosive, as if the act of painting is an act of—in his words—"obliterating people, objects, and places."[9] He charts for Dover the progress of his work thus far: "My first paintings were around Negro themes, later I tried to universalize (s)ome of the things I had found in my study of these themes and in my being a Negro—The Passion of Christ-the Joy of Life-from Rabelais—The Death of the Bullfighter—from Lorca."[10] He goes on to describe his current work, the work his new dealer would hang on the walls of the president-elect's suite.

In November of 1959, Bearden had his first encounter with his new dealer. Arne Ekstrom was making plans to open a new art gallery and scouting for work with his business partner, Michel Warren; they paid a visit to Bearden and Nanette in their loft on Canal Street. Swedish-born Ekstrom was a one-time intelligence officer in North Africa and a former diplomat. Warren, a young, French jack-of-all trades, joined him to open Cordier-Warren in New York, having convinced the successful Parisian art dealer and former French Resistance leader, Daniel Cordier, to join the partnership. In the years ahead, the gallery would take on a variety of names as the three partners settled on their business relationship. As Myron Schwartzman describes their first encounter, while Bearden and Nanette's cat, Gyppo, leaped from canvas to canvas, Warren and Ekstrom decided, on their visit to Bearden's studio, to make the large abstract oils that Bearden had completed the debut exhibition of their new endeavor.[11]

In appearance, Arne Ekstrom could not have been more different than his client. The dealer, slender and angular, favored fastidiously tailored suits, French cuffs on his starched shirts, and a meticulously folded handkerchief in his breast pocket. With his sleek cigarette holder encasing an ever-present cigarette, he spoke in a clipped accented English that gave him an Old World air. Bearden, on the other hand, had grown husky by the time they met (some even thought he resembled Nikita Krushchev, the mercurial, charismatic Soviet leader). He favored denim workman's coveralls that Nanette dutifully laid out for him, pressed and clean on the bed every morning. Bearden had developed a distinctive pattern of speech, a polished mix of the cultivated and the down-home. His co-worker Mitchell referred to it as a "drawl." It was a highly cultivated drawl, however. Speaking slowly, enunciating every word, extending his vowels, Bearden could fill his remarks with either erudite references gleaned from his reading or racy anecdotes, after which he would throw back his bald head, peals of laughter shaking his entire body. Differences aside, the two men, artist and dealer, entered into a partnership at the end of the 1950s that matured, over time, into a deep friendship. (Their wives, Parmenia Migel Ekstrom, a distinguished ballet historian, author, and scholar of dance, and Nanette Rohan Bearden, who would found the Nanette Bearden Dance Company, shared a love of dance.) The relationship proved to be fruitful for both.[12]

On January 20, 1960, the new gallery assuming the name the Michel Warren Gallery—Ekstrom and Cordier were silent partners at the outset—opened its doors with Bearden's first solo show since the 1955 Barone Gallery exhibition. Critics welcomed Bearden back. The *New York Herald Tribune* critic Carlyle Burrows titled his article "Bearden's Return" and noted "major interest in the show." "That which materializes on the walls of the gallery is not specific but remote and poetic. Thus, paintings like those entitled 'Wine Star' and 'Wings of the Dragon' are a sublimation of private experience, more than realizations of communicable subject matter."

The lush surfaces of Bearden's oils emphasized form, color, and texture. Burrows made special note of the connection to natural

forms—"the luminosity of the color of an insect's wing or the flaring form of a mysteriously lovely flower." Lofton Mitchell attended the opening and wrote an effusive letter to Bearden. "I want you to know that I think you have outdone yourself with this present show....Your use of color, as usual, is superb. The whole thing shows great imagination, feeling, and skill and the craftsmanship of a great artist flows from each painting." Bearden had made a successful comeback and had done so by working in an abstract idiom. Evocative and poetic, Bearden's paintings admitted figures from time to time but, in his public displays, still eschewed the representation of race.[13]

In addition to reconnecting Bearden to the New York art world, the affiliation with a gallery co-owned by Daniel Cordier placed him among European moderns like Jean Dubuffet, Roberto Matta, and Henri Michaux, who exhibited in Cordier's Parisian space. In New York, Warren and Ekstrom showed European iconoclasts like Marcel Duchamp and Man Ray as well as the American artists Richard Lindner and Isamu Noguchi. Literature and art were favorite topics at the gallery as well, and Ekstrom often organized themed exhibits that conjoined famous writers with the works of visual artists—Donald Barthelme, Octavio Paz, and Margaret Mead were among the contributors.[14] Arne Ekstrom was no Sam Kootz, however. Kootz was determined to give rise to an American modernist movement—even at the expense of his individual artists. Ekstrom, an equally avid promoter, was determined to develop an individual artist's career. The Museum of Modern Art's purchase, at Ekstrom's insistence, of Bearden's *Silent Valley of the Sunrise*, 1959, was another indication that it was working. The next year, Ekstrom not only negotiated Bearden's inclusion in Kennedy's pre-inaugural suite but mounted back-to-back annual solo shows for him.

Positive critical response continued with Bearden's second solo exhibition in April 1961 at what was by then the newly named, Cordier-Warren Gallery. Nature continued to be a unifying element of Bearden's work, and Brian O'Doherty, writing for the *New York Times*, referred to "remote soundings of natural fact." O'Doherty explains that the artist divides the painting into the primary elements of "air, water, earth and (in one warm painting full of glowing embers) fire" and the large

abstractions are full of "suggestions of stratified earth, sub-aqueous suspensions and clear auroras or atmosphere."[15] Large scale, the paintings of the early 1960s were the works of an artist reveling in the act of painting. Bearden seemed to delight in exploring the use of color. Line and drawing dissolve in these large abstractions and the titles of works from this period are lyrical, oblique, veiled in mystery: *Friends of the Night, Night Watches in Silence, Wine Star, Silent Valley of the Sunrise, Old Poem.* After showing two years in a row at Ekstrom's gallery, Bearden did not have a solo show at the gallery again until the fall of 1964, by which point he had changed the way he worked and the way he saw the world.

While Bearden's attention was focused on the renewal of his career, the civil rights movement was escalating rapidly. A month after Bearden opened his show at the Michel-Warren Gallery, freshmen from North Carolina A&T (Agricultural and Technical) University in Greensboro, North Carolina, the town where H. B. died and several of Bearden's relatives resided, sat down at a Woolworth's lunch counter. Testing the limits of *Brown v. Board of Education,* they ordered coffee at what was then a whites-only venue. Within a week the sit-in numbers had swollen to 300 and spread to the Kress five-and-dime. Numbers continued to grow as demonstrations took place in Durham, Raleigh, Winston-Salem, and Charlotte, Bearden's birthplace. At their height, lunch counter sit-ins attracted 70,000 young people from across the country. The next summer, integrated groups of Freedom Riders traveling on public buses throughout the South struggled to maintain calm as they were assaulted, jailed, or even killed; in one dramatic case, the bus was set afire. Bearden's art was years away from intersecting with this rising tide of activism. When change came to the art he publicly displayed, he had a new dealer to thank as one of the influences that pointed his work in the direction of that change.

Bearden's awakening to the movement was slow. Between his first solo show under Ekstrom's tutelage and the debut of *Projections* in the fall of 1964, Bearden experienced a number of life-changing events: the death of his father; his very public fight to live and work in the loft he and Nanette had settled into in Soho, a fight that reconnected him

publicly to New York's community of artists; and a trip that finally returned him to Paris, though with unexpected results.

Howard Bearden died on September 16, 1960, exactly seventeen years to the day after Bessye's death. Unlike her passing, Howard's death was expected. Bearden and Nanette had spent the summer caring for Howard as his health rapidly declined.[16] Bessye's death had been covered in the mainstream as well as black press; Howard's passing was marked only in a notice in the *New York Times*. Howard Bearden never quite found his place in the world. Held back by the Jim Crow South of his birth, he had escaped to Atlantic City to work, married the captivating Bessye, and tried to return to Charlotte. When Jim Crow Charlotte became un-livable, he brought his family north, first to the Tenderloin district, then Harlem, followed by Canada, and back to Harlem. The one-time church organist who attended college, who loved to listen to music on his Victrola, did manage to hold down a steady job with the city even as his drinking worsened. His son stood by him, living in his apartment, caring for him, at least until his own mental health and the health of his new marriage forced him to move out. Whenever Bearden spoke of his father it was always with great respect.

Moving out of his father's apartment may have afforded Bearden and Nanette their independence, but it also landed him in the middle of a major brawl between the city of New York and its large community of working artists. The new couple saw their Canal Street loft as a launch pad for Bearden's return to painting. Five stories above the fast-paced streets of Chinatown, the space featured large windows and high ceilings that filled the open floor plan with light. There were also floor-to-ceiling bookshelves, and—though at the outset they denied this was the case—living quarters.[17] Like an increasing number of artists—painters, sculptors, musicians, choreographers, dancers, filmmakers—Bearden and Nanette had set their sights on a former manufacturing space that was un-rentable (were it not for artists). City officials, however, believing that manufacturing would return, maintained zoning regulations that prohibited occupancy other than by manufacturers. After a devastating fire in an illegally occupied structure claimed the lives of three firefighters in November of 1960, the fire department stepped up its

inspections of fire code violations rampant in the old, derelict buildings, 357 Canal included.[18]

One day, less than a year after his father's death, Bearden came home from work to find that a team of fire inspectors had toured his studio and posted a "vacate order" on his door. The violations cited "illegal occupancy and structural defects."[19] Frantic because his second solo exhibition was scheduled to open in the spring, Bearden returned to the loft to collect his paintings and was arrested. His comment to the *New York Times* was not an idle threat. "Maybe I'll go to Europe. An artist can work there." In court, though his attorney tried to demonstrate that the artist and his wife still lived in Harlem, the judge fined him $50 for violating the citation.

Bearden's fine, along with others levied against the city's artists, became a rallying cry for a group of New York artists who banded together to form the Artists-Tenant Association. Unless the city came up with a viable solution that allowed artists to make use of vacated loft spaces legally, they threatened to withdraw their paintings from museums and galleries all over the city, undermining New York's position as the center of the art world. As reported in the *Ogden Standard Examiner*, the group included some of the city's most prominent artists—deKooning, Motherwell, Theodoros Stamos, Alfred Leslie, John Chamberlain, and Wolf Kuhn, to name a few. Members of the New York art world vouched for their importance to New York cultural life.[20]

At the eleventh hour, Mayor Robert Wagner averted a strike by permitting artist occupancy of vacated manufacturing space under certain conditions: artists had to file for use of the space, display a sign that indicated they were certified for use, and abide by fire and safety guidelines; in return, the city would regard them as "protected."[21] In advance of the settlement, Bearden extended an invitation to his April 1961 opening at Cordier-Warren to Fire Commissioner Edward Cavanaugh, wryly observing, "I want to let him know that there is more in the rules and regulations he is enforcing."[22] Nudged into the public arena by his personal need to preserve his work space, Bearden discovered that artists—black and white—were a force to be reckoned with in New York and that within the artistic community, his voice carried weight.

The drama of the city's loft laws aside, the move to Canal Street inspired Bearden's creative experimentation. One example was a project he worked on with the photographer Sam Shaw. Shaw characterized himself as a "sometime collaborator" of Bearden's, and identifies him as "an early advocate of new mixed-media-technique creations, often involving cartoons, oil, and collage."[23] The photographer gave Bearden a batch of his photos telling him, "I like your interpretation of Cubism, see what you can do."[24] A collage, *Paris Blues Suite*, that makes use of Shaw photographs of Duke Ellington and Louis Armstrong is dated 1961, when Bearden was exhibiting predominantly non-objective oils. According to Shaw, Bearden made Xerox copies of the photographic images, even when the originals were in color, in order to flatten the images and abstract the literalness from them. In this early collage, Bearden has left the integrity of Shaw's photos of Ellington and Armstrong intact. Shaw welcomed the impact of these experiments on the way he began to see New York: "Later as I walked the streets of New York, nature itself in the big city created accidental collages on the wall of posters, artlessly arranged, peelings of advisement of concerts, rock; other signs suddenly caught my visual eye."[25]

The Chinese calligrapher Mr. Wu was another important influence. When Bearden first moved downtown, he had a chance encounter with Mr. Wu at a lunch counter. He credited the calligrapher with teaching him the fundamental structure of Chinese classical painting. In his 1969 essay, "Rectangular Structure in My Montage Paintings," Bearden credits Mr. Wu's lessons with opening his eyes to many structural and compositional techniques, such as "the device of the open corner to allow the observer a starting point in encompassing the entire painting; the subtle ways of shifting balance and emphasis; and the use of voids, or negative areas, as sections of passivity and as a means of projecting the big shapes."[26] This study of Chinese classical painting came at the same time as Bearden's close reading of seventeenth-century Dutch masters. From them he came to understand "the way these painters controlled their big shapes, even when elements of different size and scale were included within those large shapes."[27] Bearden's lessons from Mr. Wu, coming as they did when he was studying Dutch masters,

confirmed a belief that he and Carl Holty would argue in their book, *The Painters Mind*, that good paintings, regardless of the epoch, are united by an understanding of structure.

Bearden's return to painting was no doubt one motivation for his trip to France and Italy in May of 1961. Part deferred honeymoon and part study trip, the journey reacquainted Bearden with his beloved Paris. As Nanette wrote in her diary, Bearden took her to his old haunts in the Latin Quarter, his studio on the Rue Fueillentaine, Café Deux Magots, Café du Thé, Montparnasse. They spent most of their time in the museums: the Louvre, the Jeu de Paume, the Musée de L'Homme, and the Grand Palais. But Paris was a changed city. In the years since Bearden had explored the streets of the Latin Quarter, the racial tenor of the city had grown more tense. Far from embracing the city, as discussed in the previous chapter, the 1956 Congrés des écrivains et artistes noirs had focused on the destructiveness of European colonialism and espoused the philosophy of Negritude, a celebration of black self-determination and essentialism. In the years after the conference, European colonialism was under siege and, as the conference averred, the upheaval was cultural as well as political.

Though Nanette's diaries convey delight with being abroad, Bearden was clearly less enchanted with Paris than he was on his first visit.[28] He complained in letters about contemporary French painters, noting that, save for Dubuffet, he found them disappointing. He observed that the city was filled with American consumer products. The romance was gone. Bearden wrote, "I don't know, now, if I would want to live in Paris; New York, at this time in history, is far more alive." Quoting Whistler, he went on to write, "art goes where energy is, and Paris seems a tired place."[29]

New York's energy in the 1960s was indeed palpable. Dancers, writers, painters, and musicians opened up their work to the cultural collisions disturbing the body politic. Artists shed Cold War cautions as the civil rights movement heated, and, in the words of theologian Vincent Harding, jolted the creative community with a "surge." Building on the invisible renaissance of the 1950s, black artists, such as Alvin Ailey, the dancer/choreographer with whom Bearden would later collaborate and who, as noted, had formed his own company in

1958, created his signature work, *Revelations* in 1961. He anchored his choreography in the traditional movement and gestures of black folk traditions. In celebrating the black body and traditions of movement—the gesture of fanning in the church, a hallmark of the choreography, for example, in *Revelations*—Ailey also rejected the notion of a segregated dance company. Mapping black movement, in Ailey's dance lexicon, required dancers from multiple cultural backgrounds. His approach to assembling a company signaled his interpretation of black culture as broad and expansive rather than narrow and exclusionary.

Bearden may have noted, as well, the rising influence of James Baldwin. He may have remembered hearing Baldwin read his first

Romare and Nanette Bearden about to board ship to Paris, 1961.
Romare Bearden Foundation Archives, New York.

novel-in-progress. In 1962 Baldwin published "Letter from a Region in My Mind" in the *New Yorker* magazine. The next year, "Letter," combined with an open letter Baldwin had written to his nephew, was the centerpiece of *The Fire Next Time*,[30] a blistering indictment of the cleavage between national ideals and discriminatory practices. Bearden would later come to regard Baldwin as too strident for his taste, but the letters, nonetheless, captured a national mood of indignant righteousness and grievance that was coming to a fast boil beneath the surface of Martin Luther King Jr.'s philosophy of nonviolent resistance.

Developments in jazz also reflected a shifting cultural landscape, as some of its most creative musicians rethought ties with the past. Alto saxophonist Charlie Parker, pianist Thelonious Monk, drummer Max Roach (another future Bearden collaborator), and others were forging new directions. As Waldo Martin observes, they introduced an "avant-garde idiom...with its intense emotional charge; blinding tempos; complex melodies, harmonies, and chords; increased polyrhythmic urgency; and hip style." Bearden, for his part, found his love of the music sorely tested.[31] Theater as well reflected a shifting narrative. LeRoi Jones's 1964 play, *Dutchman*, exposed a simmering rage. The following year, Jones would assume leadership of the Black Arts movement that asserted a view of the arts as a political vehicle, an instrument of staunch self-determination, and, similar to the philosophy of Negritude, cultural autonomy. As a new civic narrative emerged, judging from Bearden's abstract oils, he was not a contributor to this point of view—at least not publicly.

After his return from Paris, Bearden did not have another solo exhibition for three years. He continued painting the canvases that had heralded his return to painting and had garnered positive critical attention. Occasionally, representational elements did drift into his works— themes of the circus, harlequin, and acrobats as part of his ongoing experiments with collage. In the early 1960s several visual artists, as was the case with choreographers, composers, and theater artists, were responding to the social and political disruptions as the civil rights movement grew more urgent.[32]

Bearden knew many of these artists personally. A work of Charles White, for example, like his 1961 charcoal and crayon drawing entitled

Awaken from the Unknowing, depicting a young black woman strug-
gling to read, was gaining national attention. The image became popu-
lar with the Student Nonviolent Coordinating Committee (SNCC),
which was spearheading demonstrations on college campuses and else-
where.[33] Jacob Lawrence, whose studio was once in the same building
with Bearden and whose work had long depicted black life, made use
of his distinctive style to dramatize civil rights events. A 1962 water-
color, *Soldiers and Students*, opaque watercolor over graphite, or the
saturated colors in his 1963 small-scale but vividly painted *Ordeal of
Alice,* present a tableau of racial conflict. Though there is no evidence
that Bearden knew Norman Rockwell, the bedrock artist of traditional
Americana, his work was ubiquitous because of his role as an illustra-
tor with the popular *Saturday Evening Post*. Rockwell believed strongly
enough in his statement on civil rights that he left his long-held position
with the conservative *Post* after it refused to publish his 1963 painting,
The Problem We All Live With. The painting depicted Ruby Bridges's
effort to integrate the William Franz Public School in New Orleans.
Look magazine published the image in its January 14, 1964, issue.

Younger artists, who would come to admire Bearden for his mature
collages, were often ahead of him in terms of their response to the cul-
tural transformation engendered by the movement. Melvin Edwards's
Lynch Fragments, for example, exquisitely composed nonobjective ab-
stract sculptures as impassioned representations of lynching. Welded
during the summer of 1963, the summer of the March on Washington,
each work in the series was the size of a mask, and each contained
debris—chains, locks, bits of saws, hammers, and mallets—twisted, and
wrenched in almost painterly layers, their beauty, nonetheless, evoking
violence and force. Edwards's innovative response, emphatically an-
chored in racial experiences, made use of the language of the avant-
garde. A contrast to Edwards's intensity is the social critiques of Pop
Artists, who were supplanting Abstract Expressionists as the focal point
of the critical art establishment. The same year that Edwards completed
his first *Lynch Fragments*, Warhol created *Mustard Race Riot*—acrylic,
silkscreen ink, and graphite on canvas. *Mustard Race Riot* repeated mass
media imagery, in this case a newspaper photograph of police beating

a black citizen. Warhol's serial repetition of someone else's photograph inserts a distance between the artist and the racial violence portrayed. Bearden, too, would turn to photographic images but with the distinctly different effect of immediacy rather than distance. James Dine's 1962 *Black Bathroom #2*, reminded viewers of racial separatism with a cool observational tone as does James Rosenquist's *Painting for the American Negro*, 1962–1963.[34]

Bearden's experiments with collage coincided with a resurgence not only in the popularity of the medium, but in the use of the medium for the exploration of race and identity. Edward Kienholz's 1961 assemblage of painted dolls, dried fish, and glass in a wooden box, 31 ¼ x 22 ½ x 7 ½ in., entitled *It Takes Two to Integrate (Cha Cha Cha)*, is one example.[35] Robert Rauschenberg's 1961 assemblage *Co-existence*, oil, fabric, metal, and wood on canvas, 66 ¾ x 49 ⁷/₈ in., another example, made use of materials laden with allusive power—"damaged remnants of a police barricade, along with sheets of rusted metal, bent wires, stained rags, and other detritus attached to a mostly white canvas."[36]

Two major exhibitions in the early 1960s reminded Bearden of the versatility and surreptitious potency of assemblage and collage. An exhibit of Matisse's Jazz cut-outs, the basis for the book published in 1947, opened at MoMA during the summer of 1960, and *The Art of Assemblage* the following year, also at MoMA, brought home the power of collage as an expression of twentieth-century shifts and disruptions. Several of Bearden's 1960s experimentations with cut paper mimic the amoebic forms and bold color prevalent in Matisse's Jazz cut-outs.[37]

The Art of Assemblage, curated by William Seitz—250 works and 130 artists—by some of Modernism's leading practitioners provided an encyclopedic display of the medium.[38] Many of Bearden's artistic heroes were exhibited—in addition to Matisse, the founders of assemblage, Picasso and Georges Braque, and several of modernism's major movements, including futurism, dadaism, and surrealism. George Grosz, Bearden's mentor and teacher at the Art Students League, was represented with his 1919 collage, *Remember Uncle August, The Unhappy Inventor*. A portrait of the art of masking and dissembling, and a prime example

of Dada's post–Great War cynicism, it showed the medium's capacity to embrace political and social critique.

Seitz's inclusion of such contemporary artists as Robert Rauschenberg, James Dine, John Chamberlain, Larry Rivers, and Richard Stankiewiwz continued the tradition of social and political critique that Dada introduced to collage. Referencing André Gide's phrase, "the squalor of reality" and what the performance maven, Allan Kaprow, refers to as "the nameless sludge and whirl of urban events,"[39] Seitz summarizes the critiques as a catalogue of discontents. His comments in the catalogue convey his disdain for the decidedly anti-authoritarian content.[40] What Bearden would have seen in this exhibition is the medium's capacity to speak in a wide range of cultural and aesthetic languages, its ability to accommodate disparate, apparently conflicting, points of view and emotional valences. The exhibition was timely. Already experimenting with collage, Bearden was able to study closely a vast array of techniques, mediums, and approaches to collage and assemblage. His confident grasp of many of those techniques would be on display when his new work debuted years later.

Photography, a medium that would be foundational to Bearden's radical shift toward representation, assumed a prominent role in the 1960s as well. Bearden's interest in the medium was evident in his photostatic experimentations and his collaboration with his good friend Sam Shaw.[41] Photography proved to be a potent public instrument, when *Jet* magazine published a photograph of Emmett Till in his open casket, his face mutilated and bloated. The photograph of the teenager, who had been abducted, beaten, and thrown in the Tallahatchie River by white men for allegedly whistling at a white woman, was a call to the world by his mother to witness the atrocity of racial hatred.

Photographs continued to be clarion calls for action during the civil rights movement. Charles Moore's May 3, 1963, photo captured the assault by Bull Connor on peaceful protesters.[42] Danny Lyon became the official photographer for SNCC and not only recorded the clashes and encounters of SNCC members but helped shape the way in which the public perceived encounters between protesters and law enforcement, preserving the heroism and moral authority of civic resistance.

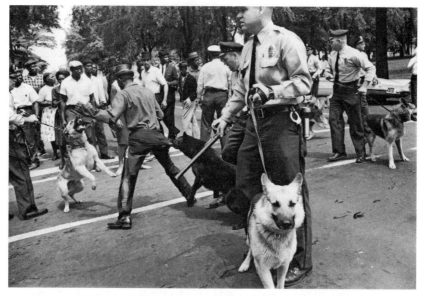

Dogs attack protesters in Birmingham, Alabama, May 3, 1963.
Charles Moore, Masters Collection, Getty Images.

Gordon Parks, a photographer for *Life* magazine; Moneta Sleet, a photographer for *Ebony* magazine, and Robert Sengstacke, who worked for Bessye Bearden's former employer, the *Chicago Defender*, each presented to their publications images that captured ordinary citizens carrying out heroic acts of civic courage. The work of these photographers circulated widely in the pre-digital, pre-social media era. Bearden's on-again, off-again relationship with photography began with his effort to make a visual statement with photojournalism in 1937. As a creative tool, he had used photostats of his own work to translate from one medium to another as well as to study the work of masters that he copied through a process of photostatic reproduction. His early experiments with collages sometimes included scraps of photos possibly as early as 1952. Along the way, he began to assemble his "paper bag" archive, accumulating photos torn out of the stacks of Nanette's magazines scattered throughout the loft, stored in a paper bag for safekeeping.

On the evening of June 11, 1963, President Kennedy took to the airways to announce proposed civil rights legislation—the grand gesture Roy Wilkins had requested. Using the language of conscience and moral obligation, he described civil liberties as a moral as well as legal issue, his rhetoric redolent with the language Martin Luther King Jr. had used months earlier in his "Letter from a Birmingham Jail." An open letter to a group of Alabama clergy who criticized him for his activism, King's letter, now a classic text, evoked the founding fathers, ancient wisdom, scripture, and moral imperative as the basis for his opposition to "unjust law." Kennedy's televised speech, like King's letter, was urgent and underscored that "now is the time." The day after Kennedy's speech, civil rights leader Medgar Evers was assassinated; the division of the nation and the high stakes of the movement were laid bare once again.

A high point of the summer was the August 28, 1963, March on Washington for Jobs and Freedom. The march, with speakers and performers standing at a podium, their backs to the marble figure of Abraham Lincoln, as they looked out over hundreds of thousands of participants gathered around the reflecting pool, presented a majestic visual tableau. I was a fifteen-year-old high school student, watching the speech on television. Even from my living room in Philadelphia, I felt an awakening when Martin Luther King Jr., the last speaker of the day, described the movement as the striving toward an ideal, the calling to account of an undelivered promise. As he did in his "Letter from a Birmingham Jail," he framed the ideals as "sacred obligations." Nationally televised, the appeal conferred a moral high ground to the movement and looked down on the frailties of failed law or failed social practice and elevated civil rights activism to national purpose.[43] Momentous to the nation, the months leading up to the March and after were a turning point for Bearden.

A month before the March on Washington, Bearden organized a meeting of artists to, in his words, "hire a bus...and go down to represent the Negro artists."[44] The artists who attended that meeting became the core of what would become the collective called Spiral, the first community of black artists Bearden had joined since he was a

member of the Harlem Artists Guild during the Depression and the "306" group in Harlem. For the next two years, Spiral gave all of the participants, Bearden included, a forum in which they could argue issues given new life and force by the civil rights debate. For the eventually fifteen artists who became Spiral members the collective served as explicit recognition that, in addition to their artistic identities, they lived inside a racial identity as well. For some this meant a forum in which they could surface the inequities of the art world. For others, Spiral was a place that allowed them the freedom to discuss aesthetic ideas. And for some of the younger artists, it was an arena in which black artists could probe what their racial identity meant to their artistic work and what that work meant to the world.

Accounts of Spiral's history vary. Some credit A. Philip Randolph, a founder of the first black labor union, the Brotherhood of Sleeping Car Porters, and one of the March's organizers as a catalyst for Spiral. As the story goes, a call from the white-haired activist spurred Bearden to organize artists to attend the March.[45] Twenty years earlier, Randolph had threatened the Roosevelt administration with a March on Washington to protest the president's failure to support an anti-lynching bill or the integration of the defense industry. Randolph, an admirer of Bearden's Depression-era article lambasting the patronage of the Harmon Foundation, turned to him to help with making visual artists an integral part of the March.[46]

Whatever the impetus, on the evening of July 5, 1963, Bearden assembled a small group of black artists in his Chinatown loft. His minutes of the meeting record that they gathered "for the purpose of discussing the commitment of the Negro artist in the present struggle for civil liberties." But the group also decided that they needed "a discussion group to consider common aesthetic problems."[47] Spiral was by no means the only black collective that formed in the early 1960s. For example, Chicago was home to the Organization of Black American Culture. (OBAC) Under OBAC's aegis, the Coalition of Bad Relevant Artists (COBRA) concentrated on making the content of their work accessible. The group was also intent on a "realignment of vision, a reconceptualization of what constituted beauty."[48] Murals, executed in

the heart of inner-city Chicago, became a signature activity for the organization. *The Wall of Respect,* its first work, attracted a mass audience.[49] Artist and art historian Jeff Donaldson organized the artists from the workshop in Chicago into what became the African Commune of Bad Relevant Artists, AfriCOBRA. AfriCOBRA artists agreed to a set of aesthetic principles and agreed to work collaboratively as well as individually. Brooklyn was the site of Kamoinge Workshop (Kamoinge means collective in the Kenyan dialect of Kikuyu). The workshop was a loose-knit group of photographers that formed in order to meet and critique each other's work; it originated in Chicago and New York. Young black artists in Louisville, Kentucky—Jack Whitten, Sam Gilliam, and Houston Conwill—banded together. The movement they started was a call to arms for artists. They sought each other out, organized, and became the basis for an institutional presence as well. Bearden would become a central player in both the artists collective and the institutional presence.

Spiral formalized its first meeting in Bearden's loft by agreeing to contribute to the monthly rental of a Soho studio at 147 Christopher Street and to meet twice a month. In addition to Bearden, who would become the secretary/treasurer of the group, the first summer meeting included eight artists. Among the original members were Norman Lewis, opinionated and argumentative, who with Bearden had been part of the emerging Abstract Expressionist circle of painters; and Hale Woodruff, whom Bearden met during his journey south during the 1940s and who had shaped major university art departments in both Atlanta University and New York University. Bearden, as we have seen, butted heads with Woodruff over his participation in the Atlanta Annuals that Woodruff started, but he deeply respected the murals detailing the *Amistad* mutiny that Woodruff painted for Talladega College in Alabama. Spiral revived Bearden's relationship with Alston, his cousin by marriage, who had been a leader in Depression-era Harlem. One of the organizers of "306" and a director of the Harlem Hospital WPA mural, Alston, university trained, like Bearden, Lewis, and Woodruff, was producing sophisticated abstract canvases. Some affectionately (and some derisively) referred to Woodruff, Lewis, Alston, and Bearden

as "the old men of Black art."[50] Others who gained admission to the group included African art dealer, jazz musician, and painter, Merton Simpson; painter and one-time comic book artist, Alvin Hollingsworth; color field painter and MoMA guard by day, William Majors; painter, photographer, and graphic artist, Reginald Gammon; and Abstract painters Calvin Douglas, Earl Miller, and Perry Ferguson. Emma Amos, talented figure painter and the youngest member, was the only woman admitted to the group. James Yeargans, Felrath Hines, Richard Mayhew, and sculptor William Prichard completed the group. Hines was a respected conservator and skilled abstract painter who favored hard-edged geometric forms. Mayhew created precisely yet poetically rendered, chromatically subtle landscapes.

For the next two years, Spiral grew to fifteen, its membership decisions betraying the group's biases—male and abstract artists. Faith Ringgold, who in 1963 had begun her landmark *American People* series, filled with figures in social settings that offered a cultural critique of bourgeois aspirations, wrote to Bearden, whom she admired. She sent him slides with a request for admission to Spiral. His response included a technical critique of her painting and suggestions for other artists for her to study, but was silent on her request for admission. She took his silence as a no.[51] The ages of the artists ran from twenty-eight to sixty-five.

The civil rights movement's urgency and ever-present violence reasserted itself just weeks after the peaceful march. On the morning of September 15, four girls—Addie Mae Collins, Cynthia Wesley, Carole Robertson, and Carol Denise McNair—died during Sunday service when a bomb ripped through the 16th Avenue Baptist Church in Birmingham, Alabama. Two months later, Bearden returned home from work to a commotion outside an electronics shop on the ground floor of his building. Televisions in the storefront window were stacked one on top of the other, covering the assassination of President Kennedy. Co-workers who were with him recall that Bearden's face was pale and his body started trembling as he repeated over and over, "This is bad. This is really bad. Like the announcement of the second World War."[52] By the time of his death, Kennedy had not only proposed civil rights legislation but he had also begun to argue publicly a case for the role of the artist in a

democratic culture. On October 26, 1963, at Amherst College, on the occasion of the dedication of the Robert Frost Library, the president gave what would be his last speech and it assigned to the artist the role of conscience and keeper of the truth. In Kennedy's words, artists are "the men who question power" and whose work "establishes the basic human truths, which must serve as the touchstone of our judgment."[53] Artistic freedom was key: "If art is to nourish the roots of our culture, society must set the artist free to follow his vision wherever it takes him." Kennedy went on to say, "In serving his vision of the truth, the artist best serves his nation." As art and the civil rights movement converged, his words could have served as an anthem for Bearden's emerging artistic vision.

Despite the overwhelmingly masculine nature of Spiral and its penchant for abstract artists, there were as many points of view as there were members in the group. Scholar Courtney Martin presents an excellent summary of the individual perspectives.[54] Some like Norman Lewis wanted to use the gathering as a place to air grievances; Alston and Douglas were attracted to the opportunity to exchange ideas; some of the younger artists called for a more aggressive stand, along the lines of that of AfriCOBRA. In the end, they resisted a set of unifying principles, they rejected a themed exhibition, and they rejected the idea of collaborative work—an idea that Bearden explicitly urged for the group. Emma Amos and Richard Mayhew both remembered the bag of photographs Bearden brought to the meeting. He had been cutting faces, trees, and commercial objects out of Nanette's ladies' magazines; the national news magazines, *Life* and *Look*; black magazines like *Ebony*; and an African art journal. He tried to get the group interested. Amos and Mayhew quickly lost interest. They rejected his proposal because, in Bearden's words, "The fellows [There is rarely acknowledgment of the one woman] had ideas of their own. Each of the members was a capable artist and had their own métier."[55]

Bearden's experiments with his paper bag full of scraps of photographs received their first public display in May 1964, where the Congress on Racial Equality (CORE) solicited work from black and white artists for a fundraising auction. In response, Bearden contributed a collage, composed in part of those photographic scraps and

entitled *The Evening Meal of Prophet Peterson*, a complex composition of photographs, bits of magazines, cut and painted paper, reproductions of African and European art. A striking departure from his large oils, in which space feels expansive and sprawling, the collage constructs a cramped, fractured interior, the bits and pieces of photographs, surgically spliced, crammed together as if they barely fit. Space is cluttered, overstuffed. A man sits at a table laden with food. A young boy, a son, maybe a grandson, sits beside him, as a woman stands across the table with a heaping platter of food. At first glance, the collage depicts a familiar routine—a black family sits down for a meal. Yet, bodies are disjointed. The woman's face is an accordion of three photographic strips—Shirley Temple, a white woman; a black woman; and a slice of an ancient African artifact. Half of the body of the black man, the eponymous Prophet Peterson, is composed of the clothes of a workingman; the other half, an inchoate jumble of disparate fragments. Half of his face is intact and looks cheerfully out of the picture as if extending an invitation; the other half is an incomprehensible combination of elements.

The setting Bearden has constructed, like a hastily assembled puzzle, is a clash of incongruities: on the left a black and white news clipping of a white man in a business suit is plastered to the wall; on the right wall is what looks like a yearbook photograph of a young black woman. A white Santa grins cheerfully from a television screen. Bearden has made use of a snippet of a reproduction of a painting, a formal chandelier, to define its improbable presence as a lighting fixture in the down-at-the-heels interior. He represents the food of the meal as magazine clippings and the jarring combination of white woman, black woman, African artifact, television image, photos of a suited white man and young black woman—snippets of painting all jammed into a cramped space, creating the explosiveness of cultural collision.

When Ekstrom paid him a visit in preparation for the fall 1964 show, Bearden did not offer up this new work; instead, he showed the dealer more of the same—the nonfigurative oils that had heralded his return to the New York art world (and earned him a spot on the wall of the presidential suite in the Waldorf). Ekstrom, however, sensed that the oils were losing energy, that the work lacked "movement" and suffered

from "a sort of lost momentum."[56] While they were looking at paintings, Ekstrom spotted something rolled up in the corner. "What's that," he asked. Bearden, thinking the images he had created were "too strong," shrugged off the question. "Just something I've been working on." Reginald Gammon, a Spiral member, had seen some of Bearden's collages in the style of the *The Evening Meal of Prophet Peterson*, and suggested that he turn them into black and white photographic blow-ups. Ekstrom took one look at one of the billboard size black and whites and recognized immediately that he was looking at the "the new spark, the thing to get him moving again."[57] Ekstrom suggested that Bearden title the works *Projections*, because, as he noted, people just seemed to "project" from the surface. There was Bearden's fall show.

On the evening of October 6, 1964, Bearden and Nanette were glowing as they stood in the Madison Avenue Gallery surrounded by twenty-one billboard size black and white *Projections*. Scenes of the rural South, the cotton fields of Mecklenburg County, trains that connected North and South, the urban streets of Pittsburgh, and Harlem dominated the gallery. Oversized heads and hands, eyes in faces pushed to the front of the picture plane glared unflinchingly at spectators, setting up a dramatic confrontation between spectator and *Projection*. Bearden introduced the phrase "The Prevalence of Ritual," signaling his intent to connect the literal scenes depicted to a broader context, what he explained as the "continuation of ritual" that gives a dimension to the works.[58]

Critics were nearly unanimous in their praise of the new works. *Time* magazine applauded *Projections* as "the most moving show on the avenue." The *New York Herald Tribune* commented that it was "easily one of the best shows in town." The *New York Times* echoed those sentiments: "This is knockout work of its kind, propagandist in the best sense." Beyond the exclamatory phrases, a number of critics wrote thoughtful extended analyses. Charles Childs, for example, writing for *Art News*, observed: "The work that this Negro-American painter has been doing will surprise many who thought they knew Bearden from his abstractions. He suddenly has produced a brilliant proliferation of collages on Negro themes."[59] Bearden's statement to Childs in the

article echoes sentiments he had written to Cedric Dover. "I have tried," he wrote in the Dover letter, "to look at anything in my encounters with the outside that might help translate the innerness of the Negro experience." Bearden's use of the words "translates" and the "innerness" of his Negro experience is telling. He implies that aspects of his experience as a black person will be foreign to some and requires a translation. To perform this translation, Bearden had invented a new visual language, what Childs describes as being "like a personal dictionary whose self-definition is its own voice and its own authority."[60]

Bearden's work argued its case openly and out loud. Conflict abounds in *Projections*. A glorified gilded past—Chicago's 1930s Big Band era contrasts with a somber present in *The Street* or the *Dove*. Bearden celebrates the generative, the promise of generations to come in *Tidings*, a meeting between two women composed to resemble a Renaissance scene of the Visitation. He contrasts the generative with the apocalyptic. An example is *In that Number*, named after a famous sermon; it pictures civil collapse, as if the Flood had suddenly returned this time without the salvation of the ark. He contrasts the puritanical with the erotic. In *Ritual Tidings* an older woman winged—perhaps a "conjure woman," dressed primly—sits across from a nubile nude; the erotic image of the male, a bull, is in the background. *Conjure Woman* contrasts the grotesque with the beautiful in the same image. Geographically Bearden sets the rural South in contrast to the urban North. Refusing to choose between the representational and the abstract—the choice he felt he had been forced to make for his entire artistic life—he instead made the representational profoundly abstract. Images that could easily be trapped in the provincial precincts of race spiral outward, explosively, dislocated by the clash of multiple heritages.

Bearden's personal triumph only strengthened his resolve to make Spiral an effective artists' collaboration, despite differences among member artists. Spiral artists' aesthetic differences were especially manifested when the group finally followed Bearden's suggestion and tried to organize their first group show. At first the group intended to focus on Mississippi 1964, the year of a campaign to register voters in the Mississippi Freedom Democratic Party (MFDP). That effort attracted

volunteers, black and white, many of them young college students, who boarded buses for Mississippi to "register voters, to teach in the freedom schools to mobilize national attention." The deaths of three young activists, two white and one black—Andrew Goodman, Michael "Mickey" Schwerner, and James Chaney—were another reminder of the very real dangers inherent in claiming basic citizenship rights. Though the Civil Rights Act was passed the very same year, nonviolent resistance strained against mounting anger. Harlem exploded in riots the summer of 1964. Cities around the country began to unravel. Resistance to Vietnam, fueled by a draft that targeted minorities, grew more belligerent. Spiral members decided that Mississippi 1964 or any political theme was too volatile a topic for a group exhibition. They elected, instead, to limit their palette to black and white. Their first and only exhibit, simply titled Spiral, opened in the Christopher Street studio in May of 1965.[61]

Spiral formed at an auspicious time for Romare Bearden. As he debuted new work, Spiral offered an opportunity to discuss openly "the identity of the Negro, what a Negro artist is, or if there is such a thing"—a topic he had last addressed publicly in writing in 1946. With Spiral, most importantly, as Bearden would later acknowledge, the bi-monthly meetings in the Christopher Street studio "meant a great deal...in the formulation of my present ideas and way of painting."[62] Bearden's "present ideas and way of painting" were more than a modern portrayal of black life; they offered a new way of seeing and understanding cultural permutations. Culture was not fixed; rather, it was a fluid creative collaboration, or at times a creative collision with multiple cultures that constantly forged something new. Critic Dore Ashton rightly points out that Bearden's use of photomontage was essential to the impression that *Projections* were delivering news from an unfamiliar place. Bearden himself noted that at least one guest at *Projections'* debut, upset by the content of that news, walked out.

Bearden's work defiantly resisted "the accepted world." For his assault on world-weary habits of seeing he used as weapons the rip and tear of collage. Cubism and collage reset the relationship between art and external reality. In his 1946 essay, "The Negro Artist's Dilemma," Bearden had warned that truth is veiled by an inability to see, by the

distortions of false representations. Bearden used the destructive impulses of Cubism and collage, infusing them with the constructive force of ritual, ceremonies, and traditions to construct a new way of seeing. Ralph Ellison, who would write about Bearden's collages several years after their debut, discerned two fundamental qualities in Bearden's art—the expansiveness and inclusiveness of his visual allusions and his penchant for combining conflicting points of view within one tableau. Bearden's artistic journey had given him access to an encyclopedic trove of visual images, from ads and photojournalism to Giotto, Juan Gris, Picasso, and Mondrian, as well as the "metaphysical richness of African sculptural forms."[63] In possibly Ellison's most quoted passage, he noted that Bearden's meaning was "identical with his method," which consisted of "leaps in consciousness distortions, paradoxes, reversals, telescoping of time and surreal blending of styles, values, hopes, and dreams which characterize much of Negro American history. Through an act of creative will, he has blended strange visual harmonies out of the shrill, indigenous dichotomies of American life."[64]

Ellison's essay was prophetic. Bearden had traveled far and had arrived at a new place, one completely of his own making.

Nanette and Romare Bearden at the Museum of Modern Art
opening of *Prevalence of Ritual*, 1971. Photo by Sam Shaw,
© Sam Shaw, Inc. Licensed by Shaw Family Archives, Ltd.

THE PREVALENCE OF RITUAL

PART II

It is the right of everyone now to re-examine history to see if Western culture offers the only solutions to man's purpose on this earth.[1]

—Romare Bearden, September 1966

On the evening of Tuesday, March 23, 1971, the Museum of Modern Art hosted a black tie gala to preview two landmark exhibitions.[2] One was a retrospective of fifty works constructed over a fifteen-year period by a young sculptor from Chicago named Richard Hunt, known in the art world for his abstract constructions of welded steel and found objects. The other was a retrospective of fifty-six paintings, collages, and *Projections* entitled *The Prevalence of Ritual* by Bearden, spanning thirty years of his career.

Both openings were big news; not since 1937, when MoMA featured the sculpture of folk artist William Edmundson, had the museum mounted a retrospective of the work of a black American artist.[3] Now there were two, both opening at the same time. Two thousand guests attended the festivities; American and British camera crews captured the historic event.[4] Bearden, looking fit and trim, substituted his customary blue denim overalls that night for a tuxedo; Nanette looked regal in a flowing designer gown. Neither looked like a fervent art world activist.

But the goodwill and media attention of the exhibition's opening, however, masked the anxiety of a museum and an entire city in turmoil. MoMA staff, a group of curators and administrators, were threatening to strike, and between 1969 and 1971 there had been three museum directors, at least two trailing clouds of controversy in their

wake.[5] Artists mounted protests—one group threatened to close the museum; sculptor Takis Vassiklakis attempted to remove his sculpture that was on display; and the museum staff itself staged an anti-war protest.[6] Protests were erupting all over the city. Bearden himself had been an active participant in an artist protest against the Metropolitan Museum's controversial *Harlem on My Mind*, and he would become embroiled in a controversy, soon after the opening of his MoMA show, at the Whitney Museum of American Art, centered on an exhibition of contemporary black artists.[7] Like most American institutions during the era, museums were pelted at every turn with questions that disturbed what had once appeared to be an imperturbable status quo: Who gets to work at American museums? Or sit on the boards? Or decide funding? Who chooses artists for exhibits or permanent collections? Who defines the canon? And what is the canon anyway?

Outside the museum world, the tone and tenor of a once-hopeful civil rights movement was becoming angry. Stoicism and nonviolence, badges of the movement, gave way by the mid-1960s to chants of "Black Power," with King's melodic cadences taking a back seat to Malcolm X's defiant rhetoric of self-determination. Malcolm's assassination on February 21, 1965, and the posthumous publication the same year of *The Autobiography of Malcolm X* called attention to his worldview. His fierce insistence on the right to self-defense and separatism overshadowed his call, at the end of his life, for brotherhood and unity. The Student Nonviolent Coordinating Committee (SNCC), once allies with King, had turned militant; the Black Panther Party had established itself on the West Coast, and poet and playwright, LeRoi Jones, had shed his downtown identity, moved to Harlem, and changed his name to Amiri Baraka. Baraka, along with poet Don L. Lee and Larry Neal, assumed leadership of the Black Arts Movement.[8] A call for separate institutions joined the demands for inclusion in existing cultural organizations. Pressure on established museums continued to mount as a growing feminist movement lobbied for the presence of women on museum and gallery walls. Free speech and anti-war protests targeted museums as sites of corrupt power and authority.[9] The precarious state of American cities—where the country's most important museums resided—heightened

the pressure. Ironically, Bearden, one of the subjects of MoMA's gala celebration in the spring of 1971, had played a role in the years leading up to the retrospective as one of the status quo's most persistent critics. His activism in these years merits close scrutiny.

Bearden's activism, as noted earlier, had been rekindled during his fight with the city in the early 1960s over his right to occupy his Canal Street loft. His personal protest was a rallying cry for a movement on the part of New York City artists to force the city to give them live/work access to the city's vacant lofts that once housed its long-gone manufacturing enterprises. Then, Spiral in July 1963 marked a turn toward activism that was pointedly race based, a departure from the race-neutral position he had championed for his art in the years after World War II. Less than a year after the launch of Spiral, he assumed the position of artistic director of the newly formed Harlem Cultural Council (HCC), an advocacy organization for black artists of all disciplines. An early effort to revive Harlem's cultural centrality, the organization reconnected Bearden to Harlem almost a decade after he moved out of his uptown studio.

Reconnecting to Harlem reconnected him to his past. But that past, as Bearden soon discovered, had been as chipped and fractured as the brownstones he pieced together in his collages. Invited by MoMA's education department in 1966 to speak to schoolchildren about black artists, Bearden quickly discovered that published information about black artists was virtually nonexistent. The material evidence of his Harlem—painting, sculpture, photography, and the products of a community of artists—was difficult to come by. Exhibitions, workshops, lectures, salons, artist studios, not to mention the plethora of nightclubs, cabarets, and juke joints that Bearden and his friends frequented before World War II—an entire world— were, by the 1960s, virtually invisible. Taking on the responsibility of documenting that past became a critical part of his awakening activist spirit.

In the spring of 1966, Bearden's newfound racial solidarity, manifest in his Spiral membership, spurred him to make plans to participate in the Premier Festival Mondial des Arts on Gorée Island. Gorée, an island

off the coast of the Francophone city of Dakar in Senegal, was the last stopping place for slaves before they embarked on the middle passage to the New World. Gorée is a stark physical reminder of the link between the African continent and New World African Americans. A last-minute dispute about payment to visual artists caused Bearden and several other black artists to withdraw their work. Philosophically, however, he embraced the aims of the exhibition "to celebrate Black creativity as an integral part of nation building in post-independence Africa," and his intent to participate lent a global diasporic perspective to his racial identity.[10] Bearden discarded his earlier antipathy to all black exhibitions and became not only a champion of their necessity but a curator and organizer of two important group shows.

As artistic director of HCC, having reduced his workload in 1966 as a caseworker to part-time, Bearden co-curated an all-black show in the basement of a former furniture store at 144 West 125th Street (the building would be the future home of the Studio Museum in Harlem or SMH). The show opened on June 25, 1966, a block away from his old studio over the Apollo Theater, bringing Bearden back to his old neighborhood. He contributed one piece to the exhibition, *Conjure Woman*, a *Projection* he eventually gifted to the SMH.

Though he plunged into this activism with purpose and fervor, Bearden still held fast to a pessimism about the country that tugged at him like a powerful undertow. He shared his dark thoughts during a September 1966 symposium that he moderated, hosted at the Metropolitan Museum of Art. Titled "The Black Artist in America," the event assembled some of his former Spiral artists to comment on the need for the organization and the state of art and culture in America generally.[11] Bearden observed, "I suggest that Western society, and particularly that of America, is gravely ill and a major symptom is the American treatment of the Negro." Spiral had been an effort by him and his fellow artists to gain visibility for black artists. They had intended to use their Christopher Street space not only for the exhibition of their own work but to support emerging artists as well.[12] But it had not survived their internal quarrels. His frustration was that the art world had no place for the artists like those who belonged to Spiral and, in his first attempt to rectify

that absence, he had failed. He would try again until, eventually, his efforts would bear fruit.

Bearden's bleak view of the state of Western culture was not surprising, given the continuing civic upheavals that gripped major cities around the world. Featured on the cover of the October 27, 1967, issue of *Time* magazine, which also contained a review of Bearden's solo Cordier-Ekstrom show, was a photograph of the largest anti-war protest to date—one of many protests that erupted all around the country and all over the world. To some, Bearden's words at the Met sounded prophetic and his apocalyptic scenes prescient. Yet Bearden, as was often the case, proved himself difficult to pin down artistically and the fifteen large collages in his 1967 solo exhibition at Cordier-Ekstrom presented a meditative, less fractured view of the city than his 1964 *Projections*, as if Bearden were searching for an invisible calm at the heart of a storm. Compositionally, the work was less frenetic than *Projections*; larger swaths of color replaced splinters of cut paper. By eliminating the practice of photographing and enlarging the collages, he produced work that was less documentary and more painterly. The Cordier-Ekstrom show caught the attention of *New York Times* critic John Canaday. Canaday betrayed his sensitivity to the social critiques that black artists were delivering with increasing passion and candor when he praised Bearden for having avoided a "mawkish tirade," a sentiment that other mainstream critics would repeat.[13]

October of 1967 was a busy month for Bearden. Not only did he open a solo exhibition at his gallery but he also partnered with curator and writer, Caroll Greene (who would curate the MoMA retrospective), to co-curate an ambitious survey of African American art. They chose a site considerably more majestic than the basement of a former furniture store for an exhibition of black artists. And they chose a timeline for the artists that spanned 150 years. Titled "The Evolution of Afro-American Artists 1800–1950," the exhibition was housed in the City College of New York's Great Hall, a cathedral-like building perched on a hill in the middle of Harlem's Sugar Hill neighborhood. Bearden and Greene assembled over 100 paintings and sculptures by fifty-five black artists from the nineteenth and twentieth centuries. Several prominent

New York City institutions collaborated to help bring about this ambitious effort—City University of New York, the New York Urban League, and the Harlem Cultural Council. Greene and Bearden produced a catalogue and co-wrote the essay, the first of what would be several major writing projects for Bearden on the history of black American art.

Bearden and Greene's show involved a prodigious research effort. Tracking down works and researching and writing the catalogue required major investigative work on their part, since formal archives did not yet exist for many of the artists. The two had to scavenge storage rooms of libraries, Historically Black Colleges and Universities (HBCUs), and major museums, referring to their curatorial work as a "rescue mission." For decades, many of the works had not been exhibited nor had they benefited from conservation efforts. Bearden and Greene were convinced that an exhibition of this type saved many of the works from "obscurity and oblivion."[14] Their statement may have been over-dramatic, but the exhibition proved a point. A vast number of art works were hidden and therefore not only unknown to historians and the general public, but their physical condition and preservation may have been compromised as well.

By the end of the year, Bearden had not only mounted another critically successful solo show that reinforced his reputation as a first-rate collage artist but he had emerged as well as a budding historian and curator. His reputation on the ascent, he received two commissions from major mainstream mass media publications—*Fortune* and *Time*—in 1968. Both showcased his talent for capturing something essential about urban life, but between the two covers, the events of 1968 might have shaped the tone and tenor of the images he chose for each. *Fortune*, that had published his work over twenty years before, commissioned him to illustrate its January 1968 cover titled, "A Special Issue on Business and the Urban Crisis."[15] For the *Fortune* cover, Bearden depicted a man and a woman sitting on the stoop of a brownstone, decrepit-looking but still retaining remnants of Harlem's glorious architectural history. The woman looks directly at the reader, as if she were extending an invitation to talk. Bearden's work divides the old brownstone into three registers and places, each offering a separate cinematic scene.

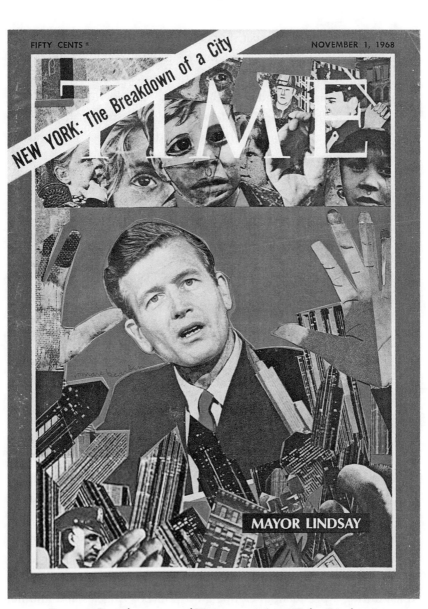

Romare Bearden cover of *Time* magazine, "John Lindsay's
Ten Plagues," November 1, 1968.

In the lower register is a barber shop, an example of urban entrepreneurship. Above the barbershop is a church, its stained-glass windows reminders of the ubiquitous presence of the church and the presence of faith. Staring from the window of the top floor are the resigned-looking faces of the neighborhoods' residents. Outside the brownstone, a boy and girl play on the corner, their energy and playfulness a contrast to the man and woman who slouch on the stoop. Bearden deflects realism with color and composition. Grays, whites, and blacks dominate, yet the intense highlights of red, white, and blue remind us to read the scene as part of American life.

Bearden's cover pits what could be read as the creeping entropy of the inner city against an underlying structural and, by implication, cultural order that resists the impending decay. A mathematically precise composition, anchored by what he refers to as rectangular structure, serves as a controlling grid on which he has ordered the bits and pieces of cut paper, photos, and hard-edged shapes that define people, faces, fragments of eyes and hands, as well as the buildings, stoops, and sidewalks. Bearden would later write a lengthy article, "Rectangular Structure in My Montage Paintings," explaining one of the major organizing principles of his collage paintings.

Whatever equilibrium Bearden may have conveyed in the urban image on the cover of *Fortune* was shattered on April 4, 1968, with news of the assassination of Dr. Martin Luther King, Jr. Bearden was on the campus of Spelman College as a visiting artist when King's body lay in repose at the Atlanta college's Sisters Chapel. As thousands filed past his coffin, Bearden was keenly aware that King's death marked the end of an era. In the days after his death, a spate of civil unrest swept through cities all over the country. Two months later, Robert Kennedy was killed during a presidential campaign trip in Los Angeles and another wave of hopelessness washed over the country. The national elections in 1968 brought the divisions in the country to an ideological head. Democrats had promised social progressivism—passage of the Civil Rights Act and Voting Rights Act and a roster of Great Society anti-poverty programs. Republicans challenged the incumbents with a "Law and Order" agenda, a response to volatile cities and waves of campus

protests. Youth protests in 1968 were global, erupting in Prague, Paris, and Mexico City. In August 1968, the Democratic national convention in Chicago displayed a municipal authority brutally asserting itself against thousands of anti–Vietnam War protesters. Against a backdrop of civic unrest and upheaval, during the summer of 1968, Bearden found himself caught up in what would become one of the most controversial cultural dramas in the history of New York City—the exhibition, *Harlem on My Mind: The Cultural Capital of Black America, 1900–1968.*

Harlem on My Mind was devised by Thomas Hoving, director of the Metropolitan Museum of Art, and Allon Schoener, art historian and curator.[16] Hoving, a Tiffany heir and former New York City Parks commissioner, was appointed director of the Met in March 1967 and immediately revealed a flair for showmanship. In an effort to wake up what he believed was an institution disconnected from the life of the city, he invited Schoener, a Yale and Courtauld Institute–trained art historian and program director of visual arts at the New York State Council on the Arts, to be the guest curator for an exhibition that would highlight the cultural contributions of Harlem. Schoener had previously organized a popular exhibition for the Jewish Museum, an immersive multi-media experience entitled *Portal to America. Portal* charted the history of Eastern European Jewish immigrants who lived on the Lower East Side in the first half of the twentieth century.[17] His plan was to do for Harlem and black culture what he had done for the Lower East Side and Jewish culture. As for the extraordinary output of painting and sculpture produced in Harlem by artists like Richmond Barthé, Augusta Savage, Aaron Douglas, Charles Alston, Norman Lewis, Jacob Lawrence, or Bearden—to name a few—Schoener planned to use color transparencies of their work. Bearden, for one, was enraged.

In a series of polite but angry letters and meetings during the summer and early fall of 1968 with Schoener, Hoving, and the black historians and archivists whom Hoving had assembled as an advisory group, Bearden made his case. He and the artists who comprised the artistic and intellectual scene in Harlem wanted originals of their work included. To represent them with mere reproductions was to offer a caricature of their artistic production.[18] Bearden also objected to the Met's failure to

consult with the artists and curators who were expert on the art and culture of Harlem. Months before the scheduled opening of the exhibition, Bearden was led to believe that the museum was willing, in fact, to consult with his curatorial partner, Caroll Greene, and the distinguished Howard University art historian, Dr. James Porter, who together would curate the inclusion of original works of art by black artists. Bearden had already been included in group shows at the Metropolitan Museum in the 1940s and to think that somehow now he would be relegated to color transparencies must have been particularly irksome. Moreover, in 1968, when his mature work was enjoying unprecedented public and critical attention, to be omitted from an exhibition that heralded black culture was a further insult. Schoener, however, accused Bearden and others of bargaining with the white establishment "on the basis of their 'Blackness,' not artistic merit."[19]

Protests around *Harlem on My Mind* disclosed a divide between a black and a white art world, but the show also disclosed a generational divide among black artists. Several black artists, younger than Bearden, believed that polite, angry letters and meetings were not enough. Benny Andrews founded the Black Emergency Cultural Coalition expressly to oppose *Harlem on My Mind*. Andrews, who had grown up in Georgia in a large sharecropping family, painted portrayals of the rural South. He organized artists to show up at the museum and protest at the foot of the grand stairway that led up to the entrance of the Met. Artists convened but their protests were overshadowed in the press by a new controversy. Once the exhibition catalogue became public, there were charges that the catalogue essay was anti-Semitic.

The circumstances around the commissioning of the catalogue were unconventional to say the least. Dispensing with the common museum practice of engaging a scholarly expert in the field covered by the exhibit to write the catalogue essay, Schoener instead chose the term paper of a Bronx high school student, Candice Van Ellison, as the defining catalogue entry. The catalogue was quickly assailed as anti-Semitic. Art historian Meyer Schapiro, for example, spoke for many who opposed the catalogue when he called for the museum "to suspend the sale of the catalogue, or if that is too great a sacrifice financially, to

black out the ugly passages."[20] The most offensive passage in the cata-
logue, however, was not the words of the student. Schoener had removed
the quotation marks from a quote taken from the 1963 sociology text,
Beyond the Melting Pot. Co-authored by Daniel Patrick Moynihan, so-
ciologist, ambassador, and later a United States senator from New
York, and Nathan Glazer, a scholar on race and ethnicity, the book had
stirred strident controversy when it was first published. That Schoener's
edits, intended to make the catalogue essay more dramatic, manufac-
tured a racial narrative that he then placed in the voice of a teenage
black woman further undermined the integrity of the exhibition.

Harlem on My Mind, one of several efforts to redefine the American
cultural scene, underscored the challenges in that redefinition. A con-
versation about race and culture, *Harlem on My Mind* functioned as
part archival repository of fact and part narrative invention. Bearden
and others were coming to realize that if the story of black life and cul-
ture were to be told, black artists, scholars, and curators would need to
participate in the telling. The call for culturally specific institutions that
preserved the material evidence of a given culture, that documented
and disseminated that evidence, was a responsibility that went beyond
protests on the steps of offending museums. The need for authenticity
was not exclusive to black cultural institutions. During the late 1960s
all over New York City and elsewhere there were efforts afoot to estab-
lish cultural organizations that served artists, art forms, and audiences
overlooked and underserved by established institutions. Museums, dance
companies, art schools, and theaters lodged themselves in garages, store-
fronts, church basements, and old schools during the 1970s and 1980s.[21]
Even as Bearden was engaged in a verbal battle against the powers that
be at the Met, north of the Metropolitan Museum on Fifth Avenue, a
new cultural institution, the Studio Museum in Harlem, was celebrating
its launch on September 26, 1968.

An idea that took root among members of the Museum of Modern
Arts' Junior Council, some of whom became founding members of the
new institution's board of trustees, Studio Museum was designed to
challenge conventional museum orthodoxy. Located on 125th and
Fifth Avenue, the museum was considerably off the beaten path of

"Museum Mile," a stretch of art museums in New York that lines Fifth Avenue. Artists, intended to work in studios located on the floor above the handsomely designed exhibition galleries, were an anomaly in a museum world that favored objects and artifacts. The presence of working artists, an idea generated by the abstract painter, William T. Williams, gave meaning to the word "Studio" in the name. As racial arbiters, the museum was in the vanguard as well. The museum's first executive director, Charles Inniss, was quoted in the *New York Times* as saying that the museum was a place for "good Black artists to exhibit, where Black people can see their work."[22] And he added, "to be a ground where Black and white art worlds can really meet." Bearden would eventually become a member of the museum's Curatorial Council.

Despite the controversy of *Harlem on My Mind*, when the show opened on January 18, 1969, attendance at the Met during the show's tenure soared. One of the show's stars, ironically, was the visual archive of a bona fide Harlem artist James Van Der Zee. Van Der Zee's studio, once located at 135th and Lenox, as noted earlier, produced a detailed visual record of Bearden's Harlem of the 1920s, '30s, and '40s. In the process of taking photographs during his heyday, Van Der Zee generated tens of thousands of prints, glass plates, and silver nitrate negatives, an archive that documents an important aspect of Bearden's artistic heritage, capturing as it does the visual expression of style—posture, gesture, ceremonies, rituals, street life, night life, architecture.

The story of the archives' near loss serves as a cautionary tale about the fragility of material culture. Van Der Zee's business had fallen on hard times, and his business shuttered in the 1960s; he found himself and his vast archives facing eviction from his home. A freelance photojournalist, Reginald McGhee, hired as an assistant curator at the Met to work on the exhibit as part of his research, discovered the treasure trove. Obtaining temporary refuge for the Van Der Zee collection of photos at the Met, McGhee convinced Schoener to include a selection of the photographs in the show and encouraged the Met to acquire several pieces for their permanent collection. McGhee's rescue of the Van Der Zee photographs from destruction salvaged one of the most important visual and artistic archives in American cultural history and art. Young

artists and visitors to the museum may have been denied the opportunity to see the original work of painters and sculptors, but they were introduced to the master works of a master photographer and to the images of a long-ago vanished world.

By the time that Bearden received the commission from *Time* to design a cover for the November 1, 1968, issue to illustrate a cover story on New York City Mayor John Lindsay titled, "John Lindsay's Ten Plagues," his view of urban life had become ominous.[23] He chose for his *Time* cover an image more reminiscent of the apocalyptic imagery of *Projections*. Though Mayor Lindsay had been credited with keeping the city calm by walking Harlem streets, after King's assassination in the spring of that year, he was besieged by a host of unresolved and seemingly unresolvable urban problems. Bearden featured a beleaguered mayor, his hands up, a fearful look on his face, surrounded by firemen and policemen—who threatened him with work slowdowns, and schoolteachers who went out on strike. Bearden arrayed a frieze of the faces of children bereft of teachers and classrooms above the mayor's head, inserting a helmeted fireman among the children's faces. Beneath the mayor's head and torso, Bearden placed a line of buildings collapsing, as if detonated or upended by an earthquake. The magazine's cover banner read, "New York: The Breakdown of a City." Lindsay's battle to govern New York—his seemingly vain attempts to tame the city's warring factions—was the subject of the article. Bearden borrowed compositionally from his 1964 *Projection* titled *Sermon* in which the central figure holds up his hands in terrified surprise. In the *Projection*, the figure looks like a drowning man overwhelmed by the riptides of strife. In the *Time* cover Lindsay looks as though he is staring into the face of an oncoming stampede. Looking out from the twenty-fifth floor of the Time and Life Building, Bearden noted, "The buildings were full of lights," and in his imagination he "saw them toppling about the mayor."[24] Bearden's point of view permitted no heroes. Everyone except the children participated in the city's demise. Memories of Bessye Bearden's leadership of a New York City School Board through difficult times must have made the imagery for him especially poignant.

Activism for Bearden had become paramount. Protesting the establishment, curating exhibitions, and designing mass media magazine covers, as well as producing works for his continuing solo exhibitions, Bearden indulged an activism that filled his days in the years before the MoMA show. As important as his art and activism may have been, he still made time for writing. Writing proved to be a vital aspect of his creative expression, and in the summer of 1968, he began work on a long essay that would become his most important piece of writing to date—"Rectangular Structure in My Montage Paintings." Bearden emphasizes in the essay that, activism notwithstanding, he remained steadfast in insisting on the formal and structural primacy of his work. The essay, published in *Leonardo*, an international journal of science and art, in January 1969, disavowed emphatically any social or political intentions behind his collage. As a graduate student seeking information, when I sent him a list of questions, the *Leonardo* essay is what he sent in response. The autobiographical structure, along with the aesthetic assertions, served as his personal conceptual frame for his work. He argues in the essay that his artistic evolution had been a multi-decade movement away rather than toward the social and political intent of the art of his youth. As he argued in the book he co-authored with Carl Holty, *The Painter's Mind: A Study of the Relations of Structure and Space in Painting*, published the same year, form is inseparable from content.[25] Together, the essay and book presented an artist who had studied European traditions of painting along with the art of the world (with special attention to African antiquity), and one who wrestled in his own work with formal elements—composition, structure, space, line, color.

The essay could have been subtitled "The Education of the Artist" since it begins with a description of Bearden's relationship with George Grosz. Grosz's most important lesson was to teach Bearden the skills of drafting by copying the masters.[26] Grosz introduced Bearden, in his words, to "the magic world of Ingres, Durer, Holbein and Poussin."[27] As demonstrated by Bearden's multiple journal entries, his letters to colleagues, especially the detailed letters to Holty and their co-authored book, he became adept at dissecting a painting. His precision and his

belief that structure was a skill and body of knowledge to be learned is underscored by his attention to the mathematical foundation of structural analysis. He supplemented his copying by combing and annotating any number of mathematical texts in his effort to grasp the structural underpinnings of painting.[28]

Bearden's habit of copying made him a tourist in what André Malraux termed "Le Musée Imaginaire." In *The Painter's Mind,* the authors noted that "at no time in history has the art of all the world been so available to artists," such that "the possibilities for the artist seem endless, his choices and points of departure infinite."[29] Bearden freely roamed the halls of those wall-less museums, cutting and preserving images along the way.[30] As he describes in "Rectangular Structure," he continued to copy paintings by "enlarging photographs of works by Giotto, Duccio, Veronese, Grünewald, Rembrandt, De Hooch, Manet and Matisse," ever expanding his pictorial archive.[31]

In his review of influences on his art, Bearden's essay seeks to set the record straight on the influence of cubism. Though his mature collages continued to be compared to cubism, he makes a point in "Rectangular Structure" of setting himself apart from the Cubist tradition and aligns himself, instead, more broadly with traditions of flat painting. "Everything that I have done . . . has been, in effect, an extension of my experiments with flat painting, shallow space, Byzantine stylization and African design."[32] By his account, his most important tutors were "Masters of flat painting." His list of examples is long and includes De Hooch and Vermeer (both mentioned frequently in the article), "classic Japanese portrait artists, and the pre-Renaissance Siennese masters, such as Duccio and Lorenzetti," as well as the "flatly modelled drapery" of the seventeenth-century Spanish painter Zurburan.[33] Bearden argues that Picasso, Braque, and Léger sometimes employed overlapping planes in a way that overcrowds the surface of the picture plane. To further distinguish his mode of construction, Bearden discusses his use of a rectangular grid. Bearden's process is "layering," that is, of "putting something over something else," as he recounted to the *New Yorker*'s Calvin Tomkins—of accumulating layers and then tearing them away, a process of building up and tearing down. He notes that he avoided "deep

diagonal thrusts and the kind of arabesque shapes favored by the great baroque painters."[34]

Critics did not always agree with Bearden's disavowal of cubism. Critic Charles Pomeroy, for example, writing of Bearden's 1967 solo show at Cordier-Ekstrom after *Projections*, notes that Bearden "is perfectly aware of and *intends* [his italics] these pictures to be a continuation of Cubist practices."[35] The criticism that he relied on cubism followed him even after he published his rebuttal in "Rectangular Structure." Critic Lawrence Alloway went as far as to say that Bearden's collages were "derivative," a deadly charge. Hilton Kramer, writing of Bearden, referred to the works as "images of Negro life locked into an elegant cubist design."[36] Years after the publication of "Rectangular Structure," Bearden's 1975 exhibition at Cordier-Ekstrom drew comparisons with Picasso and cubism as well. David Bourdon notes that his "approach to figuration grows out of his study of cubism."[37] Cubism provided writers with a familiar lens through which to view Bearden's work and to ascribe a modernist exegesis to his relationship to African art. Bearden, however, saw his work as the culmination of a lifelong study of composition and structure, inflected by Cubist spatial innovation and figurative distortions as well as other traditions of flat painting. As his collages matured, Bearden abandoned a reliance on the regulating rectangular grids that defined spatial relationships, and as his color and the deliberately disruptive conjunctions of materials and images grew more complex, the argument of his relationship to cubism would become a moot point.

Another score he settles in the essay is the tendency to interpret his work as if it were "sending messages from the front."

It is not my aim to paint about the Negro in America in terms of propaganda. It is precisely my awareness of the distortions required of the polemicist that has caused me to paint the life of my people as I know it—as passionately and dispassionately as Brueghel painted the life of the Flemish people of his day. . . . One can draw many social analogies from the great works of Brueghel—as I have no doubt one can draw from mine—my intention, however, is to reveal through pictorial complexities the richness of a life I know.[38]

No one would describe Bearden's work as "propaganda." But as his work in collage evolved, a disparate group of writers, poets, artists, and scholars attached their ideas to his images. Bearden's representational intent, notwithstanding, artists, scholars, and the lay viewer saw more in the painting than a congregation of shapes, forms, color, and spatial relationships. What Bearden produced in "Rectangular Structure" was a controlling narrative, a script that focused writers, critics, and scholars on what he wanted his audience to see. As we will note, the world did not always view his painting limited by the frame he provided, and often there was more to see than Bearden himself was revealing.

Even as Bearden argued persuasively for the formal primacy of his own art, he remained dedicated to righting the wrongs he believed limited black artists in the art world. His encounter with the Metropolitan's resistance to the exhibition of his work fresh in his mind, he set out to establish a space where minority artists under the age of thirty could exhibit their work. An idea for which he sought funding under the auspices of Spiral finally came to fruition several years after Spiral had disbanded. Bearden applied to the Ford Foundation for support to establish a gallery for emerging artists, and in 1969, with space provided by the theater artist and impresario, Joseph Papp, founder and artistic director of the Public Theater and New York Shakespeare Festival, Bearden was successful. In partnership with his old friend and fellow Spiral member Norman Lewis and the painter Ernest Crichlow, Bearden, who retired altogether from his city job that year, established the Cinque Gallery. Cinque was the African prince who led the mutiny on the slave ship *Amistad* and, defended by John Quincy Adams in Boston, was acquitted and returned to Africa.[39] Cinque, as the gallery's name, was reminiscent, too, of Hale Woodruff's monumental representations of the middle passage, resistance, justice, and return home in his Talladega College murals that Bearden and Charles Alston had visited in the 1940s.

Writing "Rectangular Structure" provided critics and commentators a means of entering the world of Bearden's art and understanding and describing it in language Bearden himself had chosen. The influence of the essay was immediately apparent, when *New York Times* critic Grace Glueck reviewed his 1970 solo exhibition of collages at Cordier-Ekstrom

on February 22, 1970. Glueck's article, titled "A Brueghel from Harlem," assured readers that his collages "give elegant credence to Bearden's claim that his aim is not to make 'Negro propaganda,'" almost a direct quote from his essay.[40] Glueck repeats as well Bearden's insistence in "Rectangular Structure" that the source of his work is the many traditions of flat painting (as opposed to cubism) and she compares the collages to Byzantine stylization and African design. Acknowledging Bearden's "quiet" activism, Glueck reminds her readers of his work with the Cinque Gallery, his teaching forays at universities and colleges around the country, and his various writing projects. The importance of Bearden's writing assignments was evident again in the award in 1970 of a Guggenheim Fellowship that, according to the grant application, would allow him to co-author an extended history of Afro-American artists and "search for real value in terms of aesthetic and human relevance."[41] Enlisting the aid of Harry Henderson, an experienced writer and researcher, Bearden co-authored *Six Black Masters of American Art*.[42] Written for children, the text describes the artists' lives, their times, struggles with their craft, use of materials, and working conditions. *Six Black Masters* served as a prelude to Bearden and Henderson's major opus—*A History of African-American Artists: From 1792 to the Present*, published posthumously. Bearden would indicate in his final report to the Guggenheim Foundation that his research took him to libraries, archives, private collections, the Library of Congress, National Archives, and led him to conduct hours of interviews with still living artists.[43]

Given Bearden's growing artistic reputation, along with his conscientious activism, it is not surprising that the Museum of Modern Art tapped him for a retrospective. What was surprising, however, is that for an artist intent on uncovering the whole truth of African American art, the museum chose to present a "Cliff Notes" version of an artistic career that spanned several decades and explored such a diverse range of styles and genres.

Curated exhibitions can be considered a form of white paper—that is, they present a thesis and then assemble evidence in the form of physical artifacts to illustrate that thesis. Bearden's first retrospective

dramatically foreshortened the arc of his development, omitting altogether as it did several phases of his career.[44] Whether it was the choice of the curator, Caroll Greene, or the limitations placed on the exhibition by the museum, or Bearden's decision to omit certain paintings is not clear, but the retrospective, containing only fifty-six works, eliminated whole periods from Bearden's body of work. Examples of political cartoons from the Depression era, literary abstractions from Bearden's time with the Kootz Gallery in the 1940s, and the large nonobjective oils of the late 1950s and early 1960s were left out. Their omission was even more inexplicable considering that a first-rate example from the figurative abstraction period and a large abstract oil (to be discussed later), were in the museum's permanent collection.

Greene identified the organizing principle of the collages, his white paper premise, as the "Prevalence of Ritual," a phrase first used by Bearden to describe a group of works in the 1964 debut of *Projections*. Prevalence of ritual represented Bearden's quest for a conceptual framework ample enough to express the richness of black identity and culture. All fifty-six paintings, collages, and *Projections*, were scenes of black life. Six were paintings completed in the stylized social realist mode that Bearden adopted before World War II, and the remaining works were collages and *Projections* completed between the years 1964 and the opening of the MoMA show. From the social realist paintings to the collages, the show gave the appearance that Bearden had made an aesthetic leap and discovered the connection of the rituals and ceremonies of black life to representations of rituals and ceremonies from other times and other cultures. Though Greene discussed in the catalogue's essay the paintings (he omitted discussion of the cartoons) from the eras missing from the exhibition, he characterized Bearden's changing artistic styles as an effortless process of moving "gracefully" as he put it from one style to the next "on to new ground."[45] Greene's narrative gave no hint of the conflicts, dilemmas, struggles, or aesthetic experimentations Bearden worked through as he made his way from one style to the next and eventually to collage.[46] The organization of the paintings and collages in the show itself—if not the catalogue—shifted attention away from Bearden's voyage through the shoals of myriad

artistic traditions and focused instead on the evolution of his treatment of black subject matter. Bearden's belief that "modern painting progresses through cumulative destructions and new beginnings" was nowhere apparent.[47]

Greene's approach does allow him to recognize the unfurling of Bearden's expansive imagination, and track the way in which that imagination in his collages lacerates time, geography, and cultural boundaries. The omissions are a distortion of his evolution as an artist, nonetheless. Focusing on black subject matter, for one, deletes the artist's efforts to locate himself in the lineage of American modernism's evolution in the New York art world. Bearden, as noted, was one of the original members of the seminal Sam Kootz Gallery, for example. A Bearden painting in MoMA's collection, *He Is Arisen*, 1945, a gift to the museum from Sam Kootz, would have illustrated Bearden's relationship to that lineage. Similarly, another painting from MoMA's collection, would have demonstrated Bearden's foray into an Abstract Expressionist idiom, in this case, gifted by Arne Ekstrom, a large nonobjective abstraction, *Silent Valley of Sunrise*, 1959.[48] Both canvases represented stylistic expressions that Bearden worked through on his way to arriving at collage. Their absence robbed the artist of the full measure of his artistic evolution and, ultimately, the full measure of his accomplishment.[49]

Though the slender catalogue for *The Prevalence of Ritual* was a far cry from the richly resourced publications accorded other MoMA retrospectives, it did provide a solid foundation for additional Bearden scholarship. Greene's essay was accompanied by an inclusive chronology compiled by April Kingsley and a well-researched bibliography assembled by Judith Goldman. The retrospective's national tour, which took the show to the National Collection of Fine Arts, Washington, DC; University of California Art Museum, Berkeley; Pasadena Art Museum; the High Museum, Atlanta; and the North Carolina Museum of Art, Raleigh-Durham, brought national attention to Bearden. An unscheduled stop brought the show back to New York in the summer of 1972 to the newly established Studio Museum in Harlem, only blocks away from Bearden's first studio above the Apollo Theater, and a reminder of his artistic origins.

A centerpiece of MoMA's retrospective was *The Block* and MoMA's press release of Bearden's exhibition called attention to the piece in particular.[50] The large scale, multi-paneled work was accompanied by Caroll Greene's recording of actual city sounds combining a documentary literalism with the work's aesthetic complexities.[51] Bearden deliberately underscored the former by identifying the actual city block represented—Lenox Avenue between 132nd and 133rd. To look at the piece is to experience the block as if Bearden had constructed a tour from multiple vantage points, the most dominant of which was an elevated one. The artist places us alongside him as an omniscient narrator, looking down from above. His actual perspective was the roof of Albert Murray's Lenox Terrace apartment building. He and Murray would stand there and survey the Harlem neighborhood below, a practice documented by the filmmaker Nelson Breen in his 1980 video, *Bearden Plays Bearden*. In the film Bearden discusses his process of developing his ideas for *The Block* by making a set of impromptu sketches. Frank

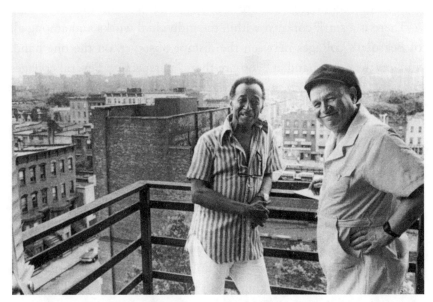

Albert Murray with Romare Bearden, standing on the balcony of Murray's Harlem apartment building, 1980. Photo: Frank Stewart.

Stewart's well-known photograph of the two artists captures Murray and Bearden during one of their rooftop perusals of the city below.[52]

The Block was a summary statement for Bearden, combining as it did imagery, composition, iconography, and narrative structure from earlier collages. Bearden first made use of the elevated perspective in a 1964 Projection/collage, *Untitled.* In the collage, two men—both white—survey the city from a roof top. One wears a top hat and tuxedo, the other a cardigan sweater over a shirt and tie. Both are far removed from the scene of mayhem below them. Unlike *The Block,* in *Untitled* the presence of the observers is explicit. They look down from the roof to a clash between police, dressed in colonial garb, and crowds of young and old, black and white citizens, whose faces are distorted by anger and emotion. Above the heads of the two rooftop observers, airplanes are dropping bombs. The Statue of Liberty is depicted as a mute symbol of democratic ideals, hand aloft—her gesture mirrored in the clenched fist gesture of a young black woman at the left of the picture frame. A portrait of warring cultures, the collage shudders with the clashes and collisions inside American cities, and foreshadows what would become fiercely divisive culture wars in the decades ahead.

There is a stark contrast within the individual works and among all of Bearden's collages between the distant observer, on the one hand, and, on the other hand, a "you-are-there" perspective. Several collages from the 1964 *Projections* place the observer, along with the artist, at street level. *The Street, Spring Way, The Dove, Pittsburgh Memory*—all open up the space of the collage to the spectator. The action, however, is always formally framed. In *The Street,* Bearden uses the practice from Chinese painting of opening up a corner to let the viewer enter. Once inside, the viewer is thrust into a deep perspective, a space that burrows into the picture plane—in this case, into the dense, jittery world of the street. Multiple mise-en-scenes circle around the couple at the center—she drapes her arm around her companion; he plays a guitar—who act as cultural tour guides. The figures are pictured in sharp detail, their eyes locking with the viewers' eyes, their hands enlarged, their expression bold; they physically engage with each other and with the viewer.

Equally immediate in its impact, *Spring Way* shifts the vantage point away from the group to that of a single silhouetted figure in a scene of urban desolation. Bearden shifts perspective yet again in *The Dove*, placing viewers directly opposite the block, as if watching from a stoop across the street. Yet another shift occurs in *Pittsburgh Memory*, in which he shoves the faces of two men, their skin and hair texture enlarged and tactile, right up against the picture plane, as if the spectators have just collided with them on the street.

The city was a presence in Bearden's oeuvre from the time that he started painting until the end of his career. His earliest cartoons and sketches included observations of scenes on city streets, the market, the city's factories, and urban workers. One of his earliest surviving paintings is of an unpeopled street, featuring an industrial warehouse. His first magazine cover for *Opportunity* was of an urban factory. In his collages, in addition to depicting the gritty realities of Harlem and Pittsburgh, and even Charlotte, he depicted cityscapes. His collages included scenes of New Orleans, Kansas City, and Chicago, geographies that chart the origins of blues and jazz. In the years after *The Block*, he would devote a major series, *The Odyssey*, to the devastation of one city, Troy, and the hero's return home to another, Ithaca—the voyager in search of his true home. Paris, the city that ignited his imagination and gave him a sense of what it was to live in a culture that honored its artists, would also reclaim Bearden's attention in the form of what would be an unfinished collaboration with Sam Shaw and Albert Murray, *Paris Blues*.[53]

By the time he tackled *The Block*, he had accumulated a structural and compositional vocabulary and developed an urban iconography. Bearden's several sketches for *The Block* survive, originally housed in Albert Murray's collection, are now in the collection of the Metropolitan Museum, where *The Block* is part of its permanent collection. The drawings, in colored ink, markers, and graphite, illustrate Bearden's attentiveness to the details: individual houses, makes of cars, street signs, architectural elements. His drawings breathe life into the street, giving character to a broken lintel, worn columns, sagging stoops, a gate, a canopy. When he translates the drawings into the materials of collage,

he leaves abundant evidence of the translation—the abrading, smudging, layering of paint over paper, and the cutting done to make the physical surface of the materials as expressive as the figures that populate the collage.

The minutest detail seems important: a piece of thread, barely visible, connects the wing of one angel to the wing of another. A fragment of printed fabric that Nanette may have discarded from her dressmaking makes up the dress of one of the women. Yet Bearden also took care to avoid a sense of visual clutter. Color slows down the internal rhythms of the piece. He has cut razor straight lines into sheets of colored paper to construct the organizing grid that orders the actions in each dramatic vignette. Color was integral to his idea of composition. "I could consider color as a place & a position in space," he wrote in a letter to the author, dated May 11, 1972. "I use gray as an interval—like a rest in music—to control the coloration. If one just doesn't tint drawings, in essentially a black and white concept, you must consider color as coincidental with form and space."

When the MoMA retrospective began its national tour in the summer of 1971, Bearden eliminated Greene's soundscape from *The Block*. Without the noise of the city as a backdrop, the monumental piece was left to speak on its own terms. Visually, the six panels presented a series of contrasts. For instance, public versus private; by cutting away the exterior wall of some of the houses, the work exposes intimacies (using a technique he first learned in Pittsburgh in Eugene Bailey's bedroom). This practice first appears in *Untitled*, in which a nude reclines in the window of a tenement, a bare lightbulb hanging over her, fully exposed and public. *The Block* retains the public/private contrast: a mother putting her child to sleep, a woman bathing, couples making love; these are juxtaposed to public rituals, such as mourners leaving a funeral home, revelers on the street, children playing. Sacred stands opposed to the profane. The miracle of an apotheosis, replete with angels, on the high floors of the building contrasts with the pallbearers carrying a casket to a waiting hearse and interment. Carnal lovemaking is pictured alongside a religious scene, the Annunciation, a winged angel kneeling before a naked pregnant woman, the child in her womb clearly visible.

Life is cheek by jowl with death: an old woman standing at her gate and the young children staring out of the window, a gigantic mousetrap and children dreaming by the window. Television's fantasy image—here the scene of a sailboat on the screen—clashes with surrounding reality.

Time is a character in the sweeping narrative of *The Block*. Bearden locates the viewer in a particular time and place, the make and models of cars always easily discernible; the television set tuned on and visible in the sixth and last panel. The iconography of Pop Art—letters, cars, television sets, and commercial signs—is present but without irony. In place of detachment there is empathy, encouraged by time. Moving from left to right, colors gradually darken from one panel to the next, to suggesting a day in the life and slow death of the block. Life, love-making and the announced moment of sacred conception, the sense of continuity and with it hope exist side by side with Death, a funeral and apotheosis. Time looks forward and backward. Once grand architectural detail—ironwork, arched windows, masonry—are chipped and crumbling, evoking the decline and decay of the streets that were once the stage for the pageants and processions he witnessed as a boy.

Bearden's monumental work on the city evoked those modernists who appropriated the rhythms and images of city life. Léger's "greatest period," "known as 'paysage animée,' . . . terminated in his great painting, *The City*, a work that Bearden and Holty cite in their book."[54] In his 1919 painting, Léger, whom Bearden visited in Paris, created an ominous image of a labyrinth of strangers, with faceless figures in silhouette, fragments of lettering, and jarring swatches of color. Piet Mondrian's 1942 *Broadway Boogie Woogie* was another iconic work that evoked the city's verticality, grid-like streets, urban pulses and rhythms.[55]

Stuart Davis, another artist who frequently chose urban motifs, was one of Bearden's mentors. Davis was adept at turning the commercialism of city life into abstractions of color, light, and space. Closer to the time frame of Bearden's collages, Pop Art, not one of Bearden's favorite idioms, captured something essential about contemporary urban life. Robert Rauschenberg's combine, for example, *Canyon*, with its abraded and smudged surfaces layered with photos, newspaper, debris, and the protrusion of a stuffed bird, is an example. Ray Saunders, yet another

collage artist, in his work, *Soda*, creates a stenciled and rubbed surface mimicking the surface of a blackboard in an inner-city schoolroom. Simon Rodia scavenged the city of Los Angeles for scraps, bits of porcelain, leftover machine parts, broken glass, and utensils to build from the city's refuse something magnificent.[56] Bearden's *Block* takes its place among the great twentieth-century works about urban life.

A modern masterpiece, *The Block* not only represented urban life; it beckoned a call and response exchange between European and American modernism and the Black Arts Movement. An example is the connection that Bearden established with Jayne Cortez (1934–2012), a highly regarded poet and member of the Black Arts Movement. Cortez had published her first volume of poetry—*Pisstained Stairs and the Monkey Man's Wares*—two years before the MoMA retrospective. At the opening of the retrospective, Bearden, noting Cortez's intense interest in *The Block*, invited her to write a poem in response to the piece. She did and sent it to him, honored to have been asked.[57] Months later, he called her with the news that he was sending her a package. Shortly after the call, a composition book arrived. Bearden had filled in every page, front and back, with the words of Cortez's poem, accompanied by sketches that consumed every square inch on every page of the notebook. Compulsive, driven, sprawling from one page to the next, it was as if Cortez's biting lyrics and vivid imagery had inscribed themselves directly in Bearden's visual imagery. A private exchange, the composition book remained in the hands of the poet for over forty years. Cortez's poem, "Collage for Romare," was later published and interprets his urban imagery as a migration narrative, viewing the scenes in *The Block* as permutations of a culture deracinated from its southern roots.

> *stand up*
> *for this slow drag of a slow death from*
> *a fast world outside of choir books*
> *dream books*
> *comic books*

junkie books &
bookies booking book
next to brick buildings
purple leaking roofs
next to lady's gardenia spray
magenta curtained hearse
next to life gone back
separated from the beautiful times
downhearted times[58]
© Jayne Cortez, 1971

Bearden's response to Cortez's poetry demonstrated his aesthetic agility and capaciousness. From his enthusiastic embrace of her poem to his covers for commercial mass media publication magazines like *Time, Fortune, or* the Sunday *New York Times Magazine* to what would be other encounters with artists of the Black Arts Movement to his immersion in global art forms, Bearden's interests extended far and wide. When the MoMA retrospective reached its final destination at the Studio Museum in Harlem, he demonstrated that his work was as well received on 125th Street as it had been in midtown Manhattan. In 1972, Trinidadian writer and co-founder and president of the Harlem Writers Guild, Rosa Guy, wrote an article for the *New York Times,* "Black Perspectives on Harlem's State of Mind." Illustrated with excerpts of Bearden's urban images, the article bemoaned the decay of a once-great community, the collages being evidence of both greatness and decline. A year after the national tour of the retrospective ended, Bearden created a stage environment for playwright, Ed Bullins's *House Party. A Soul Happening.* Bullins, another leader in the Black Arts Movement, wrote the musical while artist-in-residence at American Place Theater and was a driving force behind the New Lafayette Theater, an effort to revive the Lafayette's glory days. Bullins had also served as minister of culture of the Black Panther Party.

The exchange between Cortez and Bearden and the growing number of artistic partnerships Bearden forged revealed not only the

range of his artistic interests but what would manifest itself in his later work as an intensely collaborative sensibility. Collage itself is a form of collaboration, a willingness to surrender to shapes, colors, representations of an outside or alien hand. It requires the artist to bring together disparate, potentially conflicting elements in search of something new and unexpected. Bearden's fundamentally collaborative spirit was first sparked when the Spiral artists convened, and it manifested itself in an almost explosive creative response to Cortez's poetry. In its most conventional definition, collaboration is cooperative; but, as a dictionary definition attests, a collaborator may also be one who cooperates or willingly assists an enemy of one's country. Bearden allowed himself to align with ways of being an artist that were not necessarily his own, but challenged him. His collages and his artistic partnerships are partially responsible for the resistance his work poses to conventional art historical taxonomies. After the MoMA retrospective, his collaborative instincts would become public, more numerous and more bold.

Bearden and Hunt's retrospectives were milestones both for MoMA and for the two artists. Despite whatever complaints were lodged against its practices and policies, MOMA was still the official church of modernism in 1971 and still wielded enough power and prestige to ordain modernism's masters. Bearden and Hunt had been so ordained. For Bearden, the fact of a solo museum exhibition in and of itself was not remarkable. Since the debut of *Projections*, he had enjoyed several solo museum shows of *Projections* and collages: the Corcoran Museum of Art in Washington showed a selection in 1965, followed by a solo exhibition at Carnegie Institute and the 1968 show at the Art Gallery of the State University of New York at Albany, the exhibit that occasioned Ellison's brilliant catalogue essay. The MoMA exhibition was significant because it was New York, and New York was the international capital of the art world. Moreover, the show, whatever its limitations, was the first to make an effort to establish the arc of Bearden's career. As its curator Dr. Caroll Greene wrote in the catalogue essay, the show

displayed "the mature fruition of a theme that has obsessed Romare Bearden for over thirty years—the aesthetic expression of the life and life style of a people in visual and plastic language."[59] That there was much more to his mature fruition was a discovery that would have to wait for many decades.[60]

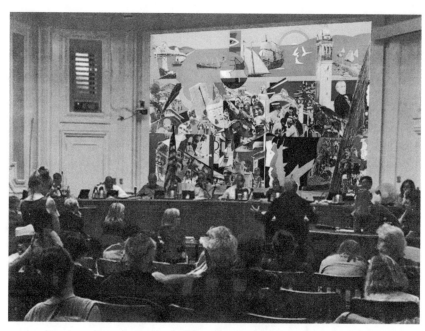

Romare Bearden's *Berkeley: The City and Its People,* 1972,
mounted in the Berkeley City Council chamber, 2006.
Composite photograph.

THE PUBLIC ROMARE BEARDEN

While no government can call a great artist or scholar into existence, it is necessary and appropriate for the Federal Government to help create and sustain not only a climate encouraging freedom of thought, imagination, and inquiry but also the material conditions facilitating the release of this creative talent.

—Excerpted from the National Foundation on the Arts and Humanities Act of 1965

"My Man," Bearden proudly wrote painter, Herb Gentry, during the summer of 1972, "the mural was dedicated. The one on 42nd St. On T.V." The unveiling of Bearden's first major public installation, a mural in Times Square, was an occasion for news coverage. Times Square—the ultimate collage, a flashy assemblage of blinking neon, billboards and people, exhortations and seductions—was the perfect setting for Bearden's first public art commission.[1] The installation was temporary—it lasted two years—and, little more than an upscale advertisement for cultural events in New York City Parks, the work demonstrated Bearden's keen sense of public place and occasion. Measuring 102 feet by 40 feet, the billboard-sized mural was filled with decorative cut-out figures that bore a strong resemblance to Matisse's Jazz cut-outs. To personalize the work, Bearden emblazoned on it in his own handwriting the words "Dance, Art, Drama, Poetry, and Movies" and entitled west side of Seventh Avenue and 42nd Street, on a tower high above the fray. Times Square would prove to be an easy assignment. As Bearden took up the gauntlet of public art commissions, he would find that

commissions would force him to make a distinction between a rich, complicated private voice and the civic needs of the public arena.

Shortly after the Times Square mural was dedicated, Bearden was at work on his next public commission—an epic collage project for the city of Berkeley, California. He finished the preliminary sketches for his new mural as he celebrated the installation of *The Grill*, a circumstance that would become commonplace (public projects lined up in a queue that extended beyond his lifetime). "Public," for Bearden, took many different forms. In addition to large public works in situ, he ventured into the worlds of artists who worked in an array of mediums—dance, poetry, theater, music, film, architecture, and design. To make his art accessible, he collaborated with master printmakers to translate costly one-of-a-kind collages into exquisitely crafted prints. His almost frenetic pace had him moving from intimate scale to monumental, translating cut paper into mosaic, stone, and fabric. At any given time, he was planning, producing, or overseeing the production of a major commission (close to twenty were planned and executed during his life and posthumously), or working on a solo exhibition, or partnering with another artist. Bearden's decision to enter the public sphere came in the middle of a resurgence in the popularity of public art that had begun in the 1960s.

After the demise of the WPA in 1943, there were few federally sponsored public art commissions until the General Services Administration resurrected the idea in 1963 with their Art-in-Architecture program. That spark kindled a conflagration. Public agencies at the federal, state, and local levels—and the private sector as well—became caught up in the enthusiasm of supporting individual artists and, at the same time, what some considered providing a public amenity. At a time when Bearden and his fellow artists were protesting against the exhibition policies of private museums, such as the Metropolitan Museum, the Whitney Museum, and MoMA, the growth of public art offered work to a diverse range of artists. Over time, public art commissions became a respectable complement to private museum opportunities as well as a means of connecting the artist to a public that extended beyond museum walls. As was the case with the WPA, public art projects also supported artists financially.[2]

The growth of public agencies devoted to art and culture in the 1960s helped gain visibility as well for a growing number of artists. Governor Nelson Rockefeller established the New York State Council on the Arts in 1964, one of the earliest state arts agencies. The National Endowment for the Arts and the National Endowment for the Humanities followed in 1965 with lofty goals that resonated with President Kennedy's aspirations for the arts. Along with New York City's Department of Cultural Affairs, state, federal, and city agencies combined with public art opportunities and the growth of alternative museums and galleries. Together they formed a network of support that acknowledged a broader band of artists, cultures, and styles than those validated by establishment galleries, museums, and canonical art histories. The countercurrents of New York in the 1960s, 1970s, and 1980s bristled with an energy that kept New York central to a global artistic conversation and provided the terms of the debate with energizing complications and contradictions. As courtyards, walls, floors, ceilings, fences, facades of schools, hospitals, prisons, police precincts, libraries, museums, public service buildings, parks, and playgrounds became venues for the display of art, the arena for battles over representation continued to grow larger and more diverse. Bearden discovered early on in his encounter with the public sphere that when issues of race and representation were at stake, those battles could ambush even the best intentions. A close look at the circumstances surrounding two of his most artistically successful murals proves this point.

Writing from California, where he was presenting a seminar at the University of California, Hayward, and beginning work on the Berkeley mural, Bearden confessed that he found life on the West Coast so "restful and handsome" that he worried that if he lived there he'd "hardly do any work." At least in New York things are "so terrible" that "there is nothing else to do but turn in on yourself and work."[3] His feelings about the two cities at opposite ends of the country—Berkeley and New York—resonate in the two very different epic collages he created for sites in each metropolis. The Berkeley mural would be his first major permanent installation; a mural for a hospital in New York would be one of his most renowned public works and the most controversial.

Bearden was not an obvious choice for a mural representing the city of Berkeley. He had never been to the city and knew very little about it. When the MoMA retrospective, *Prevalence of Ritual*, made a stop at the University Art Museum at Berkeley as part of its national tour, discussions were already under way about art for the city's soon to be renovated city council chambers. With the arrival of the collages in the *Prevalence of Ritual*, a broad consensus quickly assembled around Bearden's work. As one local, critic observed, "With a gentle sympathy, he explores his culture and our culture with the sensuality of a good physician feeling for broken bones."[4]

Bearden's supporters were numerous and diverse. Peter Seitz, founding director of the University Art Museum at Berkeley and renowned art historian and curator, chaired the city's Civic Art Commission and led the chorus of supporters. Along with collage artist Raymond Saunders, who also sat on the commission, and the artist Russell Gordon, Seitz joined forces with two newly elected black city councilmen to form a coalition of support. Saunders and Gordon, who both taught at the Hayward campus of California's university system, arranged Bearden's visit to the campus, giving the artist the opportunity to visit the city. Just a few months after he returned from his west coast seminar, Bearden's ideas gelled into sketches.[5] Though he makes no mention in his letter of the content, the challenges the mural presented were not insignificant. However much Bearden was embraced by the Civic Art Commission, their enthusiasm could not mask the fact that Berkeley was a city with a contentious past. His challenge was to confront that past and, at the same time, offer a vision of its future.

Sitting across San Francisco's East Bay, Berkeley is, of course, home to one of the world's great universities. In the mid-1960s the university was the birthplace of the Free Speech Movement. Student protests against the escalating war in Vietnam and their active support of the civil rights movement roiled the campus. Familiar campus landmarks like Sproul Gate and the Watchtower were all well-photographed backdrops to what amounted to a campus takeover by student groups rebelling against institutional authority. Student movements had reached a climax in 1968, when protests erupted in Prague, Paris, and

Mexico City. Bearden's activism in those years was sparked in part by similar events and reminiscent of the activism of his youth and in the 1960s, providing an emotional connection to the city. A backlash to campus upheavals—Ronald Reagan was California's governor throughout much of them—left in its wake a city divided. Acknowledging those divisions and yet presenting a unifying vision of its future posed a narrative and visual challenge for an artist who at this point in his life still claimed for his art work a disinterest in political and social issues.[6]

The site for the mural, Berkeley's City Council Chambers, put it at the civic and political epicenter of the city. Moreover, the site presented very real physical limitations. A high-ceilinged room in a modest brick building that faces a park, the chambers are bound on one side by large windows, the world outside—a park, city streets, university in the distance—in full view. At the front of the room, city council members sit on a raised platform, facing their audience who, during public proceedings, are seated in neat rows of folding chairs. Normally the public faced a black-and-white aerial photograph of the city, bookended by images of George Washington and Abraham Lincoln. Traditional as the background was, council proceedings were a form of public theater, full of the "polemics, compromise and exhortation" of public discourse.[7] Bearden understood full well the challenge he had been handed.

Unable to rely on his own memory and experience, Bearden turned instead to his considerable research skills. During his one-week stay in the spring of 1972, he enlisted the assistance of Carl Worth, secretary of the Civic Commission, to be his tour guide and coordinator for all of the sites he wanted to visit in the city. Years later, Worth offered his recollection of the sites they visited, including "two local church services, and a Buddhist service, . . . a City Council meeting, a Housing Commission Meeting and an Asian Youth Alliance meeting."[8] Accompanied by Nanette and a photographer, Ellsworth Mitchell, whose work found its way into the final collage, Bearden watched and listened. Just as he imagined the great cities that incubated the blues and jazz—Chicago, Kansas City, New Orleans—or life behind the facade of the Harlem panorama in *The Block,* he imagined the California past of pioneers, Indians, and ambitious industrialists, the connection to the world that

stretched out over the Pacific into Asia. The result was mounted in the Berkeley City Council Chambers on January 20, 1974.

Measuring 26 by 40 feet, consisting of six panels, the collage fills the wall behind the platform and acts as the centerpiece of the room. At the heart of the mural, Bearden placed photographs of participants in the Free Speech Movement, images of dissent and disruption he had culled from periodicals. He brings the spectator close up, face to face with the mural's center, a crowd of protesters, using black-and-white photos of faces, hands, eyes of men and women, young and old, black, white, Latino, Asian, Native American. They gesture defiantly as they stand in front of Sproul Plaza, the focal point on the Berkeley campus of the Free Speech Movement. The action in the mural radiates from top to bottom and to the left and right of the central group and draws our attention to individual passions, yet we are conscious of his hand assembling them. Close inspection of the surface of the mural reveals the slivers and shards of colored paper, color ink drawings applied over the box cutter slices of paper, and textured blitz of photographic images. The disparate elements are all held together by the classicism of a me-ticulously established underlying grid of rectangular blocks of color. Bearden represented the cultural multiplicity of the city with an explosion of fragments. Yet he was also careful to represent individuality. Faces are distinct, their ethnicities, professions—priest, medical researcher, student, mother, and child—carefully identified. He underscores indi-vidual identity as the precursor to a collective civic identity. He lays bare civic passions in order to compose a tableau of civic order.

Even as Bearden invites us to look closely at individual identity, he provides a sweeping aerial perspective, an evocation of the work that his mural replaced. He steps away from those faces and passions by placing an all-seeing eye that sweeps over the city, taking in the body politic in all of its pluralism. It moves from past to present; geographi-cally, from beyond Berkeley to the San Francisco Bay and the Bay Bridge; from Anglo-Saxon industrialists, to coonskin wearing pioneers to Native Americans, to Asians to black residents to students. Unlike the black-and-white aerial photograph that previously hung in the council chambers, the mural's aerial perspective is a radiant Technicolor rainbow

of colors. Color underscores multiplicity and pluralism. Reinforcing the figurative, Bearden has placed rainbow arcs in the sky. At the right-hand corner a series of heads cut out of colored paper—black, brown, yellow, white—echo in silhouette what he has provided in the photographs.

Bearden's collage celebrated the city's racial, ethnic, and religious diversity, making its contentious past a point of prideful departure, featuring the university as a site of learning and research and discovery as well as a place of dissent. Berkeley's citizens were and remain a diverse mix. In a population of about 100,000 (in 1974), whites made up just over a half while black, Latino, Asians, and mixed race each comprised roughly 10 percent. A few years after the mural's completion, the city formally adopted the image of the multiple heads as the City of Berkeley's official logo. When art critic Hilton Kramer saw the mural for the first time, he pronounced: "It's without doubt one of the successful achievements in public art in this country in the 20th century—and I mean aesthetically successful."[9] Aesthetic success, as Bearden would quickly come to find out, however, was necessary but not sufficient for public art.

Bearden would learn that lesson when he completed the work for what would become *Cityscape*. In December of 1974, he had submitted a design for a new commission and it had been approved by the New York City Design Commission. *Cityscape* was a collage destined for a new wing of the Lincoln Medical and Mental Health Center in the South Bronx. He accepted the design commission despite the fact that shortly after he returned to New York from the west coast installation, an accident in front of Bearden's Canal Street building in February of 1974—he slipped on some ice and broke his ankle—left him immobilized for several months. His schedule, however, barely registered the interruption.[10] Except for the postponement of his 1974 fall show for Cordier-Ekstrom until the spring of 1975, Bearden met all of his mural obligations.

In addition to Lincoln Hospital, that year there was an installation of Bearden's untitled glass mosaic in the lobby of IS 84 (now PS 811) in the Mott Haven section of the Bronx. A 28-foot-long mural, the work is a symbol of ethnic solidarity between the black and Puerto Rican students who dominated the PS 84 population at that time. At the left is a schematic

of a map of the island of Puerto Rico and at the right a schematic map of the African continent. Represented on a large open book at the mural's center are the silhouetted profiles of a black student and a Puerto Rican student facing each other. Below their silhouettes is the Manhattan skyline. Bearden's mural is an image of aspiration and Latino/African American cultural partnership. It came at a time when the Bronx, though visibly in a state of physical decay, was alive with a creative energy that percolated just below the surface, invisible to those who did not know the borough well. Although Lincoln Hospital was also in the Bronx, Bearden chose for the hospital a theme entirely different from that for the school. Instead of making a public statement to his audience about aspirations and ethnic solidarity, he chose to hold a private conversation with himself and the themes and subject matter that captivated him in his art.

Private conversations such as that were on full display in Bearden's annual solo shows at Cordier-Ekstrom. His vision was becoming increasingly sensual and intimate. His heightened sensuality reached full bloom in the context of his representation of Caribbean culture. A solo exhibition opened on March 11, 1973, at Cordier-Ekstrom, titled, *Romare Bearden: Prevalence of Ritual: Martinique, The Rain Forest Series*, showcasing Martinique, as opposed to the streets of New York or Berkeley, as Bearden's creative domain. Collages in the *Rain Forest* series re-create a paradise, bursting with flowers, and dense color and images of the black female body. Bearden pictured her sometimes as a stately silhouetted figure; sometimes he constructed hyper-literal photographs—some were taken from popular magazines, some from pornographic publications. Instead of placing his subjects inside the interiors of tenements and brownstones, Bearden has chosen to place them outdoors in lush generative settings. With a nod to a biblical moral imperative, he included the reminder that Paradise carries within it the fall, evoking Cranach's painting of the subject in the collage, *The Fall of Troy. Rainforest* gives Bearden the occasion to revel in the beauty and desirability of the black female body and the series is an unabashed celebration of that beauty.

Bearden continued his private conversation in the next series, *Of the Blues*, that opened on February 14, 1975. At Arne Ekstrom's suggestion,

he constructed the series of collages that recounted chronologically and historically the emergence of jazz, beginning with its southern blues roots. Bearden pictures the religious rituals and ceremonies—church revival, gospel music—and secular venues—juke joints, brothels, cabarets—that incubated blues and jazz idioms. He travels from the south to the north, following the geography that marked its performance styles and the evolution of its musicians—Kansas City, Chicago, New Orleans, Harlem. Brothels and cabaret scenes are the occasion for him to display the bodies of black women, a stark contrast to the matronly figures that appeared in his earliest paintings.[11]

Bearden's cabaret scenes, in particular, faithfully represented the performers and performance styles delineated in great detail and are among the most intensely expressed and beautifully executed scenes in the series. They are illustrations of what Performance Studies scholar Shaun Vogel writes about the Harlem cabaret scene, in general, and that is, it was a site for the construction of alternative racial and social identities. Cabaret life, well known to Bearden during his "Dawn Patrol," was a challenge to an ethos of respectability championed by the black bourgeoisie. The women of Bearden's childhood—Rosa Kennedy, Catherine Kennedy Cummings, Carrie Banks, and Bessye Bearden—staunchly upheld that ethos of respectability.[12] Harlem's nightlife during Bearden's youth blatantly defied the moral imperatives of "Negro Uplift" held dear by striving families like the Beardens. Women, in particular, dressed modestly, behaved temperately, and were dignified. In the context of the cabaret scene, the black female body, often in segregated venues, was exposed bedecked and bejeweled for visual consumption and sexual titillation.

For Bearden and his artist friends, who traveled to the after-hour joints, cabaret was more than voyeurism; it was a place where they could witness performers who creatively invented their own world on stage. Gladys Bentley, Johnny Hudgins, Ethel Waters, and others appeared in what were often risqué but original and innovative performances.[13] An affront to respectability, as Vogel argues, Harlem's night life was fundamentally creative, the basis for providing "new ways of seeing, feeling

and being were produced in and through night life's intimate enact-
ments and literature."[14] Bearden's new collage work was evolving and
embracing not just the compositional imperatives of the music but the
creative freedoms of its creative performance styles. He was immersed
in this discovery of the Caribbean and jazz just as he was working on
his major commission for the Lincoln Hospital.

Bearden sensed that his hospital commission in the Bronx was not
going as smoothly as had his Berkeley City Council commission. In an
undated letter to Herb Gentry, he complains about having to listen to a
variety of opinions about his work: "Now that democracy has given
everyone a voice—the charlatan, the thug, and the imbecile must be
heard equally with the sage."[15] By the time *Cityscape* was installed in
1976, complaints and opinions about his work had mushroomed into
outright anger and hostility. Unlike the celebrations that greeted the
Berkeley mural or the success of his school mural in Mott Haven,
Cityscape faced vocal opposition. In particular, the work incensed a
powerful Puerto Rican Bronx city councilman, Ramon Velez.[16] Velez,
quoted in a *Daily News* article, branded *Cityscape* as "too obscene and
not relevant," and went on to call it "a piece of junk that is not worth
anything." Bearden had stepped into a minefield, one that pitted his
private aesthetic investigations against a public need that Bearden was
either unable or, defiantly, unwilling to acknowledge.

Bearden's work was to have been the triumphant climax to the gleam-
ing new hospital facility, a major coup for the South Bronx. The new
wing of the hospital not only replaced a decrepit facility but stood as a
symbol of public reinvestment in a borough that had been given up for
lost. For many of the postwar years, the Bronx had experienced a slow
hemorrhaging of citizens and the exodus of many of the businesses that
fueled the local economy. New York in general, during the mid-1970s,
was home to any number of communities given up for dead: Harlem,
Chelsea, the Lower East Side in Manhattan; Fort Green and Bedford
Stuyvesant in Brooklyn. Like these neighborhoods, the South Bronx had
become pocked with debris-strewn vacant lots and abandoned buildings.
Arson added to its woes and the phrase, "The Bronx is burning," had
become commonplace. Presidential candidates Jimmy Carter and

Ronald Reagan would both make television appearances in the South Bronx—Carter in 1976 and Reagan in 1980—during their campaigns. Each chose the same vacant lot and abandoned buildings as a backdrop, as each attempted to present an image of America's so-called permanent underclass.

With an overwhelmingly youthful population, the Bronx was home in the 1970s to the birth of hip hop and its transient plug-ins and street jams that were spawning what would become the next decade's world-wide youth culture. Hip hop was a "do it yourself" expression of dance, music, and visual style that celebrated a renegade resistance to the status quo. Community activism, though not yet visible to the general public, was at work, and new cultural groups like Fashion Moda that opened in 1978 were becoming a force in the New York art world. Fashion Moda featured artists such as Keith Haring, Jenny Holzer, Kenny Scharf, and a number of graffiti artists. An enterprising arts council, a fledgling museum, and a cutting-edge Spanish language theater, as well as a host of arts education programs, were putting down roots in the borough; over time, they would assert their cultural presence not only in the city but nationally and globally. Along with the cultural resurgence, a cadre of ambitious young politicians was pushing to bring the borough back to life.

The new hospital was a part of this rebirth. Spearheaded by Councilman Velez, a coalition had been cobbled together. The *New York Times* characterized the alliance as "an unlikely coalition of doctors, the Young Lords street gang and the Black Panther Party to lobby City Hall to replace the hospital's aging building at 141st Street and Concord Avenue."[17] Velez's canny political moves brought real benefits: more jobs, better health care, a handsome new facility, and a visible symbol of a community struggling to reinvent itself. The expectation was that the artwork commissioned would be a celebration of that renewal and the vitality of Latino culture.

Except for the words *Productos Tropicales* on the awning at the far left of the mural, there is little in the visual landscape of Bearden's work that acknowledges either the Latino demographics of the community or a spirit of optimism. The first panel shows clusters of residents

socializing outdoors on street corners, on the stoops, as a group of children fly kites on the roof tops above the streets. As the scene progresses from left to right down the twenty-seven-foot length of the mural, Bearden abruptly shifts perspective and zooms in for a close up view of lives being lived behind the row of brick facades. Whereas *The Block* struck a lively balance between the interior tableaux and life on the street, *Cityscape*'s attention is trained on private lives—of mother and child, intimate family scenes, faces gazing pensively, an angel kneeling before a standing nude, her uterus exposed and open to public inspection.

Bearden had taken great care to link the content of the tableaux with art historical allusions that link day-to-day life in the Bronx to other cultures and traditions. Faces appear in the window, adjacent to a fragment of a classical Benin mask, a reminder of ancient origins. Daily rituals find religious equivalents, such as an image of a mother and child designed to look like a Medieval Madonna, or the exposed womb of the woman before the kneeling angel that mirrors an annunciation scene, both familiar motifs in Bearden's work. Yet, iconoclastically, he has incorporated photographic images from a porn magazine into the body of a woman standing in for the Virgin Mary, deliberately conjoining sacred and profane. The figure had more in common with the nudes he constructed for his most recent series on jazz, than it did with what might be expected for a religious scene. For a predominantly Catholic community, the image might have seemed blasphemous.

Bearden's trademark classicism—the controlling rectangular grid, columns of color that frame the action, the fragments of Corinthian columns, the rhythmic pacing, and the rectangular structure repeated in the bricks, along with the religious evocations—contrast with these carnal references. Birds that speck the sky above the rooftops and an expanse of sky peeking through an opening in the opaque facade of building fronts, suggest flight and openness, set against what Bearden represents as the constraint of the lives depicted in the buildings' interiors. As with the Berkeley mural, there is the eye of the omnipotent

narrator. Yet ultimately the narrative is one of hopelessness. In the final panel a homeless man lies on the ground covered by a newspaper.

A comparison among the three works that make up the trilogy, of which *Cityscape* is a part—*The Block* and *Block II*—makes clear that the images Bearden chose for Lincoln Hospital are the darkest of the three works. Although the explicit representations in *Cityscape* appear elsewhere in his collages and murals and are part and parcel of his imagery of urban life, there is a pessimism in *Cityscape* that distinguishes it from the other two large murals he completed on urban life. A homeless man appears in all three of the works in the trilogy. In *The Block* he is the focal point of a disapproving matron, just one in a number of scenes on the street. In *Cityscape,* as in *Block II,* Bearden places the figure of the homeless man at the end of the block, the finale, giving hopelessness greater emotional and visual weight. The tone of *Cityscape* is elegiac, a prose poem that mourns the loss of a once-vibrant community, not the celebration of rebirth the community expected.[18]

Velez's charge that the work was obscene laid bare a reality about Bearden's work that was becoming increasingly evident and that was not only its sensuousness but its often sexual explicitness. Sensuality first enters his work publicly in the 1964 *Projection, Conjur Woman as an Angel* and was becoming more commonplace in his work. The only nude in *Projections*, the work pictures two women, one old, one young who sit together in front of a house in an outdoor rural setting. A bull stands stock still in the background. The old woman is wizened, her face constructed of abrupt chops and cuts of photographs—Inez reimagined with sacred wings. Old and winged, her powers compared to those of an angel, the conjur woman commands the attention of a nubile young woman. The body of the black nude is constructed of shards of photographs. From the start, Bearden combines sacred and profane including a mix of photos of classic nudes from Western paintings affixed to bits of photos from contemporary news or porn magazines.

That same year, Bearden moved from the sensual to the explicit in a 1964 collage, unhelpfully titled *Untitled*. The work depicts a woman who, in full view of an open window, her legs spread, pleasures herself.

Courbet's *Origins of the Universe*, an early modern European effort to defy societal norms, could have served as a model. Another example from Bearden's urban scenes, completed the year that *Cityscape* was to have been installed, 1976, depicts a nude woman, in open view, again seen through a window, pleasured by her male companion. As discussed above, Bearden's representations of the black female body in the collages were a theme in his ongoing conversation with his own art, the art of the world and his explorations of race and representation. When Bearden moved from the intimacy of a small collage to the monumental dimensions of his three versions of the *Block, Block II, and Cityscape*, the images did take on the aura of a public exposé.

The exposé angered the politician. He and others in the community lobbied to have the mural removed. Opposition to Bearden's mural must have taken the Health and Hospitals selection committee, composed of art world specialists, by surprise. They had every reason to think that Bearden was the perfect choice for the Lincoln Hospital commission. A master of urban themes, he had demonstrated keen sensitivity to context and community, as well as the complexity of American identity. The Times Square mural attracted positive media attention; Berkeley, as noted, had adopted a portion of his collage as the city's logo; PS 84 warmly welcomed its new mural. Elsewhere in the country, Bearden continued to enjoy the same kind of heartfelt welcome that greeted him in Berkeley. Later in 1976, the year of the attempted installation of *Cityscape*, the city of Atlanta, on the occasion of the unveiling of a 96-foot mural (since demolished with the building) declared "Romare Bearden Day," making him an honorary citizen of Atlanta and giving him the keys to the city.[19]

The year 1976 was also the bicentennial of the American Revolution, and Bearden was invited to design and oversee the production of a collage composed of pieces of fabric. A silhouetted portrait of Cinque, the heroic figure in 1839 on the slave ship *Amistad*, was the centerpiece of the fabric collage, completed on the occasion of the opening of the Philadelphia African American Museum. Bearden places the head of Cinque at the center of the cloth collage and circles his head with historical episodes, related to the *Amistad* narrative: the *Amistad* filled

with its middle passage cargo; John Brown's rebellion and execution; scenes of the Union and Confederate soldiers clashing; and the scales of justice weighing the commercial value of the slave trade with the value of human life. The scales also allude to the scales of justice in the courts and the successful defense of Cinque by former president John Quincy Adams. The mural portrays the national ideals celebrated on the occasion of the bicentennial—justice, creative resistance, freedom—and the contributions of black culture.

Cityscape stayed on the walls of Lincoln Hospital less than a week. After the protest against its content, it was taken down and buried in a Health and Hospitals storage facility. In 1983, the work, as part of a general reevaluation of the Health and Hospitals Corporation collection, was disinterred and underwent a thorough restoration. The mural was reinstalled, this time at Bellevue Hospital, a homecoming of sorts for the artist, who had been briefly hospitalized there in the 1950s.[20] Returned from restoration, the mural was hung in a dimly lit, narrow corridor where it is still on view outside of the Hall of Chapels.

The incident with Lincoln Hospital only intensified Bearden's growing weariness with city life, and his representation of Martinique as "paradise" betrays the lure of the island of St. Martin, Nanette's family home. First introduced to him when the couple traveled together in the 1960s, the island immediately captivated him. A tiny piece of land in the Caribbean, St. Martin, with its population under 100,000, was a sharp contrast to New York. Half an extension of France and the other half of the Netherlands, the island is filled with a multi-cultural population of Arawak Indian, Chinese, East Asian, European, and African, reflecting its colonial and slave trading past. By 1972, when he landed his commission for Berkeley, Bearden and Nanette had begun building a home and a studio on land that belonged to Nanette's family. He confessed to Herb Gentry that part of the reason for his furious pace and for assuming so many commissions was his need to finance the house. The site Bearden and Nanette chose for their new home and his work space could not have been more different from the clutter and noise of Canal Street or the spare industrial space of his studio in Long Island City. Sited atop a hill at the end of a dusty road, their island home

offered a spectacular view of L'Embrouchure Bay. Years later, Bearden added a studio adjoined by stone steps to a sunlit space close by. The sensual joy he derived from St. Martin, evident in the solo exhibition he completed in 1973 for Cordier-Ekstrom, is a sharp contrast in tone, subject matter, and style to the mural he was composing for Lincoln Hospital.[21]

In the midst of his work on the Lincoln Hospital mural, Bearden added an important new person to his business management team. June Kelly became Bearden's manager in 1975 and though Arne Ekstrom remained his primary New York dealer, in the face of the sheer volume of Bearden's activities, Kelly took over the management of all of Bearden's activities outside the gallery. Kelly was a no-nonsense negotiator who unapologetically protected her client's interests. She was able to balance Ekstrom's interests as his New York dealer with a network of galleries outside of New York in Boston, Washington, Detroit, Charlotte, Cambridge, and on the island of St. Martin—and, when necessary, in the living rooms of private patrons, which allowed her to find new audiences for his work. Bearden got to know Kelly when she arranged a Paris show at the Loeb Gallery in 1975. After the success of that engagement, he invited her to take on the role of business manager, which included managing his rapidly growing roster of public commissions and collaborations with other artists. Paris, as we'll see later, was the site for the genesis of one of those collaborations.

In the years that Bearden developed his rich collage vocabulary in his private and public works, he also proved to be an agile collaborator, engaging artists in a range of disciplines.[22] Some of Bearden's collaborative projects required very little effort on his part. *Five on the Black Hand Side*, a 1973 light-hearted urban comedy with an all-black cast, included a panoramic sweep (poorly filmed) of *The Block* in the opening credits.[23] Others, like the illustrations he drew that same year for Samuel Allen's *Poems from Africa*, offered a visual context for the poetry. A visual context is what Bearden contributed, as well, to Ed Bullins's quasi-musical, *House Party*. *House Party*, discussed in an earlier chapter, and referred to by one observer as "a collage of

voices and images from Blacktown." Bearden contributed the stage sets that accompanied the play, which was constructed as a series of soliloquies linked by music.[24] Bullins, then artist in residence at the American Place Theater and a major figure in the short-lived New Lafayette Theater in Harlem, planned a "Twentieth Century Cycle" of plays—not unlike the ten-play cycle that August Wilson would complete. A surviving collage that serves as a model gives a sense of what the stage set must have been.

Though a number of Bearden's collaborations were unrealized, they illustrate, nonetheless, his strong attraction both to dance and theater. Dance had seduced him as a discipline as early as the 1940s, when Katherine Dunham had invented a vocabulary of movement that asserted the black female body on stage.[25] Culled from West Indian and African sources, Dunham's movement was precise, elegant, and firmly rooted in her research into diasporic culture.[26] Her stage sensibility reflected what Bearden would come to embrace in his collages. Bearden's ideas for collaboration with Dunham never materialized. Bearden gifted a series of sketches for an unproduced opera in the early 1970s titled *Conjur: A Masked Folk Ballet*, to Parmenia Miguel Ekstrom, Arne Ekstrom's spouse and renowned dance scholar. Another unproduced project, *Bayou Fever*, was conceived in collaboration with actor, director, and producer Billie Allen Henderson. *Bayou Fever*, like *Conjur* and the Ailey collaboration *Passages*, was based on the theme of conjuring.[27] Working with Bearden, Henderson completed at least a draft of a choreographic libretto, but the pieces remain merely a set of sketches and draft movements. A stage collaboration with Ntozake Shange went unrealized when Bearden proposed set designs for a 1979 Public Theater production of Ntozake Shange's *Spell #7*.[28] Thulani Davis, assistant director for the production, remembers that after Joseph Papp rejected Bearden's idea, Bearden left the meeting and angrily dumped the watercolors in the trash. Davis let Bearden know that she was retrieving them. "I don't care what you do with them," he replied hotly.[29] Bearden's unrealized collaborations suggest that his involvement with dance and stage would have been even more extensive had those collaborations

succeeded. His fully realized work is evidence of the importance of collaboration to the evolution of his new artistic persona.

Bearden did complete several collaborations with Alvin Ailey, a Dunham devotee, and would go on to work with Dianne McIntyre and Talley Beatty.[30] Nanette, who had produced and directed the Broadway Dance Festival in 1975, a prelude to launching her own dance company the following year, shared her husband's deep love of dance.[31] Dance as the embodiment of cultural language, history, and experience was an important inspiration for Bearden's ongoing artistic evolution. In his earliest collaboration with Ailey, this interplay was tentative at best. While in Paris during his exhibition at the Loeb Gallery on the Rue des Beaux-Arts, Bearden and Nanette—accompanied by longtime friend and scholar, Dr. Richard Long—saw a performance of Ailey's ballet, *Night Creatures* at the Palais des Sports. Ailey, in turn, viewed Bearden's collages at the Loeb and subsequently invited him to join in a creative partnership. Bearden produced a slide show of *Projections* that featured collages with jazz motifs when *Night Creatures* was performed in New York in 1976. Two years later, he provided sets for Ailey's *Passage*, a solo performed by Judith Jamison.[32]

Dianne McIntyre, then a young choreographer and dancer invited to work with Ailey, was a catalyst for a more integral collaboration with the premiere of her January 1977 work *Ancestral Voices*. At Ailey's suggestion, Bearden designed the costumes and the scrim, an amplification of *Ritual Bayou*, a scene of a silhouetted black nude in a West Indian rain forest. Interviewed in *Studio Magazine* by Katrina DeWees many years after the premiere of *Ancestral Voices*, McIntyre reflected on the influence of Bearden's collages on her work.

"You feel, through his images. He touches on something you cannot translate into words. I wanted to be like Romare Bearden."[33] Bearden's interest in McIntyre was reciprocal. He sat in on rehearsals, asked questions, listened to the music—by the pianist and composer Cecil Taylor in this case—and watched the musicians, immersing himself in the compositional experience.[34] Dance historian Veta Goler describes that compositional process in the essay, "Moves on Top of Blues."[35] As Goler notes, the "improvisational and collaborative" became a "compositional

tool." Bearden's compositional process as he described it in "Rectangular Structure" claimed the same type of play or improvisational space.

After the very public rejection and criticism of *Cityscape*, Bearden continued his private artistic conversation with a newfound energy. *Of the Blues* (second chorus), thirty-seven monotypes, was exhibited in 1976, and Bearden's April 1977 solo show took an unexpected turn, thematically and stylistically. He completed a series of collages based on Homer's *Odyssey*. Attracted to the story in which the hero returns home from war, after years of voyaging, Bearden constructed the series while he was in the midst of being interviewed by Calvin Tomkins for a *New Yorker* magazine profile. In the collage series, the search for home is the thematic thread that binds one image to the next. Tomkins wrote the introduction, which also has as its thematic thread the search for home. Tomkins's quote from Julian Jaynes suggests the perils of that search. Jaynes characterizes the longing for home as "an odyssey toward the subjective identity and its triumphant acknowledgment out of the hallucinatory enslavements of the past."[36] Bearden's approach in this series gives new meaning to the scholar Paul Gilroy's view of the transatlantic voyaging of the African diaspora. As Gilroy reminds us, black modernism reshaped the modern world as much as it reshaped displaced African identities. Bearden refers to the diaspora by recasting the characters of Homer's epic in stylized black silhouettes, similar to the style he used for the Cinque mural. Stately and classical, the silhouettes nonetheless picture the violence and seductions that threatened to destroy Odysseus during his search. Without direct statement, Bearden's black faceless silhouettes metaphorically allude to the tribulations of middle passage, civil war, the uprooting of migration, and the obstacles to finding a safe harbor, and a place to call home.

Bearden's fascination with the classic story began with his 1948 series of watercolors of the *Iliad* exhibited at the Niveau Gallery. At the center of those paintings, however, were males, warring and wounded. Returning to Homer with the *Odyssey* series almost thirty years later, Bearden endows women with prominent roles. Disruptive women appear in the *Odyssey* collages and reappear in the several iterations of the theme that Bearden completed in watercolors and print. As Robert G.

O'Mealley, observes, the women in Bearden's *Odyssey* are pictured as shape-shifting, dangerous, powerful, yet essential to the hero's survival.[37] Bearden's various representations of Circe—for example, *Circe's Domain*, 36 x 48 in.; *Circe Turns a Companion of Odysseus into a Swine*, 32 x 44 in.; and *Odysseus Leaves Circe*, 32 x 44 in., 1977 *Odysseus Series*—are mini-narratives within the larger narrative. He establishes her domain, her threat, and his escape from that domain to travel to his true home. The *Odyssey* provided yet another context; Calvin Tomkins reminds viewers, in his 1977 catalogue essay, that Odysseus was "one of the original suitors for the hand of Helen," a woman who was the cause of war and destruction.

Tomkins's essay for the Odyseus series was a prelude to the extensive profile of Bearden that appeared in the November 28, 1977, *New Yorker* titled "Putting Something over Something Else." The Profile charted the geographies of Bearden's life and their impact on his artistic vision. Extensive recorded interviews with Bearden, transcribed into a set of voluminous notes, yielded incidents and anecdotes from Bearden's life that had never before been published. The impact of this experience on Bearden's work was immediate. Less than a year after the publication of the article, on November 8, 1978, Bearden exhibited a series of twenty-eight collages, at Cordier-Ekstrom titled *Profile/Part I, The Twenties.* Albert Murray worked closely with the artist to name each collage, to supply written text that accompanied each and that was inscribed on the wall of the gallery and published in the catalogue of the exhibition. Bearden often stated that he created the collages and Al Murray named them, a collaboration that kept the two artists closely connected. *Profile/Part I* portrays Bearden's idea of home beyond the classical domain of the Homeric epic: domestic interiors, men and women at work in cotton fields, southern brothels and church picnics, desire, death, a violent coming of age ritual—Bearden has allowed himself an unfettered freedom and intimacy in his disclosure of home. The collages of *Profile/Part I* recall the words of his teacher at the Sorbonne, French philosopher Gaston Bachelard, who refers to home as "our first universe." Home, whether it was Odysseus seeking home or Bearden exploring the visual representation of his multi-dimensional homes, remained an overarching theme.[38]

Autobiography would preoccupy Bearden for several years. In 1980, he contributed a selection of collages for the republication of *Dusk of Dawn* by W. E. B. Du Bois, originally published in 1940. Du Bois subtitled the book *An Essay Toward an Autobiography of a Race Concept.* In it Du Bois documents his life's journey from the vantage point of his changing perspectives on race, a journey not dissimilar from the ebbs and flows Bearden would experience. Bearden included as a frontispiece a sketch of his former patron and supporter. Capturing a classic Du Bois pose, he pictures Du Bois sitting in a chair with his legs crossed, assuming a slightly haughty posture. Each of the nine essays in the leatherbound edition opens with an image of a Bearden collage, with the exception of one essay that opens with a reproduction of a painting of three men on a street corner, the same image that accompanied a 1942 *Fortune* article and a reminder of social conditions when Du Bois's work was originally published.

The biographical sweep of Bearden's life received another prompt from a retrospective organized in the city of his birth, Charlotte, North Carolina. The Mint Museum opened the exhibition, *Romare Bearden: 1970–1980*, a decades-long look at the evolution of Bearden's collages. Bearden returned south, not having visited the South since his trip with Charles Alston in 1940–1941. His return to Charlotte gave him the opportunity to locate where his childhood home used to be—it had become a parking lot—and to visit his ancestors' graves. It was during that visit that he found the photo of his great grandparents, Henry and Rosa, sitting on their porch, the photo that became a fixture in his Long Island City studio. Loss and the reclamation of a time and a place grew more urgent in his work immediately following the visit.

The extended essay written by Albert Murray for the Mint Museum exhibition, like the Tomkins article and the Ralph Ellison essay before that, became an important conceptual touchstone. Murray, Bearden's constant companion and collaborator who provided written commentary for many of Bearden's solo shows, was a voice that Bearden trusted. The title of Murray's catalogue essay clearly stated its premise: *The Visual Equivalent of the Blues.* Murray insisted in his essay that no matter how complex and intentional Bearden's subject matter, the final

content of each collage was not preconceived; rather, the subject matter emerged as the result of the process of improvisation. As Bearden compositionally arranged and rearranged "neutral shapes," content emerged. In Bearden's words, "You put something down. Then you put something else with it, and then you see how that works, and maybe you try something else and so on, and the picture grows in that way."[39] Murray likened Bearden's compositional explorations in collage to "vamping" or creating "visual riffs" or "call and response" patterns that were analogous to the techniques of jazz musicians.

Murray's essay was dense with knowledge of individual performance styles, and examples of the technical mastery of individual jazz musicians, and histories that attach not only to each era but to each musician of that era, and this gave his work an unmatchable authority. His essay demonstrates his command of the history of European art as well, and he deftly locates Bearden at the intersection of great jazz and the Western canon. Murray's examination of Bearden's relationship to jazz set the stage for countless interpretations that followed, and the relationship between the collages and music has been well covered. The Mint Museum exhibition, curated by Jerald Melberg, who later represented Bearden in his gallery in Charlotte, traveled nationally, confirming to the art world not only Bearden's productivity but his evolving mastery of the collage medium and, improvisatory or not, the expanding repertoire of subject matter his collages had mastered in just over a decade.

Bearden's collages and his public commissions continued to evolve after the Mint Museum retrospective. Returning from the show, he embarked on the second part of his autobiography, *Profile/Part II: The Thirties*. The series is particularly important because it included one of his few known self-portraits. Set in his studio at 243 West 125th Street over the Apollo Theater, the 1981 collage, *The Artist with Painting & Model*, is a visual memoir and a defining work in the series and offers the artist's view of the generative sources of his work. The written commentary that accompanied the portrait sets the stage: "Every Friday, Licia used to come to my studio to model for me upstairs above the Apollo Theater." In the self-portrait, Bearden represents himself in the background, standing next to an easel on which a painting is propped. He

faces the viewer, a paint brush in his right hand, establishing his artistic identity as painter, his left hand draped over the easel. His body is painted and the features on his face, barely legible, are drawn in pencil, a sketch, preparatory to something that will evolve in the future. Facing him, standing to the right of the easel in the foreground is Licia, his model, her back to the viewer, her body, unlike his, cut from brown paper. Licia is nude except for a piece of cloth wrapped around her waist.

Bearden has placed on the easel a transcription of a 1941 painting, *Visitation*, a reminder that he is an artist who has sustained a long-standing conversation with his art. The original painting on which the transcription is based is painted in earth tones; in the self-portrait, he has substituted for painted figures black silhouettes, and for a painted background, he has substituted swatches of colored paper. His pictorial past is his to reinterpret at will, and he surrounds himself in the self-portrait with remnants of the archival sources he plunders as he needs them. At his feet, he pasted the fragment of an actual notebook and a sheet of paper with pencil sketches of Licia, without her cloth, references to his studio drawings from the 1950s. (The kneeling sketch of the nude in the self-portrait is almost identical to the sketch of a kneeling nude that he made of a young Joan Sandler.) On the same note paper is a sketch of a Benin head, a visual analogy between the ancient royal artifact and the black body in the sketch.

Bearden has included in the self-portrait, *Artist with Painting and Model*, art historical references as well. Taped to the wall that is the background of the collage, behind the artist's elbow, a portion of Duccio's fourteenth-century Byzantine fresco, *The Maesta*, is visible. From photographs of Bearden's studio we know that a reproduction of Duccio's Sienese, multi-paneled masterpiece hung in his studio at one point as did reproductions of other masterworks. A photograph that Sam Shaw took of Bearden in his studio in the 1940s includes a photograph of Cézanne's *Cardplayers*. Bearden references the multiple origins of his work—his own art, the work of other artists from other times and other cultures, the live model, the very materials he uses, the generative studio space of the working artist—that allow him to create the world of each collage.

As Bearden continued to produce solo shows for his gallery—his private conversations with his art—he continued as well to work on major public commissions. During the 1980s, three subway commissions were the occasion for the production of three major murals. Subways were familiar to Bearden, who never learned to drive and depended on them. In New York, subways had sped him out of Harlem to the West Village to attend NYU; he relied on subways to get to his upper eastside office for his work as a caseworker; subways spirited him out of Manhattan to his studio in Long Island City, Queens. Bearden's most beautifully executed subway commission began life as part of the opening credits for a film. Sam Shaw, film producer as well as photographer, invited Bearden to contribute watercolors for the opening credits of the 1980 John Cassavetes film, *Gloria*. Set in the Bronx and starring Gena Rowlands, the independent film won a Golden Lion at the Venice Film Festival. Bearden's watercolors that open the film are views of the city skyline at night, picturing the city as if he were recording the view from an elevated subway. His images of tenements, skyscrapers, and night sky are shimmering and lush, and retain the elegiac tone of *Cityscape*. In this instance, the tone perfectly fits the bleak fortunes of the film's characters.[40] These same watercolors were translated into stained glass, installed almost five years after Bearden's death, for an above-ground subway station in the Bronx, the Westchester Square–East Tremont Avenue Station. Bright as a jewel set within an unremarkable stone structure, the windows invariably surprise busy riders running up the steps of the station with their brilliance and clarity.[41]

His first subway commission completed during his lifetime was for a Baltimore station. Installed in 1983, the ceramic and glass tile mosaic was titled *Baltimore Uproar*. Bearden chose to depict a larger-than-life female jazz vocalist, perhaps Billie Holiday, who grew up in Baltimore, accompanied by an ensemble of musicians. Bearden's motifs for the Baltimore mural were derived from his solo show at Cordier-Elstrom in 1975, *Of the Blues*. For the subway mural, Bearden pictures the legendary singer as a larger than life figure that looms over the heads of the subway travelers, who dash into and out of the busy Laurens Street station, occasionally looking up at the work above them. The piece,

occupying a place on the city's list of tourist attractions, sets the tone of the station.

A year after the Baltimore commission, Bearden completed a ceramic tile mural installed opposite the subway platform in the Gateway Center Station in Pittsburgh. *Pittsburgh Recollections* is sometimes compared to the Berkeley mural in that it is an attempt to capture the heritage and history of a city. But *Pittsburgh Recollections* dispenses with the high drama of the Berkeley tableau; instead, the mural unfolds a lively but conflict-free chronological account of the emergence of Pittsburgh as an industrial behemoth. The mural's original location was on a wall opposite a platform, difficult to see as trains sped back and forth in front of it. In 2009, the city had become so oblivious to the mural that when the station was slated to be closed, an official in the city's transportation agency recommended its destruction. The cost of paying for its removal and restoration was high, and demolition seemed to be a choice more prudent than preservation, a fate that befell Bearden's Atlanta mural. A protest ensued, however, and the mural was saved and relocated to a new site. Details of its preservation, however, highlight the challenge of maintaining his works in the public sphere, given their sometimes fragile and volatile materials.[42]

Despite a steady stream of public commissions for urban sites, Bearden and Nanette visited their home in St. Martin more and more frequently. Bearden's attraction to St. Martin reflected his skepticism about modernity as well as his urban fatigue.[43] A 1983 *New York Times* article— "An Artist's Renewal in the Sun"—contrasts his dark view of New York City with the sense of openness and light that St. Martin represented for him. In the *Times* essay he describes his Canal Street loft as "an ancient building in lower Manhattan," noting that "artists are like rats and mice; they get along best in old houses where no one sets traps for them."[44]

Bearden's suspicion of the modern world, in general, increased as he aged. In an interview with biographer Myron Schwartzman in 1986, Bearden bemoaned a lost connection with nature. "I think modern man has in many ways completely protected himself from nature: airconditioning, refrigeration, type of housing, pesticides, all of these things

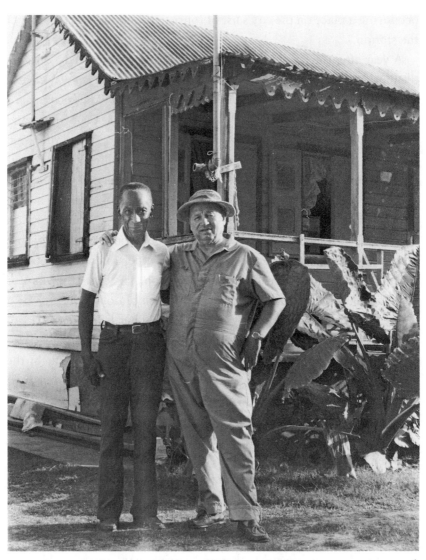

Romare Bearden with Oswald Rohan, St. Martin, ca. 1975.
Romare Bearden Foundation Archives, New York.

that protect us from what we feel takes us down, which is nature." Living in St. Martin was restorative and his writings glow with vivid descriptions like "the deep blue Atlantic with white threads of surf breaking over coral reefs" or his description of egrets that look like "a great patch of sea-island cotton," or as he watches the sunset, "the undersides of the low rolling clouds take its last orange darts and glide into Paradise Peak. With the sun diminished, there is a short afterglow as the night eases in along with the stars."[45] As Bearden and Nanette spent more time away from New York, they became adherents to all things natural. When Bearden began to experience joint pain, weakness and trouble walking, he and Nanette, distrustful of modern medicine, began subscribing to a panoply of mail order herbal medicines. Time would reveal that their home remedies were attempting to "cure" an illness far more devastating than muscle aches and pain.

Fortuitously, Bearden would meet a young collage artist during the 1980s with whom he would forge a relationship as his physical condition continued to deteriorate. André Thibault has described meeting Bearden at the opening of one of his shows. Unable to gain entry because of the long lines of people waiting to get into the gallery, Thibault spotted a carton, hoisted it on his shoulders and pretended to be delivering catalogues. Once inside he introduced himself to Bearden as a fellow collage artist and described himself as a lifelong fan of Bearden's work. The two hit it off and, as Bearden's mobility became impaired, Thibault's assistance became critical in helping Bearden construct collages in his Long Island City studio.[46]

As Bearden deepened his connections to the Caribbean, he began a collaboration in 1983 with Derek Walcott, poet and Nobel Laureate, born in St. Lucia. Bearden discovered in Walcott a kindred spirit. Walcott's multiple inheritances were not unlike the layers of influence that over the decades defined Bearden's multiple creative sources. Walcott succinctly defined his inheritance in a few lines of his poetry.[47]

> *I'm just a red nigger, who love the sea,*
> *I had a sound colonial education,*

I have Dutch, nigger, and English in me,
and either I'm nobody, or I'm a nation.

Their collaboration resulted in a volume titled *The Caribbean Poetry of Derek Walcott and The Art of Romare Bearden*. Bearden chose to paint a set of original watercolors for the volume. The reproductions sprawl between pages of poetry as separate but related expressions, as if the poems were the vocalist, the paintings the accompanist, propelled by a pattern of call and response. At the back of the book, Bearden's essay speaks of Walcott's writing as if language were line and color. Bearden writes: "The islands are a palimpsest with traceries of pirate and merchant vessels, of old houses and harbours, papaya trees, and of ancient Caribbean faces almost obscured. He etches these things in his poems with clarity of form in a line that is firm, sometimes restrained, balanced, then again of sharp contours."[48]

Bearden allows language to inspire him as well in his 1984 collaboration with Ntozake Shange. His response to Shange, like his response to Jayne Cortez or Derek Walcott, is clearly liberating and he allowed himself to consume the entire page with an exhilaration and freedom that is an artist's homage to the poet's language. A line of Ntozake's poetry appears on the page, "I live here in music," bordered by full page color reproductions on one page of a collage of Savoy dancers circling one of the legendary bands that played there in a haze of fluorescent color. On the opposite page a collage of abraded surfaces depicts performers—musicians in the band, dancers, vocalists in a cabaret, images of African antiquity inscribed over the proscenium. Walcott and Shange's poetry beckoned the artist like expert dancers who brought out the best in their partners on the dance floor.[49]

Despite his disappointment with not being able to complete the sets for Ntozake's *Spell # 7* he continued to work on stage productions. An opera by Thulani Davis and her brother Anthony, titled *X, The Life and Times of Malcolm X* provided another collaborative opportunity for Bearden that year. Thulani wrote the libretto and Anthony, an accomplished pianist and composer, composed the music and lyrics. Bearden contributed wall-sized images that served as backdrops to sets designed by City Opera set

designer John Conklin. A full production was performed at the New York City Opera in September 1986. Bearden's densely packed urban drawings survive, and his black and white drawings of street scenes are reminiscent of the photographic enlargements of *Projections*. Dense, jittery, the space compressed, they are meant to re-create the almost smothering environment that threatened to trap Detroit Red, as Malcolm X had once been known. Performance; the stage; black bodies moving in space, in conflict, entwined in desire, realized and thwarted—all these show up in the collages Bearden did for theater and dance.

Bearden's final major public commission during his lifetime united him with one of his artistic heroes, Diego Rivera. In 1986, the Detroit Edison Company (now DTE Energy) and the Detroit Institute of Art (DIA) commissioned a glass mosaic, titled *Quilting Time*, on the occasion of the museum's centennial. To celebrate the mural's unveiling the DIA organized a retrospective accompanied by a catalogue that would become another milestone in Bearden scholarship. Bearden's commission placed his mural in the same museum as Rivera's fresco of twenty-seven panels, titled *Detroit Industry Murals*. Completed in 1933, Rivera's mural represents Detroit's historic role as the center of automobile manufacturing and celebrates the nobility of the blue-collar worker as well as the wonder of modern technology. Whereas Rivera's creation is an encyclopedia of work in the modern world, Bearden's collage mosaic is one essay on one aspect of American life. Bearden pictures a multi-generational family that sits in a rural setting to participate in a quilting bee. The figures are black silhouettes, regal, staid in their bearing, the patterns of the quilts in their hands animating the surface of the mosaic. The exhibition, *Romare Bearden: Origins and Progressions*, Detroit Institute of Art, September 16–November 16, that accompanied the mural provided a rich context that demonstrated the progression of Bearden's aesthetic development as well as the iconographical source for some of the imagery in *Quilting Time*. Even with the Detroit show opening and the completion of the mural, Bearden still delivered to Cordier-Ekstrom in September of 1986, what would be his last solo show for the dealer who had so completely changed the trajectory of Bearden's career. Bearden had one more solo show, this one in

Boston at the Thomas Segal Gallery that included works that he and André Thibault worked on together.[50] Though he managed to produce works, many lacked the energy and focus of his earlier collages.

Romare Bearden: Origins and Progressions traveled to New York to the Bronx Museum, back to the borough that had rejected Bearden a decade earlier. This time, the borough greeted him warmly and the show was celebrated as a high point for the artist.[51] Modest in size, like the MoMA and Mint museum surveys before it, this show of fifty-seven collages, watercolors, and oils, included Bearden's figurative abstractions from the 1940s and examples of his large nonobjective oils from the 1950s and 1960s as well as his collages. Excerpts from Bearden's journals were published in the catalogue along with an essay by art historian, Lowery Sims. Titling her essay "Romare Bearden: An Artist's Odyssey," Sims underscored the decades-long searching, exploratory voyage of discovery that characterized Bearden's career. Though the mural could not travel, the fact that the show was organized around the public commission called attention to Bearden's dual mastery—in addition to the exquisite intimacy generated by the collages, Bearden was an artist with a booming public voice who could move easily from a modest to a monumental scale.

A look at Bearden's output in the almost twenty-five years that he constructed collage reveals that he mastered an extraordinary number of materials: marker, pen and ink, graphite, watercolor, fragments of everyday odds and ends, safety pins, thread, tinfoil, fabric swatches, samples of wall paper, linoleum, and photographs. As he continued to work, large scale and small, he paid more and more attention to the chemical composition of the adhesives he used and became more demanding of the workmanship of the armatures that served as the brace for the surface of large works. A frequent visitor to Robert Blackburn's printmaking workshop, Bearden experimented endlessly with techniques and methods of reproducing his work in forms accessible to a wide public. Blackburn, whose printmaking workshop was home to a number of major artists from all over the world, welcomed Bearden's experiments and facilitated his use of multiple mediums. Often Blackburn would bring scraps from the workshop to Bearden's loft, where they would

find their way into the paintings. Despite Bearden's care in the assemblage of materials, his collages with their multitude of different materials are a preservationist's nightmare. Major museums exhibit his works infrequently because they are so perishable. Taken together, the intrinsic volatility of the collages and the relative obscurity of some of his public commissions mean that Bearden's work, devoted to seeing and truth in seeing, at times, by their very physical nature, simply cannot be seen. His legacy, by necessity, is one that requires an avid and unrelenting advocacy of curators and scholars and the artists who came after him. Artists who continually find lessons and models for their own work are perhaps the most important part of Bearden's legacy.[52] Bearden's legacy is as complicated as his art; he would become many things to many people—all at once.

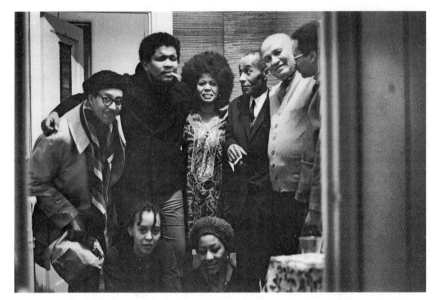

Group photo taken October 1969 at a party in the apartment of Jayne Cortez, 192 Sixth Avenue, New York. Seated left to right: Nikki Giovanni and Evelyn Neal. Standing left to right, Bob Rogers, Ishmael Reed, Jayne Cortez, Leon Damas, Romare Bearden, and Larry Neal. Photo: Melvin Edwards. Léon-Gontran Damas papers, Schomburg Center for Research in Black Culture, The New York Public Library Astor, Lenox and Tilden Foundations.

EPILOGUE

THE BEARDEN LEGACY

In June 1987, President Ronald Reagan announced that Bearden, along with eleven other recipients, had been awarded the National Medal of the Arts, the nation's highest honor for achievement in the arts. When he and Nanette traveled to Washington, DC, for the dinner in honor of the awardees, he joined, among others, jazz vocalist Ella Fitzgerald, sculptor Isamu Noguchi, and novelist Robert Penn Warren. Those of us who saw photographs of the occasion were stunned. Bearden's once rotund body had become shrunken and emaciated. His frailty notwithstanding, later that year he sent me an upbeat congratulatory note when I assumed a new job.

When Bearden finally sought medical advice, the aches and pains that he and Nanette had been treating with mail order remedies was diagnosed as bone cancer. In the last few years of his life, as movement became difficult and painful, he became increasingly dependent on three men who would be his constant companions near the end and who made it possible for Bearden to continue working—Russell Goings, André Thibault, and Frank Stewart. Goings, a former professional football player, assumed the role of caretaker and close companion. Fond of reminiscing about their time together, Goings recounted details of his relationship in private and public settings: "He took me to museums, he took me to shows, he talked to me, he gave me all kinds of books and he taught me how to see."[1] A former board chair of the Studio Museum in Harlem, one-time stockbroker, and collector of Bearden's work and the work of other notable black artists, Goings took on the responsibility of looking after his friend as if it were his job. He bathed him, transported him to his studio and back and forth

from doctor's appointments. His Upper West Side apartment remains full of Bearden's notebooks, sketches, collages, and journals, and stories that he amassed during Bearden's last years.

André Thibault, an adoring fan, was equally as important during the last three or four years of Bearden's life. A fellow collage artist, Thibault made it possible for Bearden to keep working almost up to the very end. Thibault variously describes himself as the artist's mentee, his assistant, and occasionally, according to him, his collaborator, though some have contested this claim. Thibault would work in the Long Island City studio alongside Bearden, building armatures for the surfaces of the collages, and, at Bearden's instruction, laying down bits and pieces of paper, photos, and fragments of objects; carefully mixing glues, adhering fragments of cut paper, and occasionally applying paint to the surfaces.

Frank Stewart, now senior photographer for Jazz at Lincoln Center, had been a constant companion of Bearden's since the 1970s, when Stewart was a young photographer and, as noted earlier, the two artists bought a car together. Serving often as a driver for Bearden, Stewart used his constant proximity to take literally thousands of photographs of his mentor and friend. He captured the artist at work in his studio, in his home relaxing with friends and family, in attendance at formal occasions and public events all over the country, and just sitting alone, pensively. Ruth Fine, who wrote an introduction to Stewart's book of photographs of Bearden, notes that they shared not only an interest in subject matter but a concern for the formalist impulses that undergirded their art.[2]

In the last months of 1987, Goings continued to pick Bearden up in the mornings from his Canal Street studio to drive him to Long Island City; Thibault assisted in the construction of his collages; Frank Stewart was present with his ongoing companionship. On the business end, he had the support of his manager, June Kelly, and his dealer, Arne Ekstrom—and, of course, the daily attentions of Nanette. With this structure, Bearden continued to work up until January 1988, when he made his last visit to his studio. Shortly after that visit, he entered New York Hospital, where he died on March 12, 1988.[3]

Newspapers all over the country covered his death. A memorial service at the Cathedral of St. John the Divine on April 6, 1988, included speakers who represented the various parts of his life—old friend Ralph Ellison, collaborator Derek Walcott, St. Martin writer Fabian Badejo, and I spoke to an audience of almost 2,000. Having recently awarded Bearden a National Medal of the Arts, President Reagan sent a telegram.[4]

As I stepped up to the pulpit to deliver my words, I remembered my first encounter with Mr. Bearden, as I would always call him. I was twenty-four years old and a candidate for a master's degree in fine arts at Syracuse University, when, at the Studio Museum in Harlem, I first came face to face with his artwork. The year was 1973. My academic advisor, Ellen Oppler, a Picasso scholar, had handed me a copy of the *Prevalence of Ritual*—the same catalogue that would captivate August Wilson—with its bright, lemon-yellow cover bordering a black silhouette of an odalisque stretched out on a bright patchwork quilt.

Opening the slender volume, I turned to the color reproduction of the collage *Ritual Bayou*. A nude, a black silhouette, the curve of her shoulder lovingly sculpted, her head tilted, sat in a lush Garden of Eden filled with fauna and flora. Bearden made her ripe, beautiful, self-contained. Who was this artist, so unabashedly sensuous, who reveled joyfully in his depiction of black life, who executed his images with such technical deftness and self-assurance? My advisor had handed me the catalogue of this retrospective after giving me the assignment of delivering a lecture on some aspect of American art not adequately covered in historical art surveys. I had chosen to write about black artists. Jacob Lawrence was the artist I knew best and he was to be the subject of my talk. After seeing reproductions of Bearden's work, however, I decided to include him as well and wrote to him immediately, peppering him with a long list of questions. He answered my letter and included a reprint of an essay he had recently written, "Rectangular Structure in My Montage Painting."

When the retrospective arrived at the Studio Museum, my husband and I traveled to New York, to 125th Street and Fifth Avenue, to see it, climbing the dark narrow staircase to the second-floor galleries over a fast-food joint and a liquor store. All fifty-six collages and *The Block*,

Bearden's monumental panoramic mural of a city block in Harlem, radiant in the spacious galleries, had come home. Women bathing in a zinc tub, conspiring in kitchens and courtyards, hanging their wash like banners in the outdoor sun, stretched out on bright quilts greeted us. Men and women, performing rites of passage, transitions, baptisms, and funerals; musicians in clubs making music; men and women making love; families gathered for a meal, working with their hands in the fields; work, sacred as any religious rite, all were an invocation to private memory. Even in their intimacy and familiarity the collage heralded their global ligatures—Dan and Benin artifacts, Japanese portraiture, Persian Khatam-karis, classical Chinese painting. They were a cavalcade of Walt Whitman's "nation of many nations" or Albert Murray's OmniAmericans. A United Nations coalition could have crowded into the galleries and each member would have found some connection to the paintings on the wall.

We left the galleries and immediately went to search out more Bearden collages, darting from one New York City museum to another. We found none. In the summer of 1972, finding a work of art by a woman or an artist of color at a New York City Museum was rare. Exasperated, I called Mr. Bearden from a public phone (his number and address were listed in the thick Manhattan telephone book that hung by a chain from the phone booth). Not knowing us, and with no prior introduction (other than my letter), he invited us to visit. That afternoon we traveled downtown to Canal Street and amid the clutter of storefronts and vendors hawking their wares, we found the address "357" stuck on the door and climbed a set of narrow stairs to his fifth-floor loft. Mr. Bearden waited at the door at the top of the stairs, smiling, as if greeting long-lost friends.

Romare Bearden and I were never close friends, but his impact on my career, as would be the case with countless artists, scholars, and curators, was inestimable. Three years after that first encounter, as a PhD candidate at Syracuse University, I curated my first museum show—*Mysteries: Women in the Art of Romare Bearden* at the Everson Museum in Syracuse, New York. I praised his uplift of women in that essay.

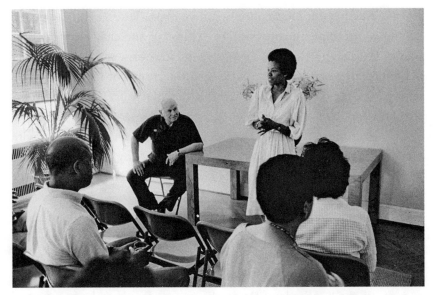

Bearden with the author lecturing prospective African American
collectors in a gallery in the New York apartment of Ron
and Janet Carter, ca. 1980. Photo: Frank Stewart.

No one could doubt the reality of the women in Romare Bearden's art.
Women as he perceives them, are the heart of his community, the black
community, and his concept of women is particularly well-suited to the
sensuousness of his collage technique: he has penetrated their reality and
found something profound, basic.[5]

Bearden, in response to the catalogue essay, wrote that he was trying to
portray "the dignity of Black women."[6]

Even more generously, in the midst of his hectic schedule—in 1975
he was working on the Bronx commission, his solo shows, a show in
Paris—he and Nanette, accompanied by Barrie Stavis and his wife, Bernice,
found time to attend the opening. With Bearden's assistance, I had
borrowed several outstanding abstract paintings from the Stavis's private
collection as well as watercolors, oils, and collages from other willing

private and institutional collectors. Two years later, a call from him prompted me to pursue the position of director and chief curator at the Studio Museum in Harlem. The move to New York came as his career continued to ascend. That call changed the course of my professional career. Looking out at the audience that day in April, I finally got to say thank you, publicly.

Bearden's life was full of contradictions; his death was fraught with conflict. First, there was the matter of his will. Many of those closest to him were surprised to learn that they were to have little to no say in the disposition of his estate. His gallery dealer since 1960, Arne Ekstrom, who had so masterfully resurrected Bearden's career and, on more than one occasion, steered his collages in fruitful directions, was replaced. The husband and wife team, Jeffrey and Dorian Bergen of ACA (American Contemporary Art) Galleries, were chosen by his attorney, Morris Cohen, to manage the hundreds of art works, except for those he bequeathed specifically to Nanette. Nanette, a beneficiary of the will, was given no control over the estate, nor was Bearden's manager since 1975, June Kelly. Cohen was exclusively in charge. Bearden's will also charged Cohen with the establishment of the Romare Bearden Foundation to be made up of the artist's extensive archives, photographs, floor-to-ceiling shelves of books, unpublished writings, plays, essays, journals, notebooks, personal papers, grant applications, business dealings, and correspond-ence. At Bearden's direction, the Foundation was to support emerging artists and to provide scholars access to Bearden's legacy.

I was serving as New York City's cultural affairs commissioner at the time of Bearden's death and, much to my surprise, I received a letter from Mr. Cohen informing me that I was to be one of the advisors to the Foundation (I remain on the advisory board of the Foundation). A law suit filed by Nanette coupled with the sudden death of Mr. Cohen less than a year after Bearden died left Bearden's widow in charge of the estate. Nanette, following Bearden's wishes, established the Romare Bearden Foundation in 1990. Her sudden death, August 18, 1996, less than ten years after Bearden's, was yet another unexpected turn. Nanette's and Bearden's family, nonetheless, quickly stepped in to make sure that

the institutional structure of the Romare Bearden Foundation was secure and the Foundation carried out his wishes The Romare Bearden Foundation now manages the estate, represented by the D. C. Moore Gallery in New York.

Despite the challenges of his will, Bearden's artistic legacy continued to grow after his death, but not without other serious challenges. Questions about the authorship of his later collages emerged. Some were completed with the assistance of Thibault, and though Bearden supervised the collages, some were not made by his own hand. Others were outright collaborations and those are markedly different in style to collages completed by Bearden in his own hand. Space is shallow, the internal rhythms of the paintings are more kinetic, and Bearden's calm classical line has been replaced by a more baroque style. An even more serious threat to Bearden's legacy was the FBI's discovery of forged collages. Fabricated by two forgers, who also turned out bogus works by the sculptor Alexander Calder, the fake collages gave themselves away because the forgers made use of materials that Bearden rarely used in his works. Though the forgers were apprehended and tried, the introduction of fake work cast another shadow of suspicion on the work at a time when ACA and other galleries that eventually sold his work were trying to nurture a growing market for Bearden's collages, oils, watercolors, and prints. Though their fraudulent paintings were worthless, the forgers had guessed correctly—the market for his collages, in particular, would continue to expand after his death.[7]

Soon after Bearden's death, a steady stream of mural commissions, publications, and exhibitions memorialized the artist. To name all of them would require a separate book. Some highlights, nonetheless, are useful to establish the resilience of his continuing influence. Aside from the Bronx subway station work installed in 1988 that Bearden, based on his watercolors, had designed, there were others based on collages designed and installed after his death. One of the most prominent was executed by his widow, Nanette Bearden. Bearden had given permission for one of his collages to be translated into a mosaic mural for the Mecklenburg Public Library in Charlotte. With assistance from

Nanette, a year after Bearden's death, the mural *Before Dawn* was installed.

Based on a collage no larger than a sheet of printer paper, the mural is 9 feet by 13 feet and fills the first floor entry wall of the Library. A visit to the Library inevitably generates an invitation from the librarians to view the work by the city's native son. In addition to murals, two writing projects affirmed Bearden's legacy. Myron Schwartzman, who spent hours with the artist recording interviews, completed the first Bearden biography, published in 1990 by Harry N. Abrams, the fine arts publisher. Handsomely illustrated, the monograph includes lengthy transcriptions of the interviews that contained details of Bearden's life. Schwartzman's conversations with the artist probed beneath the mere recitation of fact to capture some of the emotional texture of his early life growing up in the South and the urban North during the 1920s and 1930s.

Bearden himself, working closely with his writing partner, Harry Henderson, had been co-authoring for over a dozen years an encyclopedic survey of African American artists. After Bearden's death, Henderson worked tirelessly to publish posthumously in 1993 *A History of African-American Artists: From 1792 to the Present*. A dense compendium of the conditions, people, and institutions that supported black artists, the book is a reminder of Bearden's fierce devotion to writing, history, and the active work of preserving his heritage.

A centerpiece of Schwartzman's book is a foreword by the playwright August Wilson. Wilson's tribute has since become a classic piece of writing on Bearden. The playwright, who had never met Bearden, marveled at the artist's ability to transcribe ordinary black experience, and in Wilson's eyes "ennobled it, affirmed its value and exalted its presence." A friend had introduced Wilson to the collages, giving him a copy of the same catalogue that moved me, the catalogue for the 1971 MoMA retrospective *The Prevalence of Ritual*. Bearden's collages, according to Wilson, gave him a way to think about the structure of his own epic ten-play cycle covering a century of black life in America. In his praise of Bearden, Wilson unwittingly called attention to a dichotomy, some would say contradiction, in the artist's work, particularly as it

related to his treatment of women. On the one hand, as Wilson observes, Bearden lifts black people, women included, to an exalted position. On the cover of the catalogue that inspired Wilson, a nude reclines on a quilt, her silhouetted body evoking Egyptian funerary painting.

Wilson's interpretation of Bearden seems especially apt, if the focus is on Bearden's representations of the regal black woman. There are any number of examples. A seated woman becomes a black biblical monarch, *She-Ba,* sacred and regal. Black women advancing in a Palm Sunday processional compositionally echo a sixth-century Byzantine mosaic. Bearden has said that he wanted an art that is "strict and classical" and "historically durable," and one of the ways he accomplished that was by classicizing the black female body. Along with the Conjur Woman, a figure he invented visually in his *Projections* and repeated frequently, Bearden created a body of work in which black women defy age-old caricatures and stereotypes and instead elicit reverence and exude power. But this side of Bearden was but one side of a multi-faceted artistic persona; subsequent shows and analyses of his work called attention to other facets of his work, some often difficult to reconcile with one another.

Bearden's first retrospective, organized by MoMA, had traveled to the Studio Museum when the museum was a modest loft on Fifth Avenue and 125th Street. A year after Schwartzman's book appeared, the Studio Museum in Harlem mounted its own retrospective, *Memory and Metaphor: The Art of Romare Bearden 1940–1987.* This 1991 retrospective was held in the museum's home on West 125th Street, in the building that once housed the furniture store where Bearden had mounted a group show almost twenty-five years before. Curated by art historian and chief curator Sharon Patton, the show was the largest retrospective of the artist to date with 146 works, a catalogue published by a major university press, and an essay by Patton.[8] In response to this large selection of work, Michael Brenson, a *New York Times* critic, in his review of the show, made note not only of Bearden's emphasis on women but on the wide range of roles he has assigned to them—"mothers, lovers, gardeners, conjurers, healers, and prostitutes."

Brenson wrote that the artist has "no fear of sensuality" and that his work embodies "a raciness and promise that a number of American artists have sought and few have found."[9]

Patton, too, had commented on the raciness in her catalogue essay to the 1991 retrospective, referring to Bearden's "heightened eroticism" and placing his nudes in an art historical lineage that represents a "voyeuristic point of view." She compares Bearden's nudes with a tradition of voyeurism not unlike canonical examples of nudes in Western painting— "Titian, and Rubens, Delacroix or of Renoir and Manet."[10] Lowery Sims, writing an essay for a Rizzoli series on art, compares Bearden's paintings of women to those of Edgar Degas, noting that like Degas, Bearden makes us complicit in his voyeurism, as he captures glimpses of women caught unaware in intimate settings or in private moments like Degas's fascination with the black circus performer Lala.[11]

Observers noted that a part of Bearden's legacy was an attention to the black female body that was unusual at that time in fine art. A comparison between Bearden's early work and the later collages demonstrates how completely differently he came to regard the representation of the black female body. His earliest paintings are filled with black men and women who are models of respectability, restraint, and rectitude. They play out tense dramas of survival with quiet dignity as they conduct courtships, tend to their families, labor in factories or fields, futilely look for work, or tend their home-grown gardens. Exterior scenes in the early paintings often depict a bleak desiccated landscape or a background of stifling factories. Interiors, austere and parsimonious, bear very little of the intimacy and sense of shelter of the collages. The black female body in these early paintings is solid, the rock in the family, breasts ample, arms thick, limbs, neck, arms covered. She is always fully clothed. Somber in tone, the paintings could have hung in Rosa Kennedy's parlor.

Bearden includes iconographic and stylistic elements that will reappear in the collages: photographs hanging on the wall, lamps lit, tables set for meals, the accoutrements of family, evidence of care and attention. Exterior scenes feature tools of work and musical instruments. Hands, enlarged and gesturing, are the principal means of expression in

otherwise stiff, almost wooden representations of the body—male or female. Biblical allusions, as noted earlier, lift some of the painted images beyond the literal—*Visitation*, an evocation of the encounter between the elder Elizabeth and the young Virgin Mary, and *They That Are Delivered from the Noise of the Archers*, bearing a line from the book of Judges written across the surface of the painting. The paintings evoke the quiet and reverence of Renaissance paintings of religious scenes. Sanctity, stoicism, and rectitude as well as the suppression of movement, emotion, and any hint of the sensual prevail.

Shortly after the national tour of *Memory and Metaphor* ended, Judith Wilson (no relation to August Wilson) made note of the contrast. Her essay recalls the charge of "lewd" and "obscene" raised by Bronx politicians over his mural, *Cityscape*, almost twenty years earlier. Titled "Getting Down to Get Over: Romare Bearden's Use of Pornography and the Problem of the Black Female Body in Afro-U.S. Art," the essay is direct and to the point.[12]

Unable to gain permission to publish photographs of his explicit nudes, Wilson nonetheless is pointed in her observations: "By 'getting low,' culling images from pornography, the least reputable of pop cultural sources, and dealing with Black sexuality in an unusually explicit manner—Romare Bearden managed to transcend the widespread stigmatization of Black sexuality." Wilson praises Bearden's "reinscription of Black beauty and eroticism in the context of African-American vernacular culture" and characterizes his nudes as "recuperative." At the same time, Wilson laments the silence that surrounds Bearden's use of "pornography's standard tropes."[13] Though several authors, as noted above, alluded to the explicitness, raciness, or heightened eroticism of Bearden's work, none pointed out pornography as a source of his imagery. The contrast between the exalted and the "low-down" was nonetheless very real, part of the shrill dichotomies that were intrinsic to Bearden's work.

There's no doubt that part of Bearden's legacy has been his sloughing off the restraints of what Evelyn Brooks Higginbotham would call the "politics of respectability."[14] Negro uplift was a strategic path to full citizenship. The black press from the nineteenth century to the early

years of the civil rights movement, especially, was a principal champion of the tenets of "respectability," and Bearden's mother, a leading journalist, had been the epitome of the phrase. Her social columns kept track of the comings and goings of respectable black people and her successful public career was a testament to the wisdom of the strategy.

Bearden's upbringing in the homes of Henry and Rosa Kennedy, Cattie Bearden Cummings and Carrie and George Banks swathed him in Negro respectability. He married Nanette Rohan, a former model, whose image in mass media publications and television commercials was almost always part of a tableau of bourgeois respectability. Throughout his career Bearden complained of the suffocating judgments he heard about his work not representing what was best about black people. The stinging criticism that greeted *Cityscape* reminded him that uplift and respectability had a public dimension as well. Bearden's maturation as an artist meant freeing himself of those judgments and painting what he wanted to paint. There is a measure of creative defiance that sometimes surges through his collages like a stray electric charge.

It's no accident that Bearden's breakthrough work came during the civil rights movement. Everything about the movement was reenvisioning: a black woman sitting in the front of the bus in the South; students asking to be served at a segregated lunch counter; protesters marching peacefully across the Edmund Pettis Bridge; registering to vote in certain counties in the South—all of that was a mass disruption of the way people thought and behaved. Laws were broken, social practices ignored, and, as the writer Margo Jefferson would say, assumptions violated. Bearden's *Projections* and the collage work was as much a disruption, with its stark representations of the black body and black culture, confounding popular culture with so-called high art, as any law that was broken. Bearden's disruptions extended as well to limits imposed by the expectations of his past. Today in fine arts, Kara Walker's brash silhouettes in various explicit poses, some by themselves, others with males, or Mickalene Thomas's self-portraits or Wangetchi Mutu's explorations of

black female identity make Bearden's nudes look almost modest by comparison.

Disruption was not his only legacy, and the full impact of Bearden's work has become evident with the passage of time. The Foundation that Bearden insisted be part of his legacy has played a critical role in establishing both broad overview of his work and in-depth probes. The current co-directors Diedre Harris-Kelly, his niece, an artist in her own right, and Johanne Bryant-Reid, retired first vice-president of Merrill Lynch, have led the Foundation since 2009 and taken on that responsibility. One of their first activities was to organize symposia at leading research universities and cultural centers across the country. Starting with Bearden's alma mater, New York University, they continued with convocations at Duke, Harvard, and, in Pittsburgh, the August Wilson Center. The symposia were occasions for convening scholars, students, researchers, and other artists and generating papers and publications on Bearden. Their strategy worked, and although Bearden is not a household name, over the years his reputation has undergone periodic revivals. Harris and Reid commissioned the cataloguing of Bearden's papers accompanied by a finding aid that turned a mass of papers into an invaluable archive for the study of his life and work.[15] Before they assumed responsibility for the Foundation, two of Nanette's sisters, Sheila Rohan and Dorothy Dow, asked first Joan Sandler, then Grace Stanislous, both Foundation directors, to launch one of the most important projects, a retrospective exhibition with the National Gallery of Art in 2003. The exhibition catalogue stands as one of the most important on the artist to date.

The exhibition, curated by Ruth Fine, opened in 2003. The catalogue's comprehensive bibliography, detailed chronology, and collection of essays, beginning with Ms. Fine's carefully researched overview of Bearden's life and work, provided the public with a reliable source for close study of his work. At 131 works, the show, somewhat smaller in number than the Studio Museum retrospective, included the 1974 Berkeley mural, examples of Bearden's several versions of *The Block*, and sketches of unproduced collaborative projects. The show traveled

extensively for two years accompanied by symposia, lectures, and public conversations at every stop. Reviews were unanimously favorable. Fine and other collaborators were frequent participants on popular television and radio shows and networks, such as PBS and NPR. And after an extremely successful national tour, Fine continued to champion the work by hosting symposia and participating in important publications that continued the conversation around Bearden's work. The catalogue from the National Gallery exhibit has become foundational for Bearden studies. Other exhibitions followed, including those held at ACA, Michael Rosenfeld, and the D. C. Moore Galleries.

The Nasher Museum added to the series of exhibitions that were mounted with the 2006 exhibition titled *Conjuring Bearden*, curated by Richard Powell, then chair of the art history department at Duke University. Powell's focus on one motif, the Conjur Woman, highlighted Bearden's talent of layering, almost archeologically, multiple layers of history, folk lore, literature, desire, and experience.[16] Images of conjure women are acts of sabotage. What they assault is commonplace ways of seeing. Early versions of the Conjur Woman carry with them the hint of violence. But even as the image grew more alluring in later versions of the motif, implicit in her representation is power and control, something the artist spent a lifetime discovering for himself.

One of the most potent forms of legacy is the work of other artists. Artists—dancers, theater artists, musicians, as well as other visual artists—have been drawn to Bearden's work, reinventing, reliving, and revising it. August Wilson is the most well-known theater artist to credit Bearden with influencing him. The play *The Piano Lesson* takes its name from Bearden's collage of the same name. The play *Joe Turner's Come and Gone* chose characters out of one of the autobiographical paintings. Most important for Wilson, as noted earlier, is the playwright's indebtedness to Bearden for the concept of the ten-cycle play. Garth Fagan, an acclaimed choreographer, met Bearden in the company of Alvin Ailey and was immediately taken with his generosity and wisdom. Bearden was a mentor to Fagan and in November 2003, many years after Bearden's death, Fagan premiered *A Collage for Romie* at the Joyce Theater as

homage to the collage artist.[17] On the occasion of Bearden's National Gallery of Art retrospective, choreographer Walter Rutledge, who was part of the Nanette Bearden Dance Company, choreographed a ballet entitled *On the Block*, based on Bearden's multi-panel mural, *The Block*. Branford Marsalis, acclaimed jazz saxophonist, produced a record album titled, *Romare Bearden Revealed*, in 2003 in honor of Bearden. He included compositions inspired by Bearden, some jazz classics, and *Seabreeze*, for which Bearden wrote the lyrics during his brief song-writing period.

Perhaps the most ambitious celebration of the Bearden legacy occurred during the centennial of his birth. The Bearden Foundation set in motion a series of national events by extending an invitation to museums and cultural centers all over the country to mount a celebratory exhibit at their sites. Some, like the Metropolitan Museum, installed holdings from their permanent collection—in the case of the Met, the monumental 18-foot mural, *The Block*, along with the preparatory drawings and sketches Bearden completed. Bearden's hometown of Charlotte hosted several events.

On the morning of September 2, 2011, the city of Charlotte broke ground on the Romare Bearden Park, a public space that occupies 5.4 acres of land at the corner of South Church and Third Street. To mark the event, the city sponsored a performance by the choir from All Saints and Michael's Episcopal Church, where the artist was baptized Fred Romare Howard Bearden a hundred years earlier. Later in the day, the Mint Museum, which had mounted a ten-year retrospective in 1980, opened a major retrospective, *Southern Recollections*, that included seventy works based on southern themes. As part of the opening ceremonies, the museum hosted a rare performance of some of Bearden's jazz compositions. The show was accompanied by a PBS special, produced by Steve Crump. And the much-heralded park opened August 2013 and quickly became one of the city's most popular attractions. Designed to recall the layered textures of the collages and evoke the subject content, the park is an unusually beautiful oasis in the middle of the city that brings to Charlotte a lively presence for its native son. In the fall of

Romare Bearden Park, 5.4 acres, Charlotte, NC, opened by
the city in 2013 to honor their native son. In the fall of 2017,
a sculpture by Richard Hunt, titled *Spiral Odyssey*, was
installed in Bearden's honor. Photo: Jody Mace.

2017, Richard Hunt, the sculptor whose retrospective opened at the same time as Bearden's retrospective at MoMA, dedicated a monumental sculpture in Bearden Park in Bearden's honor.

Studio Museum in Harlem extended the centennial celebration over two years with a particularly meaningful memorial, given Bearden's relationship to the museum. Since the WPA era, Bearden believed that an institution devoted to the support of living artists and the preservation of the legacy of artists of the diaspora was necessary. The WPA-sponsored art center had been a start in that direction. Studio Museum, becoming an accredited fine arts museum just before his death, moved the museum closer to the kind of institution Bearden envisioned. (The National Museum of African American History and Culture, a Smithsonian Institution museum, though not an art museum, has attained the status of the nation's black museum.) Having moved from the loft space that was home to his MoMA retrospective, the Studio Museum acquired its own building on West 125th Street. Exhibitions, permanent collection, publications, and education programs joined by artist-in-residence studios in support of the working artist in many ways realized Bearden's vision of a home for black art and artists.[18]

The museum's current director, Thelma Golden, invited contemporary black artists to celebrate the centennial of his birth. The museum mounted a series of three exhibitions, the *Bearden Project*, in 2011 and 2012 with over 100 artists who credited Bearden with having had influence on their work.[19] Golden describes the process of catalyzing the exhibition's content, noting that artists were invited to create "a work of art that is inspired, influenced, instigated, or informed by Bearden's life, work, and legacy." The invitation yielded a cross-generational response that captured the imagination of artists from vastly different mediums and approaches to image-making. To visit the museum during the exhibition was to be reminded of the extent to which the retrospective in 1972 cloistered in the museum's galleries over a liquor store had spawned a richly complex lineage. That lineage, as Lauren Haynes, the museum's assistant curator, notes, was a "living archive of the most exciting contemporary Black artists working today."

As time passes and Bearden's legacy continues to influence contemporary artists, one thing is certain: the war of images that greeted H. B. and Rosa Kennedy in the nineteenth century continues to be waged into the twenty-first. In the early twenty-first century that war was fought most publicly, and most virulently, in the election of the country's first black president. Candidate Barack Obama understood the potency of visual images, and his ability to create his own narrative—written and visual—was key to his success. Before he declared his candidacy, Obama wrote two autobiographies, *The Audacity of Hope* and *Dreams of My Father*, texts that framed his life and political ascendance in terms controlled by the candidate. During his campaign, candidate Obama attached to his campaign a team of young videographers who, on a daily basis, captured images of the candidate at his campaign events, edited them into marketable presidential images, and circulated the images to news media and social media platforms.[20]

Candidate Obama's capacity to produce first a written narrative in the form of his two autobiographies followed by his own inventory of visual images allowed him to invent an illustrated presidential storyline that recounted his beliefs, values, and principles and made visible what an Obama presidency might mean for the country. Conversely, those same tools, once he was elected, were used to manufacture derogatory images designed to undermine his credibility as a leader and cast aspersion on his presidential agenda. By the end of his presidency the visual satire that issued from his detractors, not to mention the outcome of the 2016 election, disabused anyone who held dreams of a post-racial society.

The proliferation of visual imagery has accelerated exponentially since Bearden's death, and with that growth, black image-makers have grown in prominence exponentially, not only in the fine arts but also in film and television. On television, audience and critical powerhouses like the shows of Shonda Rhimes, Ava DuVernay, and Donald Glover present dramatic and comedic images of black life through complex characters and original, sophisticated storylines. Filmmakers, fiction and documentary, have created unsentimental portrayals of the state of American culture through a black lens—Spike Lee, Malcolm Lee, Stanley

Nelson, Raoul Peck, Ava DuVernay, Dee Rees, Carl Franklin, Barry Jenkins, Jordan Peele, and Ryan Coogler are just a few of the filmmakers who have sustained careers that have built audiences for sophisticated image-making. Ralph Ellison's observations about Bearden applies to their images as well. They have destroyed clichéd images. Yet Wakanda notwithstanding, there is no triumph in these successes, only the knowledge that the battle continues. "Black Lives Matter" has supplanted the chants of "We Shall Overcome" in the 1960s and "Power to the People" in the 1970s. Mass incarceration has replaced Jim Crow as the number one civil rights issue. The urgency of image-making remains.

Given the exponential growth of cinematic and television images, one might think that Bearden's fine arts images would seem old-fashioned. Yet, as new exhibitions are organized in the United States and abroad, when his collages are included, they inevitably stand out as a revelation. The "dis-interred" truths of Bearden's work, like the words of James Baldwin, still feel fresh and relevant. The Tate Liverpool's 2010 exhibition, for example, *Afri Modern: Journey through the Black Atlantic*, inspired by Paul Gilroy's text, *The Black Atlantic: Modernity and Double Consciousness*, referenced earlier, prominently included Bearden. Artists, black and white, European, Caribbean, and North American were included to illustrate the impact of black culture globally as a result of the clash and disruption of the slave trade. More recently, at the Tate Modern, *The Soul of the Nation* opened in July 2017. The *Guardian* made note of *Pittsburgh Memory,* one of the original 1964 *Projections*. A survey of Bearden's abstract paintings organized by the Neuberger Museum opened in September 2017. The exhibition *Posing Modernity: The Black Model from Manet to Matisse and Beyond* (*Le Modèle noir, de Géricault à Matisse* in Paris), which will be on view at the Wallach Art Gallery at Columbia University Lenfest Center for the Arts from October 24, 2018, to February 10, 2019, is based on a doctoral dissertation completed by Denise Murrell. Murrell's thesis considers the role of the black female body in shaping the direction of modernism and traces the lineage of the black female body from Manet and Matisse through its American iterations by Bearden and other American artists such as Mickalene Thomas. An expanded

version of the show is scheduled for the Musée d'Orsay from March 25 to July 14, 2019.[21] The High Museum of Art in Atlanta plans a major exhibition of Bearden's two autobiographical profile series for April 27, 2019, to September 9, 2019, casting the subject of autobiography center stage once again.

Bearden best summarized the long-term value of his work himself. In the text that accompanied one of the autobiographical collages in *Profile/Part II: The Thirties*, titled *Johnny Hudgins Comes On*, collage on board, 16 x 24 in., Bearden writes of Hudgins's artistry, "He was my favorite of all the comedians. What Johnny Hudgins could do through mime on an empty stage helped show me how worlds were created on an empty canvas."[22] Bearden, to use a phrase coined by the performance studies scholar José Muñoz, like Johnny Hudgins, was a world maker. He didn't construct scenes of black life and black culture; he recreated worlds. Time, place, and history lived inside the characters who populated those worlds. Like the world created by Johnny Hudgins on stage, Bearden's worlds could be a collection of contradictions. Hudgins performed in blackface but his accompanists were often first-rate jazz trumpet players, the likes of Louis Metcalf or Doc Cheatham. A vaudevillian, Hudgins was a modernist as well, appearing in French filmmaker Jean Renoir's 1927 film, *Sur un air de Charleston* (Charleston Parade) and performing along with Josephine Baker in *La Revue Negre*. Bearden admires an artist who performs in blackface but paradoxically is a futurist. He is a master of vaudeville but also a symbol of modernism. What Bearden admired is that he took what he needed for his art and, on stage, he was master of his world, the world he had invented. Bearden's homage to Hudgins is a tribute to Hudgins's ability to blend the so-called good images with the bad, to yoke together the so-called positive with the negative in order to construct his own ideology of being in the world.

Bearden's legacy, like Hudgins's, was his ability to create worlds. In that paper bag full of clippings he brought to the Spiral meeting on Christopher Street, he carried the bits and pieces of fractured images. In memory he carried multiple geographies of a lifetime: the cotton fields of Mecklenburg and brothels of New Orleans; the Pittsburgh steel

Romare Bearden, 1987. Photo: Frank Stewart.

mills; the cabarets of Harlem; Harlem from the rooftop of Mr. Murray's apartment building; the radiant glow of the Caribbean. In his imagination he recreated the voyage of Odysseus, an image of voyaging, of fighting to get home that constantly attracted him. In his imagination he saw both the continuity and the clash of cultures. How much of Bearden's world making was deliberate and planned? Bearden used to say that he kept no organized files, and his live/work space on Canal Street was filled to the brim with books and papers that spilled out of the shelves. The Long Island City studio he acquired in the 1960s was sparsely furnished, almost empty, when he first moved in. By the time of his last visit to that studio in January 1988, it was stuffed with shelves and bins packed full of books and magazines, pieces of fabric, wood—the armatures of collages— specially ordered glues, sample construction materials. Aside from the organization of art books by period or subject matter or medium, there was very little formal order. His studio space was much like the inside of the bag of clippings. He took what he needed from his bag; from the clut- ter of his studio; from museums—with or without walls. He took from the cultures of the world as he visited them, studied them, or imagined

them. Photography, theater, dance, music, performance, film, a rapidly disappearing black folklore, popular media, memory—all nourished him. In the end, when he walked out of his studio for the last time, he closed the door and left with the satisfaction that his voyage of discovery had come to an end. He had finally disembarked; he had finally found his way to a place he called home.

APPENDIX

ROMARE BEARDEN LETTERS TO THE AUTHOR

Mrs Mary S. Campbell
237 W. Castle Ave
Syracuse
— 13205 — N. Y.

Romare H. Bearden

(212) WA 5-5375 357 Canal Street, New York, N.Y. 10013

1. For my early works, I painted on heavy brown paper, using tempera colors, because it was a cheaper method of working than in oil. A big consideration then.

2. My first oils were done on masonite panels. They had to be gessoed to hold the oil properly & to provide a white base for the colors. Your husband will explain, that light penetrates thru the layers of colors and hits

the last layer, as it usually is, a white base at bottom; it gives more resonance to the colors—when the light gives back the whole color complex. This is why glazing is possible. A blue (transparent) glazed over a yellow, will give a green.

3. In my early works for Kootz I worked in a series—not now.

4. Unless I mistake your meaning I can't see their (Rothko - Gottlieb) ^{works} as particularly 'myto-religious'. They had both done figural stump in the early 40's, but changed by the late 40's. Gottlieb used some totemic concepts in his works, somewhat like the S. A. painter - Torres-Garcia → but soon, ^{his works} become almost totally non-representational.

5. A painter always tries to expand his concept.

6. I was interested in what Color could do and, as such, it tore apart the form—later, I could consider color as a place & a position in space. I used gray as an interval - like a rest in music - to control the coloration. If one just doesn't tint drawings, in essentially, a black & white concept, you must consider color as concidental with form & space.

Romare H. Bearden

(212) WA 5-5375 357 Canal Street, New York, N.Y. 10013

3

II. I feel that I can tell a good piece
of African sculpture, but I can not identify
all the tribal manifestations. I looked long at
African sculpture in the 30s. I went with Dr.
Seyfert ((a forgotten man, now deceased, who
collected a great number of volumes on African
history and used to have we young painters
to his home. Lawrence, I, and others, were
influenced by him))

In my work, if anything I seek con-
nections; So that my paintings could be only what
they appear to represent. People in a Baptism, in
a Virginia stream, are linked to John the
Baptist's ancient purification rites, and to their
african heritage. I feel this continuation
of ritual gives a dimension to the works,

so that they works are something other than
mere designs,

African ideas are interesting, but one
can't turn back the clock, that is, by trying
to live as _we_ _imagine_ they, the africans,
might have lived a hundred years ago.
What I personally incorporate from these
studies in my works are concepts of shape—
A shapes that are _expressive_ to the _emotion_
of the work. Philosophically, concepts of rhythm
(in the great ordering of life); the beauty of the
black woman; the past interwoven in the
present, etc.

In the works inspired by Martinique—
do you mean that the collages are small,
or that the women are small in them? Both
statements are true. For some shows, I planned
abroad, I did smaller works because shipment
are so expensive. The figures are small to
give _scale_ to the landscapes.

My goodness, I hope this is helpful!
RB.

Romare H. Bearden

(212) WA 5-5375 357 Canal Street, New York, N.Y. 10013

Dear Mrs. Campbell: I've just returned from
the West Coast, where I did a bit of a semi-
nar at the Uni. of Calif (at Hayward) and saw
about a mural - to be done in Berkeley. This
was a first trip to the W. Coast for my wife
and myself; and it is certainly a beautiful
section of the country. So much so, that for
me at least, I'm afraid the whole ambiance
is so restful and handsome I'd hardly do
any work. Here, everything is so terrible there
nothing else to do but turn in on yourself
and work.

Im glad your lecture
went so well, and your comparison of Donne
and Bernini should also be very interesting. I'm
very fond of Bernini as a sculptor and al-
though you don't hear to much about him
these days. during his life time he was even

314

more revered than Michel Angelo. Invited by the King to France and received like a King himself.

Both of these men were Baroque artists — their works constantly spiraling and turning in on each other.

Good luck on your project and indeed when you nova are in town again please call me.

Sincerely

Romare Bearden

5-10-72

R. Bearden
357 Canal St
N.Y. N.Y. 10013

MRS. MARY S. Campbell
237 W. Castle St.
Syracuse,
New York - 13205

(4) Father for Bd. of Health: Sanitary Division

(4) <u>In home</u>: Paul Robeson: Garvey: Hubert Harrison (Garvey's associate) Harold Jackman: Langston Hughes: Countee, etc. Andy Razaf & "Fats" Waller (the great song writing team of the 1920s) Turner Layton - "Way Down Yonder in New Orleans" - later went to London & with Tandy Johnston became the outstanding vaudeville team - So many others - Heywood Broun - In other words, all the people in politics - the arts - the theater - passed thru the home. A'Lelia Walker (Mme Walker's daughter - Mrs. Bethune - all close friends.
 Bill Attaway was more a friend of mine and while he did visit the house - he was somewhat younger than the persons who were at the house all thru the 20's & early 30's.

==

Page (13) I don't think now I would be as harsh as I was then. I have seen some of Palmer's ptgs. at a retros pective - following his death - that were quite good. Then to, these artists of the 1920s had to prove something to themselves & to the white world, unfortunately, that they were actually capabaple

of producing art — or ART. The great jazz music was not accepted then (the 1920s) as anything of artistic importance. It was the Frenchman Hughie Panassee — 'Le Jazz Hot' who did the first cogent analysis of this form.

Page 16 Douglas — what saved him — he was a better painter. He had studied at the Barnes Fd. & with Winold Reiss, where he was certainly given a real appreciation of African arts.

page 26 — About 1939 (I think) Jacob Lawrence told me of a studio for rent about his at 33 W. 125 ST. $8⁰⁰ a month — fee lite. I stayed there for several years — Until my mother went to Mr Schiffman — over at the Appollo Theater — and got a new place for me. (It was once the theatre, rehearsal hall) for 15⁰⁰ nitely — I stayed there for

some time 1942 - 1956 - (3)

Page 32 - "Showed exculsively in Downtown
galleries." True - until I organized the ex-
hibit - "Contemporary art of the american
negro" at 125 St. during the summer of
1966 - there had been no such compre-
hensive showing of negro artists in Harlem
since the 1930s - In other words, not much
was happening in the uptown art world
at the time. Possibly, only the Barnett-Aden
Gal. in WASH. D.C. was functioning as an outlet for Bl. artists.

38 Why lorca - There may have been some
unconscious reason (so a few friends of mine
say) My mother's death - the period after
the war. etc.

However, I did read a lot &
was very interested in lorca's work. Actually,
during the late 1940's a friend of mine
Frank Fields (Black composer who dies several
years ago) did a cantata on lorca's poem
(death of the bull fighter) & section of it was reproduced in Portfolio -
a series of portfolios that Caresse Crosby
published during the late 1940's. In it, is

a colored reproduction (4) A a water color,
I did, illustrating Frank's score.

Lorca was also to my mother's house
In the 1920's, Lorca stayed in NYC for
several years - attending Columbia Uni -
I was a good friend of Langston's - who
brought him by the house.

Page 40 "not conducive to painting" - That is
for me. Paris is a bad place to go to
find yourself - it Offers too many diver-
gencies. —

41 Nanette - not A Martinique - St. Martins
sto altho both are French islands.

42 this was a time Of getting my head
together. American ptg. was coming
to the fore (internationally) But I
felt the Abst. Exp. style was not for
me, as I wanted a more formal dis-
cipline, somehow.

them to. I wanted to explore the art of painting more—to see where I stood in the nature of that art. My copies were systematic, in a way. Starting with Giotto—Duccio—Veronese—Rembrandt—Monet—Matisse—.

The Rembrandt—"Pilate Washing His Hands" at the Met. gave me so much trouble. Of all ptgs, Rembrandt's structure is most hidden—difficult to follow—

I had some idea of song writing as a means of getting back to Paris: but it was a forlorn hope.

The studies I did, I feel, gave me a lot of information as to the way a ptg. is put together. As I look back, this was very valuable. We put too much emphasis of being immediately creative—To damn an artist, mention is made of his influences.

Also, during this period I had read the notebooks of Delacroix—who copied constantly in the Louvre. Only in recent

years has this method(6) been discarded –
I think unfortunately.

Page 45 not me alone. The artists met at
my studio (as you state) to all about going
to Wash. as a group. Later, the fellows
were so interested – we decided to stay
together. That late Fall, we rented a
meeting place & studio on Christopher.
St. Hale Woodruff suggested the name
Spiral. ◎ as a symbol of a constant
expansion outward & upwards.
The Archimedian spiral.

page 45 We were not 15 at first –
Earl Miller – Wm Majors – Reg. Gammon –
Calvin Douglass (2 s') Emma Amos came
along afterwards.

page 47 my words – "they didn't know
what I meant" are wrong. The fellows
had ideas of their own. Each of the

members were capable artists & had their
own metier.

page 58 ④ ↙ (Layout)

1st stage
lay out shapes
in the same
ratios (almost)

as the large, or mother, rectangle —
This then would give me an idea of
what next to do. As the smaller sect.
were in the same overall ratio — some
sort of unity was established at the outset.

In the 2nd stage composition really begins. All that you read about triangular basis of composition is wrong. that is laid out. Composition is binding of the separate elements together.

2nd Stage
so I start with
a lady (for ex.)
over a fire in the
backyard — cooking

a child approaching — in front of a house.
I've never painted such an actual scene —
but you can see where the relationships
were maintained — My idea of what I will do comes
at this point. I have nothing prefixed in and 3rd to refine
my mind
& try a brief things together. —

(8)

<u>63</u> I don't care very much for surrealism.
I feel my work - or seek, I might say -
for fantasy. I don't look to the dream,
In the life I know best, the fantastic, or
what might seem so to others, was but
normal. That's what I try to incorporate -

=

<u>70</u> no literal copies of Cranach - but
works inspired by it. Why not an inspiration
from a work of art, as well as an apple,
or a mountain.

 At a rehearsal of Duke's a few years
back, Duke had to incorporate some of
Tchaikowsky music. He was thinking of
changes. But Billy Strayhorn said -
"Duke, this is Tchaikowsky's music!" "That's
all right", Duke said," but for us it
has to go this way."

 So I transposed Cranach to a
Black circumstance. The Prince - who

324

sits in judgement is black. ~~Religion~~ The Goddess is real too. All is brought to a flat plane, eliminating the depth perspective in the admittedly great work of Cranach, & etc.

Paris is, indeed, not so much in judgment - as in a position of <u>acceptance</u> - my <u>Paris</u> doesn't need a stud horse in the background to point up the erotic elements. I wanted a calm, classic grandeur.

<u>70</u> <u>Manet</u>: Is one of my most favorite artists. One of the last painters to be able to truly paint in the <u>grand manner</u> - after him, art was to be more informal.

I like his elegance, his personality. I find him a very comfortable ~~plan~~ artist. Had we lived in the same time, I'm sure we would have been friends. Art is a continuation. Chesterton said great poets write poems short it

(10)

the Spring, because each year people
forget how beautiful the Spring is - only
the mediocre ones seek novelty - for that
Sake alone. I cherish the steel, classic
values. This means I sacrifice ~~movement~~
the [⦿⦿⦿] arabesque of motion (- not
movement, though.

71 "West. civilization is ~~dying~~"
changing, really. We are between 2
kinds of ~~culture~~ ages, one not yet quite born -
 What began with the Ind. Revolution &
the machine - together with those concepts
of humanism, etc are passing away -

71 Born in Staten Island (but both parents
in St. Martin) We do love Martinique
also - And a lot of my last ideas
germinated from sketches, & thoughts,

originating these. (11)

—

73 "one which cannot quite comprehend
the opposite sex."

What men can? But I do try, always,
to conceive the woman, I portray, with
real dignity. Also. I come from another culture—
I never knew my grandfather's first name was
George T. until I could read; because I never heard my grand-
mother call him anything but Mr. Banks. He had to ask to
come in my grandma's kitchen. B—men & women had great
respect for each other.

77 "to mirror the Black community."

me → to try & interpret that community
in terms of a personality; in terms
of art; in terms of the dignity of life.

89-92 → There are other reasons:

① Art is, in some ways, now big
business — in that world — there are few
Blacks presidents — or real executives of Gen. Motors,
U.S. Steel, etc.

② There are only, now, a growing
number of Black collectors—

(3) Also, this exclusion does not apply just to contemporaries.

In Paris: the great collection of African Art is in the "Musée de l'Homme" - not the Louvre! So its in an Anthropological mus.

In NYC: Its the Mus. of Primitive art - not the met -

Also, to be fair, how many of our magazines, until recently, did anything significantly on Af. Art. Look thru Ebony. for example.

Tanner, in my opinion, is one of the 3 or 4 best Am. painters. Better by far than Homer, or his (Tanner's) teacher Eakins. Few people know who Tanner is, however.

~~What ...~~

Also, I recall in the writings of Ab. Expressionism. if mention was made of the artists showing at the Kootz Gallery - that is during the mid - 50's and early 1960's my name would be left out - this was constantly

(13)

done.

Sometimes I feel that one of the reasons
for the continuing racism in America - is
the very hetro-genous nature of the country.
There is no, no reason why refugees - coming
into America penniless, just before, and right
after World War II - for example - should now be
so far ahead of black people. But the blacks
are the very leverage by which many of
these persons have arisen - if thats the cor-
rect word. "At least", they'd say, "I'm better
than those people". In the meantime, using the
money from the State to open their business in
the black neighborhoods.

What has this to do with art?

Go back to anyone of the Histories of
American art - look at the names - Winslow
Homer - Thomas Eakins - John Singer Sargent.
Mary Cassat - Albert Ryder - Whistler - De
Wing, etc. All good WASP names.

Now - names have changed - A number of our
leading American artists were born in Europe - Rothko - for
ex. - Others 2nd generation - Room must constantly be
made for new arrivals -

Who is moved aside?

Also - I feel that concluding section should look
more at your personal feelings - even about the

state of art in general. But, in all,
Splendid!

Sincerely
R.B.)

Regards to the styquait

If you want your manu-
back write me and I'll forward it
right away —

ACKNOWLEDGMENTS

Writing a book is a paradoxical combination of intense solitude and massive team effort. I take this opportunity to thank the members of the team who have made this book possible.

My colleagues at New York University (NYU) have been invaluable. First and foremost, Klara Palotai, who, as chief research assistant, searched for obscure photos, identified texts in out-of-the-way archives, and located previously unknown correspondence. To the end, she was a trusted reader and thought partner, and I owe her an incalculable debt of gratitude.

My Cinema Studies colleagues at NYU, Robert Stam and Sheril Antonio, generously read early versions of the text, and Manthia Diawara and Dan Streible offered insights into sources about early black cinema. In Performance Studies, the ideas of my late colleague, José Muñoz, on world making greatly influenced my thinking about Bearden. In Photo and Imaging, Deb Willis was an invaluable resource on photography in particular and black image-making in general. My thanks to her and Awam Amkpa for the invitation to present a portion of the research at *Black Portraitures II: Imaging the Black Body and Re-Staging History* in Florence, May 2015, and in March 2018 at *Black Portraitures IV* in Cambridge, hosted by Henry Louis Gates at Harvard's Hutchins Center for African and African American Research. David McLaughlin, NYU provost, provided sabbatical time and much needed research support in the book's final phase. Research assistance from Liz Andrews helped support the early stages of the work, and Bobst Library and the New York University Archives were extremely helpful in providing background on Bearden's NYU years as well as the early twentieth-century arts environment in the village. My thanks to

Lynn Gumpert, director of NYU's Grey Art Gallery, for her insights and defining exhibitions of the downtown art scene and for hosting an exhibition of the Hale Woodruff *Amistad* Murals. Thanks as well to former NYU president John Sexton for his illuminating views on the subject of baseball.

A special thanks to my colleagues at Spelman College, who, during the early years of my presidency, endured the interruptions of my attention necessary to the completion of this book. Chief of Staff Helga Greenfield was especially helpful in tracking down information at a number of historically black colleges and universities (HBCUs). Holly Smith, Spelman College archivist, was extremely resourceful in identifying information about Bearden's connection to Spelman College. Jarvis Ridges was invaluable.

Versions of this book have appeared in many lectures and symposia. Without naming them all, I especially want to thank the Romare Bearden Foundation for the series of symposia they organized and co-hosted at colleges and universities around the country. I am grateful for the opportunity to have presented at several of these including the 2010 Bearden symposium at the August Wilson Center in Pittsburgh and in 2011, at the invitation of Henry Louis Gates, at Harvard's W.E.B. Du Bois Institute, now named The Hutchins' Center of African and African-American Research and, thanks to Ruth Fine, in 2011 as the keynote speaker at a Bearden symposium at the Center for Advanced Study in the Visual Arts held at the National Gallery of Art.

A special word of thanks to Oxford University Press and especially to my patient editor, Tim Bent, whose questions and suggestions always led me to sharper prose and a more cogently organized text. Thanks also to Alyssa O'Connell at Oxford for her careful editorial notes and Mariah White and Joellyn Ausanka for their assistance in the final phases of the book.

A number of artists, scholars, and private collectors have been particularly supportive and, in many cases, exceedingly generous in sharing their memories of Bearden. During his lifetime, Mr. Bearden himself tolerated countless interviews and questions from me when I first met him. He also engaged in a correspondence with me that spanned

several years and provided critical insights into his "voyage of discovery." Frank Stewart, a colleague and photographer who has an extensive archive of Bearden photographs and who sometimes served as Bearden's driver in New York, has been an important resource throughout the project. From Spiral, Emma Amos and Richard Mayhew generously offered their memories of the collective's dynamics and discussed with me the various prevailing points of view. The late Albert Murray was always generous with his views on Bearden's work, as was the late painter Herb Gentry, who offered important details about Bearden's life in Paris. Correspondence between Gentry and Bearden opened a view into Bearden's thinking about various topics in the last decade of his life. Though I never spoke to Harry Henderson, Bearden's long-standing writing partner, his son, Albert K. Henderson, generously shared correspondence between the two writers.

Melvin Edwards and his late wife, the poet Jayne Cortez, were generous to share the notebook of Bearden's illustration of her poem. The late Billie Allen Henderson shared her memories of the staging of Ed Bullins's *House Party* to which Bearden contributed and allowed me to see a collaborative project on which she and Bearden worked. Choreographers Dianne McIntyre offered insights into Bearden's collaborative process and Garth Fagan provided insights into Bearden's relationship with dancers. Mr. Fagan graciously arranged a showing of the work he choreographed in Bearden's honor and kindly opened his home in Rochester for a viewing of his works by Bearden. Writers Ntozake Shange and Thulani Davis were helpful in providing insight into Bearden's collaborations with writers. Suzanne Randolph provided information on Bearden's earliest public commission. Interviews with June Kelly, Bearden's manager from 1975 until his death, provided important details about the artist's life and work habits. Conversations with André Thibault and Russ Goings provided insights into Bearden's work practices near the end of his life. Dr. Kathe Sandler introduced me to Bearden's sketches of her mother, rare examples of his drawings from the 1950s. Sheila Rohan, one of Nanette's sisters, was very helpful in constructing the early years of Bearden and Nanette's marriage.

In cinema, Spike Lee's 2000 film, *Bamboozled*, was a defining piece of work in providing a visual anthology of a long history of cinematic and television stereotypes of black people. My thanks to his researcher Judith Ailey who documented the source of the material throughout the history of film and television. Thanks as well to musician and composer John Davis, whose collection of nineteenth- and twentieth-century American sheet music was also instructive. A'Lelia Bundles, author, scholar, and great-great-granddaughter of Madame C. J. Walker, introduced me to invaluable information about Bessye Bearden's early life and her relationship to A'Lelia Walker. A special thank you to George Wein for research support from the Wein Foundation.

Private collectors who own the work of Bearden have been extremely generous in opening their homes to me or allowing me access to images from their collections. I am especially grateful to Albert Murray, Bernice and Barrie Stavis, Florence Ladd, Laurie Tisch Sussman, Garth Fagan, Pamela Joyner and Fred Giuffrida, Sherry DeCarava, and Russell Goings. Thanks, too, to Raymond McGuire and Crystal McCrary and Warren Spector for access to work from their collections.

Various galleries now represent Bearden. Especially helpful to me have been Jonathan and Dorian Bergen at ACA Gallery, Michael Rosenfeld at the Michael Rosenfeld Gallery, as well the D. C. Moore gallery and Swann Gallery all in New York, and Jerald Melberg at the Jerald Melberg Gallery in Charlotte, North Carolina.

In New York, co-directors Diedre Harris-Kelly and Johanne Bryant Reid as well as Sheila Rohan of the Romare Bearden Foundation have been imminently available and open to what must have seemed like a series of never-ending inquiries. Under Harris-Kelly and Reid's leadership, the foundation developed a finding aid for the vast collection of Bearden papers in his estate and their leadership has enabled a lively series of lectures, symposia, exhibitions, and publications vital to keeping Bearden's presence alive in the history of art. My thanks to the Schomburg Center for Research in Black Culture of the New York Public Library, vital to any topic on black life and culture. A special word of thanks to the Studio Museum in Harlem, especially Director Thelma Golden and the Studio Museum curatorial staff for creating

The Bearden Project. The project, a "living archive" of artists who were invited to celebrate Bearden's legacy in 2011, the centennial year of his birth, charts the resilience of his legacy across a multi-generational slice of contemporary artists.

Thanks also to the archives of the Museum of Modern Art, the Metropolitan Museum of Art, the Benny Andrews Archive, the Carl VanVechten Trust, the John F. Kennedy Archive and Library, the Smithsonian American Art Museum, the Library of Congress, the National Archives and Records Administration, the New York City Human Resources Administration, Charlotte City Directories (1879–1929). The Federal Bureau of Investigation (FBI) helped supply details of posthumous forgeries made of Bearden's work. The Archives of American Art in Washington, DC, was indispensable, especially for the transcribed interviews of Bearden's peers—Hale Woodruff, Charles Alston, Norman Lewis, Carl Holty, and Samuel Kootz as well as the two transcribed interviews of Bearden. Ruth Fine—who, in the course of curating the 2003 retrospective at the National Gallery of Art, compiled an extensive Bearden archive, now housed at Temple University—was exceptionally generous in making all of her materials available to me while she was curator at the National Gallery of Art. Ruth also generously offered to read the manuscript in its late stages. Her corrections and insights were invaluable.

Thanks also to the Beinecke Rare Book and Manuscript Library at Yale University. The Mecklenburg County Public Library and the Mint Museum have been very supportive in providing information on Charlotte and Bearden's early life there. I am grateful to the Special Collections Research Center, Morris Library, Southern Illinois University, Carbondale, for providing access to the correspondence between Bearden and Caresse Crosby.

Several personal archives were very important, as well: Anne Ekstrom, the daughter of Bearden's long-standing gallery dealer, Arne Ekstrom, provided access to his records in New York City; Jane Stavis, in Swarthmore, Pennsylvania, who manages the archive of her father, Barrie Stavis, allowed access to his archives; Sherry DeCarava shared thoughtful reflections on the work of her spouse, photographer Roy DeCarava, as well as access to images in the Roy DeCarava Archives.

Also, the Shaw Family Archives in New York City were very generous in providing access to the many photographs that Sam Shaw, photographer and film producer, took of Bearden.

In Atlanta, Randall Burkett at the Stuart A. Rose, Manuscript, Archives and Rare Books Library at Emory University, and Holly Smith at the Spelman College Archives led me to important new material. Thanks also to the Robert Woodruff Library of the Atlanta University Center, especially the President Rufus Clements Archives. Bearden attended three institutions of higher education. At these, my thanks to the Langston Hughes Memorial Library at Lincoln University in Pennsylvania, the Boston University Archives, and the New York University Archives and the collections at the Elmer Holmes Bobst Library. The archives of Bennett College, where Catherine Bearden was preceptor and where Howard Bearden attended college when the school was co-educational, was extremely helpful with details about Bearden Gate, a gift to the college from Bessye and Howard Bearden. My thanks to former Bennett president, Johnetta B. Cole, for providing the social and educational significance of Bearden Gate, and thanks to Selicia Gregory Allen, archivist and special collections librarian, L. Douglas Wilder Special Library at Virginia Union University, for information on Bessye Bearden.

My thanks to Calvin Tomkins, whose *New Yorker* Profile is a seminal piece of writing on Bearden. Many years ago, in connection with my PhD dissertation, he provided the transcripts of his interviews with Bearden's circle of friends and associates. Conversations with Myron Schwartzman, who taped hours of interviews with Bearden, were helpful as well. Steve Lynch, who now resides in Mexico, was one of Bearden's work partners when they were both social workers. His remembrances of their work environment and assignments provided useful insights into Bearden's life as a New York City caseworker.

My family has been ever supportive, specifically my three sons— Garikai, Sekou, and Britt—and my daughter-in-law, Jasmine Peña Campbell, who assisted with the manuscript. They have endured work on the book for many years, and I am grateful for their tolerance of my many absences and thank them for their patience and support.

This project would not have been possible without the unconditional support and unflagging editorial efforts of my husband of a half century, Dr. George Campbell Jr., who has read and edited every word of the manuscript, challenged me when necessary, and been an indefatigable cheerleader and champion during what must have seemed like an interminable gestation period for this book. His enduring faith gave me faith.

NOTES

INTRODUCTION

1 Dore Ashton, an early commentator on *Projections*, connected them to the photomontage technique used by John Heartfield during World War I. See Dore Ashton, "Romare Bearden: Projections," *Quadrum* 17 (1964): 99–110, 185.

2 Several years after Bearden debuted *Projections*, the work was exhibited in the Art Gallery at the State University of New York at Albany, mounted from November 25 to December 22, 1967. Ralph Ellison wrote a catalogue essay for the exhibition, *The Art of Romare Bearden*, that became one of the most important and shrewdly observed texts on Bearden.

3 Ellison, *The Art of Romare Bearden*, xii.

4 Bell hooks, nee Gloria Jean Watkins. See bell hooks, *Art on My Mind: Visual Politics* (New York: New Press, 1995).

5 Robin G. Kelly, Foreword to Deborah Willis, *Reflections in Black: A History of Black Photographers, 1840 to the Present* (New York: Norton, 2000), x.

6 Frederick Douglass, "Pictures and Progress: An Address Delivered in Boston Massachusetts on 3 December 1861," in *The Frederick Douglass Papers: Series One, Speeches, Debates and Interview*, Volume 3, ed. John Blassingame (New Haven, CT: Yale University Press, 1985).

7 Henry Louis Gates, "The Trope of the New Negro and the Reconstruction of the Image of the Black," *Representations* 24 (Fall 1988): 129–155.

8 Romare Bearden and Carl Holty, *The Painter's Mind: A Study of the Relations of Structure and Space in Painting* (New York: Crown, 1969).

9 André Malraux, *The Voices of Silence: Man and His Art*, translated by Stuart Gilbert (Paris, 1952). (Abridged from *The Psychology of Art*) Princeton, NJ: Princeton University Press, 1978. First published 1952.

10 Kevin Young, *The Grey Album: On the Blackness of Blackness* (Minneapolis, MN: Graywolf Press, 2012).

11 Charles H. Rowell, editor, "Inscription at the City of Brass: An Interview with Romare Bearden," *Callaloo* 36 (Summer 1988): 428–446.

12 Ernest Crichlow, quoted in an interview with Calvin Tomkins. Calvin Tomkins graciously gave me his typed manuscript of interviews and notes for his November 28, 1977, *New Yorker* Profile on Bearden, "Putting Something Over on Something Else."

CHAPTER ONE: ORIGINS

1 The Main Public Library of Charlotte and Mecklenburg County, Charlotte, North Carolina, holds the county deeds and city directories that list H. B. Kennedy's property holdings, boarders, and various livelihoods. The earliest land and financial transaction for H. B. Kennedy is listed as April 5, 1878, for a parcel of land at Graham and 2nd Street. Richard Bearden, Cattie's spouse, purchased his first piece of land August 12, 1882, located at the northeast corner of South Mint and West 2nd Street. Records indicate that H. B. bought additional land nearby in the ensuing years. Bearden's namesake was a Joplin, Missouri, harness maker, born in Chester, South Carolina, as was H. B., whom Mr. Kennedy knew. See www.historicJoplin.org?/cat=552.

2 Throughout his lifetime, the year of Bearden's birth has appeared variously as 1912, 1913, and 1914 on official documents. Bearden's biographer, Myron Schwartzman, accurately provides his birth date as September 2, 1911, and cites as evidence a November 19, 1911, baptismal record. As well, he records the sponsors who were present at the baptism. See Myron Schwartzman, *Romare Bearden: His Life and Art* (New York: Harry N. Abrams, 1990), 15. Ruth Fine in her essay that accompanies the encyclopedic retrospective that she curated for the National Gallery of Art reproduces an image of Bearden's baptismal record in Fine, *The Art of Romare Bearden*, "Romare Bearden: The Spaces Between" (Washington, DC: National Gallery of Art, in association with New York: Harry Abrams, 2005), 5.

3 Romare Bearden, "The Negro Artist's Dilemma," *Critique: A Review of Contemporary Art* 1, no. 2 (November 1946): 16–22, 17.

4 Henry B. Kennedy's date of birth is listed in the 1870 census record in Augusta, Georgia, as 1845. He gave his birth place as Chester, South Carolina, in 1925, when he served as informant in Charlotte on the death certificate for his daughter Rosa Catherine Bearden Cummings. His death certificate also lists a birthdate of January 1845, and the *Charlotte Sunday Observer*, May 15, 1932, records his death as Thursday, May 12, 1932, at the age of eighty-seven years and four months.

5 The year of Rosa Catherine Gosprey's birth is listed on the 1870 census as 1844 and South Carolina is listed as the state in which she was born. The 1900 census for Charlotte, North Carolina, records her date of birth as May 1847 and her age as fifty-three. The year accords with her obituary in the July 22, 1925, *Charlotte Observer* (she died July 21, 1925, at the age of seventy-eight). Also, her tombstone in Pinewood cemetery gives a date of birth as May 18, 1847.

6 In the 1900 census for Charlotte, North Carolina, the birth date of Rosa Catherine Bearden is recorded as April 1865. Henry Kennedy, as informant, however, in recording the details of the date and place of birth on his daughter's Greensboro, North Carolina, death certificate, indicates that she was born on December 22, 1863, in Chester, South Carolina. The death certificate records her death on September 1, 1925, a few months after her mother.

7 Scholar Glenda Elizabeth Gilmore speculates that Henry may have been a teenager when he arrived to be Reverend Wilson's "servant," and, most likely, served as an indentured servant. See Gilmore, "Romare Bearden's Mecklenburg Memories," in *Romare Bearden: Southern Recollections*, edited by Mary L. Corlett, Leslie King Hammond, Jae Emerling, Carla Hanzal, and Glenda Gilmore (Charlotte, NC: Mint Museum, in association with D. Giles, London, 2011), 40. Reverend Wilson had been assigned to a pastorate at the First Presbyterian Church in Augusta in 1858 and remained in Augusta until the fall of 1870.

8 The 1870 census and city directories list Henry as working in an ice cream saloon: 1870; Census Place: Augusta Ward 3, Richmond, Georgia; Roll: M593_172; Page: 116A; Image: 501; Family History Library Film: 545671. 1870 US Census, population schedules. NARA microfilm publication M593, 1,761 rolls. Washington, DC: National Archives and Records Administration. Documents from the Freedman's bank in Augusta, Georgia, in 1871 record Rosa's bank account and her address on Greene, corner of Kollock Street (today's 11th Street), walking distance from the Wilson household. Registers of Signatures of Depositors in Branches of the Freedman's Savings and Trust Company, 1865–1874. Washington, DC: National Archives and Records Administration. Micropublication M816, 27 rolls.

9 See city directory and financial transactions in Mecklenburg Library, Charlotte, NC.

10 Janette Thomas Greenwood, *Bittersweet Legacy: The Black and White "Better Classes" in Charlotte, 1850–1910* (Chapel Hill: University of North Carolina Press) provides an analysis of the brief period in time when the Black and white communities in Charlotte sustained a productive relationship. Greenwood writes: "Members of the Black better class shared many of the same values as their white counterparts. They, too, sought economic advancement in the New South and prized hard work, discipline and ambition. . . . But their agenda included a key element that their white counterparts never had to worry about: they aspired to be full-fledged participants in New South society, politically, socially and economically." She goes on to assert that the impact, however, brief, was salutary for race relations. She writes: "In their attempt to achieve this goal, the Black better class frequently interacted with the white better class, at times forming alliances that challenged the seemingly intransigent mores of southern race relations. For a brief period in the 1880's, their association suggested an alternative vision of race relations" (1–2).

11 Fortune's testimony is reported in Howard Zinn, *A People's History of the United States* (New York: Harper and Row, 1980; reprinted, Harper Perennial, 1990), 204.

12 Quoted in Greenwood, *Bittersweet Legacy*, 77. Clarence Smith, the founder of the *Charlotte Messenger*, delivers the advice.

13 Greenwood, *Bittersweet Legacy*, chapters 3 and 4, "Black and White Together" and "Industrialization."

14 H. B. Kennedy was endorsed by a petition signed by the Conference of the A.M.E. Zion Church for the prestigious position of assayer of the Charlotte mint. A conservative mainstream newspaper, the *Charlotte Observer* in a front page article describes H. B. Kennedy as "a prominent member of the colored race in North Carolina." *Charlotte Observer*, April 8, 1897, 1.

15 For a discussion of Bearden's attachment to trains, see Myron Schwartzman, *Romare Bearden: His Life and Art* (New York: Harry N. Abrams, 1990), 20–21.

16 For an exploration of the train metaphor, see Albert Murray, *Stomping the Blues* (New York: Da Capo Press, 1976).

17 For details on Bearden's early years including Charlotte, see Calvin Tomkins, "Profile: Putting Something Over Something Else," *New Yorker*, November 1977; and Myron Schwartzman, "The Oldest of Places: Carolina Interior Charlotte Roots," 10–29 in *Romare Bearden: His Life and Art*. Both Tomkins and Schwartzman relied on extensive interviews with Bearden. Schwartzman, in particular, interviewed surviving relatives, and both interviewed close artistic associates. See also Archives of American Art (AAA), Washington, DC, Roll 3196, for Bearden's narrative of his early years and oral history interview with Romare Bearden by Henri Ghent, June 29, 1968, Archives of American Art, Smithsonian Institution, Washington, DC, online transcript available at www.aaa .si.edu/collections/interviews/oral-hstory-interview-romare-bearden-11481. See also Fine, "Romare Bearden: The Spaces Between," 4–6.

18 Schwartzman, *Romare Bearden: His Life and Art*, 15–17.

19 Richard P. Bearden is listed in the 1880 Charlotte census as a single, twenty-three-year-old harness maker living on South Tryon Street. 1880, Census Place: Charlotte, Mecklenburg, North Carolina, Roll: 972, Family History Film: 1254972, Page: 315A, Enumeration District: 107, Image: 0055. By 1882, Richard had purchased property at the northeast corner of South Mint and W. 2nd (Registrar of Deeds Office, Mecklenburg County 1879–1924) and was presumably married to Cattie. According to a Mecklenburg County Court of Probate document, Richard passed away in July 1891 at the age of thirty-four. Archives of American Art, Washington, DC, Romare Bearden Papers, Folder 1.

20 Alan Trachtenberg, *Reading American Photographs: Images as History, Mathew Brady to Walker Evans* (New York: Hill & Wang, 1989).

21 Rosa Bearstin [*sic*], aged thirty-five, who lived with Rosa Kennedy, is listed in the 1900 North Carolina Census along with her three children: Harry was

seventeen; Anna, sixteen; and Howard, Bearden's father, was twelve at the time.

²² See "Rev. C. G. Cumming Married at Greensboro," *Baltimore Afro-American*, July 6, 1912, 8.

²³ Schwartzman details Romie's visits to Lutherville, Maryland, paying particular attention to his encounter with the blind guitarist Mr. Johnson and stories of the watermelon cake. Bearden's connection to Baltimore through his eventual employment at the *Baltimore Afro-American* as well as to his grandparents remained strong.

²⁴ The family donated $500 (more than $8,000 in today's value). See *Bennett College: Campus Heritage Plan*, www.scup.org/asset/53470/Bennett_College_CHP_Final_Report.pdf. The report is divided into chapters and each chapter describes a period of development on campus. Chapter 1, "Evolution of the Campus Landscape," 17 gives a brief description of the gate. Bessye delivered a presentation address followed by the dedication of the gate. The event was described in the *Carolina Times*, May 17, 1941, 3, and *Chicago Defender*, May 17, 1941, 6, as part of the commencement ceremonies; it was also reported in the *Amsterdam News*, June 14, 1941, 14. The plaque attached to the pier just east of the gateway opening reads: "The Catherine Kennedy Bearden Way, presented to Bennett College by her children as a token of their appreciation."

The description is in Bennett College's National Register of Historic Places Registration Form, United States Department of the Interior, National Park Service, www.hpo.ncdcr.gov/nr/GF1131.pdf, p. 10.

"Catherine Kennedy Bearden Way (contributing structure c.1941) The southern end of the quadrangle terminates at brick walls and posts and a wrought iron gate. The brick posts step back from Gorrell Street, connected by a semicircular run of iron pickets. The tall central gate posts, which support a decorative iron gate, are topped by concrete caps and acorns. Affixed to the east post is a plaque with the legend 'The Catherine Kennedy Bearden Way.' The gates, posts, and walls were probably built around 1941, completing the bottom end of the quadrangle. From Gorrell Street one looks through the gates, up the center of the quadrangle to the chapel. Catherine Kennedy Bearden was a Greensboro resident and dormitory matron."

²⁵ The full text of Bessye Bearden's speech dedicating the gate and the walkway is located in the Bessye Bearden papers, 1922–1944, Schomburg Center for Research in Black Culture, Manuscripts and, Archives and Rare Books Division, Sc MG 73.

²⁶ In the 1900 Atlantic City census, recorded on June 13, 1900, Bessie [*sic*] is listed as the daughter of Clara and George Banks. Her birth date is recorded as October 1888 and place of birth as North Carolina.

²⁷ *New York Age*, January 28, 1909, 5. This news report gives the time of Bessye's arrival in Pittsburgh. "Ms. Banks is a young woman of education, who has won

many friends during her residence of two years in the city. Mr. and Mrs. Banks and their daughter came two years ago to Pittsburgh from Atlantic City." And later in the same year, *New York Age*, August 5, 1909, 3, reports the following: "A charitable concert was given at Good Hope Baptist Church, Thirty-fourth street and Penn avenue last week, under the direction of Miss Bessie J. Banks and Mr. J. Soles. It was given for the benefit of the first payment on a home for the orphans of Pittsburg. Miss Banks is a young girl of exceptional educational training and an elocutionist of much ability. She has staged some of the most interesting amateur plays ever witnessed here, and is just as willing to use her talents in uplifting our people as she is well qualified to do so. Whenever the public knows of Miss Banks' connection with movements of this kind, she has always a crowded house."

28 The 1910 United States Federal Census lists Bessie [*sic*] Banks as a boarder in the Fitzgerald household: year 1910 Census Place: Atlantic City Ward 3, Atlantic, New Jersey; Roll: T624_867; Page: 7A: Enumeration District: 15; Image: 321. 32. 1910, Census Place: Atlantic City Ward 3, Atlantic, New Jersey, Roll: T624_867, Page: 7A, Enumeration District: 0015, FHL microfilm: 1374880.

29 Quoted from the obituary for Benjamin Fitzgerald, "Hold Funeral for Benj. Fitzgerald," *Chicago Defender*, May 24, 1930, 2. A reference to the café appears in the obituary of Benjamin Fitzgerald's widow, Laconia. "Civic Leader Dies in Atlantic City Following Illness," *New York Amsterdam News*, January 26, 1946. I am most grateful to A'Lelia Bundles, author and Madame C. J. Walker's great-great granddaughter, who brought to my attention not only the connection between Bessye Bearden and the Fitzgerald family but Bessye's highly visible social life in Atlantic City and her eventual close friendship with A'Lelia Walker, Madame C. J. Walker's daughter.

30 See *New York Age*, January 12, 1911, 3, for a report of a social event where the host "entertained the suffragettes…who exchanged ideas and gathered material for the coming great event for women's rights to vote." Guests include Bessye Banks and the Fitzgerald girls. Mention of Bessye's attendance at the party is also included in A. E. Edwards, "Noted Comedian Dined by Elks: Lighthouse Lodge Honors Theatrical Manager," *Baltimore Afro-American*, January 28, 1911, 7. Along with the Fitzgerald daughters, Estelle and Maude, Bessie is mentioned as a member of the Poinsettia Club, a leading social organization of the city. Also see "Secret Society Hears Sermon. First Anniversary of Atlantic Chapter, Orr Eastern Star," *Baltimore Afro-American*, February 25, 1911, 6.

31 Class Bulletins for the years 1903–1904 and 1904–1905 list Bessie Johnson Banks, Atlantic City, New Jersey, as attending Hartshorn Memorial College. There is no record of her graduation. Hartshorn Bulletins are located in L. Douglas Wilder Library, Virginia Union University.

32 A request to Bennett College Archives turned up no evidence of Howard Bearden's attendance at Bennett College.

33 Howard is listed in the 1910 United States Federal Census as a servant along with names of other men and women all different from each other. Source citation: Year: 1910, Census Place: Atlantic City Ward 2, Atlantic, New Jersey, Roll: T624_867, Page:17A, Enumeration District: 11, Image: 644.

34 See records for Philadelphia County Pennsylvania Clerk of the Orphans' Court, "Pennsylvania, Philadelphia marriage license index, 1885–1951." Clerk of the Orphans' Court, Philadelphia, Pennsylvania, Marriage License Number: 262995, and "Atlantic City Notes," *New York Age*, April 6, 1911, 5. Schwartzman and Fine both record 1910 as the date of their marriage but the wedding certificate and press announcement suggest that the two married about six months before Romie was born.

35 Land and Financial Transactions from Grantee and Grantor Books at the Registrar of Deeds Office, Mecklenburg County, document two transactions involving Bessye and Howard Bearden which place them in Charlotte after Romie's birth. One involves a loan to the family—in addition to Howard and Bessye, Rosa Kennedy Bearden, sister Anna and brother Harry—of $600 recorded, December 4, 1911, and satisfied a year later. A second transaction in 1914 was the sale by the family group of property for $3,500 a year before Howard and Bessye left for New York.

36 Schwartzman, *Romare Bearden: His Life and Art*, chapter 1, "The Oldest of Places," 10–29.

37 Greenwood recounts the political shift, including the details of the 1898 Wilmington, North Carolina, race riots, in *Bittersweet Legacy*, chapter 6, "White Supremacy," 185–213.

38 Bevard Nixon, "The White Man Must Rule. Mr. B. Nixon on the Negro Problem," *Charlotte Observer*, May 20, 1900, 12.

39 Schwartzman, *Romare Bearden: His Life and Art*, 17.

40 Leon F. Litwack, *Trouble in Mind: Black Southerners in the Age of Jim Crow* (New York: Alfred A. Knopf, 1996). See also James Allen, Hilton Als, Congressman John Lewis, and Leon F. Litwack, *Without Sanctuary: Lynching Photography in America* (New York: Twin Palms, 2008), 24.

41 *Crisis*, June 10, 1915, 71.

42 For a chronology of the development of Kodak technology, see the timeline of the Kodak Corporation. http://www.kodak.com/ek/US/en/Our_Company/History_of_Kodak/Milestones_-_chronology/Milestones-_chronology.htm.

43 Litwack discusses the intersection between photography and lynching in his essay "Hellhounds," in *Without Sanctuary*, 8–37. For a discussion on the artists who took up the anti-lynching cause during the Depression, see Dora Apel, *Imagery of Lynching: Black Men, White Women and the Mob* (New Brunswick, NJ: Rutgers University Press, 2004).

44 The pamphlet can be found in the Carolina Room of the Robinson-Spangler Collection held at the Charlotte/Mecklenburg Public Library Charlotte, North Carolina.

45 In preparation for the profile he wrote, Calvin Tomkins conducted several interviews with Bearden as well as with artists, and Bearden's dealer, collectors, and friends. Mr. Tomkins was kind enough to provide the transcripts of those interviews to me in April 1977 when I was a graduate student at Syracuse University. They remain with my personal papers in New York City. Bearden tells the story of the flower in one of his interviews with Tomkins. Around the time of the interviews, Bearden also began to write his own narrative memoirs. Copies can be found in the Romare Bearden Foundation Archives, Box 49, Folder 18.

46 The autobiographical memoirs contain a description of the character, Liza. See Romare Bearden Foundation Archives, Box 49, Folder 18.

47 Located in the April 1977 typed transcripts of interviews of Romare Bearden by Calvin Tomkins.

48 Robert Sklar, *Movie-Made America: A Cultural History of American Movies* (New York: Vintage Books, 1994), 54–56; quote 55–56.

49 John Hope Franklin, "*Birth of a Nation*: Propaganda as History," *Massachusetts Review* 20, 3 (1979): 426. This article also contains a compendium of protests, 417–434.

50 W. E. B. Du Bois, "Fighting Race Calumny," *Crisis*, May/June, 1915.

51 Franklin, "*Birth of a Nation*: Propaganda as History."

52 Quoted in a March 30, 2003, review of *The Birth of a Nation* by Roger Ebert at http://www.rogerebert.com/reviews/great-movie-the-birth-of-a-nation-1915.

53 In the 1849 review of "A Tribute for the Negro" in Douglass's *North Star* newspaper, the specific distortions he lists are "high cheekbones, distended nostrils, depressed nose, thick lips, and retreating foreheads." Frederick Douglass, "Review of 'A Tribute for the Negro' by Wilson Armistead," *North Star*, April 7, 1849.

54 Frederick Douglass, "Pictures and Progress: An Address Delivered in Boston, Massachusetts on 3 December 1861," in the Frederick Douglass Papers: Series One, Speeches, Debates, and Interviews, Volume 3, ed. John Blassingame (New Haven, CT: Yale University Press, 1985), 452–453. Douglass is quoted in Maurice Wallace and Shawn Michelle Smith, *Pictures and Progress: Early Photography and the Making of the African American Identity* (Durham, NC: Duke University Press, 2012), 6.

55 For a discussion of expositions and their racial constructions, especially the Chicago and Atlanta expositions, see Alessandra Lorini, "International Exhibitions in Chicago and Atlanta," in *Rituals of Race: American Public Culture and the Search for Racial Democracy* (Charlottesville: University of Virginia Press, 1999), 33–75. Details about the organization of the Negro Exhibit are outlined in David Levering Lewis and Deborah Willis, *A Small Nation of People: W. E. B. Dubois*

and African American Portraits of Progress (New York: HarperCollins and the Library of Congress, 2003). Lewis's essay, "A Small Nation of People: W. E. B. Du Bois and Black Americans at the Turn of the Twentieth Century," 23–49, concentrates on the organization of the Negro Exhibit and details of Du Bois's life and thought. Deborah Willis's essay, "The Sociologist's Eye: W. E. B. Du Bois and the Paris Exposition," 50–78, focuses on the photographs, the photographers, and the significance of the images. The source for Booker T. Washington's "Atlanta Compromise Speech" is Louis R. Harlan ed., *The Booker T. Washington Papers*, vol. 3 (Urbana: University of Illinois Press, 1974), 583–587.

[56] Linda Barrett Osborne, "Introduction" to Lewis and Willis, *A Small Nation*, 13."

[57] Osborne, "Introduction," 18.

[58] Lewis, "A Small Nation of People: W. E. B. DuBois and Black Americans at the Turn of the Twentieth Century," 29.

[59] Lewis, "A Small Nation," 25.

[60] Lewis, "A Small Nation," 48.

[61] Deborah Willis, "The Sociologist's Eye: W. E. B. DuBois and the Paris Exposition," in Lewis and Willis, *A Small Nation*, 55.

[62] James Billington, Librarian of Congress, pays tribute to Murray's role in the preface to Lewis and Willis, *A Small Nation*.

[63] Lewis and Willis, *A Small Nation*, 49.

[64] Bearden, "The Negro Artist's Dilemma," 17.

[65] James Weldon Johnson, *Black Manhattan* (New York: Knopf, 1930; reprinted by Da Capo Press, 1991), 283–284.

CHAPTER TWO: HARLEM

[1] See *New York Times*, "Negroes in Protest March on Fifth Av.," July 29, 1917, 12; *Baltimore Afro-American*, "5,000 March in Silent Parade," August 4, 1917, 1; and *Chicago Defender* (big Weekend Edition), "Thousands March in Silent Protest," August 4, 1917, 1. The numbers reported varied from 3,000 to 10,000.

[2] For details on the organization of the Silent Parade, see James Weldon Johnson, *Along This Way: The Autobiography of James Weldon Johnson* (New York: Da Capo Press, 1933). Also see Aberjhani and Sandra West, with Clement Alexander Price, contributor, *Encyclopedia of the Harlem Renaissance*, Volume 2, p. 751 (New York: Facts on File, 2003).

[3] The protest of 500 against D. W. Griffith's *The Birth of a Nation* preceded the Silent Parade though the numbers were nowhere nearly as large and the protest was not as well orchestrated theatrically and visually as the Silent Protest of 1917.

[4] Johnson, who taught at New York University for a time during the 1930s, invited Bearden to assist him. See Noelle Morrissette, *James Weldon Johnson's Modern Soundscapes* (Des Moines: University of Iowa Press, 2013). Johnson died

tragically on June 26, 1938, in an automobile accident. Bessye Bearden wrote an admiring obituary on Johnson for the *Chicago Defender*: "Final Tribute Paid J. Weldon Johnson at New York Rites," July 9, 1938, 1ff. In the article, Bessye lists Romie as one of the pallbearers.

5 James Weldon Johnson's editorial, "An Army with Banners," *New York Age*, August 3, 1917, reprinted in Sondra Kathryn Wilson, editor, *The Selected Writings of James Weldon Johnson*, Volume 1: *New York Age Editorials (1914–1923)* (New York: Oxford University Press, 1995), 65–66.

6 The New York City Directory for 1915 lists Richard as lab (presumably short for laborer), living at 332 West 52nd street. The 1918 City Directory lists two addresses. One shows Howard Bearden as a porter living at 213 West 131st Street and the other has a home address for Richard Bearden at 173 West 140th.

7 Tracking Howard Bearden's itinerant life between 1915 and 1922 is a challenge. The address that appears on Howard Bearden's World War I Registration card, issued 1917–1918, is 231 West 131st Street. He is also listed in the 1918 New York City directory at the same address. His name does not appear again in a city directory until 1922. His occupation on the draft card is dining car waiter on the Atlantic Coast Line. Howard is described as a tall, slender Negro with light brown eyes with a wife and child. As an example of the difficulty establishing dates, there is a discrepancy between the information on Howard Bearden's World War I draft card and his World War II draft card. World War I Draft Registration Card for Richard Howard Bearden. http://search.ancestry.com/cgi-bin/sse.dll?db=ww1draft&ti=0&gss=angs-i&ssrc=pt_t22475…Howard reports his date of birth as July 9, 1889, on the World War I draft card. Yet, on the World War II registration card he reports July 9, 1888, http://search.ancestry.com/cgi-bin/sse.dll?db=wwiidraft&ti=0&gss=angs-i&ssrc=pt_t22475…

8 A photograph of Bessye standing outside the First National Bank of Canada is one of the few mementos of the family's time in Moose Jaw. Though Howard Bearden may not have returned to New York until 1922, we know that Bessye appears in the 1921 Oscar Micheaux film, *The Gunsalaus Mystery* and had relocated to New York by then.

9 *New York Times*, "Fifth Ave. Cheers Negro Veterans," February 18, 1919, 1, 6.

10 *Chicago Defender*, March 30, 1918, 5.

11 Her employment by Brown is reported in Bessye Bearden's obituary, Schomburg Center for Research in Black Culture, New York. (Note: if Bessye worked at the Lafayette while Brown was the owner, it would have been during the Lafayette's heyday of the Lafayette Players and the great black figures of the theater. See her obituary for reference to her working in his New York Office.

12 Bernice Dutrieuille, "Bessye Bearden, Civic Welfare Worker, Got Cold Shoulder When She Came to New York: Courier Reporter Gets Interesting Interview with New York's 'Personality Woman,'" *Pittsburgh Courier*, June 28, 1930, 6.

13 Bessye's name appears regularly in New York's *Amsterdam News*, the *Pittsburgh Courier*, and the *Chicago Defender*.

14 Romare Bearden produced numerous handwritten narratives of his memories of his childhood, held in Box 11, Folder 11, at the Romare Bearden Foundation Archives, New York. Combined with accounts in Myron Schwartzman, *Romare Bearden: His Life and Art* (New York: Harry N. Abrams, 1990), other sources for these remembrances are oral history interview of Romare Bearden by Henri Ghent, June 29, 1968, Archives of American Art, Smithsonian Institution, Washington, DC, online transcript available at www.aaa.si.edu/collections/interiews/oral-history-interview-romare-bearden.11481; typed transcripts of interviews with Calvin Tomkins for the *New Yorker* Profile, "Putting Something Over Something Else," November 28, 1977, provided to the author, April 1977; and Albert Murray, "The Visual Equivalent of the Blues," in *Romare Bearden: 1970–1980*, edited by Jerald Melberg and Milton J. Bloch (Charlotte, NC: Mint Museum, 1980), 17–28.

15 Autobiographical narrative, Romare Bearden Foundation Archives, Box 11, Folder 11.

16 Tandy would go on to design the Ivy Delph apartment building at 19 Hamilton Terrace in 1949, which is now on the National Registry. He died before the building was constructed.

17 The time of the Banks's arrival in Pittsburgh is estimated from the appearance of Bessye's name in Pittsburgh social columns.

18 Bearden's memories of Pittsburgh are included in his handwritten autobiographical narrative held at the Romare Bearden Foundation, Box 11, Folder 11.

19 Romare Bearden Foundation, Box 11, Folder 11.

20 Calvin Tomkins ("Putting Something Over Something Else," *New Yorker* Profile, November 28, 1977), Myron Schwartzman (*Romare Bearden: His Life and Art*), and Ruth Fine (Ruth Fine, "Romare Bearden: The Spaces Between," in *The Art of Romare Bearden* [Washington, DC, and New York: National Gallery of Art in Association with Harry N. Abrams, 2003]; Ruth Fine and Jacqueline Francis, editors, *Romare Bearden, American Modernist: Proceedings of a Symposium Organized by the Center for the Advanced Study in the Visual Arts, National Gallery of Art* [Washington, DC: National Gallery of Art, 2011]; and Ruth Fine, *Romare Bearden* [New York: Pomegranate, 2004]) are three sources of anecdotes about Eugene.

21 Bearden's narrative about his drawing of the Victrola is located in his papers from the Bearden Foundation Archives, Box 11, Folder 11.

22 For discussions of the politics of the time, see James Weldon Johnson's *Black Manhattan* (New York: Alfred A. Knopf, 1930); Claude McKay's *Harlem: Negro Metropolis* (New York: Dutton, 1940); and Jervis Anderson, *This Was Harlem: A Cultural Portrait, 1900–1950* (New York: Farrar, Straus and Giroux, 1983).

[23] *Crisis* magazine, March 1924, announces her election to the school board and her appointment to the position of president of the National Colored Women's Democratic League.

[24] Bessye Bearden files, Schomburg Center for Research in Black Culture, New York, contain her original appointment letter.

[25] All of Bessye Bearden's *Chicago Defender* columns are accessible via Proquest from 1927 until she stopped writing in 1941/1942.

[26] Dutrieuille, "Bessye Bearden, Civic Welfare Worker," *Pittsburgh Courier*, June 28, 1930, 6.

[27] Display Ad 21—No Title, *Chicago Defender* (National edition) September 26, 1931, 7.

[28] Dutrieuille, *Pittsburgh Courier*, June 28, 1930, 6. The reporter includes a detailed description of the Bearden apartment.

[29] Letter to the author, postmarked September 22, 1973. (See Appendix.)

[30] Letter to the author, postmarked September 22, 1973. (See Appendix.)

[31] "Investigation of Communist Activities in the San Francisco Area, Part I." Hearing before the House Un-American Activities Committee, House of Representatives, 83rd Congress of the United States, December 1, 1953, p. 3065.

[32] Letter to the editor, *New York Amsterdam News* August 5, 1961, 10.

[33] Verner D. Mitchell, "To One Not There: The Letters of Dorothy West and Countee Cullen, 1926–1945," *Langston Hughes Review*, January 1, 2010.

[34] Letter to the author, postmarked, September 22, 1973. (See Appendix.)

[35] Albert Murray, "The Visual Equivalent of the Blues," in *Romare Bearden 1970–1980*, edited by Jerald Melberg and Milton J. Bloch (Charlotte, NC: Mint Museum, 1980), 19.

[36] Dutrieuille, *Pittsburgh Courier*, June 28, 1930, 6 . Dutrieuille offers this description of Bessye's exotic appearance.

[37] An ad for *Gunsalaus Mystery* appeared in the *New York Age*, April 16, 1921, 6. Bessye Bearden is listed as part of the cast of the film. Bessye's name also appears in a list of the cast of *Gunsalaus Mystery* within the Micheaux filmography; see Pearl Bowser, Jane Gaines, and Charles Musser, editors and curators, *Oscar Micheaux & His Circle: African-American Filmmaking and Race Cinema of the Silent Era* (Bloomington: Indiana University Press, 2001), 241–243.

[38] Bowser, Gaines, and Musser, *Oscar Micheaux & His Circle*, xvii–xxx.

[39] Bowser, Gaines and Musser, *Oscar Micheaux & His Circle*, xvii–xxx.

[40] Charlene Regester, "The African-American Press and Race Movies, 1909–1929," in Bowser, Gaines, and Musser, *Oscar Micheaux & His Circle*, 34–39.

[41] Schwartzman, *Romare Bearden*, and Tomkins, "Putting Something Over Something Else."

[42] A'Lelia Bundles, great-great-granddaughter of Madame C. J. Walker and great-granddaughter of A'Lelia Walker, is the author of a biography of Madame

C. J. Walker, *On Her Own Ground: The Life and Times of Madame C. J. Walker* (New York: Scribner, 2001). She is currently working on a biography of A'Lelia Walker, *The Joy Goddess of Harlem: A'Lelia Walker and the Harlem Renaissance.* In preparation for the Madam Walker and A'Lelia Walker books, she has amassed an archive of newspaper clippings and interviews. The Madame C. J. Walker Family Archives is located in her home in Washington, DC. Bundles's interview with Gerri Major in 1982 is quoted with permission from A'Lelia Bundles.

43 According to the North Carolina death certificate, she had been living in Goldsboro, North Carolina, and died on September 1, 1925. See hip://search.ancestry.com/cgi-bin/sse.dll?h=2256318&db=NCdeathCerts&indiv=try.

44 The *Charlotte Observer* reported that she passed away on July 21, 1925, "after a brief illness," 37.

45 Charles Alston, though not Romare Bearden, is listed on the notable alumni list. See dewittclintonalumni.com.

46 Schwartzman, *Romare Bearden*, 56.

47 Schwartzman, *Romare Bearden*, 58.

48 Schwartzman, *Romare Bearden*, 46–48.

49 Schwartzman provides a detailed description of the events leading up to Bearden's winning the approval and support of his gangster patron; see Schwartzman, *Romare Bearden*, 58–61.

50 Locke, "Enter the New Negro," 1.

51 Locke, "Enter the New Negro," 1.

52 Romare Bearden and Harry Henderson cover the origins of the Harmon Foundation in detail in their co-authored history of African American art, *A History of African-American Artists: From 1792 to the Present* (New York: Pantheon Books, 1993), 124–125. Bearden and Henderson are considerably more forgiving and acknowledge the Foundation's value at that time.

53 In the nineteenth century, in addition to Tanner, Edmonia Lewis traveled to Paris as did Meta Warrick.

54 For varying perspectives on the Harmon Foundation, see the online transcripts of interviews with the following black artists in the Archives of American Art, Smithsonian Institution, Washington, DC: Oral history interview of Archibald Motley by Dennis Barrie, January 23, 1978–March 1, 1979, www.aaa.si.edu/collections/interviews/oral -history-interview-archibald-motley-114666; oral history interview of Hale Woodruff by Al Murray, November 18, 1968, www.aaa.si.edu/collections/interviews/oral-history-interview-hale-woodruff-11463; oral history interview of Charles Alston by Al Murray, October 19, 1968, www.aaa.si.edu/collections/interviews/oral-history-interview-charles-henry-alston-11460; and oral history interview of Romare Bearden by Henri Ghent, June 29, 1968, www.aaa.si.edu/collections/oral-history-interview-romare-bearden-11481.

[55] See Colin Grant, *Negro with a Hat: The Rise and Fall of Marcus Garvey* (New York: Oxford University Press, 2008), 164.

[56] See Johnson, *Black Manhattan*, 254. Also, earlier examples of pageantry are Mardi Gras in New Orleans and the New Orleans second line of musicians who accompanied mourners to the cemetery, playing dirge-like music. After the burial, they broke out into jubilant, life-goes-on music on the way back from the grave site, the mourners, following, dancing in procession. Celebrations of emancipation—Juneteenth—were common throughout the South and were often accompanied by costumed revelers and parades. Parades customarily greeted Negro League baseball games as well, when the players traveled from town to town.

[57] Johnson, *Black Manhattan*, 200–201, and Murray, "The Visual Equivalent of the Blues," 19.

[58] Johnson, *Black Manhattan*, 150.

CHAPTER THREE: THE EVOLUTION OF A RACE MAN

[1] Quoted from Romare Bearden's application to Lincoln University, located in the Langston Hughes Memorial Library at Lincoln University, Oxford, Pennsylvania.

[2] Arnold Rampersad, *The Life of Langston Hughes*, Vol. I (New York: Oxford University Press, 1986), 127.

[3] Reported in Ruth Fine, "Romare Bearden: The Spaces Between," in *The Art of Romare Bearden*, Ruth Fine, with contributions by Mary Lee Corlett, Nnamdi Elleh, Jacqueline Francis, Abdul Goler, and Sarah Kennel (Washington, DC: National Gallery of Art in association with Harry N. Abrams, 2003), 7.

[4] 1930 Yearbook from Lincoln University, held in the Langston Hughes Memorial Library at Lincoln University, Oxford, Pennsylvania.

[5] Garcia Lorca, *Poet in New York*, translated by Greg Simon and Steven White (New York: Farrar, Straus and Giroux, 1998), 244.

[6] Jervis Anderson, *This Was Harlem: A Cultural Portrait, 1900–1950* (New York: Farrar, Straus and Giroux, 1982), 229.

[7] "Brilliant Parties Feature Yuletide," *Amsterdam News*, December 31, 1930, 5.

[8] "Crowds Filled Streets Saturday for Funeral of Harlem's Queen: A'Lelia Walker Buried in $3,500 Bronze Casket," *Baltimore Afro-American* August 29, 1931, 1, 8.

[9] Langston Hughes, *The Big Sea: An Autobiography* (New York: Alfred Knopf, 1945), 247.

[10] The description of the difference between his mother's generation and the generation of the Depression is described in detail in Romare Bearden and Harry Henderson, *A History of African American Artists: From 1792 to the Present* (New York: Pantheon Books, 1993), 227.

[11] For an excellent discussion of Du Bois's commitment to visual images as editor of *Crisis*, see Amy Helene Kirschke, *Art in Crisis: W.E.B. Du Bois and the Struggle*

for African American Identity and Memory (Bloomington: Indiana University Press, 2007).

12 *Norfolk Journal and Guide*, March 5, 1932, 4.

13 *Beanpot*, November 1931.

14 Fine, "Romare Bearden: The Spaces Between," in *The Art of Romare Bearden*, 7.

15 See Robert Peterson, *Only the Ball Was White: A History of Legendary Black Players and All-Black Professional Teams* (Old Tappan, NJ: Prentice-Hall, 1970). For an assessment of baseball's spiritual value in American life, see John Sexton with Tom Oliphant and Peter J. Schwartz, *Baseball as the Road to God: Seeing beyond the Game* (New York: Gotham Books, 2013).

16 Calvin Tomkins, "Putting Something Over Something Else," *New Yorker*, November 28, 1977, 53–58 ff.; Myron Schwartzman, http://www.theatlantic. com/entertainment/archive/2012/03/the-man-who-spurned-a-baseball-career-to-become-a-renowned-artist/254451/; and Bijan C. Bayne, "Black Baseball in Boston: Recovering a Lost Legacy," Bayne www. baystate-banner.com/ archives/stories/2006/04/042706-03.htm.

17 "Tigers at Farmington," *Lewiston Daily Sun*, July 4, 1930, 7.

18 Later in life Romare Bearden always retained an interest in the body. He married a model, collaborated frequently with dancers and choreographers, and, as artist Melvin Edwards recalls, he would watch basketball players on television and comment on the choreography and the balletic grace of their movements with the intuitive understanding of a born athlete. Interview with sculptor Melvin Edwards, interviewed by the author.

19 Schwartzman, *Romare Bearden*, 70–71.

20 Bayne, "Black Baseball in Boston: Recovering a Lost Legacy," www. baystate-banner.com/archives/stories/2006/04/042706-03.htm.

21 See Schwartzman, *Romare Bearden*, 70–71, for a discussion of Bearden's baseball experience at Boston University and his encounter with the opportunity to play baseball professionally.

22 The notice reads as follows: "Old and highly respected Negro, resident of Charlotte, who died Thursday, at the home of his grand-daughter in Greensboro. The deceased had been a member of the church for more than 50 years. He is survived by three grandchildren and 3 great grandchildren."

23 Fine, "Romare Bearden: The Spaces Between," in *The Art of Romare Bearden*, 7, for Bearden's course of study at New York University.

24 *George Grosz: An Autobiography* (New York: Macmillan, 1983).

25 Romare Bearden, "The Negro Artist and Modern Art," *Opportunity: Journal of Negro Life* 12 (December 1934): 371–372.

26 The 1935 Harmon Foundation review included the kinds of pejorative adjectives that Bearden abhorred. See Harmon Foundation, *Negro Artists: An Illustrated Review of Their Achievements* (New York: Harmon Foundation, 1935), 5.

27 The co-authored volume that Bearden and Henderson wrote goes to great lengths to establish the tone and tenor of the 1930s and its expectations from earlier years. "The politics of the visual" is a term that bell hooks uses in her essay "Art on My Mind" from her book *Art on My Mind: Visual Politics* (New York: New Press, 1995).

28 Romare Bearden, "The Negro Artist and Modern Art," *Opportunity* 12 (December 1934): 372.

29 For a complete list of exhibitions at the Museum of Modern Art, see https://www.MoMA.org/research-and-learning/research-resources/archives/archives_exhibition_history_list.

30 Bearden, "The Negro Artist and Modern Art," 372.

31 Bearden and Harry Henderson recount the reaction to his article in their co-authored *A History of African American Artists: From 1792 to the Present*.

32 Roi Ottley, "Hectic Harlem: Pages from a Town Crier's Diary," *New York Amsterdam News*, June 1, 1935, 11.

33 Bearden, "The Negro Artist and Modern Art," 371.

34 George S. Schuyler, "The Negro-Art Hokum," *Nation*, June 16, 1926; Langston Hughes, "The Negro Artist and the Racial Mountain," *Nation*, June 23, 1926; W.E.B. Du Bois, "Criteria of Negro Art," *Crisis*, October, 1926, in *The Emerging Thought of W.E.B. DuBois: Essays and Editorials from The Crisis with an Introduction, Commentaries and a Personal Memoir by Henry Lee Moon* (New York: Simon and Schuster, 1972), 360–368.

35 Bearden may have been disdainful of his mother's soiree society, but he could not deny that her activism played a major role in the massive political shift that had taken place in the country with the 1932 election of President Franklin D. Roosevelt. Large numbers of black citizens abandoned the Republican Party for the promise of the Democratic Party, and Bessye had been tireless in her role as president of the Colored Women's Democratic League, making use of her status as "the best liked and most affable member of New York's smarter set" to corral the votes of "colored women" to help make a decisive difference. See H. Binga Diamond, "New York Society: Mrs. Bessye Bearden; Political Leader," *Pittsburgh Courier*, November 7, 1925, 6. Her reward was not only an invitation to the 1932 inauguration party and an introduction to First Lady Eleanor Roosevelt, but in 1935, an appointment to the position of deputy tax collector, an influential position she held until her death in 1943.

36 The author became familiar with the four panels in the course of curating *Harlem Renaissance: Art of Black America*, 1987 Studio Museum in Harlem (New York: Harry Abrams, 1987). Damaged panels were taken out of storage, cleaned, and restored in preparation for the 1987 exhibition. The physical unavailability for many years rendered the canvases all but invisible to critics and art historians alike. Douglas's work, when first exhibited in 1934, by virtue of its scale and the originality of content, was groundbreaking.

[37] An excellent account of the Harlem Hospital controversy can be found in Diana L. Linden and Larry A. Greene, "Charles Alston's Harlem Hospital Murals: Cultural Politics in Depression Era Harlem," *Prospects* 26 (2001): 391–421, p. 391, doi:10.1017/s0361233300000983391.

[38] Verner D. Mitchell comments on Savage's Paris studio in his article "To One Not There: The Letters of Dorothy West and Countee Cullen (1926–1945)," *Langston Hughes Review* 24 January 1, 2010.

[39] Norman Lewis interviewed by Henri Ghent, July 14, 1968, online transcript available at Archives of American Art, Smithsonian Institution, Washington, DC, www.aaa.si.edu/collections/interviews/oral-history-interview-norman-lewis -11465.

[40] Seifert's life is discussed extensively in Bearden and Henderson, *A History of African American Artists*.

[41] Quoted in Patricia Hills, "1936: Meyer Schapiro, Art Front, and the Popular Front," *Oxford Art Journal* 17, no. 1 (January 1994): 30–41, 34.

[42] Hills, "1936: Meyer Schapiro, Art Front, and the Popular Front."

[43] Quoted from an article by Romare Bearden, "The 1930's—An Art Reminiscence," *New York Amsterdam News*, September 18, 1971, D24.

[44] According to records obtained as the result of a Freedom of Information Law (FOIL) request, Bearden's employment record was made available to the author. Bearden is listed as an employee of the city dating back to 1935, not 1938 as is commonly reported. His early employment is marked T which could indicate temporary, his permanent employment not beginning until 1938.

[45] Hills, "1936: Meyer Schapiro, Art Front, and the Popular Front," 32.

[46] Bearden wrote a lengthy paper on the history of cartoons in which he argued for their artistic importance dating back to antiquity (Fine dates the paper to 1933, 1934, or 1935 at New York University; see Fine, "Romare Bearden: The Spaces Between," in *The Art of Romare Bearden*, 7). His paper, written in a patient longhand, argues that "true art grows logically out of the age which produces it," and that "cartooning developed by the various nations will take on a great deal of the 'racial characteristics of that nation.'" He declares emphatically that "great cartoons...often changed the ideals, problems and practices of the life of the age in which it was produced or created." To support his premise, he charts the progress of cartoons from the caricatures Egyptians made of their pharaohs, Greeks made of their gods, Romans made of Christians, and Martin Luther made of the "Pope, Cardinals, and the Bishops." Hogarth's eighteenth-century moralizing series stand out for him as the ideal, and he cites the English eighteenth- and nineteenth-century drawings of Thomas Rowlandson, George Cruikshank, and James Gilray as the height of satiric wit and insight into the political and social mores. American cartoons, first introduced by Benjamin Franklin, reached their peak in the work of Thomas Nast, whose cartoons, despite their occasional racial caricature, in Bearden's eyes rose to the level of "great art." He sidesteps

completely the caricatures of black people that filled the pages of late nineteenth-century magazines.

Not forgetting the economic advantage of cartoons, Bearden cites an April 1933 article on their economic viability: Between 70 and 75 percent of the readers of any newspaper follow its comic sections regularly. Of 2,300 US dailies, only two of any importance (*New York Times* and *Boston Transcript*) see fit to exist without funnies. "US Funny Paper, Inc....grosses about $6,000,000 a year. Some twenty comic-strip headliners are paid at least $1,000 a week for their labors. Even the advertiser has succumbed to the comic...and in 1932 spent well over $1,000,000 for comic-paper space." ("Funny Papers," *Fortune* 7, no. 41 (April 1933): 45.

47 Bearden's research confirmed that cartoons could instigate serious political consequences, as did those of Thomas Nast that brought down the government of "Boss" Tweed. He may also have learned that in the 1920s cartoons in *The Masses,* critical of the United States government, were considered treasonous and contributed to the revocation of the magazine's postal privileges. (Bearden might also have learned that Stuart Davis, an artist he came to admire, was not above drawing caricatures of black people in his cartoons for *The Masses*). For details of *The Masses* trial, see Victor S. Navasky, *The Art of Controversy: Political Cartoons and Their Enduring Power* (New York: Alfred Knopf, 2013), 105. Amy Kirschke notes that Davis focused on the "exotic" and "lurid" details of black life. Amy Helene Kirschke, *Art in Crisis: W.E.B. DuBois and the Struggle for African American Identity and Memory* (Bloomington: Indiana University Press, 2007), 32. Cartoons were frequently used to protest racial injustice as well. Reginald Marsh, for example, an artist whom Bearden would come to admire and who drew cartoons for the *New Yorker,* published one in which white spectators are pictured as enjoying the spectacle of a lynching. In taking up cartoons in the 1930s, Bearden was joining artists as varied as Ad Reinhardt, William Gropper, Hale Woodruff, and Norman Lewis; working for a range of publications, they drew political cartoons that were brazen, unabashed visual polemics. When Reinhardt was in the army during World War II, he drew a scathing critique of racism. After the war, he and Bearden became friends.

48 Benjamin Stolberg, "Big Steel, Little Steel," *Nation* 145, no. 5 (July 31, 1937): 119–123.

49 Romare Bearden, "They Make Steel," *New York Amsterdam News*, October 23, 1937, 13; Romare Bearden, "The Negro in Little Steel," *Opportunity*, December 1937, 362–365, 380. Bearden is introduced in the *Opportunity* article as "a young artist with sensitive social consciousness." His conscientiousness is underscored by the fact that he "utilized his vacation to observe the strike in 'Little Steel' and the part that Negro workers played in Warren, Canton, Youngstown and other cities of the steel empire." "The Negro in Little Steel," 362. Close in content, the two articles are not identical. Bearden's *Amsterdam News* article is poetic in stretches, evoking an image of the working life in the

towns of "Little Steel." He writes of the consequences first of the loss of jobs with the onset of the Depression, followed by the growing opportunities as the production accelerated with the talk of a European war and the production of armaments. In both articles, Bearden walks a fine line. On the one hand, he sympathizes with the need of black migrants and their need to work when they served the role of strikebreakers. On the other hand, he is clearly a union sympathizer. Both articles though sympathetic with the role of strikebreakers, gently but firmly come down on the side of collective bargaining. On the other hand, Bearden is not blind to the shortcomings of the union and his light skin gives him access to the persistent racism that steelworkers faced at the hands of union workers. A white union worker tells Bearden that he "wouldn't care to work alongside of a Negro or have a Negro as my foreman." And Bearden chastises the unions for not always acting in good faith. Both articles end, however, with his expression of faith in unions as the wave of the future. Journalism was clearly an option that Bearden at this point in his career was considering.

50 For an excellent overview of the Harlem cabaret scene, see Shaun Vogel, *Scene of Harlem Cabaret: Race, Sexuality, Performance* (Chicago: University of Chicago Press, 2009).

51 Albert Murray, "The Visual Equivalent of the Blues," in *Romare Bearden: 1970–1980*, edited by Jerald Melberg and Milton J. Bloch (Charlotte, NC: Mint Museum, 1980), 19.

52 Bearden quoted in Murray, "The Visual Equivalent of the Blues," 20.

53 Charles Alston interviewed by Albert Murray, October 19, 1968, Archives of American Art, Smithsonian Institution, Washington, DC, online transcript available at https://www.aaa.si.edu/collections /interviews/oral-history-interview-charles-henry-alston-11460. Bearden quoted in Anderson, *This Was Harlem*.

54 Charles Alston interviewed by Albert Murray, October 19, 1968, Archives of American Art.

55 Tomkins's *New Yorker* Profile ("Putting Something Over Something Else") chronicles Bearden's experiences with Harlem cabarets, 57.

56 Anderson reports Bearden's reference to the phrase, "Dawn Patrol," 241.

CHAPTER FOUR: THE MAKING OF AN AMERICAN ARTIST

1 Address by President Franklin Roosevelt, March, 17, 1941, Washington, DC, section of Fine Arts, Special Bulletin, National Archives, Record Group 121, entry 122. Also see Marlene Park and Gerald Moskowitz, *New Deal for Art: The Government Art Projects of the 1930s. With examples from New York City and State* (Albany: Gallery Association of New York State, 1977), 132.

2 Marlene Park and Gerald Moskowitz, *New Deal for Art: The Government Art Projects of the 1930s*, 131.

3 Francis V. O'Connor, *Federal Support for the Visual Arts: The New Deal and Now: A Report on the New Deal Art Projects in New York City and State with Recommendations for Present-day Federal Support for the Visual Arts to the National Endowment for the Arts* (Greenwich, CT: New York Graphic Society, 1969).

4 Stuart Davis, "Abstract Painting Today," 121–127, and Walter Quirt, "On Mural Painting," 78–81, reprinted in *Art for the Millions*, edited by Francis V. O'Connor (New York: New York Graphic Society Books, 1974).

5 "Large Crowd at Art Show: Romare Bearden Scores at 1st One-Man Exhibit," *New York Amsterdam News*, May 11, 1940, 8.

6 "Large Crowd at Art Show."

7 *Chicago Defender*, May 4, 1940, 3.

8 The affinity between Bearden's work and these artists has been frequently noted. See Sharon Patton, "Memory and Metaphor: The Art of Romare Bearden," in *Memory and Metaphor: The Art of Romare Bearden 1940–1987* (New York: Oxford University Press and Studio Museum in Harlem, 1991), 23. Also see Ruth Fine, "Romare Bearden: The Spaces Between," in *The Art of Romare Bearden* (Washington, DC: National Gallery of Art in association with Harry N. Abrams, 2003), 11.

9 Quoted from the Artist's Statement in *Romare Bearden,* exhibition catalogue, New York: "306," 1940, Romare Bearden Papers, in Archives of American Art, Smithsonian Institution, Washington, DC (Roll N68-87). Myron Schwartzman notes that Arthur Steig, brother of William Steig, assisted Bearden with the written statement (Myron Schwartzman, *Romare Bearden: His Life and Art* (New York: Harry N. Abrams, 1990) 112. Steig's assistance with Bearden's statement would be the first of several occasions that Bearden relied on input from his literary friends with narratives that accompanied his painting.

10 Bessye J. Bearden, "New York Society," *Chicago Defender*, December 13, 1941, 18.

11 The quotes are from a letter that Romare Bearden wrote to Cedric Dover in what must have been 1958 or 1959 just prior to the publication of Dover's book, *Modern Negro Art*. See Bearden letter to Cedric Dover, ca. 1958 or 1959, Cedric Dover Papers, Stuart A. Rose Manuscript, Archives and Rare Book Library (MARBL), Emory University, MSS 1108, Box 1. The exchange is a frank disclosure between Bearden and Dover that documents Bearden's feelings about the artistic environment from the 1930s to the late 1950s. Future quotes from the letter will be identified as Dover letter, RB to Dover or Dover to RB.

12 See interview with Avis Berman, "I Paint Out of the Tradition of the Blues," *Art News* 79 (December 1980): 64, and oral history interview with Romare Bearden by Henri Ghent, June 29, 1968, online transcript available at Archives of American Art, Smithsonian Institution, Washington, DC, www.aaa.si.edu/collections/interview/oral-history-interview-romare-bearden-11481.

13 Writings of Nanette Rohan Bearden, undated Box 20, Folder 42, Romare Bearden Foundation Archives, New York.

14 Quoted from Romare Bearden's application to the John Simon Guggenheim Foundation for a special grant for enlisted men. Bearden submitted the grant in 1944 from his posting at Fort Devens, Massachusetts, hoping to take advantage of the grant when he was discharged the following year: Box 1, Folder 1, Romare Bearden Foundation Archives.

15 Box 1, Folder 1, Romare Bearden Foundation Archives, from Bearden's Guggenheim application.

16 Oral history interview with Hale Woodruff by Al Murray, November 18, 1968, online transcript available at Archives of American Art, Smithsonian Institution, Washington, DC, www.aa.si.edu/collections/interviews/oral-history-interview-hale-woodruff-11463.

17 Oral history interview of Woodruff by Murray, 1968, Archives of American Art.

18 *Phylon: The Clark Atlanta University Review of Race and Culture* 2, no. 1 (1941): 5–6.

19 See Buell G. Gallagher, "Talladega Library: Weapon against Caste," *Crisis*, April 1939, 110–111, 126. For a detailed account of the murals, see Edmund Barry Gaither, "The Mural Tradition," published online on August 5, 2009, with permission of the Indianapolis Museum of Art, which was granted to Traditional Fine Arts Organization (TFAO) on June 10, 2009. See www.tfaoi.org/aa/9aa/9aa160.htm. The essay originally appeared in the catalogue accompanying the exhibition, *A Shared Heritage: Art by Four African Americans*, which was on view at the Indianapolis Museum of Art (February 25–April 21, 1996); Terra Museum of American Art, Chicago (May 11–July 6, 1996); Museum of the National Center of Afro-American Artists, Boston (September 23–November 30, 1996); and Hunter Museum of Art, Chattanooga (January 19–March 2, 1997).

20 Because these murals are rarely exhibited outside of Talladega College, their scale, audacity, and lucid narrative approach are generally unknown to the general public and to critical and scholarly attention. Most observers of Bearden's work mention the murals only in passing. A recent national tour of the work, however, demonstrated that the paintings, singularly innovative and unique for their time, are still groundbreaking. It is important to keep in mind that the impact on Bearden and Alston would have been even more consequential, given the freshness and ambition of Woodruff's execution. Woodruff, having recently studied with Rivera, brought into the murals the narrative and visual forcefulness that characterizes their best Mexican-based frescoes.

21 From 1940 to 1942, Woodruff completed three companion panels—resistance in the form of the underground railroad; opening day at Talledega; and the building of Savery Library, the site of the mural series.

22 Roberta Smith, "In Electric Moments, History Transfigured: Hale Woodruff's Talladega Murals, in 'Rising Up' at N.Y.U.," *New York Times*, August 15, 2013, www.nytimes.com/2013/08/16/arts/design/hale-woodruff-talladega-murals-in-rising-up-at-nyu.html.

23 Several versions of this story have been recounted in various places including Calvin Tomkins, "Putting Something Over Something Else," *New Yorker* magazine, November 28, 1977; Schwartzman, *Romare Bearden, His Life and Art*, and as related on the website of photographer, Chester Higgins, www.chesterhiggins.com.

24 See Bearden and Henderson in their account of the struggles with the WPA in Romare Bearden and Harry Henderson, *A History of African American Artists: From 1792 to the Present* (New York: Pantheon Books, 1993), 238.

25 Elizabeth Hutton Turner, Patricia Hills, Paul J. Karlstrom, Leslie King-Hammond, Lizzetta LeFalle-Collins, Richard J. Powell, Lowery Stokes Sims, and Elizabeth Steele, *Over the Line: The Art and Life of Jacob Lawrence*, edited by Peter T. Nesbett, illustrated by Jacob Lawrence (Seattle: University of Washington Press, 2011).

26 Oral history interview with Charles Henry Alston by Al Murray, October 19, 1968, online transcript available, Archives of American Art, Smithsonian Institution, Washington, DC, at www.aaa.si.edu//collections/interviews/oral-history-interview-charles-henry-alston-11482.

27 There are a number of noteworthy histories of the migration. Among them are Isabel Wilkerson, *The Warmth of Other Suns* (New York: Random House, 2010); Nicholas Lemann, *The Promised Land: The Great Migration and How It Changed America* (New York: Vintage Books, 1991); and Farah Jasmine Griffin, *Who Set You Flowin'? The African-American Migration Narrative* (New York: Oxford University Press, 1995).

28 See Holland Cotter, *New York Times*, "Review: 'One Way Ticket' at MoMA Reunites Jacob Lawrence's Migration Paintings," April 1, 2015, see https://www.nytimes.com/2015/04/03/arts/design/review-one-way-ticket-at-moma-reunites-jacob-lawrences-migration-paintings.html?_r=0. Cotter writes: "Standing in the middle of the room, you can pick up the formal links and syncopations. Dark dense compositions, alternate with open, light ones. Geometric dominance—vertical, horizontal, diagonal—shifts from panel to panel."

29 Oral history interview of Carl Holty by William Agee, December 8, 1964, Archives of American Art, Smithsonian Institution, Washington, DC, www.aaa.si.edu./collections/interviews/oral-history-interview-carl-holty-11685. See also interview of Carl Holty by Paul Cummings, September 25–October 1, 1968, online transcript available at Archives of American Art, Smithsonian Institution, Washington, DC, www.aaa.si.edu/collections/interviews/oral-history-interview-carl-holty-11785. These interviews are full of Holty's observations about his contemporaries.

30 See Fine, "Romare Bearden, The Spaces Between," in *The Art of Romare Bearden* (Washington, DC: National Gallery of Art in association with Harry N. Abrams, 2003), 10. Fine references Myron Schwartzman's interviews with Bearden concerning his experience with John Graham.

31 Details of Lewis's biography come from Romare Bearden and Harry Henderson, *A History of African American Artists: From 1792 to the Present* (New York: Pantheon Books, 1993), 317.

32 Samuel Melvin Kootz, *Modern American Painters* (New York: Brewer and Warren, 1930), 101.

33 Clement Greenberg, "Avant-garde and Kitsch," *Partisan Review* 6, no. 5 (1939): 7.

34 Greenberg, "Avant-garde and Kitsch," 7.

35 "Work Relief Act of 1939," *Monthly Labor Review* (1939): 376. The Federal Theater Project was abolished effective June 30, 1939. See also Jane DeHart Mathews, *Federal Theatre, 1935–1939: Plays, Relief, and Politics, I–VI* (Princeton, NJ: Princeton University Press, 1967).

36 For a discussion of the source of what became Flanagan's slogan for the FTP, "free, adult and uncensored," see Dorothy Chansky, *Composing Ourselves: The Little Theatre Movement and the American Audience* (Carbondale: Southern Illinois University Press, 2005), 97.

37 The black press praised the work of the Harlem Art Center. See, for example, "What Art Study Has Done in Harlem; There Is a Definite Trend to Things Artistic and Cultural in New York's Teeming 'Black Republic,'" *Chicago Defender*, May 27, 1939, 13. The press also covered Gwendolyn Bennett's suspension. See "Suspend Harlem Art Center Head in Red Probe: No Truth to Story She Says," *Amsterdam Star-News*, April 26, 1941.

38 Helen Shannon gives an excellent analysis of the influence of African art on the work of Romare Bearden: "African Art and Cubism, Proto-Collage, and Collage in the Work of Romare Bearden," in *Romare Bearden in the Modernist Tradition: Essays from the Romare Bearden Foundation Symposium*, edited by Pamela Ford (Dalton, MA: Studley Press, 2007), 21–30.

39 Walter Quirt Correspondence, 1941–1971, Romare Bearden Foundation Archives, Box 10, Folder 49.

40 Quoted from Walter Quirt letter to Bearden, August 28, 1941, Romare Bearden Foundation Archives, Box 10, Folder 49.

41 Quoted from letter from Bearden to Quirt, January 20, 1942, Romare Bearden Foundation Archives, Box 10, Folder 49.

42 Bessye Rearden, "New York Society," *Chicago Defender*, December 13, 1941, 18.

43 Wallace Thurman quoted in Jervis Anderson, *This Was Harlem: A Cultural Portrait, 1900–1950* (New York: Farrar, Straus and Giroux, 1983), 337–338.

44 Frazier quoted in Anderson, *This Was Harlem*, 337.

45 Robert Sklar, *A World History of Film* (New York: Harry N. Abrams, revised and expanded edition, 2001).

46 I am grateful to Judith Ailey who was the research assistant for Spike Lee's 2000 film, *Bamboozled*, a satirical tragedy that excoriated in film Hollywood's obsession and encyclopedic indulgence in racial stereotypes. Examples are abundant in

live action, animation, and television. Lee's film is a fictional but truthful account of the distortions that have populated American film. Ailey's research, used to support the film's allegations, spanned popular Hollywood films, animation, and television shows produced by major studios and popular with audiences during the 1920s, 1930s, 1940s, and 1950s. Prior to the release of *Bamboozled*, Donald Bogle published a comprehensive scholarly review of Hollywood stereotypes in *Toms, Coons, Mulattoes, Mammies and Bucks* (New York: Continuum, 1973).

47 Bessye Bearden, "New York Society," *Chicago Defender*, March 7, 1942, 17.

48 Description of Bearden's visit to his mother in the hospital is recounted in Schwartzman, *Romare Bearden: His Life and Art*, 124.

49 "Final Rites Held for 'Great American Lady': Bessye Bearden Dies in Harlem Hospital FRUITFUL CAREER ENDED!," *Pittsburgh Courier*, September 25, 1943, 10.

50 For a quantitative presentation of housing, employment, health, and education conditions in Harlem subsequent to the 1935 riots, see *Complete Report of Mayor La Guardia's Commission on the Harlem Riot of March 19, 1935* (New York: Arno Press & New York Times, 1969).

51 Billy Rowe, "Billy Rowe's Notebook: Few Items and Duke Ellington," *Pittsburgh Courier*, February 6, 1943, 21.

52 From "America's Greatest (Overlooked) Artists," *Newsday*, January 17, 1988, http//blogs.lib.unc/ncm/index.php/2013/01/04/bearden-2/#sthash.YAfL4L6J .dpuf. See also Schwartzman's description of the segregated meals at Officers' Candidate School in North Carolina: Schwartzman, *Romare Bearden*, 122.

53 Melvin Lader, "David Porter's 'Personal Statement: A Painting Prophecy, 1950,'" *Archives of American Art Journal* 28, no. 1 (1988): 17–25, http://www.jstor.org/stable/1557536.

54 James Porter, "Notes on Romare Bearden," in *Ten Hierographic Paintings by Sgt. Bearden* [exhibition catalogue, G Place Gallery] (Washington, n.d. [1944]).

55 Letter from Caresse Crosby to Sgt. Romare Bearden, 243 W. 125th St., January 31, 1944. Crosby's letters to Bearden are held in the Morris Library, Southern Illinois University, Carbondale.

56 Printed as an edition of only 1,000, the Portfolio was also produced as a deluxe edition of 100.

57 Quoted from undated letter from Romare Bearden to Crosby, from 1210 S.C. S.U. Hq. Co., Pine Camp, New York. Since Bearden references his preparation for a Guggenheim Fellowship, we can surmise that the letter was written in the fall of 1944. Bearden writes on Service Club, Pine Camp, letterhead. Crosby's letters to Bearden are held in the Morris Library, Southern Illinois University, Carbondale.

⁵⁸ Letter to Caresse Crosby, February 25, 1945, from Camp Edwards, MA, Crosby Papers, Morris Library, Southern Illinois University, Carbondale, Box 31, Folder 9.

⁵⁹ Caresse Crosby letter to Romare Bearden, April 17, 1945, Crosby Papers, Morris Library, Southern Illinois University, Carbondale.

⁶⁰ Crosby did not bite her tongue when it came to offering criticism, and a month later in a letter to Bearden dated May 21, 1945, she wrote, "I was disappointed not to have received a black and white that was a more definite expression of your work. I do not think the one you sent would hold up by itself with Moore, Mata or Helion." Crosby Papers, Morris library, Southern Illinois University, Carbondale.

⁶¹ Letter from Bearden dated February 24, 1945, to Commanding General, First Service Command, Boston Massachusetts, Subject: Discharge Under AR-C15-362, Section III. Bearden was required to present supportive documentation from three witnesses. Bearden's letter indicates that he obtained that documentation from the attendant nurse, a Dr. King, and Reverend John H. Johnson's affidavits. Johnson's quote is from his letter dated February 14, 1945. Both Bearden and Reverend Johnson's letters are in the Bearden Foundation Archives, New York, Box 10, Folders 17 and 18. Also, a copy of Bearden's signed Army Separation Qualification Record can be found in the Bearden Foundation Archives, Box 10, Folder 17. His date of separation is listed as April 30, 1945. There is an interesting entry under education. In addition to his 1935 B.S. from New York University, Bearden lists having studied art for "1 full year" at Columbia University and engineering at Columbia for forty-two hours. In the box marked Military Occupation and Civilian Conversions, he is listed as ARTIST, "Designed and printed posters by use of silk screen process for visual aids section. Posters used to illustrate in special training unit." In a second box he is identified as a "Classification Specialist" who "Administered army general classification and mechanical aptitude tests. Did some interviewing and kept personnel records up to date."

CHAPTER FIVE: FAME AND EXILE

¹ "The Negro Artist's Dilemma," *Critique: A Review of Contemporary Art* 1, no. 2 (November 1946): 22.

² For an inventory of the exhibitions in which Bearden participated, see Ruth Fine, editor, *The Art of Romare Bearden* (Washington, DC: National Gallery of Art in Association with Harry N. Abrams, 2003), chronology compiled by Rocío Aranda-Alvarado and Sarah Kennel with Carmenita Higgenbotham, "Romare Bearden: A Chronology," 214–247. For the Atlanta Annual, in particular, see *In the Eye of the Muses: Selections from the Clark Atlanta University Art Collection*, with an introduction by Richard A. Long (Atlanta: Clark Atlanta University Art Galleries, 2012).

3 For an inventory of critical assessments of Bearden's exhibitions throughout his career, see the essay by Abdul Goler, "A Refracted Image: Selected Exhibitions and Reviews of Bearden's Work," in Fine, *The Art of Romare Bearden*, 190–210.

4 Letter to Cedric Dover, ca. 1958 or 1959, Cedric Dover Papers, Stuart A. Rose Manuscript Archives and Rare Book Library (MARBL), Emory University, MSS 1108, Box 1.

5 In their survey, Bearden and his co-author Harry Henderson detail the years after the war for Aaron Douglas, Augusta Savage, Jacob Lawrence, Norman Lewis, all of whom were a part of Bearden's circle of artists during the 1930s and 1940s. See Romare Bearden and Harry Henderson, *A History of African American Artists: From 1792 to the Present* (New York: Pantheon Books, 1993).

6 Bearden's discharge date has been referred to as May 1, 1945. His Army Separation Qualification Letter, recorded at Fort Dix, NJ, documents April 30, 1945, as the date of separation. The application is located in the Romare Bearden Foundation Archives, Box 10, Folder 17. A letter to Walter Quirt, July 10, 1945, copy in the Romare Bearden Foundation Archives, New York, Box 10, Folder 49, references his return to his studio and work. A Freedom of Information request to the New York City Human Resources Administration resulted in the disclosure of partial employment records for Bearden that indicate he returned to work from military leave on June, 1945.

7 Letter to Walter Quirt, July 10, 1945. See Walter Quirt Papers, 1928–1976. Archives of American Art, Smithsonian Institution, Washington, DC.

8 In the September 1 issue of the *New York Age,* a notice appeared on page 4 announcing that "Sgt. Romare Bearden had opened an art studio in the Apollo Theatre Building." The announcement suggests that he considered his space to be more than a private space but a gathering place for artists.

9 All quotes regarding Bearden's Guggenheim application come from a copy of the application, dated 1945 and submitted by Bearden, who is listed both as Sgt. and Mr. Bearden with an address at Ft. Devens, Massachusetts, and 351 West 114th Street, New York. His occupation is listed as Sergeant, US Army; a copy of the application is located in the Romare Bearden Foundation Archives, Box 1, Folder 1.

10 Sarah E. Lewis refers to James Soby's letter in her essay "New Encounters," in the exhibition catalogue, *Romare Bearden: Idea to Realization* (New York: D. C. Moore Gallery, 2011), 6–12, 6.

11 Bearden's 1945 Guggenheim application contains comments of his referees, including Deborah Calkins. A copy of the application is held in the Romare Bearden Foundation Archive, New Yorki, Box 1, Folder 1.

12 Letter to Walter Quirt, July 10, 1945, Walter Quirt Papers, Archives of American Art.

13 Letter to Walter Quirt, June 1945. The letter is dated based on the reference to the June 10th opening of the *Passion of Christ* exhibition at the G Place Gallery in Washington, DC. A copy of the letter resides in the Romare Bearden Foundation Archives, New York, Box 10, Folder 9.

14 Letter to Walter Quirt, July 10, 1945, Walter Quirt Papers, Archives of American Art.

15 Letter to Quirt, June 1945, Romare Bearden Foundation Archives, Box 10, Folder 9.

16 Romare Bearden, "Rectangular Structure in My Montage Painting," *Leonardo: Journal of the International Society for the Arts, Sciences and Technology* 2, no. 1 (January 1969): 11–19.

17 Bearden, "Rectangular Structure," 12; Sarah Kennel, "Bearden's Musée Imaginaire," in Ruth Fine, *The Art of Romare Bearden* (Washington, DC: National Gallery of Art in association with Harry N. Abrams, 2003), 140–155.

18 See Bearden, "Rectangular Structure," 11, and undated letter to Holty about the mau mau dance of the Poussin; see Holty Letters, Romare Bearden Foundation, Box 10, Folder 60.

19 Bearden, "Rectangular Structure," 14.

20 One of Stavis's plays, *Lamp at Midnight,* was about Galileo and dealt with a man who was out of synch with the beliefs of his day and age. The quote, an excerpt of Schwartman's interview with Stavis on October 2, 1984, is taken from the Schwartzman biography (Myron Schwartzman, *Romare Bearden: His Life and Art* (New York: Harry N. Abrams, 1990), 131.

21 Samuel Kootz, *New Frontiers in American Painting* (Norwalk: Hastings House Book Publisher, 1943).

22 Kootz offered his painters an appealing deal. He would pay them a monthly living stipend which eliminated their need to find work. In return, Kootz kept the painters' monthly output, save for three or four paintings that they each got to keep. See oral history interview of Samuel M. Kootz by Dorothy Seckler, April 13, 1964, online transcript available at Archives of American Art, Smithsonian Institution, Washington, DC, www. aaa.si.edu/collections/interviews/oral-history-interviews-samuel-m-kootz-12837. Bearden, who worked by day as a caseworker and who had been advised not to accept Kootz's offer of support, did not participate in the quid pro quo financial arrangement.

23 In this instance Bearden uses photostatic copies to quickly translate watercolors into oils. Photostats were also his method of making copies of masterpieces so that he could study and copy paintings in the privacy of his studio in order to discover their internal structure and composition. The method was instrumental as well in the 1960s when he used photostats to reproduce his own collages as black and white photographic enlargements, the now classic 1964 *Projections*. Later in the 1970s he would use photostats to make copies of small-scale sketches, in preparation for his monumental murals.

24 Ben Wolf, "Bearden—He Wrestles with Angels," *Art Digest* 20, no. 1 (October 1, 1945): 16. Quoted in Abdul Goler, "A Refracted Image: Selected Exhibitions and Reviews of Bearden's Work," in Ruth Fine, *The Art of Romare Bearden* (Washington, DC: National Gallery of Art in association with Harry Abrams, 2003), 193.

25 Schwartzman, *Romare Bearden,* 132.

26 Nora Holt, "Romare Bearden Wins High Praise for Exhibition, 'The Passion of Christ': Bearden Passion of the Cross," *New York Amsterdam News*, October 27, 1945, 6.

27 Alain Locke, Letter to Bearden, held in Romare Bearden Foundation Archives, New York, Box 10, Folder 10.

28 E. A. Carmean Jr., "Introduction," in E. A. Carmean and Eliza Rathbone, with Thomas Hess, *American Art at Mid-Century* (Washington, DC: National Gallery of Art, 1978), 15.

29 Ellen Landau, editor, *Reading Abstract Expressionism: Context and Critique* (New Haven, CT: Yale University Press, 2005), 5.

30 See the list of notices that Bearden received during the Kootz years, in Goler, "A Refracted Image."

31 A seminal figure in the evolution of American abstract art, Ad Reinhardt worked at first as a cartoonist and then as editor and reporter at *PM Magazine*, a satirical magazine, from 1942 to 1947. For *ARTnews* and other outlets, he published a satirical series, "How to Look at Art" between 1946 and 1961. The tree was published as part of this series. A version of the tree can be found in the form of a pamphlet at the New York Historical Society; Pamphlets; Pamph PN4700.PS 164 1940 Oversize.

32 The trunk of the tree and its roots represent the major sources—overwhelmingly European modernists—though at the roots is an array of non-Western influences: "Primitive Negro Sculpture, Persian Miniature, Japanese Prints, Polynesian," and others. Objects tied to the tree weighing it down are trends or movements Reinhardt thought were no good for contemporary art—prizes, business as art patron, subject matter, Mexican art influence, regionalism illustration, and landscapes. Reinhardt's art world tree is noteworthy for its inclusiveness. The names of several black artists—Ernest Crichlow, Jacob Lawrence, Norman Lewis, Horace Pippin—are leaves on his tree, an acknowledgment of the work of serious black artists rare in the 1940s.

33 Quoted from an undated, handwritten letter, signed by Ad Reinhardt with the salutation, "Dear Bearden." Located in the files of the Romare Bearden Foundation, Box 10, Folder 30.

34 Bearden, "The Negro Artist's Dilemma," 16-22.

35 Bearden, "The Negro Artist's Dilemma," 17.

36 Bearden, "The Negro Artist's Dilemma," 17.

37 Bearden, "The Negro Artist's Dilemma, 17.

38 Romare Bearden, "The Negro Artist and Modern Art," *Opportunity: Journal of Negro Life* 12 (December 1934): 371-372.

39 Bearden held on to these guiding principles in his letter to Cedric Dover. In the letter he articulates the principles as follows: "There was no common style linking Negro artists, such as the regional African sculpture. 2) Most of the large group shows, museum shows, private gallerys [sic] did not bar Negro [sic] artists, but judged all works according to what the persons in charge regarded the

merits of the work submitted. 3) it was felt that further all-Negro shows would be a form of self-segregation. 4) Also, some of the groups that had heretofore sponsored the all-Negro shows had been patronizing in their attitude toward the negro artist. For instance in the Chicago World's Fair in the early 30's the work of Negro artists was displayed in a section allotted to the work of the blind, and other handicapped people. The Harmon Fd. Made a movie of certain Negro painters, one of the subject was a painter who had once worked as a janitor. For the movie he was again dressed as a janitor painting at this easel." See Bearden letter to Cedric Dover, ca. 1958 or 1959, Cedric Dover Papers, Stuart A. Rose Manuscript, Archives and Rare Book Library (MARBL), Emory University, MSS 1108, Box 1.

40 Bearden, "The Negro Artist's Dilemma," 17.

41 Two years after the publication of the essay, Bearden would write to the president of Atlanta University (now, after merging with Clark College, re-named, Clark Atlanta University) a letter arguing against keeping the Atlanta Annual exclusively for black artists; letter addressed to the Art Exhibition Committee, undated, located in the Atlanta University Presidential Records—Rufus Clement Records, Atlanta University Center Robert W. Woodruff Library, Box 558, Folder 9.

42 Bearden, "The Negro Artist's Dilemma," 22.

43 Bearden, "The Negro Artist's Dilemma," 22.

44 Norman Lewis interviewed by Henri Ghent, Archives of American Art, Smithsonian Institution, Washington, DC, www. aaa.si.edu/collections/interviews/oral-history-interview-norman-lewis-11465.

45 Letter from Hale Woodruff to Romare Bearden held in Romare Bearden Foundation Archives, New York, Box 10, Folder 30.

46 David Sylvester, *Interviews with American Artists* (New Haven, CT: Yale University Press, 2001), interview with Adolph Gottlieb, pp. 27–33, recorded March 1960 in New York City.

47 "Mrs. B. J. Bearden, Negro Leader, 52: Deputy Collector, 3rd Internal Revenue District Here, Dies in the Harlem Hospital," *New York Times*, Sept. 17, 1943.

48 Adolph Gottlieb and Mark Rothko, "The Portrait of the Modern Artist," WNYC radio interview on art in New York by H. Stix on October 13, 1943, cited in Irving Sandler, *The Triumph of American Painting: Abstract Expressionism* (New York: Harper and Row, 1976), 63–64.

49 Robert Hughes, *American Visions: The Epic History of Art in America* (New York: Knopf, 2009).

50 Quoted from the *Passion of Christ* exhibition catalogue for G Place Gallery exhibition, Washington, DC, June 1945.

51 Ibid.

52 Quoted from Ralph Ellison in his essay in the catalogue for Bearden's 1968 Albany Institute show. Also see Ralph Ellison, "The Art of Romare Bearden," *Massachusetts Review* 18, no. 4 (Winter 1977): 673–80, 676.

53 Bearden's use of myth to "order experience" was evident, too, in his second series, this one based on Garcia Lorca's "Elegy for Sanchez Mejias." He focuses the images of the series on the ritualistic setting of the bullfighter's ring, the life-and-death struggle between bullfighter and bull, and themes of death and rebirth. When asked decades later why he chose Lorca, in a letter to the author, postmarked, September 22, 1973 (see Appendix), he recounts reasons that are more personal than aesthetic. Lorca had lived in New York, and Langston Hughes had brought him to Bessye's house. Bearden notes, too, his intellectual interest not only in Lorca but also in the musical composition of the composer Frank Fields who wrote a cantata of Lorca's "Death of a Bull Fighter" published in the late 1940s.

54 Harold Rosenberg, introduction, "Introduction a la peinture moderne Americaine," exhibition, Galerie Maeght, Paris, March–April, 1947.

55 Serge Guilbaut, *How New York Stole the Idea of Modern Art: Abstract Expressionism, Freedom and the Cold War*, translated by Arthur Goldhammer (Chicago: University of Chicago Press, 1985), 152.

56 Quoted in Guilbaut, *How New York Stole the Idea of Modern Art*, 152. For an extended discussion of the circumstances surrounding the Galerie Maeght exhibition, see April Paul, "Introduction a la Peinture Moderne Americaine: Six Young American Painters of the Samuel Kootz Gallery: An Inferiority Complex in Paris," *Arts Magazine* 60, no. 6 (February 1986): 65–71.

57 A large painting for Bearden would have been *Madonna and Child,* 1945, oil on canvas, 38 x 30 in., from his *Passion* series; typical of the paintings in the Lorca series is *Now the Dove and the Leopard Wrestle,* 1946 oil on canvas, 23½ x 29 1/4 in. The painting *Some Drink, Some Drink,* 1946, oil on canvas, from the Rabelais series, exhibited at the Kootz Gallery in New York, the same year as the Galerie Maeght show, measures 25 x 32 in.

58 Pepe Karmel, "Adolph Gottlieb: Artist and Cosmos," adapted from "Adolph Gottlieb: Self and Cosmos" in Karmel, *Adolph Gottlieb: A Retrospective* (23–52) (New York: Solomon R. Guggenheim Foundation, 2010). Adapted with permission. See pdf online at https://s3.amazonaws.com/academia.edu.documents/ 36130594/Karmel_Gottlieb_Artist_and_Cosmos_Pace_2012.pdf?

59 Excerpts from Bearden's diaries appear in *Romare Bearden: Origins and Progressions,* Davira Taragin, curator and introduction, Lowery Sims, essay (Detroit: Detroit Institute of Arts, 1986). See "The Journals of Romare Bearden," August 21, 1947, 25.

60 My thanks to Barrie Stavis's daughter, Jane Stavis, for making available her father's archives including the drafts and final version of the catalogue essay for the 1947 exhibition. The Barrie Stavis archives are located in her home in Swarthmore, Pennsylvania.

61 Excerpt of Bearden's journal in "The Journals of Romare Bearden," entry dated September 6, 1948, in *Origins and Progressions*, 29.

62 See Goler, "A Refracted Image," 197, quoted from William Carlos Williams, "Woman as Operator," in *Women: A Collaboration of Artists and Writers*, exhibition catalogue, Samuel M. Kootz Gallery, New York, 1948.

63 For an excellent overview of critical response to Bearden's exhibitions, see Abdul Goler, "A Refracted Image: Selected Exhibitions and Reviews of Bearden's work," in Ruth Fine, *The Art of Romare Bearden* (Washington, DC: National Gallery of Art in association with Harry N. Abrams, 2003), 192–221.

64 Undated letter to Carl Holty in the Archives of American Art. Bearden's handwritten letter to Holty runs for twenty pages and has been written over several days; Ruth Fine mentions the television appearance as September 27, 1948, in the chronology in Fine, *The Art of Romare Bearden,* 219. Bearden received a letter from the network thanking him and asking him to consider appearing in future programs. See letter to Bearden from Irvin Paul Sulds, producer, *Court of Current Issues,* September 28, 1948. Romare Bearden Foundation Archives, Box 10, Folder 30.

65 "Pickle Man in Pickle as He Beats Bearden," *New York Amsterdam News,* November 13, 1948, 27. The case received ongoing attention in the black press. See "Postpones Case of Attacker of Howard Bearden," *New York Amsterdam News,* November 27, 1948, 5, and "Pickle Heir Unpickles Self from Pickle," *Baltimore Afro-American,* March 5, 1949, 12.

66 Oral history interview with Samuel Kootz by Dorothy Seckler, April 13, 1964, online transcript of the interview at www. aaa.si.edu/collections/interviews/oral-history-interview-samuel-m-kootz-12578.

67 Samuel Kootz in the catalogue for the exhibition *Intrasubjectives*, September 14–October 3, 1949, with contributions from William Baziotes, Hans Hofmann, Adolph Gottlieb, and Samuel Melvin Kootz (New York: Kootz Gallery, 1949).

68 Serge Guilbaut used exactly the word "tyranny" to describe the dominance of the New York Style. See Guilbaut, *How New York Stole the Idea of Modern Art,* 178.

CHAPTER SIX: A VOYAGE OF DISCOVERY

1 Letter from Romare Bearden to Harry Henderson, October 25, 1949, courtesy of Mr. Henderson's son, Albert K. Henderson.

2 In an undated letter to Carl Holty, Bearden mentions a gift to Holty of Eugène Delacroix drawings with an essay by Charles Baudelaire (Romare Bearden Foundation Archives, Box 10, Folder 60). The date of the gift was Christmas 1948 and the letter is circa January 1949, given a reference to Matisse's work on Vence Chapel that appeared in the Sunday *New York Times* of that year.

3 Oral history interview with Samuel M. Kootz, by Dorothy Seckler, April 13, 1964, online transcript, Archives of American Art (AAA), Smithsonian Institution, Washington, DC, www.aaa.si.edu/collections/interviews/oral-history-interview-samuel-m-kootz-12837.

4 *New York Times*, May 22, 1950, 1 and 15.

5 Bearden's painting, *Factory Workers,* already featured in *Fortune* magazine, was reproduced in the July 22, 1946, issue of *Life* in an article titled "Negro Artists: Their Works Win Top U.S. Honors," 62–65.

6 For evidence of materials Bearden used in his collages, see the National Gallery of Art Paper Sample Collection. See especially, Restricted Manuscript box with six folders of un-catalogued papers from the 1960s and 1970s.

7 *Jet* published, for example, a photograph of the open casket of Emmett Till. Till was a fifteen-year-old teenager from Chicago who, during a summer visit to his family in Mississippi, made the mistake of flippantly calling a white woman "Baby." Till was murdered and mutilated beyond recognition in revenge. Memories of the photograph to this day are vivid for those of us who opened the pages of the September 15, 1955, edition of *Jet.*

8 Romare Bearden, letter to Harry Henderson, postmarked October 25, 1949. Letter courtesy of Albert K. Henderson.

9 Romare Bearden and Carl Holty, *The Painter's Mind* (New York: Crown, 1967).

10 Bearden rarely included the year when dating his letters. Dates have been determined by references in the content and/or by Holty's always meticulously dated response to issues or ideas raised in Bearden's letter.

11 Holty was born in Frieburg, Germany, to American parents and attended school in the United States, returning to Germany to study painting in Munich in the 1920s.

12 Romare Bearden Diaries, #13, October 1, no year, possibly 1948. Published excerpts of the journals between 1947 and 1949 appear in the catalogue of the exhibition entitled *Romare Bearden: Origins and Progressions*, Davira S. Taragin, curator and introduction, Lowery Sims, essay (Detroit: Detroit Institute of the Arts, September 16–November 16, 1981), 32.

13 Joan Miró was commissioned to paint what became a thirty-foot mural for the restaurant in a Cincinnati hotel. The mural now resides in the Cincinnati Art Museum. A 1947 photo of the trio (Miró, Holty, and Bearden) together has been reproduced often.

14 Putting the paintings up for sale in a department store in and of itself was not shameful. Kootz had successfully sold paintings by Picasso at a department store in Texas for the store's clients who spent over $50,000 a year. But the Gimbel Brothers sale was a bargain basement event meant to get rid of the paintings quickly at whatever price they would sell, no matter how low. See interview with Samuel M. Kootz by Dorothy Seckler, April 13, 1964, Archives of American Art, Washington, DC.

15 Serge Guilbaut, *How New York Stole the Idea of Modern Art: Abstract Expressionism, Freedom and the Cold War*, translated by Arthur Goldhammer (Chicago: University of Chicago Press, 1985).

16 Samuel Kootz, in Holty's mind, was demonstrating his "impotence in protecting an artist whose work he has acquired." He astutely recognized that Kootz faced the wrath of collectors who "may wonder what he will do with his other stock once the popularity (as in the case of Gottlieb) begins to wane." Carl Holty letter to Romare Bearden, November 19, 1951, held in Romare Bearden Foundation Archives, New York, Box 10, Folder 60.

17 Shortly after the *Intrasubjectives* show opened without his work, Bearden began preparing an application for a Fulbright Fellowship to support an extended stay in Paris. In a letter to Harry Henderson, Bearden describes in detail his efforts to pull together the application. The letter is postmarked October 25, 1949, and a typed transcript was made available to me by Henderson's son, Albert K. Henderson.

18 Romare Bearden in an undated letter to Carl Holty ca. early 1949 in Carl Holty Papers, Series 1: Correspondence, 1940–1972, Box 1, Folder 1, Archives of American Art, Smithsonian Institution, Washington, DC.

19 Romare Bearden in an undated letter to Carl Holty ca. early 1949 in Carl Holty Papers, Archives of American Art, Smithsonian Institution, Washington, DC, Box 1, Folder 1.

20 Post-Paris undated Romare Bearden letter to Carl Holty in Carl Holty Papers, Archives of American Art, Smithsonian Institution, Washington, DC, Box 1, Folder 1.

21 The caption of a photo published on March 4, 1950, in the *Chicago Defender* notes that the ship had departed the preceding week.

22 Caption for ship photo, March 4, 1950, *Chicago Defender*.

23 Notes to Bearden's employment records indicate "STUDY/LWOP 3/29/50" presumably noting a leave without pay for the purpose of study. His return is documented as 8/22. This document was obtained by the author from New York City records as a result of a Freedom of Information Law (FOIL) request.

24 On his transcript from the Sorbonne, Bearden, as a veteran, was ranked satisfactory in all three categories of the transcript: conduct, progress, and permission to continue. The document certified that Bearden began his studies 3-1-50 and ended his studies 6-30-50. In the section for remarks, the writer notes that the new semester begins in November, presumably 1950. See Romare Bearden Foundation Archives, New York, Box 10, Folder 13.

25 His experience living in Paris also placed him in the lineage of black artists who had long sought opportunities in Paris unavailable in the United States. The lure of studying in leading ateliers, living without the burden of Jim Crow, and working in a country that welcomed them attracted artists who considered the trip a rite of passage for serious practitioners. Sculptors Meta Warrick Fuller and Edmonia Lewis had both worked in the nineteenth-century atelier of Rodin. In the early decades of the twentieth century, painters Palmer Hayden, Archibald

Motley, Aaron Douglas, and Hale Woodruff, and sculptor Augusta Savage used their time abroad to develop their work and incubate an artistic persona.

[26] Romare Bearden to Carl Holty, Archives of American Art, Smithsonian Institution, Washington, DC, Roll 670. Also Schwartzman, *Romare Bearden: His Life and Art*, 160-170 and Fine, "Romare Bearden: The Spaces Between," in *The Art of Romare Bearden*, 23-24, provide excellent descriptions of Bearden's time in Paris.

[27] Bearden in an undated letter about Paris to Carl Holty in Carl Holty Papers, Series 1: Correspondence, 1940-1972, Box 1, Folder 1, in Archives of American Art, Smithsonian Institution, Washington, DC. In a recorded conversation with Al Murray, James Baldwin, and Alvin Ailey (Ailey was not in Paris at the same time as the other three artists), Murray ribs Bearden about being too light to appeal to the Scandinavian women who were attracted to black Americans resident in Paris during the 1950s. See "To Hear Another Language: Alvin Ailey, James Baldwin, Romare Bearden, and Albert Murray, 1978," in *Conversations with Albert Murray*, edited by Roberta S. Maguire (Jackson: University Press of Mississippi, 1997), 25-45.

[28] On a trip to Marseilles, possibly on his way to Italy, and in a rare display of political awareness during the decade, Romare Bearden describes conditions he witnessed in a letter to Barrie Stavis, dated only April 23, and sent from #5 Rue des Feuillantines. He states that he saw "some of the camps where the people stay waiting to go to Palestine. Conditions worse than bad and this is not necessary for so much money is being collected in America. People living on dirt floors—no shoes etc. Lots of those in charge using American shipments—soap, etc. to deal on the black market." He criticizes explicitly the "Joint Distribution Committee. Racketeers over here trading on misery." He suggests to Stavis that he make a trip to the camps and write an article. See Barrie Stavis archives. Access to Barrie Stavis's papers was made possible by his daughter, Jane Stavis, who holds his papers in her home in Swarthmore, Pennsylvania.

[29] Letter to Carl Holty, ca. summer 1950, in Carl Holty Papers, Series I: Correspondence, Box 1, Folder 1, Archives of American Art, Smithsonian Institution, Washington, DC.

[30] Quoted in James Campbell, *Exiled in Paris* (Los Angeles: University of California Press, 2003).

[31] Campbell, *Exiled in Paris*, 3.

[32] Painter Herb Gentry, who owned a nightclub in Paris called Honey's, named after his then wife, where artists gathered, would become a close friend. He and Bearden maintained a correspondence over several decades in the 1960s and 1970s. Sam Allen, a poet, who was also in Paris at the same time as Bearden, would become a collaborator as well. Bearden visited the home of Henry Tanner, the black painter who left the United States in 1891 and lived and worked productively in Paris until his death before World War II.

[33] Jack Flam and Miriam Deutch, editors, *Primitivism and Twentieth Century Art: A Documentary History* (Los Angeles: University of California Press, 2003), 13.

34 French filmmaker Jean Renoir's casting of Harlem vaudeville performer Johnny Hudgins, to play the role of a futurist astronaut in blackface in his 1927 avant-garde film, *Charleston*, is yet another example. On English stages, the talents of Paul Robeson, Florence Mills, and Andy Razaf were on display with productions of Eugene O'Neill's *Emperor Jones*, the Gershwins' *Porgy and Bess*, and *Blackbirds*.

35 Romare Bearden letter to Barrie Stavis, undated in the Barrie Stavis archives, courtesy of Jane Stavis, Swarthmore, Pennsylvania.

36 Howard Zinn, *A People's History of the United States* (New York: Harper and Row, 1980), 432.

37 An examination of his passport, Sorbonne transcripts, various news articles that document his presence in New York, and correspondence suggest that after Bearden returned from Paris in August 1950, he did not go to Paris again until he and Nanette went together in 1961.

38 See letter from Andy Razaf, dated October 25, 1951, in the Romare Bearden Foundation Archives, Box 10, Folder 31. Also, in a 1973 letter to Mary Schmidt Campbell, Bearden makes note especially of Razaf and Layton as visitors to his home and notes that Razaf was Waller's collaborator and Layton was the author of "Way Down Yonder in New Orleans."

39 Loften Mitchell, *Black Drama*, "Introduction" (New York: Hawthorne Books, 1967), 1.

40 My thanks to Steve Lynch who worked with Bearden in the early 1960s and who emailed me. Lynch provided written details of their working conditions at the department of welfare.

41 Newspaper accounts document Bearden's participation in a range of lectures at Barnard, the Letchner Center, and other places, and in an undated letter to Carl Holty, Bearden mentions a group of New York University students who had recently come to visit. See undated Bearden letter to Carl Holty in Carl Holty Papers, Series 1: Correspondence, 1940–1972, Box 1, Folder 1, in Archives of American Art, Smithsonian Institution, Washington, DC.

42 My thanks to Kathe Sandler, who facilitated an interview with her mother, Joan, and who graciously shared with me the two nude drawings of Joan Sandler that Bearden gave to Joan. Joan provided details of her friendship with Lorraine Hansberry as well. Matisse's influence is not surprising since there was a Matisse retrospective at the Museum of Modern Art from November 13, 1951, to January 13, 1952, and Bearden mentions seeing the show in an undated letter to Holty in the Carl Holty Papers, Series 1: Correspondence, 1940–1972, Box 1, Folder 1, in Archives of American Art, Smithsonian Institution, Washington, DC.

43 See Malia McAndrew, "Selling Black Beauty: African American Modeling Agencies and Charm Schools in Post War America," *OAH Magazine of History*, January 2010, 29–32. A'Lelia Bundles (*On Her Own Ground: The Life and Times of*

Madam C. J. Walker [New York: Scribner, 2001]) and Deborah Willis (*Posing Beauty: African American Images from the 1890s to the Present* [New York: W. W. Norton, 2009]) examine, on the one hand, the rise of the modern black businesswoman's domain of selling beauty and, on the other hand, the self-conscious representations in photographs of a female persona for the past 100 years. In a biographical summary of Romare Bearden's life, Nanette writes of meeting Bearden in 1953. Her writings are held in Romare Bearden Foundation Archives, New York, Box 20, Folder 42.

44 "About Art and Artists: Exhibitions at Two Galleries Here Show Painters Profited by Their Absence," *New York Times*, November 5, 1955, 28L. As Abdul Goler points out in his essay, "A Refracted Image: Selected Exhibitions and Reviews of Bearden's Work," in Ruth Fine, *The Art of Romare Bearden* (Washington, DC: National Gallery of Art, in association with Harry Abrams, 2003), 192–211. The reviewer wrongly states that Bearden had been in Paris for most of the early 1950s.

45 The account of Bearden's growing frenzy and anxiety can be found in an undated biography of Romie, written by Nanette, in which she recounts his personal biography from Paris through their meeting, marriage, and his emergence as a major collage artist. See Romare Bearden Foundation Archives, New York, Box 20, Folder 42.

46 Nanette Bearden biographical writings, Romare Bearden Foundation Archives, New York, Box 20, Folder 42.

47 Nanette Bearden biographical writings, Romare Bearden Foundation Archives, New York, Box 20, Folder 42.

48 Bearden has stated that he was hospitalized at Bellevue. Hospital records for the 1950s were not available to the author. Nanette, recently married, notes in her biographical summary that she assisted him in the recovery from his breakdown. See Schwartzman, who dates his breakdown sometime in 1954, based on an undated letter to Carl Holty in which Bearden describes his illness, states that Bearden met Nanette shortly after the illness. An alternative date of 1952 for Bearden's nervous breakdown is in the exhibition catalogue, Tracy Fitzpatrick, with an introduction by Lowery Sims, *Romare Bearden Abstraction* (Purchase, NY: Neuberger Museum, 2017), 23–24. Bearden describes his nervous breakdown in some detail (but does not reveal, when it took place) in an interview with Barbaralee Diamonstein. See Barbaralee Diamonstein, "Romare Bearden," *Inside New York's Art World* (New York: Rizzoli, 1979), 33–34.

49 Nanette Bearden's biographical notes recount Bearden's breakdown and recovery. See Romare Bearden Foundation Archives, New York, Box 20, Folder 42.

50 Schwartzman, *Romare Bearden: His Life and Art*, 176; Fine, "Romare Bearden: The Spaces Between," 26.

51 An excellent example of an early collage signed by Bearden was made available to the author for examination at the ACA Gallery. From the dated material visible

on the surface, the collage is circa 1955/56. Several examples of early collages can be found in Tracy Fitzpatrick, *Romare Bearden: Abstraction* (Purchase, NY: Neuberger Museum, 2017).

52 Ruth Fine, "Romare Bearden: The Spaces Between," 27. Harlequin is dated ca. 1956; measuring 24 5/8 x 17 ½ in. it is smaller in scale than the large-scale non-objective oils.

53 All quotes are from DeCarava's application to the Guggenheim Foundation, stamped by the foundation, received October 22, 1951. My thanks to his widow, Sherry DeCarava, who has retained a copy of the application, for access to this material.

54 For its insight about Ellison and visual culture, I am indebted to Maurice Berger's catalogue essay, *For All the World to See: Visual Culture and the Struggle for Civil Rights* (New Haven, CT: Yale University Press, in collaboration with the Center for Art, Design and Visual Culture, University of Maryland, Baltimore County, and National Museum of African American History and Culture, Smithsonian Institution, Washington, DC, 2010). See especially 20–24.

CHAPTER SEVEN: THE PREVALENCE OF RITUAL, PART I

1 Romare Bearden letter to Cedric Dover undated, ca. 1958 or 1959, Cedric Dover papers, Stuart A. Rose, Manuscript, Archives and Rare Book Library (MARBL), Emory University, MSS 1108, Box 1.

2 See "Kennedy to Arrive Here Today; Pre-Inaugural Suite Prepared," *New York Times*, January 4, 1961, 21, for details of the contents of the suite.

3 "Bearden Painting in Presidential Suite," *Amsterdam News*, Saturday, January 7, 1961, 7.

4 For a discussion of Kennedy's priorities at the time of his inauguration, see Robert Dallek, *An Unfinished Life: John F. Kennedy, 1917–1963* (New York: Little, Brown, 2003), 2013.

5 Mitchell refers to the questioning in an undated manuscript in the Romare Bearden Foundation Archives Box 10, Folder 31. See also "Two More Quit Jobs in Welfare Red Quiz," *New York Times*, August 14, 1951.

6 The testimony regarding Bessye's membership on the selection committee can be found in the government report titled "Investigation of Communist Activities in the San Francisco Area—Part 1: Hearing before the Committee on Un-American Activities House of Representatives," Eighty-third Congress, First Session, December 1, 1953, Printed for the use of the Committee on Un-American Activities (Washington, DC: US Government Printing Office, 1954), 3065.

7 In his autobiography, Roy Wilkins retells the experience of meeting with Kennedy and seeing the Bearden painting. Wilkins was accompanied by the head of the Leadership Conference. See *Standing Fast: The Autobiography of Roy Wilkins* (New York: Da Capo Press, 1974), 280.

8 Romare Bearden, letter to Cedric Dover, date estimated as 1958 or 1959, Cedric Dover Papers, Stuart A. Rose Manuscript, Archives and Rare Book Library (MARBL), Emory University, MSS 1108, Box 1.

9 Years later, Bearden's seminal essay, "Rectangular Structure in My Montage Painting," *Leonardo: Journal of the International Society for the Arts, Sciences and Technology* 2 (January 1969): 11–19, reconstructs a narrative of the evolution of his painting. He references the tension between the demands of painting and the requirements of representation: "I started to play with pigments, as such, in marks and patches, distorting natural colors and representational objects. I spent several years doing this, until I gradually realized the tracks of color tended to fragment my compositions."

10 See Bearden's letter to Dover, ca. 1958/1959, MARBL, Emory University.

11 For an excellent description of their first meeting, see Myron Schwartzman, *Romare Bearden: His Life and Art* (New York: Harry N. Abrams, 1990), 204.

12 Their wives had common interests as well. Parmenia Migel Elstrom was the author of several volumes on dance including a biography of Isak Dinesen. Her papers reside in the Harvard University Archives. Nanette, a dancer/choreographer, founded the Nanette Rohan Dance Company, which as of the publication of this book is still an active company.

13 The summary of reviews appears in Goler, "A Refracted Image: Selected Exhibitions and Reviews of Bearden's work," in Ruth Fine, editor, *The Art of Romare Bearden* (Washington, DC: National Gallery of Art in Association with Harry N. Abrams, 2003), 198–199. For the entire review, see also Carlyle Burrows, "Bearden's Return," *New York Herald Tribune*, January 24, 1960, 6. Loften Mitchell, letter to Romare Bearden, January 26, 1961, Romare Bearden Foundation Archives, Box 10, Folder 31.

14 In January 1971, Bearden's collage entitled *Patchwork Quilt* was included in the Cordier-Ekstrom exhibition, *She*. Donald Barthelme wrote a *New York Times* essay, "Woman: A Net as Big as the Sea," though the essay is not about Bearden's work (*New York Times*, January 3, 1971).

15 Brian O'Doherty, "Art: O'Keeffe Exhibition: Her Pictures Displayed at the Downtown—Bearden and Resnick Works on View," *New York Times*, April 11, 1961.

16 A copy of the funeral program dated September 20, 1960, is in the Barrie Stavis archive, managed by his daughter, Jane Stavis, Swarthmore, Pennsylvania. A handwritten note on the program to Stavis from Bearden observes that his father died peacefully. In stark contrast to the expansive coverage of Bessye's death, Howard received a few lines that appeared in the *New York Times*, Deaths Section, September 18, 1960, 87. His funeral was at St. Martin's Episcopal Church.

17 One of Bearden's co-workers, Steve Lynch, concedes in his blog that the two lived at 357 Canal though they listed his father's apartment as their formal address. Steve Lynch's recollections are recorded on Askart.com, an online

subscription service that compiles data about artists. Mr. Lynch, a photographer now living in Mexico City, confirmed the accuracy of his online account in an email to the author. See the bulletin posted by Lynch, March 8, 2010, at www .askart.com.

[18] The story of New York City artists' colonization of vacant former manufacturing space is well known. Two excellent summaries can be found in "How an Urban Artists' Colony Was Inadvertently Created," *New York Times*, June 8, 2003. See also the article by Mary Therese O'Sullivan, "Home Is Where the Art Is: The Impact That Housing Laws and Gentrification Policies Have Had on the Availability and Affordability of Artist Live/Work Space," *Seton Hall Journal of Sports and Entertainment Law* 23, no. 2, April 17, 2003. Online at http://scholarship.shu .edu/sports_entertainment/vol23/iss2/8/.

[19] "Abstract Artist, 46, Loses to Firemen on Studio in a Loft," *New York Times*, March 24, 1961, contains an account of the violations notice posted on January 30, 1961, and the account of his arrest, trial, and fine.

[20] "Artists Threaten to Strike over Evictions from Lofts," *Ogden Standard Examiner* (Ogden, Utah), August 6, 1961, 5A. See also Sanka Knox, "Artists Meet with City Officials on Dispute over Loft Studio," *New York Times*, August 16, 1961.

[21] See "Strike over Lofts Put off by Artists as Formula Is Set," *New York Times*, August 23, 1961, and for a summary of the subsequent laws that protected artists' living and working space, see O'Sullivan, "Home Is Where the Art Is."

[22] "Feuds with Fire Dept: Artist Wants Cavanaugh to Attend His Showing," *New York Amsterdam News*, April 1, 1961, 30. Bearden also wrote a letter to the editor that appeared in the *New York Times*, April 9, 1961. He noted that a pricey apartment was advertised in the *Times* with the inducement that it was close to two art museums.

[23] For a discussion of Shaw's view of Bearden's collages, see Lorie Karnath, *Sam Shaw: A Personal Point of View* (Ostfildern: Hatje Cantz Verlag, 2010), 232.

[24] Karnath, *Sam Shaw*, 235.

[25] During Bearden's lifetime, Shaw, Murray, and Bearden attempted to revive the spirit of the early 1960s collages for publication, but the project was never consummated. An exhibition at Jazz at Lincoln Center titled *Paris Blues Revisited: Romare Bearden, Albert Murray, Sam Shaw* was mounted in September 2011 to celebrate the centennial of Bearden's birth and the fiftieth anniversary of the film, *Paris Blues*, produced by Sam Shaw.

[26] Bearden, "Rectangular Structure," 12.

[27] Bearden, "Rectangular Structure," 12.

[28] Letter from Bearden to Carl Holty, dated Friday, May 28, with no year noted, in the Carl Holty Papers, Series 1: Correspondence, Box 1, Folder 1, Archives of American Art, Smithsonian Institution, Washington, DC.

[29] Romare Bearden letter to Carl Holty dated Friday, May 28, with no year noted, in the Carl Holty Papers, Archives of American Art, Washington, DC, Box 1, Folder 1.

30 James Baldwin, *The Fire Next Time* (New York: Dial Press, 1963).

31 For an excellent summary of the artistry of jazz musicians during this era, see Waldo E. Martin Jr., *No Coward Soldiers: Black Cultural Politics and Postwar America*, Nathan Huggins Lecture Series (Cambridge, MA: Harvard University Press, 2005), 52. Martin identifies the freedom of the musicians with trends in other mediums and includes Bearden among those who participated in a liberating avant-garde ethos. Though Bearden certainly belongs in Martin's list, ironically, he was avowedly opposed to the music of be-bop.

32 See the 2014 exhibition that traveled nationally; Teresa A. Carbone and Kellie Jones, authors, editors and curators, *Witness: Art and Civil Rights in the Sixties,* with contributions from Connie Choi, Dalila Scruggs, Cynthia Young (New York: Monacelli Press, 2014). See also Mark Godfrey and Zoe Whitley, authors, editors and curators, *Soul of a Nation: Art in the Age of Black Power* (London: D.A.P. and the Tate Modern, October 2017).

33 Kellie Jones writes about the impact of white and other images that emerged at the time of the movement. See Jones, "Civil Rights Act," in *Witness: Art and Civil Rights in the Sixties,* Teresa Carbone and Kellie Jones, authors, editors, and curators (New York: Monacelli Press, 2014), 19–20.

34 Carbone and Jones, *Witness*, illustrations, 88, 99, 85.

35 Carbone and Jones, *Witness*, 29.

36 Carbone, "EXHIBIT A: Evidence and the Art Object," in *Witness*, Carbone and Jones.

37 Undated Romare Bearden letter to Carl Holty reflects on the Matisse show. See Carl Holty Papers, Archives of American Art, Smithsonian Institution, Washington, DC, Box 1, Folder 1.

38 Picasso's groundbreaking collage was not included in the exhibition, *The Art of Assemblage*, though the curator, William C. Seitz, credits the piece with the beginning of the use of collage in the modern era. William C. Seitz, "Introduction," *The Art of Assemblage*, Museum of Modern Art, in collaboration with the Dallas Museum for Contemporary Art and the San Francisco Museum of Art (Garden City, NY: Doubleday, 1961), 9.

39 Seitz, *The Art of Assemblage*, 88.

40 Seitz, *The Art of Assemblage*, 89.

41 See Carbone and Jones, *Witness*, for Connie Choi's discussion on the care taken by photographers of that era who were vigilant in making sure that their photos were cropped and captioned accurately to preserve the intent of the visual image.

42 Bull Connor, Birmingham's Commissioner of Public Safety, ordered the use of German shepherd dogs and fire hoses armed with "monitor nozzles"—attachments that could knock the bricks out of mortar at 100 feet—on nonviolent protesters, among them children.

43 Some of the material relating to both Spiral and to the cultural activities has been drawn from the exhibition *Tradition and Conflict: Images of a Turbulent Decade,*

1963–1973, mounted in New York, Studio Museum in Harlem, January 27 to June 30, 1985. The exhibition was co-curated by the author, Roland Freeman, and Lucy Lippard and contained 150 artifacts from fifty artists. The catalogue included essays by Benny Andrews, Lerone Bennett Jr., Dr. Vincent Harding, Lucy Lippard, and Mary Schmidt Campbell and was one of the earliest exhibitions about the era to include black and white artists as well as photographers. The exhibition had a national reach. A national board of advisors included Benny Andrews, artist; Lerone Bennett, senior editor, *Ebony Magazine*; J. Max Bond, architect; Jayne Cortez, writer; Dr. Jeff Donaldson, art historian, Howard University; Dr. Vincent Franklin, Yale University; Roland Freeman, photographer; Dr. Vincent Harding, historian, professor of theology, Iliff School of Theology; Hon. A. Leon Higginbotham Jr., judge, US Court of Appeals for the Third Circuit; Dr. Samella Lewis, art historian; Lucy Lippard, critic and writer; William Miles, filmmaker; Dr. James Turner, director, Africana Studies and Research Center. *Witness: Art and Civil Rights in the Sixties* and *Soul of a Nation: Art in the Age of Black Power* have been invaluable resources that expand the discourse on the art of the era.

44 Oral history interview of Romare Bearden by Henri Ghent, June 29, 1968, online transcript available at Archives of American Art, Smithsonian Institution, Washington, DC, www.aaa.si.edu/collections/interviews/oral-history-interview-romare-bearden-11481.

45 The exact details of Spiral's founding, the conduct of the meetings, and the points of view of individual members vary according to accounts given by members in interviews and in scholarly versions of events. The account presented here is based on the description given in Romare Bearden and Harry Henderson's survey of African American art (Romare Bearden and Harry Henderson, *A History of African American Artists: From 1792 to the Present* [New York: Pantheon Books, 1993]); and Sharon Patton in Sharon Patton, *Memory and Metaphor: The Art of Romare Bearden, 1940–1987*, Introduction by Mary Schmidt Campbell (New York: Oxford University Press in Association with the Studio Museum in Harlem, 1991). Additionally, Jeanne Siegel convened a group of Spiral artists for a symposium (Bearden included). Her article documents the symposium and captures the different perspectives of member artists. The article was originally published in *ARTnews* 65, no. 5 (1966): 48–52, 67–68; reprinted in *NKA: Journal of Contemporary African Art* 29 (Fall 2011), available online, https://read.dukeupress.edu/nka/article/2011/29/78/48905/Why-Spiral. See also Courtney Martin, "From the Center: The Spiral Group, 1963–1966," *NKA* 29 (Fall 2011): 86–98. Bearden discusses Spiral briefly in a September 1973 letter to the author. The Archives of American Art interviews with individual artists provide perspectives on Spiral from each of the founding members. See oral history interview with Charles Alston by Albert Murray, October 19, 1968, online transcript available at Archives of American Art, Smithsonian Institution,

Washington, DC, www.aaa.si.edu/collections/interviews/oral-history-interview -charles-henry-alston-11460; oral history interview with Hale Woodruff by Albert Murray, November 18, 1968, online transcript available at Archives of American Art, Smithsonian Institution, Washington, DC, www. aaa.si.edu/col-lections/interviews/oral-history-interview-hale woodruff-11463; oral history in-terview with Norman Lewis by Henri Ghent, July 14, 1968, online transcript available at Archives of American Art, Smithsonian Institution, Washington, DC, www.aaa.si.edu/collecions/interviews/oral-history-interview-norman-lewis-11465; and oral history interview with Romare Bearden by Henri Ghent, June 29, 1968, online transcript available at Archives of American Art, Smithsonian Institution, Washington, DC, www. aaa.si.edu/collections/oral-history-interview-romare-bearden-11530. The author also interviewed surviving Spiral members, Emma Amos and Richard Mayhew.

[46] Mary Schmidt Campbell, co-curated with Roland Freeman and Lucy Lippard; essays by Benny Andrews, Lerone Bennett Jr., Vincent Harding, and Lucy Lippard, *Tradition and Conflict: Images of a Turbulent Decade* (New York: Studio Museum in Harlem, 1985), 17. For excellent cultural, political, and social analyses of the era, see Daniel Matlin, *African American Intellectuals and the Urban Crisis* (Cambridge, MA: Harvard University Press, 2013); Waldo Martin, *No Coward Soldiers*; and James Hall, *Mercy, Mercy, Me: African American Culture and the American Sixties (Race & Culture)* (New York: Oxford University Press, 2001).

[47] See Bearden and Henderson, *A History of African American Artists*, 400, for specific date and attendees at the meeting. The text references Bearden's minutes for the meeting. Pritchard's name appears only in Bearden's account of the meet-ing and is not on the roster of artists in the first exhibition.

[48] Jones, *Witness*, 43.

[49] Campbell et al., *Tradition and Conflict*, 57.

[50] Faith Ringgold attributes the origin of the term to the painter, Vivian Browne. See Faith Ringgold, *We Flew over the Bridge: The Memoirs of Faith Ringgold* (Durham, NC: Duke University Press, 2005), 150.

[51] Ringgold, *We Flew over the Bridge*. Ringgold prints Bearden's letter in full. See 150–151.

[52] Details come from Steve Lynch who worked with Romie as a caseworker at the nonresident welfare center on East 68th Street. He supplied this account of Bearden's discovery of the president's death in his March 8, 2010, bulletin at Askart.com. He subsequently confirmed the details of the account in an email exchange from Mexico City with the author, dated July 12, 2014.

[53] John F. Kennedy, speech at the convocation in his honor at Amherst College, October 26, 1963. Kennedy received an honorary LLD and after the convo-cation participated in the groundbreaking ceremony for the Robert Frost

Library. The quotes are all taken from the version of the speech posted on the Amherst College library website at www.jfklibrary.org/Asset-Viewer/80308LXB5kOPFEJqkw5hIA.aspx.

54 See Martin, "From the Center: The Spiral Group, 1963–1966," Martin's essay contains biographies of each member, quotes from interviews with individual members, and includes a brief chronology of key events in the history of the group.

55 Romare Bearden, letter to the author, September 1973, and author's interviews with Emma Amos and Richard Mayhew.

56 Calvin Tomkins manuscript and his lunch with Arne Ekstrom, February 28, 1975. This interview is recorded in the written transcript that Mr. Tomkins made available to the author in April of 1977 and remains in her personal papers.

57 Tomkins interview with Ekstrom, February 18, 1975.

58 Letter from Bearden to the author, postmarked September 22, 1973.

59 Charles Childs, "Bearden: Identification and Identity," ARTnews 63, no. 6 (October 1964): 25.

60 Childs, "Bearden," 55.

61 Courtney Martin cites a measure of uncertainty about the dates of the Spiral exhibition. Some accounts give 1964; others note 1965. The later date seems more plausible, since Spiral members in interviews report that events occurring in Mississippi in the summer of 1964 were a consideration. An exhibit in Westchester also in 1965 included most of the Spiral artists as well as Ernest Crichlow and Vivian Browne and may be the second Spiral exhibition sometimes referenced.

62 Oral history interview with Romare Bearden by Henri Ghent, June 29, 1968.

63 See Ralph Ellison, The Art of Romare Bearden, Art Gallery at the State University of New York at Albany, November 25–December 22, 1967.

64 Ellison, The Art of Romare Bearden.

CHAPTER EIGHT: THE PREVALENCE OF RITUAL, PART II

1 Romare Bearden, quoted in Jeanne Siegel, "Why Spiral?" ARTnews, September 1966.

2 Museum of Modern Art (MoMA) press release. See Museum of Modern Art Archives, New York, Romare Bearden: The Prevalence of Ritual [MoMA Exhibit #958, March 25–June 9, 1971], Department of Drawings Records, Folder 958.3, 1970–1971.

3 Listed in the MoMA inventory of exhibitions as Sculpture by William Edmondson [MoMA Exhibit #63c, October 20–November 4, 1937], http://www.MoMA.org/learn/resources/archives/archives_exhibition_history_list.

4 "Gala Preview Held for Bearden, Hunt," Amsterdam News, April 10, 1971, 18.

5 Bates Lowry, who served as director for less than ten months, was the recipient of a letter of protest from artist organizers, Tom Lloyd and Faith Ringgold, who demanded that a Martin Luther King Wing be added to the museum for black and Latino artists; John Hightower, who followed Lowry in 1970 and resigned January of 1972, was greeted at his opening reception by an artists' protest as well as protests inside the museum. Richard Oldenburg, who assumed the position first of acting director in January 1972 and then of permanent director in June of that year, weathered a strike of MoMA staff and went on to serve as director for over twenty years. See Grace Glueck, "Lowry Out as Director of the Modern Museum," *New York Times,* May 3, 1969; Paul Vitelli, "John Hightower, Besieged Art Museum Director Is Dead at 80," *New York Times,* July 13, 2013.

6 A press release issued by Black Mask announced that they would close MoMA. At the appointed hour, a sticker marked closed was stuck on the front door of the museum amid an enhanced security presence. Sculptor Takis Vassiklakis raised the stakes of the protest, when, unhappy about the way his art had been handled by the museum, he walked in, deinstalled one of his small sculptures displayed in the museum's galleries, and took the piece to the museum's sculpture garden and staged a sit-in. For a comprehensive survey of interventions and protests, see Roman Petruniak, "Art Workers on the Left: The Art Workers Coalition and The Emergence of a New Collectivism," master's thesis, School of the Art Institute of Chicago, 2009.

 A year before Bearden's retrospective opened, the discontent fomenting outside the museum began echoing inside. Vietnam, not artists' rights, was the catalyst this time. Museum staff, intending to co-sponsor a poster with dissident artists that protested the massacre of civilians at My Lai, were overruled by trustees who were offended by the graphic images and confrontational content of the poster. Splits between trustees and staff deepened when over 100 of the 400 museum staff members organized into a professional union—PASTA—the Professional and Staff Association, theirs yet another in a city filled with fractious unions. In the months after Bearden's show closed in New York, MoMA was crippled by a PASTA organized strike. Within the space of two years, the board forced two museum directors to leave. One of the issues at the heart of the Art Worker's Coalition complaint was the question of representation.

7 Benny Andrews documents the Whitney protest in Mary Schmidt Campbell et al., *Tradition and Conflict: Images of a Turbulent Decade* (New York: Studio Museum in Harlem, 1985).

8 For discussion of the Black Arts Movement, see James Hall, *Mercy, Mercy, Me: African American Culture and the American Sixties* (Race and Culture Series) (New York: Oxford University Press, 2001); Waldo E. Martin Jr., *No Coward Soldiers: Black Cultural Politics and Postwar America* (Cambridge, MA: Harvard University Press, 2005); and Teresa Carbone and Kellie Jones, *Witness Art and Civil Rights in the Sixties* (New York: Monacelli Press, 2014).

9 Lucy Lippard, "Dreams, Demands and Desires: The Black, Antiwar and Women's Movement," in *Tradition and Conflict: Images of a Turbulent Decade, 1963–1973,* Introduction by Mary Schmidt Campbell (New York: Studio Museum in Harlem, 1985); Jeff Chang, *Who We Be: A Cultural History of Race in Post–Civil Rights America* (New York: Picador Press, 2016); Todd Gitlin, *The Sixties: Years of Hope, Days of Rage* (New York: Bantam, 1993).

10 David Murphy, editor, *The First World Festival of Negro Arts, Dakar 1966* (Post Colonialism across the Disciplines) (Liverpool: Liverpool University Press, 2016), http://www.jstor.org/stable/j.cttign6dzd.

11 *Bulletin of the Metropolitan Museum of Art,* January 1969.

12 See Romare Bearden's 1962 application to the Guggenheim Foundation in the Romare Bearden Foundation Archives, New York, Box 1, Folder 3. See also the letter to the author, postmarked September 22, 1973, in which he complains of the invisibility of black artists. See Appendix.

13 John Canaday, "Romare Bearden Focuses on the Negro," *New York Times,* October 14, 1967.

14 See Romare Bearden and Carroll Greene Jr. (co-directors), *Evolution of the Afro American Artist, 1800–1950,* exhibition catalogue (New York: City University of New York, Harlem Cultural Council, and National Urban League, 1967).

15 Bearden's painting *Factory Worker* appeared as the Frontispiece of the June 1942 issue of *Fortune* magazine. He and Alston had been invited to illustrate a story, "The Negro's War," that discussed the high unemployment among Negroes despite labor shortages in wartime industries. The article discussed A. Philip Randolph's role in putting pressure on the White House to issue an executive order addressing this situation.

16 See the museum's press release dated November 16, 1967, *Harlem on My Mind* exhibition record, 1966–2007, Box 1, Folder 39, Archives of American Art, Smithsonian Institution, Washington, DC. For Hoving's perspective, see Thomas Hoving, *Making the Mummies Dance: Inside the Metropolitan Museum of Art* (New York: Touchstone, 1994).

17 For an excellent account of *Harlem on My Mind,* see Susan E. Cahan, "Performing Identity and Persuading a Public: The Harlem on My Mind Controversy," *Social Identities: Journal for the Study of Race, Nation and Culture* 13, no. 4 (2007): 423–440, doi: 10.1080/13504630701459115. Cahan interviewed Schoener, and her article is the principal source for biographical information on him. See also the catalogue of the exhibition, Allon Schoener, editor and curator, *Harlem on My Mind: Cultural Capital of Black America, 1900–1968, 18 January–6 April 1969* (New York: Random House, 1968).

18 Bearden's letters to Schoener, Hoving, and John Henrik Clarke, a member of the advisory committee, are in the Romare Bearden Foundation Archives. Bearden's letter to Schoener dated, June 6, 1968, is especially telling: "As I have told you there are several things that the community is just not going to accept, and rather

than completely antagonize people it might actually be best to phase the show out, or else start immediately to work in the interest of the kind of a show the community as a whole would want." Bearden goes on to write, "I know the artists are not going to tolerate color transparencies of their work in an Art Museum." To Hoving, Bearden writes in a July 9, 1968, letter, "A number of artists, photographers and other interested persons have serious questions relating both to the organization and the plans for presenting the artistic material in this important exhibit." Hoving responds to Bearden in a letter dated September 4 and in his characteristically oracular tone invites Bearden to join the advisory group. All letters cited in this note are in the Romare Bearden Foundation Archives, New York, Box 10, Folder 51.

19 Letter from Allon Schoener to Thomas Hoving, November 26, 1968, Archives of American Art, Smithsonian Museum, Washington, DC, *Harlem on My Mind* Papers, Series 1: Correspondence, 1967–2007, Box 1, Folders 1–3.

20 Letter from Meyer Schapiro to Thomas Hoving, January 18, 1969, Archives of American Art, Smithsonian Museum, Washington, DC, *Harlem on My Mind* Papers, Series 1: Correspondence, 1967–2007, Box 1, Folder 1.

21 See Mary Schmidt Campbell, "New York Re-imagined: Artists, Arts Organizations and the Re-birth of a City," in *Artistic Citizenship: Artistry, Social Responsibility, and Ethical Praxis,* edited by David Elliott, Marissa Silverman, and Wayne Bowman (New York: Oxford University Press, 2016).

22 Grace Glueck, *Art Notes,* "A Very Own Thing in Harlem," *New York Times,* September 15, 1968.

23 "John Lindsay's Ten Plagues," *Time,* November 1, 1968, 20–29.

24 "John Lindsay's Ten Plagues," *Time,* November 1, 1968, 20–29.

25 A note states that the article was received April 27, 1968. Romare Bearden and Carl Holty, *The Painter's Mind: A Study of the Relations of Structure and Space in Painting* (New York: Crown, 1969), reflects many of the same perspectives on form and content.

26 Former president of the Art Students League, Henry Schnakenberg, wrote a letter to the editor of the *New York Times,* October 26, 1969 in which he recalled Groxz's intention. As Schnakenberg reports, "His teaching would be founded particularly on classic draftsmanship."

27 Romare Bearden, "Rectangular Structure in My Montage Paintings," *Leonardo: Journal of the International Society for the Arts, Sciences and Technology* 2 (January 1969): 11.

28 Sharon Patton, *Memory and Metaphor: The Art of Romare Bearden, 1940–1987.* Introduction by Mary Schmidt Campbell (New York: Oxford University Press in association with the Studio Museum in Harlem, 1991). See note 14, p. 107, where Patton references an undated Bearden notebook in Schomburg.

29 Bearden and Holty, *The Painters' Mind,* 215.

30 The entire book, *The Painter' Mind,* is a tour of the world's museums.

31 Bearden, "Rectangular Structure," 12.

32 Bearden, "Rectangular Structure," 11. See also Sarah Kennel, "Bearden's Musee Imaginaire," in Ruth Fine, *The Art of Romare Bearden* (Washington, DC: National Gallery of Art in association with Harry N. Abrams, 2003), 138–156.

33 Bearden, "Rectangular Structure," 15.

34 Bearden, "Rectangular Structure," 14.

35 *Art News*, October, 1967, 73.

36 Hilton Kramer, "Black Experience and Modernist Art," *New York Times*, February 14, 1970.

37 "Music to the Ears," *Village Voice*, March 10, 1975, 84.

38 Quoted in Kramer, "Music to the Ears," *Village Voice*, March 10, 1975, 84.

39 Bearden submitted a 1962 application to the Guggenheim Foundation to request support for Spiral. His application request stated that the intent of the group, in addition to showing their own work in the Christopher Street gallery, was to show the work of worthy young artists as well. See Romare Bearden Foundation Archives, Box 1, Folder 3.

40 Grace Glueck, "A Brueghel from Harlem," *New York Times*, February 22, 1970.

41 Bearden's application to the Guggenheim Foundation, p. 3; Romare Bearden Foundation Archives, New York, Box 1, Folder 3.

42 Romare Bearden and Harry Henderson, *Six Black Masters of American Art* (New York: Doubleday, 1972). Bearden states in his final report to the Foundation dated June 5, 1971, that *Six Black Masters* is the result of his progress to date. He notes that he has traveled extensively "to Washington, D.C. to research files at the Congressional Library and the Archives. I have visited Boston, Wilmington Providence, Atlanta, Lincoln Uni. Penna., Philadelphia. . . . This fall I plan to go to West Coast and I will go to Europe on June 10th to conduct interviews and to do research." Quoted from a copy of a letter to Mr. Ray from the archives of John Simon Guggenheim Foundation in the Romare Bearden Foundation Archives, New York, Box 1, Folder 4. Bearden's application, his report, and—as confirmed by Harry Henderson's son, Albert Henderson—the project consumed a great deal of Bearden's time and was extremely important to the artist.

43 Letter from Romare Bearden to Guggenheim Foundation, June 6, 1971. Romare Bearden Foundation Archives, New York, Box 1, Folder 4.

44 Thelma Golden, chief curator and executive director of the Studio Museum refers to this idea of a white paper in her TED Talk, "How Art Gives Shape to Cultural Change," published on YouTube, February 24, 2013. As a white paper, an exhibition presents a theme that is explicated in the works chosen, the logic of their display, and the accompanying interpretive documents.

45 Carroll Greene, curator and introductory essay, *Romare Bearden: The Prevalence of Ritual* (New York: Museum of Modern Art, 1971).

46 The size alone of the retrospective was unusually modest. By contrast, in the years after Bearden's death, the Studio Museum organized a 1991 retrospective

of over 100 works and similarly, the National Gallery of Art organized its retrospective in 2003, of over 100 works. MoMA's 1939 Picasso retrospective included over 300 works.

47 Bearden, "Rectangular Structure in My Montage Paintings," 12.

48 In their introduction to *The Painter's Mind*, Holty and Bearden state their objection to Abstract Expressionism. It may be that Bearden did not want his large abstractions exhibited in his first museum retrospective.

49 Shortly after the MoMA retrospective ended its national tour, a major art publisher produced a lavishly illustrated volume on Bearden's work. Like the retrospective, an illustrated coffee table book was a first for a black American artist. Full page color reproductions included the omitted literary abstractions from the 1940s and his nonobjective oils from the 1950s and early 1960s. The two essays included in the book reinforced Bearden's identity as a black artist: one by black novelist, John Williams, and a rambling autobiographical essay by an aspiring artist, M. Bunch Washington, the driving force behind the book's publication. See John Williams, Introduction, in M. Bunch Washington, *The Art of Romare Bearden: The Prevalence of Ritual* (New York: Harry N. Abrams, 1973), 9. Williams sees the works as representing specifically a "Black truth," and that truth is the "hell of America" for black people. Washington, looking for a model of how to be an artist and after lamenting his difficulty in finding his way as an artist, praises the way in which Bearden "orders, clarifies, and makes classic our social reality." A devotee of the Baha'i religion, Washington alludes to Bearden's adoption of Buddhism. Washington gave a place of prominence in the book to *The Block*—a double page color reproduction that opens to four full pages. A small exhibition (*Mysteries: Women in the Art of Romare Bearden, 1975*) at the Everson Museum, curated by the author, included figurative abstractions, and Lowery Sims curated an exhibition in 1986 for the Detroit Institute of Art that restored the importance of the large abstract oils. Sharon Patton, curator for the Studio Museum in Harlem, mounted a posthumous Bearden retrospective in 1991 also includes ample representation in the years between the social realist paintings and the collages.

50 See press release in Museum of Modern Art archives, New York, 958. Romare Bearden: The Prevalence of Ritual, Department of Drawings Records, Folder 958.3, 1970–1971.

51 More than one critic complained that it was a distraction.

52 Co-authored by Billie Allen and Nelson Breen, *Bearden Plays Bearden,* is a two-disc video (144min.) directed by Nelson Breen, released on PBS in 1980. Produced by Third World Cinema Productions (St. Petersburg, FL), the film is a biographical survey of the life and work of the artist that includes conversations with Alvin Ailey, James Baldwin, Bearden, Albert Murray, Ntozake Shange, and Joseph Campbell; it is narrated by James Earl Jones. There is a scene in which Bearden says that he is waiting for Murray to come give names to his "orphan" collages.

Also, a photograph of Bearden and Murray on the roof of Murray's building can be found in Ruth Fine, *Romare Bearden: Photographs by Frank Stewart* (New York: Pomegranate, 2004). Another photograph in Fine's book of Frank Stewart photographs of Romie pictures him waiting with completed collages for Murray to come give them titles. Stewart, who bought a car with Romie and served as his driver on many occasions, by necessity spent hours with both artists and, with his ever-present camera, documents the contours of the artists' relationship with each other. In his video, *Bearden Plays Bearden*, Breen captures footage of a funeral procession similar to the one represented in *The Block* and documents the corner intersection, liquor store sign, and the rhythms of the buildings' facades. The National Gallery of Art's 2003 *The Art of Romare Bearden* also pictures the view of the street from Mr. Murray's rooftop. Fine, *The Art of Romare Bearden* (Washington, DC, and New York: National Gallery of Art in association with Harry N. Abrams, 2003).

There are many stories that Bearden tells in which an elevated view is important. Myron Schwartzman (*Romare Bearden: His Life and Art* [New York: Harry N. Abrams, 1990]) describes the view from film producer Michael Tolan's apartment, and in a brief conversation with Bearden for the November 1, 1968, issue of *Time* magazine, for which he illustrated the cover, he notes the view from the *Time* offices of a city in decline.

53 New York was not the only city that Bearden documented. A ghostly picture of Pittsburgh as a charnel house is in the collection of Dianne Whitfield-Lovett. Yellow and orange dominate as if he were representing a sky overheated by blasting furnaces. Later in his autobiographical series of the late 1970s and early 1980s, Bearden contrasts the tidy residential warmth of his grandparents' boarding house to the streets outside where soot soiled everything it touched. In the 1968 collage, however, he focuses instead on the deathliness of the work, picturing a wagon of skulls, a face visible among them, as if it were a wheelbarrow carting skulls away from a guillotine. The city of Pittsburgh would eventually claim Bearden as a native son and commission a major public work from him for its subway. Though he represented other cities in the years between *Projections* and the retrospective, it was the scenes of New York that consumed him most as the city faced an uncertain future.

54 Bearden and Holty include this observation in their caption for another painting by Léger (*The Painter's Mind*, 210).

55 Greg Foster-Rice characterizes *The Block* as an example of metonymy and syndedoche—that is, the part stands in for the whole. Foster-Rice argues that *The Block* is "a metonym for 'the city,' of which it is a part, and a synecdochical reference to 'urbanism,' with which city blocks are associated." See Greg Pamela Ford, symposium and publication manager and Ellie Tweedy, editor, *Romare Bearden in the Modernist Tradition: Essays from the Romare Bearden Foundation Symposium* (New York: Romare Bearden Foundation, 2008); Foster-Rice,

"Romare Bearden's Tactical Collage," in *Romare Bearden in the Modernist Tradition*, 103.

56 Rodia's scavenging was not dissimilar to Bearden's process. Bearden did not roam the city for his material but he turned to materials at hand—books; bits of billboard advertising; and cut, torn, and pasted paper; scraps of photos; and printed material for *The Block*. Disparate materials, their interfaces carefully joined, require attention to their sustainability. A former New York University classmate of Bearden's, also a cabinet maker, Jack Shindler, assisted in constructing a surface for the collages that would inhibit warping. Shindler constructed a sturdy wooden trellis that braces and reinforces the back of the masonite that serves as the surface on which Bearden assembled his multi-media fragments. He took great care in determining how the piece was to be exhibited. When *The Block* was last exhibited at the Metropolitan Museum, each of the six panels was framed and placed under glass as if each panel were a separate painting, a decision that dramatically altered the viewer's panoramic experience of Bearden's view from Mr. Murray's roof.

57 As told to the author by the late Jayne Cortez. After her death in 2012, the composition book became the property of her widower, the sculptor, Melvin Edwards. "Collage for Romare" is published in Jayne Cortez, *Festivals and Funerals,* with illustrations by Mel Edwards (New York: Cortez, 1971).

58 Years after Bearden's death, choreographer Walter Rutledge, associate director of the Nanette Bearden Dance Company, choreographed "On the Block" during the National Gallery's retrospective, 2004–2005, when the piece was once again on public view. *The Block*'s public visibility is limited because it is a work on paper, highly volatile and sensitive to light and environmental stresses. An excerpt of Rutledge's piece, "Intimate Strangers," was performed July 7, 2011. *The Block* was exhibited that year at the Met in celebration of the centennial of Bearden's birth.

59 Greene, *Prevalence of Ritual*, p. 3.

60 As Albert Henderson reports, Doubleday, publisher of *Six Black Masters*, was to have been the publisher of the survey, but because the publishing house was experiencing financial difficulties, it was not able to proceed. Harry Henderson took the manuscript to Pantheon. I am grateful to Albert K. Henderson, Harry Henderson's son, for the telephone interview of June 30, 2011, during which he recounted his father's commitment to the project after Bearden's death.

CHAPTER NINE: THE PUBLIC ROMARE BEARDEN

1 The account of Bearden's first commission comes from an interview with Suzanne Randolph, who, in 1971, was serving as director of Works of Art in Public Places, in New York City's Department of Cultural Affairs, then a division of the

city's parks department. When asked by her supervisor for a suggestion, she gave Bearden's name as the perfect fit for the assignment. For a description of the mural, see "Times Sq. Billboard Depicts Parks Events," *New York Times*, August 31, 1972. Bearden's comments on the mural are recorded in one of a series of letters he wrote to his friend, the artist, Herb Gentry. During the 1970s, Gentry was living in Stockholm and he and Romie wrote to each other frequently. The letters are warm, filled with humor, personal exchanges, and discussions of his work and the art world.

2 For an excellent discussion on public art, see Tom Finkelpearl, *Dialogues in Public Art* (Cambridge, MA: MIT Press, 2001).

3 May 10, 1972, letter to the author.

4 Paul Allman, *Berkeley Gazette*, November 1971.

5 Undated typewritten letter from Bearden to Herb Gentry. References to Times Square, Studio Museum in Harlem exhibition, and Munich Olympics date the letter to summer 1972. For a discussion of the Berkeley mural, see Fine, "Romare Bearden: The Spaces Between," in *The Art of Romare Bearden,* (Washington, DC: National Gallery of Art in association with Harry N. Abrams, 2003), 66–68. Bearden references his research for the Berkeley mural in a letter to the author, dated 5–10–72. See Appendix.

6 Romare Bearden, "Rectangular Structure in My Montage Paintings," *Leonardo: Journal of the International Society for the Arts, Sciences and Technology* 2 (January 1969): 11–19.

7 John Geluardi, "Mr. Bearden's Mural Goes to Washington for Show," *Berkeley Daily Planet*, Tuesday, May 27, 2003.

8 Geluardi, "Mr. Bearden's Mural Goes to Washington."

9 Hilton Kramer, "Romare Bearden Tied His Work to Race, but Was a Cubist," *New York Observer*, October 26, 2003.

10 In a letter to Gentry, Bearden writes, "Guess what happened to your boy? I fell & fractured my ankle & tore a ligament. Now, I'm in one of those casts DRAWS A CAST up to my crotch nearly—and I understand it'll be 8 weeks or so before the cast can come off. So my April show must be cancelled, etc. Some break, eh?"

11 Myron Schwartzman, *Romare Bearden: His Life and Art* (New York: Harry N. Abrams, 1990), 229.

12 See Shaun Vogel, *The Scene of Harlem Cabaret* (Chicago: University of Chicago Press, 2009) for his discussion on the conflict between the guardians of uplift and those writers, artists, and musicians who championed the cabaret scene's liberated ethos.

13 Renowned sociologist, Allison Davis, for example, was grieved to see that "our Negro writers have been 'confessing' the distinctive sordidness and triviality of Negro life, and making an exhibition of their own unhealthy imagination, in the name of frankness and sincerity," quoted in Vogel, *The Scene of Harlem Cabaret*, 4.

W. E. B. Du Bois, a future patron of Bearden's, railed against Claude McKay's 1928 novel, *Home to Harlem*. Accusing McKay of "pandering" to the interests of white people, he rails against McKay's portrait of Harlem as a realm of "drunkenness, fighting, lascivious sexual promiscuity and utter absence of restraint in as bold and as bright colors as he can." Du Bois quoted in Vogel, *The Scene of Harlem Cabaret*, 132.

14. Vogel, *The Scene of Harlem Cabaret*, 28.

15. In an undated letter to Herb Gentry, Bearden makes references to Philadelphia mural and Atlanta, 1976.

16. The *New York Times* obituary, December 2, 2008, for Ramon Velez provides an overview of Velez's influence. See also "Hospital Art Wasting Away in Warehouse," *New York Daily News*, October 22, 1976, 4.

17. Brett Paulety, "Treatment for Many Ills; An Area Centers on Lincoln Hospital," *New York Times*, June, 11, 1995.

18. "Hospital Art Wasting Away in Warehouses," *New York Daily News,* October 22, 1976, 4.

19. Undated Bearden letter to Herb Gentry.

20. In response to a research request submitted by the author to the New York City Design Commission, the following documents were forwarded and currently reside in the New York City Design Commission Archives, New York: (1) November 4, 1974, agreement between the artist and the New York City Design Commission to produce work for Lincoln Hospital; (2) December 18, 1974, certificate of approval from the New York City Art Commission approving Bearden's plans for the *Cityscape* mural; (3) April 1983 approval by the New York City Art Commission for the transfer of the mural to Bellevue Hospital; (4) Treatment Proposal, submitted to the New York City Art Commission by the fine arts conservator, Luca Bonetti, dated November 9, 1998, and final report on the June 6, 1999, treatment of the mural *Cityscape*.

21. The Beardens started business ventures in St. Martin that included Nanette's Gallery, a cookbook Bearden published of Ma Chance's recipes, and an arts festival which they both launched.

22. The collaborators interviewed by the author included Billie Allen Henderson, Jayne Cortez, Ntozake Shange, Dianne McIntyre, and Thulani Davis.

23. See IMDB for full cast and crew credits for *Five on the Black Hand Side*.

24. Don Evans, "The Theater of Confrontation: Ed Bullins, Up Against the Wall," *Black Worlds*, April 1974, 14–20, 17, and Jervis Anderson, "Profiles: Dramatist, Ed Bullins," *New Yorker*, June 16, 1973, 40–79.

25. See Ruth Fine and Jacqueline Francis, editors, *Romare Bearden, American Modernist* (Washington, DC: National Gallery of Art, 2011); Richard A. Long, "Bearden, Theater, Film, Dance," in *Romare Bearden, American Modernist*, edited by Ruth Fine and Jacqueline Francis (New Haven, CT: Yale University Press and

Washington, DC: National Gallery of Art, 2011), 90–99. Long, a distinguished Atlanta scholar, museum director and archivist, was a close friend of Nanette and Romie and often accompanied them to theater and dance performances.

26 References to his efforts to work with Dunham are in his undated letters to Holty during the late 1940s as well. See Carl Holty Papers, Series 1: Correspondence, 1940–1972, Box 1, Folder 1, Archives of American Art, Smithsonian Institution, Washington, DC.

27 See Fine for a discussion of unproduced work, "The Space Within," in *The Art of Romare Bearden* (Washington, DC: National Gallery of Art in association with Harry N. Abrams, 2003), 124–127.

28 Thulani Davis provided the details of the encounter between Bearden and Papp in an email exchange with the author and Diedre Harris-Kelly, dated September 16, 2014.

29 An account of the circumstances of the encounter between Bearden and Papp are in the email from Davis to the author and Harris-Kelly dated September 16, 2014.

30 Long records Alvin Ailey's ecstatic response to Dunham. See Richard Long, "Bearden, Theater, Film, Dance," in Ruth Fine and Jacqueline Francis, editors, *Romare Bearden: American Modernist* (Washington, DC: National Gallery of Art in association with Yale University Press, 2011), 91–99.

31 Long, "Bearden, Theater, Film, Dance," 91–99.

32 Letter from Bearden to Herb Gentry.

33 Katrina DeWees, "Dancing Visual Art: An Interview with Dianne McIntyre," *Studio* (Winter/Spring 2013): 71.

34 In February 2015, McIntyre shared her memories of Bearden's participation with the author in an informal interview. The interview was given on the occasion of a panel at Columbia University in which McIntyre shared publicly her collaborative experience working with Bearden.

35 Veta Goler, "Moves on Top of Blues," in *Dancing Many Dreams: Excavations in African American Dance*, edited by Thomas Frantz (Madison: University of Wisconsin Press, 2002).

36 Tomkins references Julian Jaynes, *The Origin of Consciousness in the Breakdown of the Bicameral Mind* (New York: Houghton Mifflin, 1976).

37 Robert G. O'Mealley, *Romare Bearden: A Black Odyssey* (New York: D. C. Moore Gallery, 2007), accompanied an exhibition November 13, 2007–January 5, 2009.

38 Gaston Bachelard, *The Poetics of Space*. Translated by Maria Jolas (Boston: Beacon Press, 1958), 4. Bachelard writes, "We comfort ourselves by reliving memories of protection. Something closed must retain our memories, while leaving them their original value as images. Memories of the outside world will never have the same tonality or those of home and, by recalling these memories, we add

to our store of dreams; we are never real historians, but always near poets and our emotion is perhaps nothing but an expression of a poetry that was lost," 6.

39 Romare Bearden, quoted in Albert Murray, "The Visual Equivalent of the Blues," in *Romare Bearden: 1970–1980*, edited by Albert Murray and Dore Ashton, exhibition catalogue (Charlotte, NC: Mint Museum, 1980), 18.

40 IMDB, *Gloria*.

41 After his death, on at least two occasions the Romare Bearden Foundation gave permission to have one of his collages or an existing public work be the basis for a public project: "Jazz at Lincoln Center," a mural based on the collage, "Family," in Queens and the mural in the Mecklenburg County Public Library were executed after his death.

42 A description of the work is in the article by Mary Thomas, "Romare Bearden's Tile Mural Once Again Shows His Love for City and Its People," *Pittsburgh Gazette*, March 14, 2012, at www.post-gazette.com/ae/art-architeccture/2012/03/14/Romare-Bearden-s-tile-mural-once-again-shows-his-love-for-city-and-its-people/stories/201203140182: "The mural comprises 780 ceramic tiles, each 12 by 12 inches and 1/4-inch thick. They were adhered to a 3-foot-thick concrete wall reinforced with rebar. McKay Lodge Conservation Laboratory of Oberlin, Ohio, was contracted for the de-installation and employed a chain saw with a diamond bladed chain saw to cut into the concrete behind each tile at a 11/2-inch depth. An ultra-thin cutting blade (6/100-inch thick) was used to cut between each tile. Back in Ohio, a specially designed CNC [computer numerical control] machine with a diamond blade saw cut grooves through the remaining concrete to the backs of the numbered tiles. The remaining concrete could then be chipped away by hand. The residual cleaning, including desalination, was accomplished at the rate of five to seven tiles a day.

The problems the conservators found—cracks, stains, mineral deposits from seeping water—were 'pretty routine matters to deal with,' said Robert Lodge. Conservators found areas of red glaze that had been lost or damaged. Some had been retouched with red paint, which had failed, and the conservators touched up those areas. (Mr. Bearden himself painted the stoneware tiles, which were fired by Bennington Potters in Vermont)."

The material fragility of Bearden's work was not the only threat to his mural commissions. The city of Hartford commissioned two murals, 10' by 16' each, for the Hartford Civic Center in 1980, where the works received very little visibility. With a renovation planned for the Center, the works were relocated to the Hartford Library in 2014, where they are prominently displayed.

43 In a letter to the author, Bearden softened his harsh assessment of Western civilization.

44 Romare Bearden, "An Artist's Renewal in the Sun," *New York Times Magazine*, 133 (October 2, 1983), Section 6: 46–48, 52.

⁴⁵ Bearden, "An Artist's Renewal." As Bearden was losing weight and growing ill from the bone cancer that would eventually kill him, he was trying herbal medicines, which he obtained via mail order.

⁴⁶ Thibault's story of their meeting is published in the Boston University alumni magazine. John Stromberg, "Colossal Remnants: Romare Bearden," *Bostonia: The Alumni Quarterly of Boston University* (Spring 2001): 3–18. See sidebar by Eric McHenry, 18.

⁴⁷ Quoted from Derek Walcott's poem, "The Schooner Flight," in Derek Walcott and Romare Bearden, *The Caribbean Poetry of Derek Walcott and The Art of Romare Bearden* (New York: Limited Editions Club, 1983), 152.

⁴⁸ Romare Bearden, "Artist's Note," *The Caribbean Poetry of Derek Walcott and The Art of Romare Bearden,* Introduction, Joseph Brodsky (New York: Limited Editions Club, 1983), 209.

⁴⁹ Ntozake Shange, poems; Romare Bearden, paintings; Linda Sunshine, editor, *i live in music* (New York: Welcome Books, 1984). In an interview with Ntozake Shange, conducted by the author while she was in residence at Spelman College, 2016, she said that she and Romie did not need a lot of conversation but seemed to connect to each other intuitively. Bearden enjoyed another successful collaboration with saxophonist Jackie McLean in 1986 at the Wadsworth Atheneum's Avery Theater. Bearden completed a portrait of McLean on stage and discussed his collages while McLean performed "Sound Collages and Visual Improvisations."

⁵⁰ A notice of the show appears in the *Bostonia: The Magazine of Culture and Ideas*, Boston University, no. 5 (September/October, 1987): 10.

⁵¹ Vivien Raynor, "A Glance at Romare Bearden at the Bronx Museum of Art," *New York Times,* January 4, 1987, and Michael Brenson, "Art View: A Collagist's Mosaic of God, Literature and His People," *New York Times*, January 11, 1987.

⁵² André Thibault generously shared his recollections of the time he spent as Bearden's assistant in the last years of his life. Thibault was especially helpful in sharing explicit details of the construction of the collages, including the materials Bearden used to attach paper and materials to surfaces and the structural grids he built for the surfaces of the collages. As Thibault notes, Bearden became increasingly more adept in the construction of surfaces that would hold and sustain the cut, painted, and glued paper.

EPILOGUE

¹ Felicia Lee, "His Brother's Keeper and Art Guardian," *New York Times*, October 22, 2012.

² Ruth Fine, introduction, and David Driskell, Foreword, *Romare Bearden: Photographs by Frank Stewart* (San Francisco: Pomegranate, in association with Black Light Productions, 2004), n.p.

3 Gerald Fraser, "Romare Bearden, Collagist and Painter, Dies at 75," *New York Times*, March 13, 1988.

4 Andrew Yarrow, "The Life and Works of Romare Bearden Recalled in a Tribute," *New York Times*, April 7, 1988.

5 The author was among those who avoided the obvious in a 1975 exhibition she curated of the artist's work entitled *Mysteries: Women in the Art of Romare Bearden*, Syracuse, Everson Museum of Art. The catalogue essay was a celebration of exalted imagery. See *Mysteries: Women in the Art of Romare Bearden* (Syracuse, NY: Everson Museum of Art, 1975), 1.

6 Letter to the author from Bearden, September 22, 1973. His allusion to the dignity of women suggested the theme as an organizing principle for the show.

7 For an account of the forgeries, see unclassified US Department of State Case No. F-2013-00199 Doc. No. C05306318, date: 02/24/2014. The document records the arrest for forgery of Monica Sauvignon and Manuel Fernandez. Both offered for sale fraudulent works by Alexander Calder and Romare Bearden sometime in the mid to late 1990s. For an account of estate issues, see Jeffrey Bergen on the Romare Bearden Estate, "Unfinished Dialogues: The Artist and the Gallery," in *Artists Estates: Reputations in Trust*, edited by Magda Salvesen and Daine Cousineau (New Brunswick, NJ: Rutgers University Press, 2005), 138–145.

8 Michael Brenson, "Review/Art: The All Including Work of Romare Bearden," *New York Times*, April 19, 1991. Brenson correctly calls attention to errors in my introduction and Dr. Patton's catalogue text and objects to then director Kinshasha Holman Conwill's characterization of the Studio Museum as an authority.

9 Brenson, "Review/Art: The All Including Work of Romare Bearden."

10 Sharon Patton, *Memory and Metaphor: The Art of Romare Bearden 1940–1987* (New York: Oxford University Press, 1991), 67.

11 Lowery Stokes Sims, *Romare Bearden* (New York: Rizzoli Art Series, 1993).

12 List of exhibition of "306" show is in the Archives of American Art, Smithsonian Museum, Washington, DC, Roll N68-87, according to Judith Wilson, "Getting Down to Get Over: Romare Bearden's Use of Pornography and the Problem of the Black Female Body in Afro-U.S. Art," in *Black Popular Culture*, by Michel Wallace, edited by Gina Dent (Seattle: Bay Press, 1992), 112–122.

13 Wilson, "Getting Down to Get Over," 112–122.

14 Evelyn Brooks Higginbotham, *Righteous Discontent: The Women's Movement in the Black Baptist Church: 1880–1920s* (Cambridge, MA: Harvard University Press, 1994).

15 Romare Bearden Papers, "Finding Aid," prepared by Camille Ann Brewer, August 2014, New York: Romare Bearden Foundation.

16 Along with the images of the train, birds, lighted lamps, sun, and moon, the Conjure Women is one of the most ubiquitous motifs in Bearden's art. Like the train, the motif bears the weight of past meanings. Rooted in slavery's antebellum

folklore, the character migrated to literature as early as Charles Chestnutt's nineteenth-century novel by the same name, a collection of stories collected from former slaves. See Charles W. Chestnutt, *The Conjure Woman* (New York: Houghton Mifflin, 1927). In the twentieth century, Zora Neal Hurston wrote of vengeful women with conjuring powers who are dangerous and hurtful in *Jonah's Gourd Vine* (Philadelphia: J. B. Lippincott, 1934) and *Mules and Men* (Philadelphia: J. B. Lippincott, 1935). Rudolph Fisher, a successful Harlem physician and member of Bessye's coterie, wrote the first black mystery novel in 1932, titling it, *The Conjure-Man Dies: A Mystery Tale of Dark Harlem*. A few years after its publication, writer, historian, and librarian Arna Bontemps and poet Countee Cullen wrote a stage adaptation of Fisher's novel. *The Conjure-Man Dies*, that opened at the Lafayette Theater in Harlem on March 11, 1936, a theater across the street from Bearden's apartment. In its run of twenty-four performances, the Works Project Administration–supported play, a farce, drew an estimated 20,000 people. A murder mystery, the play featured themes of conjuring. Even if Bearden had never read either Hurston or Fisher or seen the play, he recounted to his biographer, Myron Schwartzman, sightings of women of magic in Mecklenburg County, North Carolina; Pittsburgh; and Harlem. Such women are almost always judgmental, moral arbiters, capable of inflicting pain, dangerous, and most of all, powerful.

17 My thanks to Garth Fagan who mounted an excerpt of the piece for my viewing at his dance studio in Rochester, New York.

18 The Studio Museum has engaged Sir David Adjaye, architect of the National Museum of African American History and Culture, who has designed a major museum facility for the Studio Museum in Harlem that will place the museum at the forefront of art museums internationally. The expanded vision for the museum has been led by its director, Thelma Golden, since 2005.

19 Studio Museum in Harlem, *The Bearden Project*, publication organized by Elizabeth Gwinn, Lauren Haynes, and Abbe S. Schriber on the occasion of *The Bearden Project* shown November 10, 2011–March 11, 2012; March 29–May 27, 2012; and August 16–October 21, 2012 in New York.

20 Arun Chaudhary served on the Obama campaign and went on to become the first official White House videographer (2009–2011). See Arun Chaudhary, *First Cameraman Documenting the Obama Presidency in Real Time* (New York: St. Martin's Press, 2013).

21 My thanks to Denise Murrell whose dissertation, completed at Columbia University and currently embargoed until the exhibit opens at Columbia University's new art gallery, shared news of this upcoming exhibition with me.

22 Romare Bearden, *Collages, Profile/Part II: The Thirties*, picture titles and text reviewed and edited by Albert Murray, Cordier Ekstrom Gallery, May 6–June 6, 1981, n.p.

BIBLIOGRAPHY

Aberjhani, and Sandra West. Clement Alexander Price, contributor. *Encyclopedia of the Harlem Renaissance*, Volume 2. New York: Facts on File, 2003.

ACA (American Contemporary Art) Gallery. *Romare Bearden: 1911–1988, A Memorial Exhibition*, organized by Jonathan Bergen. New York: ACA Gallery, 1989.

Agee, James, and Walker Evans. *Let Us Now Praise Famous Men*. Boston: Houghton Mifflin. 1941.

Allen, James, Hilton Als, Congressman John Lewis, and Leon Litwack. *Without Sanctuary: Lynching Photography in America*. New York: Twin Palms, 2008.

Anderson, Jervis. "Profiles: Dramatist, Ed Bullins." *New Yorker*, June 16, 1973.

Anderson, Jervis. *This Was Harlem: A Cultural Portrait, 1900–1950*. New York: Farrar, Straus & Giroux, 1982.

Apel, Dora. *Imagery of Lynching: Black Men, White Women and the Mob*. New Brunswick, NJ: Rutgers University Press, 2004.

Arendt, Hannah. *The Life of the Mind: Thinking*. New York: Harcourt Brace Jovanovich, 1971.

Ashton, Dore. "Romare Bearden: Projections." *Quadrum* 17 (1964).

Ater, Renee. *Remaking Race and History: The Sculpture of Meta Warrick Fuller*. Berkeley: University of California Press, 2011.

Bachelard, Gaston. *The Poetics of Space*. Translation by Maria Jolas. Boston: Beacon Press, 1994 (originally published 1958).

Barnwell, Andrea, with contributions by Tritobia Hayes Benjamin, Kirsten P. Buick, Walter O. Evans, and Amy M. Mooney. *The Walter O. Evans Collection of African American Art*. Seattle: University of Washington Press in association with Walter O. Evans Foundation, 1999.

Baro, Gene. *Twelve American Masters of Collage*. New York: Andrew Crispo Gallery, 1977.

Baudrillard, Jean. *The Evil Demon of Images*. Sydney: Power Institute Publications, 1987.

Bayne, Bijan C. *Black Baseball in Boston: Recovering a Lost Legacy*. http://www.Baystate-banner.com/archives/stories/2006/04/042706-03.htm.

Baziotes, William, Hans Hofmann, Adolph Gottlieb, and Samuel Melvin Kootz, contributors. *The Intrasubjectives*, Wednesday, September 14 through October 3, 1949. New York: Samuel M. Kootz Gallery, 1949.

Bergen, Jeffrey. "Unfinished Dialogues: The Artist and the Gallery: Jeffrey Bergen on the Romare Bearden Estate." In *Artists Estates: Reputations in Trust*, edited by Magda Salvesen and Daine Cousineau. New Brunswick, NJ: Rutgers University Press, 2005.

Berger, Maurice. *For All the World to See: Visual Culture and the Struggle for Civil Rights*. New Haven, CT: Yale University Press in collaboration with the Center for Art, Design and Visual Culture at the University of Maryland, Baltimore County, and the National Museum of African American History and Culture, Smithsonian Institution, Washington, DC, 2010.

Berman, Avis. "I Paint Out of the Tradition of the Blues." *ARTnews* 79 (December 1980).

Blassingame, John, editor. *The Frederick Douglass Papers, Series One: Speeches, Debates and Interviews*, Volume 3. New Haven, CT: Yale University Press, 1985.

Bogle, Donald. *Toms, Coons, Mulattoes, Mammies and Bucks: An Interpretive History of Blacks in American Films*. New York: Bloomsbury Academic, 2016 (originally published New York: Viking, 1973).

Bowser, Pearl, Jane Gaines, and Charles Musser, editors and curators. *Oscar Micheaux and His Circle: American Filmmaking and Race Cinema of the Silent Era*. Bloomington: Indiana University Press, 2001.

Breen, Nelson, director. *Bearden Plays Bearden*. James Earl Jones, narrator. 2012.

Brenson, Michael. "Art View: A Collagist's Mosaic of God, Literature and His People." *New York Times*, January 11, 1987.

Brenson, Michael. "Review/Art: The All-Including Work of Romare Bearden." *New York Times*, April 19, 1991.

Bundles, A'Lelia. *On Her Own Ground: The Life and Times of Madam C.J. Walker*. New York: Scribner, 2001.

Cahan, Susan E. *Mounting Frustration: The Art Museum in the Age of Black Power*. Durham, NC: Duke University Press, 2016.

Cahan, Susan E. "Performing Identity and Persuading a Public: The Harlem on My Mind Controversy." *Social Identities: Journal for the Study of Race Nation and Culture* 13, no. 4 (2007): 423–440, doi: 10.1080/13504630701459115.

Caldwell, Erskine, and Margaret Bourke-White. *You Have Seen Their Faces*. Foreword by Alan Trachtenberg. Athens: University of Georgia Press, 1995 (originally published 1937).

Calo, Mary Ann. *Distinction and Denial: Race, Nation, and the Critical Construction of the African American Artist, 1920–1940*. Ann Arbor: University of Michigan Press, 2007.

Campbell, James. *Exiled in Paris*. Los Angeles: University of California Press, 2003.

Campbell, Joseph. *The Hero with a Thousand Faces*. New York: Pantheon Books, 1949.

Campbell, Mary Schmidt. *Harlem Renaissance: Art of Black America*. Introduction with essays by David Driskell, David Levering-Lewis, and Deborah Willis Ryan. New York: Harry Abrams and the Studio Museum in Harlem, 1987.

Campbell, Mary Schmidt. *Mysteries: Women in the Art of Romare Bearden*. Syracuse, NY: Everson Museum, 1975.

Campbell, Mary Schmidt. "New York Re-imagined: Artists, Arts Organizations and the Re-birth of a City." In *Artistic Citizenship: Artistry, Social Responsibility, and Ethical*

Praxis, edited by David Elliott, Marissa Silverman, and Wayne Bowman. New York: Oxford University Press, 2016.

Campbell, Mary Schmidt. "Romare Bearden: Rites and Riffs." *Art in America* 69 (December 1981): 134–141.

Campbell, Mary Schmidt. Co-curated with Roland Freeman and Lucy Lippard. *Tradition and Conflict: Images of a Turbulent Decade.* Introduction by Mary Schmidt Campbell; essays by Benny Andrews, Lerone Bennett Jr., Vincent Harding, and Lucy Lippard. New York: Studio Museum in Harlem, 1985.

Carbone, Teresa, and Kellie Jones, authors, curators, and editors, with contributions from Connie Choi, Dalila Scruggs, and Cynthia Young. *Witness Art and Civil Rights in the Sixties.* New York: Monacelli Press, 2014.

Carmean, E. A. Jr., and Eliza E. Rathbone, with Thomas B. Hess. *American Art at Mid-Century: The Subjects of the Artist.* Catalogue. Introduction by E. A. Carmean Jr. Washington, DC: National Gallery of Art, 1978.

Chang, Jeff. *Who We Be: A Cultural History of Race in Post–Civil Rights America.* New York: St. Martin's Press, 2014.

Chaudhary, Arun. *First Cameraman: Documenting the Obama Presidency in Real Time.* New York: St. Martin's Press, 2013.

Childs, Charles. "Bearden: Identification and Identity." *ARTnews* 63, no. 6 (1964).

Cooks, Bridget R. "Black Artists and Activism: Harlem on My Mind (1969)." *American Studies* 48, no. 1 (Spring 2007): 5–39.

Corlett, Mary Lee. *From Process to Print: Graphic Works by Romare Bearden.* Petaluma, CA: Pomegranate Communications, 2009.

Corlett, Mary L., Leslie King Hammond, Jae Emerling, Carla Hanzal, and Glenda Gilmore. *Romare Bearden: Southern Recollections.* Charlotte, NC: Mint Museum in association with London: D. Giles, 2011.

Cotter, Holland. Review, "One Way Ticket at MoMA Re-unites Jacob Lawrence's Migration Paintings." *New York Times*, April 1, 2015.

Dallek, Robert. *An Unfinished Life: John F. Kennedy, 1917–1963.* New York: Little, Brown, 2013.

De Frantz, Thomas, editor. *Dancing Many Dreams: Excavations in African American Dance.* Madison: University of Wisconsin Press, 2002.

DeWees, Katrina. "Dancing Visual Art: An Interview with Dianne McIntyre." *Studio* (Winter/Spring 2013): 71.

Diamonstein, Barbaralee, editor. *Inside New York's Art World.* New York: Rizzoli International, 1979.

Doty, Robert. *Contemporary Black Artists in America.* New York: Whitney Museum of American Art, 1971.

Du Bois, W. E. Burghardt. *Dusk of Dawn: An Essay toward an Autobiography of a Race Concept.* Illustrated with the work of Romare Bearden, selected by the artist. A Limited Edition. Franklin Center, PA: Franklin Mint, 1980.

Du Bois, William Edward Burghardt. "Fighting Race Calumny." *Crisis*, May/June 1915.

Ellington, Edward Kennedy. *Music Is My Mistress.* New York: Da Capo Press, 1973.

Ellison, Ralph. *The Art of Romare Bearden.* Exhibition catalogue. Art Gallery at the State University of New York at Albany, November 25–December 22, 1967.

English, Darby. *How to See a Work of Art in Total Darkness*. Cambridge, MA: MIT Press, 2007.

Evans, Don. "The Theater of Confrontation: Ed Bullins, Up against the Wall." *Black Worlds*, April 1974, 14–20.

Farebrother, Rachel. *The Collage Aesthetic in the Harlem Renaissance*. Burlington, VT: Ashgate, 2009.

Fax, Elton. *Seventeen Black Artists*. New York: Dodd, Mead, 1971.

Fine, Ruth, editor. *The Art of Romare Bearden*. Washington, DC: National Gallery of Art in association with Harry N. Abrams, 2003.

Fine, Ruth. *Romare Bearden*. Photographs by Frank Stewart. New York: Pomegranate, 2004.

Fine, Ruth, curator and essayist. "Romare Bearden: The Spaces Between." In *The Art of Romare Bearden*, edited by Ruth Fine. Washington, DC: National Gallery of Art in association with Harry N. Abrams, 2003.

Fine, Ruth, and Jacqueline Francis, editors. *Romare Bearden, American Modernist: Proceedings of a Symposium Organized by the Center for the Advanced Study in the Visual Arts, National Gallery of Art*. Washington, DC: National Gallery of Art, 2011.

Finkelpearl, Tom. *Dialogues in Public Art*. Cambridge, MA: MIT Press, 2001.

Fitzpatrick, Tracy, with Lowery Sims. *Romare Bearden: Abstraction*. Purchase, NY: Neuberger Museum. 2017.

Flam, Jack, and Miriam Deutch, editors. *Primitivism and Twentieth Century Art: A Documentary History*. Los Angeles: University of California Press, 2003.

Ford, Pamela, and Ellie Tweedy, editors. *Romare Bearden in the Modernist Tradition: Essays from the Romare Bearden Foundation Symposium*. New York: Romare Bearden Foundation, 2008.

Franklin, John Hope. "'Birth of a Nation': Propaganda as History." *Massachusetts Review* 20, no. 3 (1979): 417–434.

Gaither, Barry Edmond. *The Mural Tradition*. Originally published in the catalogue of the exhibition *A Shared Heritage: Art by Four African Americans*. Indianapolis, IN: Indianapolis Museum of Art (February 25–April 21, 1966. Resource Library, August 5, 2009, www.ima-art.org.

Gates, Henry Louis. "The Trope of the New Negro and the Reconstruction of the Image of the Black." *Representations* 24, Special Issue: America Reconstructed, 1840–1940 (Autumn 1988): 129–155.

Gelburd, Gail, and Thelma Golden, and a conversation with Albert Murray. *Romare Bearden in Black and White: Photomontage Projections 1964*. New York: Harry N. Abrams and Whitney Museum of American Art, 1997.

Geluardi, John. "Mr. Bearden's Mural Goes to Washington for Show." *Berkeley Daily Planet*, May 27, 2003.

Gibson, Ann. *Abstract Expressionism: Other Politics*. New Haven, CT: Yale University Press, 1999.

Gilroy, Paul. *The Black Atlantic: Modernity and Double Consciousness*. Cambridge, MA: Harvard University Press. 1993.

Gitlin, Todd. *The Sixties: Years of Hope, Days of Rage*. New York: Bantam, 1993.

Glueck, Grace. "A Brueghel from Harlem." *New York Times*, February 22, 1970.

Godfrey, Mark, and Zoe Whitley, authors, editors, and curators. *Soul of a Nation: Art in the Age of Black Power*. London: D.A.P. and the Tate Modern, 2017.

Goler, Veta. "Moves on Top of Blues." In *Dancing Many Dreams: Excavations in African American Dance*, edited by Thomas Frantz. Madison: University of Wisconsin Press, 2002.

Gombrich, E. H. *The Uses of Images: Studies in the Social Function of Art and Visual Communication*. London: Phaidon Press, 1999.

Grant, Colin. *Negro with a Hat: The Rise and Fall of Marcus Garvey*. New York: Oxford University Press, 2008.

Greenberg, Clement. "Avant-garde and Kitsch." *Partisan Review* 6, no. 5 (1939): 34–49.

Greene, Caroll. *Romare Bearden: The Prevalence of Ritual*. New York: Museum of Modern Art, 1971.

Greenwood, Janette Thomas. *Bittersweet Legacy: The Black and White "Better Classes" in Charlotte, 1850–1910*. Chapel Hill: University of North Carolina Press, 2001.

Griffin, Farah Jasmine. *Who Set You Flowin'? The African American Migration Narrative*. Race and Culture Series. New York: Oxford University Press, 1995.

Grosz, George. *An Autobiography*. Translated by Nora Hodges. Berkeley: University of California Press, 1998 (originally published 1946).

Guilbaut, Serge. *How New York Stole the Idea of Modern Art: Abstract Expressionism, Freedom and the Cold War*. Translated by Arthur Goldhammer. Chicago: University of Chicago Press, 1985.

Gwinn, Elizabeth, Lauren Haynes, and Abbe S. Schriber, publication organizers. *The Bearden Project*. New York: Studio Museum in Harlem, 2011.

"Hale Woodruff: Tribute from Friends." *New York Amsterdam News*, November 22, 1980, 35. (Remarks at Community Church memorial to Hale Woodruff.)

Hall, James. *Mercy, Mercy Me: African American Culture and the American Sixties*. Race and Culture Series. New York: Oxford University Press, 2001.

Hall, Stuart. *The Fateful Triangle: Race, Ethnicity, Nation*. Edited by Kobena Mercer. Foreword by Henry Louis Gates. Cambridge, MA: Harvard University Press, 2017.

Hamilton, Linda. *The Cramoisy Queen: A Life of Caresse Crosby*. Carbondale: Southern Illinois Press, 2005.

Harlan, Louis R., editor. *The Booker T. Washington Papers*, Volume 3. Urbana: University of Illinois Press, 1974, 583–587.

Harmon Foundation. *Negro Artists: An Illustrated Review of Their Achievements*. New York: Harmon Foundation, 1935.

Harris, Michael D. *Colored Pictures: Race and Visual Representation*. Chapel Hill: University of North Carolina Press, 2003.

Higginbotham, Evelyn Brooks. *Righteous Discontent: The Women's Movement in the Black Baptist Church: 1880–1920*. Cambridge, MA: Harvard University Press, 1994.

Hills, Patricia. "1936: Meyer Schapiro, Art Front and the Popular Front." *Oxford Art Journal* 17, no. 1 (January 1, 1994): 30–41.

hooks, bell. *Art on My Mind: Visual Politics*. New York: New Press, 1995.

Hoving, Thomas. *Making the Mummies Dance: Inside the Metropolitan Museum of Art*. New York: Simon & Schuster, 1993.

Huggins, Nathan Irvin. *Harlem Renaissance*. New York: Oxford University Press, 1971.

Hughes, Langston. *The Big Sea: An Autobiography*. New York: Alfred A. Knopf, 1945.

Hughes, Langston. "The Negro Artist and the Racial Mountain." *Nation*, June 23, 1926.

Hughes, Robert. *American Visions: The Epic History of Art in America*. New York: Alfred Knopf, 2009.

John Simon Guggenheim Foundation. *Complete List of Awardees for the John Guggenheim Foundation Fellowships, 1925–2017*. https://www.gf.org/fellows/all-fellows/.

Johnson, James Weldon. *Along This Way: The Autobiography of James Weldon Johnson*. New York: Viking Press, 1968.

Johnson, James Weldon. *Black Manhattan*. New York: Alfred A. Knopf, 1930 (reprinted New York: Da Capo Press, 1991).

Jones, LeRoi (Amiri Baraka). *Blues People: Negro Music in White America*. New York: HarperCollins, 1963.

Kahn, Eva M. "Tile by Tile, a Mural Is Saved." *New York Times*, Art and Design and Antiques, February 25, 2010.

Karnath, Lorie. *Sam Shaw: A Personal Point of View*. Photo editing by the Shaw Family Archive. Ostfildern: Hatje Cantz Verlag, 2010.

Kirschke, Amy Helene. *Art in Crisis: W.E.B Du Bois and the Struggle for African American Identity and Memory*. Bloomington: Indiana University Press, 2007.

Kirschke, Amy Helene. *Art, Race, and the Harlem Renaissance*. Jackson: University Press of Mississippi, 1995.

Kootz, Samuel Melvin. *Modern American Painters*. New York: Brewer and Warren, 1930.

Kramer, Hilton. "Black Experience and Modernist Art." *New York Times*, February 14, 1970.

Kramer, Hilton. "Romare Bearden Tied His Work to Race, but Was a Cubist." *New York Observer*, October 26, 2003.

Lader, Melvin. "David Porter's 'Personal Statement: A Painting Prophecy, 1950.'" *Archives of American Art Journal* 28, no. 1 (1988). www.jstor.org/stable/1557536.

Landau, Helen, editor. *Reading Abstract Expressionism: Context and Critique*. New Haven, CT: Yale University Press, 2005.

Lee, Felicia. "His Brother's Keeper and Art Guardian." *New York Times*, October 22, 2012.

Lemann, Nicholas. *The Promised Land: The Great Migration and How It Changed America*. New York: Vintage Books. 1991.

Levenstein, Harvey. *We'll Always Have Paris: American Tourists in France since 1930*. Chicago: University of Chicago Press, 2004.

Lewis, David Levering, and Deborah Willis. *A Small Nation of People: W.E.B. DuBois and African American Portraits of Progress*. New York: Harper Collins, and Washington, DC: Library of Congress, 2003.

Lewis, David Levering, and Deborah Willis. *A Small Nation of People: W.E.B. DuBois and Black Americans at the Turn of the Twentieth Century*. New York: Harper Collins, and Washington, DC: Library of Congress, 2006.

Lewis, Sarah E. *Romare Bearden: Idea to Realization.* New York: DC Moore Gallery, 2011.

Linden, Diana L., and Larry Greene. "Charles Alston's Harlem Hospital Murals: Cultural Politics in Depression Era Harlem." *Prospects* 26 (2001): 391–421, doi: 10.1017/s 0361233300000983, 391.

Litwack, Leon. *Trouble in Mind: Black Southerners in the Age of Jim Crow.* New York: Alfred A. Knopf. 1996.

Locke, Alain. "Harlem: Mecca of the New Negro." *Survey Graphic*, March 1925.

Locke, Alain. *Negro Art: Past and Present.* Albany: J. B. Lyon Press, 1936.

Locke, Alain. *The Negro in Art: A Pictorial Record of the Negro Artist and of the Negro Theme in Art.* New York: Hacker Art Books, 1971 (originally published 1940).

Locke, Alain. *The New Negro: An Interpretation.* New York: Albert and Charles Boni, 1925.

Long, Richard. "Bearden: Theater, Film, Dance." In *Romare Bearden, American Modernist*, edited by Ruth Fine and Jacqueline Francis. New Haven, CT: Yale University Press, and Washington, DC: National Gallery of Art, 2011.

Long, Richard A. Introduction. *In the Eye of the Muses: Selections from the Clark Atlanta University Art Collection.* Atlanta: Clark Atlanta University Art Galleries, 2012.

Lorca, Garcia. *Poet in New York.* Edited by Christopher Maurer. Translated by Greg Simon and Steven White. New York: Farrar, Straus & Giroux. 1998.

Lorini, Allesandra. *Rituals of Race: American Public Culture and the Search for Racial Democracy.* Charlottesville: University of Virginia Press. 1999.

Lynch, Steve. *Remembrance of Romare Bearden.* Bulletin: http://www.askart.com.

Maguire, Roberta, editor. *Conversations with Albert Murray.* Literary Conversations Series. Jackson: University Press of Mississippi, 1997.

Malraux, André. *The Voices of Silence: Man and His Art* (abridged from the *Psychology of Art*). Translated by Stuart Gilbert. Princeton, NJ: Princeton University Press, 1978 (originally published 1952).

Martin, Courtney J. "From the Center: The Spiral Group, 1963–1966." *NKA: A Journal of Contemporary African Art* 29 (Fall 2011): 86–98.

Martin, Courtney J. *Spiral. Art Spaces Archives Project.* www.as-ap.org/content/spiral-courtney-martin-0.

Martin, Waldo E. Jr. *No Coward Soldiers: Black Cultural Politics and Postwar America.* Nathan Huggins Lecture Series. Cambridge, MA: Harvard University Press, 2005.

Mathews, Jane DeHart. *Federal Theater 1935–1939: Plays, Relief and Politics, I-IV.* Princeton, NJ: Princeton University Press, 1967.

Matlin, Daniel. *African American Intellectuals and the Urban Crisis.* Cambridge, MA: Harvard University Press, 2013.

McAndrew, Malia. "Selling Black Beauty: African American Modeling Agencies and Charm Schools in Postwar America." *OAH Magazine of History* 24, no. 1 (January 2010): 29–32.

McKay, Claude. *Harlem: Negro Metropolis: An Account of the World's Largest Black Community during the Eventful Years of the Twenties and Thirties.* New York: E.P. Dutton, 1940.

Melberg, Jerald L., and Milton Bloch J., editors, with essays by Albert Murray and Dore Ashton. *Romare Bearden: 1970–1980.* Charlotte, NC: Mint Museum, 1980.

Mercer, Kobena, editor. *Cosmopolitan Modernisms: Annotating Art's Histories.* Cambridge, MA: MIT Press, 2005.

Mitchell, Lofton. *Black Drama.* New York: Hawthorne Books, 1967.

Mitchell, Verner D. "To One Not There: The Letters of Dorothy West and Countee Cullen (1926–1945)." *Langston Hughes Review,* January 1, 2010.

Moon, Henry Lee. *The Emerging Thought of W.E.B. DuBois: Essays and Editorials from* The Crisis *with an Introduction, Commentaries, and a Personal Memoir by Henry Lee Moon.* New York: Simon and Schuster, 1972.

Morrison, Toni. *Playing in the Dark: Whiteness and the Literary Imagination.* Cambridge, MA: Harvard University Press, 1992.

Morrissette, Noelle. *James Weldon Johnson's Modern Soundscapes.* Des Moines: University of Iowa Press, 2013.

Munoz, Jose Esteban. *Disidentifications: Queers of Color and the Performance of Politics.* Minneapolis: University of Minnesota Press, 1999.

Murphy, David. *The First World Festival of the Negro Arts, Dakar, 1966.* Liverpool: Liverpool University Press, 2016.

Murray, Albert. *Stomping the Blues.* New York: Da Capo Press, 1976.

Murray, Albert. "The Visual Equivalent of the Blues." In *Romare Bearden: 1970–1980,* edited by Albert Murray and Dore Ashton. Charlotte, NC: Mint Museum, 1980.

Murrell, Denise M. 2014. *Seeing Laure: Race and Modernity from Manet's Olympia to Matisse, Bearden and Beyond.* Columbia University Academic Commons, https:// doi.org/10.7916/D8MK69VP.

Museum of Modern Art. Exhibition History.https://www.moma.org/research-and-learning/research-resources/archives/archives_exhibition_history_list.

Navasky, Victor S. *The Art of Controversy: Political Cartoons and Their Enduring Power.* New York: Alfred Knopf, 2013.

O'Connor, Francis V. *Art for the Millions.* New York: Graphic Society Books, 1974.

O'Connor, Francis V. *Federal Support for the Visual Arts: The New Deal and Now* (a report on the New Deal art projects in New York City and State with recommendations for present day Federal support for the visual arts to the National Endowment for the Arts). Greenwich, CT: New York Graphic Society, 1969.

O'Meally, Robert G. *Romare Bearden: A Black Odyssey.* New York: DC Moore Gallery, 2007.

O'Meally, Robert, C. Daniel Dawson, and Diedra Kelly-Harris, curators. *Paris Blues Revisited: Romare Bearden, Albert Murray, Sam Shaw.* New York: Jazz at Lincoln Center, 2011.

Osofsky, Gilbert. *Harlem: The Making of a Ghetto, Negro New York, 1890–1930.* 2nd ed. New York: Harper Torchbook, 1971.

O'Sullivan, Mary Therese. "Home Is Where the Art Is: The Impact That Housing Laws and Gentrification Policies Have Had on the Availability and Affordability of Artist Live/Work Space." *Seton Hall Journal of Sports and Entertainment Law* 23, no. 2, Article 8.

Parham, Jason. *The Man Who Spurned a Baseball Career to Become a Renowned Artist.* http://www.theatlantic.com/entertainment/archive. 2012.

Park, Marlene, and Gerald Moskovitz. *New Deal for Art: The Government Art Projects of the 1930s with Examples from New York City and State.* Albany: Gallery Association of New York State, 1977.

Patton, Sharon F. *African American Art.* Oxford: Oxford University Press, 1998.

Patton, Sharon, curator. Introduction by Mary Schmidt Campbell. *Memory and Metaphor: The Art of Romare Bearden, 1940–1987.* New York: Oxford University Press in association with the Studio Museum in Harlem, 1991.

Pauley, Brett. "Treatment for Many Ills: An Area Centers on Lincoln Hospital." *New York Times,* June 11, 1995.

Peterson, Robert. *Only the Ball Was White: A History of Legendary Black Players and All-Black Professional Teams.* Old Tappan, NJ: Prentice-Hall, 1970.

Petruniak, Roman. "Art Workers on the Left: The Art Workers Coalition and the Emergence of a New Collectivism." Master's thesis, School of the Art Institute of Chicago, 2009.

Porter, James. Introduction, David Driskell. *Modern Negro Art.* Washington, DC: Howard University Press, 1992 (originally published 1943).

Porter, James. "The Negro Artist and Racial Bias." *Art Front,* July 1937.

Porter, James. Notes on Romare Bearden for the exhibition: *Ten Hierographic Paintings by Sgt. Romare Bearden.* Washington, DC: G Place Gallery, 1944.

Powell, Richard. *Black Art: A Cultural History.* 2nd ed. (World of Art). London: Thames and Hudson, 2003.

Powell, Richard. *Homecoming: The Art and Life of William H. Johnson.* New York: Rizzoli, 1991.

Powell, Richard, Virginia Mecklenberg, and Theresa Slowik. *African American Art: Harlem Renaissance, the Civil Rights Era and Beyond.* New York: Skira Rizzoli, 2012.

Price, Sally, and Richard Price. *Romare Bearden: The Caribbean Dimension.* Philadelphia: University of Pennsylvania Press, 2006.

Rampersad, Arnold. *The Life of Langston Hughes,* Volume I, 1902–1941, I, Too, Sing America. New York: Oxford University Press, 1986.

Rampersad, Arnold. *Ralph Ellison: A Biography.* New York: Knopf, 2007.

Raynor, Vivien. "A Glance at Romare Bearden at the Bronx Museum of Art." *New York Times,* January 4, 1987.

Read, Alan, editor. *The Fact of Blackness: Frantz Fanon and Visual Representation.* Institute of Contemporary Art, London. Seattle: Bay Press, 1996.

Renoir, Jean, director. *Charleston Parade.* 3 Disc Collector's Edition. Santa Monica. CA. and Paris: Lionsgate and Studio Canal, 1927 (date of original release).

Reynolds, Jock, and Beryl Wright, curators. *Against the Odds: African-American Artists and the Harmon Foundation.* Newark: Newark Museum of Art, 1990.

Rice, Gregory Foster. "Romare Bearden's Tactical Collage." In *Romare Bearden in the Modernist Tradition: Essays from the Romare Bearden Foundation Symposium.* Chicago: Romare Bearden Foundation, 2008.

Ringgold, Faith. *We Flew over the Bridge: The Memoirs of Faith Ringgold.* Durham, NC: Duke University Press, 2005.

Rosenberg, Harold. *Six American Painters Galerie Maeght, Paris.* New York: Samuel M. Kootz Gallery, 1947.

Rowell, Charles H. "'Inscription at the City of Brass': An Interview with Romare Bearden." *Callaloo* 36 (Summer 1988).

Sandler, Irving. *The Triumph of American Painting: Abstract Expressionism.* New York: Harper and Row, 1976.

Schoener, Allon, editor. *Harlem on My Mind: Cultural Capital of Black America, 1900–1968.* New York: Metropolitan Museum of Art, 1968.

Schuyler, George S. "The Negro Art Hokum." *Nation,* June 16, 1926.

Schwartzman, Myron. *Romare Bearden: His Life and Art.* Foreword by August Wilson. New York: Harry N. Abrams, 1990.

Seitz, William C. *The Art of Assemblage.* New York: Museum of Modern Art, in collaboration with the Dallas Museum of Contemporary Arts and the San Francisco Museum of Art; distributed by Doubleday, Garden City, NY, 1961.

Session, Ralph, with foreword by Bridget Moore. *Romare Bearden: Insight and Innovation.* New York: DC Moore Gallery, 2014.

Sexton, John, with Tom Oliphant and Peter J. Schwartz. *Baseball as the Road to God: Seeing beyond the Game.* New York: Gotham Books, 2013.

Shange, Ntozake. *I Live in Music: Poems by Ntozake Shange; Paintings by Romare Bearden.* New York: Welcome Books, 1994.

Shannon, Helen. "African Art and Cubism, Proto-Collage and Collage in the Work of Romare Bearden." In *Romare Bearden in the Modernist Tradition: Essays from the Romare Bearden Foundation,* Pamela Ford, Symposium and Publication Manager. Dalton, MA: Studley Press, 2007, 21–30.

Shohat, Ella, and Robert Stam. *Unthinking Eurocentrism: Multiculturalism and the Media.* New York: Routledge, 1994.

Siegel, Jeanne, moderator. "The Black Artist in America: A Symposium." *Metropolitan Museum of Art Bulletin* 27, no. 5 (1969).

Siegel, Jeanne. "Why Spiral: Remembering the Black Arts Movement." Special Issue: *ARTnews* 65, no. 5 (1966).

Sims, Lowery Stokes. *Romare Bearden.* New York: The Rizzoli Art Series, 1993.

Sims, Lowery S., June Kelly, and Davira S. Taragin, curators. Lowery Sims, essay. "Romare Bearden: An Artist's Odyssey" in *Romare Bearden: Origins and Progressions.* Detroit: Detroit Institute of Arts. September 16–November 16, 1986.

Sklar, Robert. *Movie-Made America: A Cultural History of American Movies.* New York: Vintage Books, 1994.

Sklar, Robert. *A World History of Film.* New York: Harry N. Abrams, 2001.

Smith, Shawn Michelle. *Photography on the Color Line: W.E.B. Du Bois, Race, and Visual Culture.* Durham, NC: Duke University Press, 2004.

Stewart, Jacqueline Najuma. *Migrating to the Movies: Cinema and Black Urban Modernity.* Berkeley: University of California Press, 2005.

Stolberg, Benjamin. "Big Steel, Little Steel." *Nation,* July 31, 1937.

Stromberg, John. "Colossal Remnants: Romare Bearden." *Bostonia, Alumni Quarterly of Boston University,* Spring 2001.

Sylvester, David. *Interviews with American Artists.* New Haven, CT: Yale University Press, 2001.

Tomkins, Calvin. Profile: "Putting Something Over Something Else." *New Yorker*, November 28, 1977.

Tomkins, Calvin. *Romare Bearden: Odysseus Collages*. New York: Cordier & Ekstrom, 1977.

Trachtenberg, Alan. *Reading American Photographs: Images as History, Mathew Brady to Walker Evans*. New York: Hill & Wang, 1989.

Turner, Elizabeth Hutton, Patricia Hills, Paul Karlstrom, Leslie King-Hammond, Lizzeta LaFalle Collins, Richard Powell, Lowery Stokes-Sims, and Elizabeth Steele. *Over the Line: The Art and Life of Jacob Lawrence*, edited by Peter Nesbitt; illustrated by Jacob Lawrence. Seattle: University of Washington, 2011.

Vogel, Shaun. *Scene of Harlem Cabaret: Race, Sexuality, Performance*. Chicago: University of Chicago Press, 2009.

Walcott, Derek, and Romare Bearden. *The Caribbean Poetry of Derek Walcott and the Art of Romare Bearden*. New York: Limited Edition Club, 1983.

Wallace, Maurice, and Shawn Michelle Smith. *Pictures and Progress: Early Photography and the Making of the African American Identity*. Durham, NC: Duke University Press, 2012.

Wallace, Michele, project director, and Gina Dent, editor. *Black Popular Culture*. New York: Dia Center for the Arts, 1992.

Wardlaw, Alvia, editor. *Something All Our Own: The Grant Hill Collection of African American Art*. Durham, NC: Duke University Press, 2004.

Washington, M. Bunch, with an introduction by John Williams. *The Art of Romare Bearden: The Prevalence of Ritual*. New York: Harry N. Abrams, 1973.

Wilkerson, Isabel. *The Warmth of Other Suns*. New York: Random House, 2010.

Wilkins, Roy. *Standing Fast: The Autobiography of Roy Wilkins*. New York: Da Capo Press. 1994.

Willis, Deborah. *Posing Beauty: African American Images from the 1890s to the Present*. New York: W. W. Norton, 2009.

Willis, Deborah. *Reflections in Black: A History of Black Photographers, 1840 to the Present*. New York: W. W. Norton, 2000.

Wilson, Judith. "Getting Down to Get Over: Romare Bearden's Use of Pornography and the Problem of the Black Female Body." In Michelle Wallace, *Black Popular Culture*, edited by Gina Dent. Seattle: Bay Press, 1992.

Wilson, Sondra Kathryn, editor. *The Selected Writings of James Weldon Johnson*, Volume I: *New York Age Editorials (1914–1923)*. New York: Oxford University Press, 1995.

Woodruff, Hale. "*Amistad* Murals Illustrated." *Phylon* 2, no. 1 (1941).

Wright, Richard, Edwin Rosskam, and the United States Farm Security Administration. *12 Million Voices: A Folk History of the Negro in the United States*. New York: Viking Press, 1941.

Young, Kevin. *The Grey Album: On the Blackness of Blackness*. Minneapolis, MN: Graywolf Press, 2012.

Zimmer, Heinrich, and Joseph Campbell. *The King and the Corpse: Tales of the Soul's Conquest of Evil*. New York: Pantheon Books, 1948.

Zinn, Howard. *A People's History of the United States*. New York: Harper and Row, 1980 (reprinted Harper Perennial, 1990).

PUBLISHED WRITINGS
OF ROMARE BEARDEN

Note: These writings are arranged chronologically by publication date.

"The Negro Artist and Modern Art." *Opportunity: Journal of Negro Life* 12 (December 1934): 371–372.

Letter to the editor. "Consider the Jews and the Irish." *Baltimore Afro-American*, June 27, 1936, 4.

"They Make Steel: Workers' Life Drab and Dark without Union." *New York Amsterdam News*, October 23, 1937, 13.

"The Negro in Little Steel." *Opportunity: A Journal of Negro Life* 15 (December 1937): 362–365, 380.

Artist's statement. In *Romare Bearden: Oils, Gouaches, Water Colors, Drawings 1937–1940*. Exhibition catalogue, 306 West 141st Street, New York, May 4–May 11 [1940].

Artist's statement. In *The Passion of Christ*. Exhibition catalogue, G Place Gallery, Washington, DC, June 1945.

Artist's statement. In *First New York Exhibition: Romare Bearden*. Exhibition catalogue, Kootz Gallery, New York, 1945.

"The Negro Artist's Dilemma." *Critique: A Review of Contemporary Art* 1, no. 2 (November 1946): 16–22.

"The Artistic Imagination." In *Second Annual Fall Review of Paintings and Sculpture: 1956*. Exhibition catalogue, Pyramid Club, Philadelphia, October 26–November 26, 1956.

Letter to the editor. "Good Reporting!" *New York Amsterdam News*, January 14, 1961, 8.

"Ironic Note. To the Art Editor." *New York Times*, April 9, 1961, 444. An answer by Romare Bearden to "Abstract Artist, 46, Loses to Firemen on Studio in a Loft." *New York Times*, March 21, 1961, 27.

"Harold's Friend." In *Pulse of the Public, New York Amsterdam News*, August 5, 1961, 10.

Artist's statement. "Romare Bearden Biography." In *Romare Bearden Projections*. Exhibition catalogue, Cordier & Ekstrom, October 6–24, 1964.

Artist's statement. In *Some Negro Artists*. Exhibition catalogue, Fairleigh Dickinson University, Madison, NJ, Art Gallery, October 20–November 20, 1964.

Artist's statement. In *Romare Bearden*. Exhibition catalogue, Corcoran Gallery of Art, Washington, DC, October 1–31, 1965.

Artist's statement. In *Contemporary Urban Visions*. Exhibition catalogue, New School Art Center, Wollman Hall, New York, January 25–February 24, 1966, 5.

"Art of American Negro on Exhibit in Harlem." *New York Amsterdam News*, July 16, 1966, 46.

"Art of American Negro on Exhibit in Harlem: Part II." *New York Amsterdam News*, July 30, 1966, 30.

Untitled poem. In *Ten Negro Artists from the United States. / Dix artistes nègres des Etats Unis. Premier festival mondial des arts nègres*. Exhibition catalogue, United States, Commission for the First World Festival of Negro Arts, and National Collection of Fine Arts, Smithsonian Institution, Dakar, Senegal, 1966.

Bearden, Romare, and Carroll Greene Jr., co-directors. *Evolution of the Afro American Artist, 1800–1950*. Exhibition catalogue, City University of New York, Harlem Cultural Council and National Urban League, 1967.

Artist's statement. In *Romare Bearden: Six Panels on a Southern Theme*. Exhibition catalogue, Bundy Art Gallery, Waitsfield, VT, April 12–May 29, 1967.

Artist's statement. In *Romare Bearden Collages*. Exhibition catalogue, J. L. Hudson Gallery, Detroit, November 9–30, 1967. (Reprint text by John Canaday, "Treatment Is Poignant but Not Mawkish," *New York Times*, October 14, 1967.)

Untitled poem. In *Encounters: An Exhibition in Celebration of the Charlotte-Mecklenburg Bi-Centennial*. Exhibition catalogue, Johnson C. Smith University, James B. Duke Library, Charlotte, NC, November–December 1968. Introduction by Eugene Grigsby.

"The Artist Responds." *Harvard Art Review* 3, no. 2 (Summer 1969): 31 [Response to letter sent to artists by associate editor David Stang soliciting commentary on art education.]

Bearden, Romare, and Carl Holty. *The Painter's Mind*. New York: Crown, 1969.

Bearden, Romare, and Carl Holty. *The Painter's Mind: A Study of the Relations of Structure and Space in Painting*, introduction by Ralph Ellison. Critical Studies on Black Life and Culture, Volume 9. New York: Garland, 1981.

"Rectangular Structure in My Montage Paintings." *Leonardo* 2 (January 1969): 11–19.

"Bearden Reviews Thompson Exhibits." *New York Amsterdam News*, April 26, 1969, 27.

Artist's statement. In *The Black Experience*. Exhibition catalogue, Lincoln University, Jefferson City, MO, 1970.

"The Poetics of Collage." In *Art Now: New York* 2, no. 4 (1970): unpaginated folio.

[With statements by ten others; Bearden on p. 33]. In "Black Art: What Is It?" *ART Gallery* 13, no. 7 (April 1970): 32–35.

Review of *American Negro Art* by Cedric Dover. *Leonardo* 3 (April 1970): 241–243.

Bearden, Romare, and Carl Holty. Review of *Theories of Modern Art: A Source Book by Artists and Critics* by Herschel B. Chipp. *Leonardo* 3, no. (July 1970): 361–362.

Foreword. *Fifteen under Forty: Paintings by Young New York State Black Artists*. Exhibition catalogue, Gallery Museum, Hall of Springs, Saratoga Performing Arts Center, NY, July 1–July 31, 1970.

"The 1930's—An Art Reminiscence." *New York Amsterdam News*, September 18, 1971, D24, D26.

Bearden, Romare, and Harry Henderson. *Six Black Masters of American Art: Joshua Johnston / Robert S. Duncanson / Henry Ossawa Tanner / Horace Pippin / Augusta Savage / Jacob Lawrence.* New York: Doubleday, 1972.

Bearden, Romare, and Carl Holty. Review of *Contemporary Art in Africa* by Ulli Beier. *Leonardo* 5, no. 2 (Spring 1972): 176–177.

Bearden, Romare, and Philip S. Foner. Teacher's Guide for *The Black Experience.* Stamford, CT: Sandak, [1973].

Bearden, Romare, and Carl Holty. Review of *The Living Arts of Nigeria* by William Fagg. *Leonardo* 6, no. 1 (Winter 1973): 72–73.

Bearden, Romare, and Harry Henderson. "Letters to the Editor: Black Art." *Art in America* 61 (March–April 1973): 117. [Response to Henri Ghent's review of *Six Black Masters.*]

Review of *African Design: From Traditional Sources*, by Geoffrey Williams. *Leonardo* 7, no. 3 (Summer 1974): 277.

"Historical Notes." In *The Barnett-Aden Collection.* Washington, DC: Smithsonian Institution Press, 1974. Published for Anacostia Neighborhood Museum, in co-operation with Barnett-Aden Gallery. Catalogue for exhibition at Anacostia Neighborhood Museum, Smithsonian Institution, Washington, DC, January 20–May 6, 1974; Corcoran Gallery of Art, Washington, DC, January 10–February 9, 1975. [Bearden and thirteen others contributed tributes to founders of the Gallery.]

"A Painter in the Fifties." *Arts Magazine* 48, no. 7 (April 1974): 36–37. [An article about Carl Holty.]

"Letters: More on Edmonia Lewis." *Art in America* 62 (November–December 1974): 168. [Letter to editor in response to article by Eleanor M. Tufts, *Art in America* 62 (July–August 1974).]

Review of *African Design: From Traditional Sources* by Geoffrey Williams. *Leonardo* 7, no. 3 (Summer 1974): 277.

"Humility." *New York Times*, Saturday, June 21, 1975, 27. [Part of a graduation speech given at Carnegie-Mellon University, Pittsburgh.]

"A Master Looks Back." *Black Enterprise* 6 (December 1975): 64–65, 69.

Review of *The Afro-American Artist: A Search for Identity* by Elsa Honig Fine. *Leonardo* 8 (Winter 1975): 82–83.

Comments in *Dana Chandler (Akin Duro): "If the Show Fits, Hear It!"—Paintings and Drawings, 1967–1976.* Exhibition catalogue, Northeastern University Art Gallery, Boston, March 8–April 2, 1976, n.p. [Bearden's comments are dated March 4, 1974.]

Statement. In "View from the Top: The Pluses and Minuses of Being an Only Child." *Buffalo Courier-Express,* August 15, 1976.

"The Black Man in the Arts." *New York Amsterdam News. Special Black Bicentennial Edition* (Summer 1976), C7.

"Horace Pippin." *ArtWorld* (April 1977): 10.

"Horace Pippin." In *Horace Pippin.* Exhibition catalogue, Phillips Collection, Washington, DC, February 25–March 27, 1977, n.p. Circulated at Terry Dintenfass Gallery, New York, April 5–30, 1977; Brandywine River Museum, Chadds Ford, PA, June 4–September 5, 1977.

"A Tribute to 'Spinky' Alston By Romare Bearden." *New York Amsterdam News,* June 18, 1977, A1, A6.

"An Artist's Plea for Harmony." *School Arts* 77 (September 1977): 72–73.

Foreword. In Elton C. Fax, *Black Artists of the New Generation.* New York: Dodd, Mead, 1977.

"Kosta Alex." *ArtWorld* 2, no. 9 (May 18/June 16, 1978): 12. [Exhibition review, Lee Ault Gallery, New York.]

"Eating at Ma Chance's." *Essence* 9 (April 1979): 112–114.

"A Final Farewell to Aaron Douglas." *New York Amsterdam News,* February 24, 1979, 65. (Reprinted as "Farewell to Aaron Douglas." *Crisis* 86 (May 1979): 164—165.)

"Sharing Yesterdays with Norman Lewis (1909–1979)." *New York Amsterdam News,* December 15, 1979, 27. [Reminiscences, Part 1.]

"Norman Lewis Remembered." *New York Amsterdam News,* January 5, 1980, 22. [Reminiscences, Part 2.]

Bearden, Romare, et al. "To Our Colleague." *Freedomways* 20, no. 3 (1980): 179–183. [Comments from six artists on Charles White (1918–1979); Bearden on p. 179.]

"Hale Woodruff: Tribute from Friends." *New York Amsterdam News,* November 22, 1980, 35. (Reprinted in *Harlem Cultural Review,* April 1981, 8.) [From Bearden's remarks at Community Church memorial to Hale Woodruff.]

Bearden, Romare. "Herbert Gentry." In *An Ocean Apart: American Artists Abroad.* Exhibition catalogue, SMIH, October 8, 1982–January 9, 1983, 9–10.

"An Artist's Renewal in the Sun." *New York Times Magazine* 133 (October 2, 1983): section 6: 46–48, 52.

Statement. In *Celebration: Eight Afro-American Artists Selected by Romare Bearden.* Exhibition catalogue, Henry Street Settlement, Louis Abron Arts for Living Center, New York, February 17–April 1, 1984. [The eight artists are Emma Amos, Toyce Anderson, Ellsworth Ausby, Vivian Browne, Nanette Carter, Melvin Edwards, Sharon Patton, and Richard Yarde. Also included is a statement by Susan Fleminger and artists' commentaries.]

"Scale." In "Artists on Architecture," edited by Donald Canty. *Architecture* 73 (May 1984): 230–241, 335. [Bearden on p. 240.]

"A Tribute to Robert Blackburn." In *Art in Print: A Tribute to Robert Blackburn.* Exhibition catalogue, NYPL/SC, November 30, 1984–January 19, 1985. Text by Emma Amos, Romare Bearden, and Julia Hotton.

"Clouds in the Living Room." *New York Times Magazine,* part 2 (October 6, 1985): SMA80–81.

Artist's statement. In *Romare Bearden: Origins and Progressions.* Exhibition catalogue, Detroit Institute of Arts, September 16–November 16, 1986. Text by Lowery S. Sims. [Excerpts from Bearden's 1947 and 1949 journals, edited by Davira S. Taragin.]

Artist's statement. In *Artists Observed.* Photographs by Harvey Stein. Text by Cornell Capa and Elaine A. King. New York, 1986.

"Artists in Focus: Photographs of and Statements by Contemporary Artists: Romare Bearden." *American Artist* 50 (June 1986): 12. [Photos from Harvey Stein's *Artists Observed*; commentary by Romare Bearden on approach to art.]

Perspectives: Angles on African Art. Exhibition catalogue, Center for African Art, New York, and Harry N. Abrams, 1987. Interviews, conducted by Michael John Weber, with James Baldwin, Romare Bearden, Ekpo Eyo, Nancy Graves, Ivan Karp, Lela Kouakou, Iba N' Diaye, David Rockefeller, William Rubin, and Robert Farris Thompson. Introduction by Susan Vogel.

Artist's statement. In "1988: Previews from 36 Artists." *New York Times*, January 3, 1988, H1, H30. H31. [Bearden on H31.]

"Reminiscences." In *Riffs and Takes: Music in the Art of Romare Bearden*. Exhibition catalogue, North Carolina Museum of Art, Raleigh, January 23–April 3, 1988.

Poems ("Andre's Dream," "Eugene," "Have We Played Enough?" "Hungry Morning," "Sometimes I Remember My Grandfather's House") and journal entries (September 5, 1947, and December 19, 1947), from the collection of Nanette Rohan Bearden. In *Romare Bearden: A Memorial Exhibition*. Exhibition catalogue, ACA (American Contemporary Art) Galleries, New York, May 11– June 10, 1989. (Reprinted in *Romare Bearden in Black and White: Photomontage Projections 1964*. Exhibition catalogue, Whitney/Philip Morris, January 17–March 20, 1997.)

Bearden, Romare, and Harry Henderson. *A History of African American Artists: From 1792 to the Present*. New York: Pantheon Books, 1993.

Li'l Dan, the Drummer Boy: A Civil War Story. New York: Simon & Schuster, 2003. Foreword by Henry Louis Gates.

INDEX

Note: Page numbers in *italics* indicate photographs, illustrations, and associated captions.